C000318826

Sp
Heroes

The Book of British

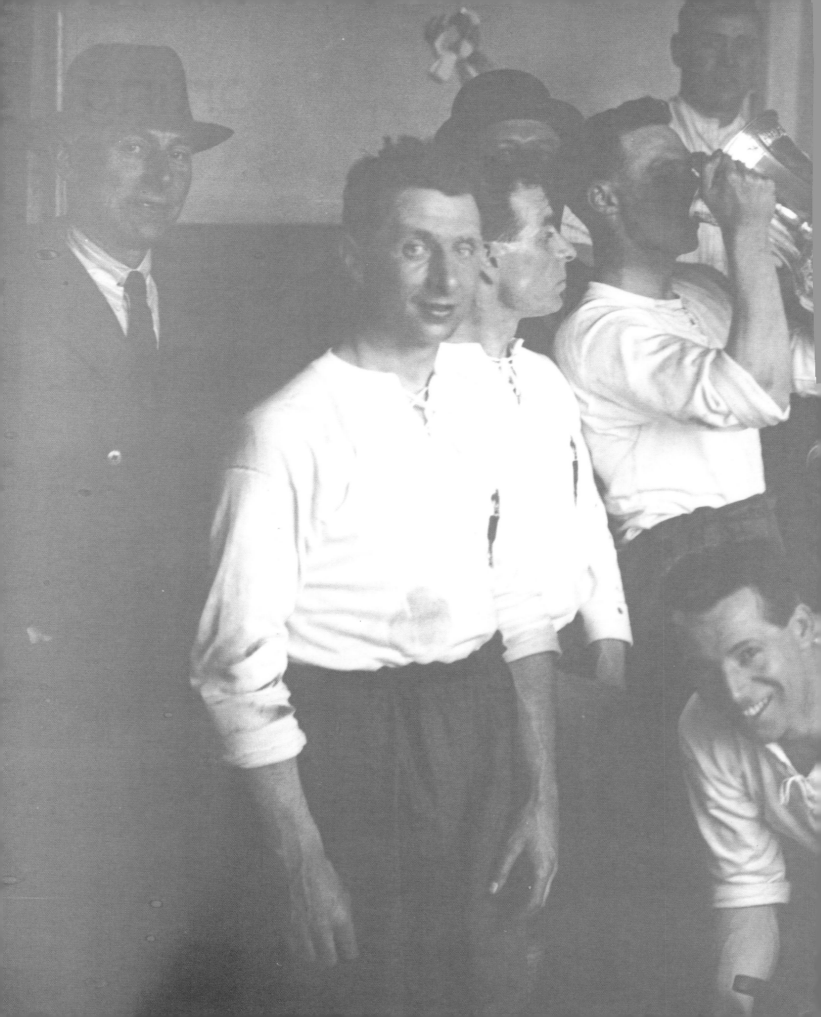

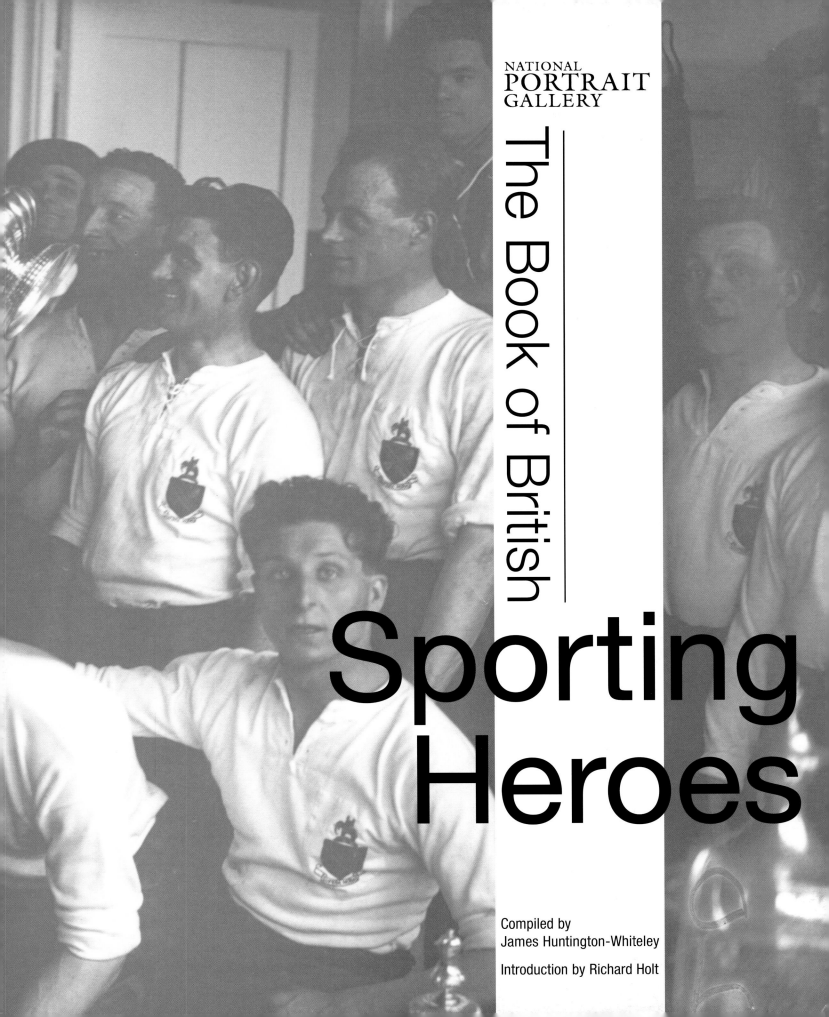

NATIONAL
PORTRAIT
GALLERY

The Book of British

Sporting Heroes

Compiled by
James Huntington-Whiteley

Introduction by Richard Holt

Published to accompany the exhibition *British Sporting Heroes*, held at the National Portrait Gallery, London, from 16 October 1998 to 24 January 1999

Published in Great Britain
by National Portrait Gallery Publications,
National Portrait Gallery, St Martin's Place,
London WC2H 0HE

Copyright © National Portrait Gallery, 1998
Introduction Copyright © Richard Holt, 1998
Unless otherwise stated (see picture credits), all images reproduced in this book are copyright the National Portrait Gallery.

The moral right of the authors has been asserted. All rights reserved. No part of this publication may be reproduced, stored in a retrieval system or transmitted in any form or by any means, whether electronic or mechanical, including photocopying, recording or otherwise, without the prior permission in writing from the publisher.

ISBN 1 85514 249 X

A catalogue record for this book is available from the British Library

Senior Editor: Lucy Clark
Designer: Blackjacks
Printed by BAS Printers, England

Cover (left to right): James (Jem) Robinson, 1850; Wavell Wakefield, 1923; Jack Hobbs, 1920s; Naseem Hamed, 1996; W.G. Grace, 1890; David, Lord Burghley, 1926; Kitty Godfree, 1924 and George Best, 1968

All of the above portraits are illustrated in full in the book. The National Portrait Gallery expresses its gratitude to all the lenders of the above images for their kindness and generosity. Full lender and copyright details are given in the Picture Credits to this book.

Frontispiece: Bolton toast their FA Cup victory, 24 April 1926

Imprint and contents pages: Sebastian Coe leading Steve Cram and Steve Ovett in the 1500m, Moscow Olympics, 1980

For a complete catalogue of current publications, please write to the address above.

Unless otherwise stated, all biographies and boxed features are written by James Huntington-Whiteley. Initials at the end of entries denote other authors and are as follows:

ERC (Elinor Clark. Curator, British Golf Museum)
HC (Honor Clerk. Curator, Twentieth-century Collection, National Portrait Gallery)
JC (John Cooper. Head of Education, National Portrait Gallery)
FRF (F.R. Furber. Royal Blackheath Golf Club)
PNL (Peter Lewis. Director, British Golf Museum)
PR (Peter Radford. Professor of Sports Science, Brunel University)
WV (Wray Vamplew. Director of International Centre for Sports History and Culture, De Montfort University)

 Hulton Getty

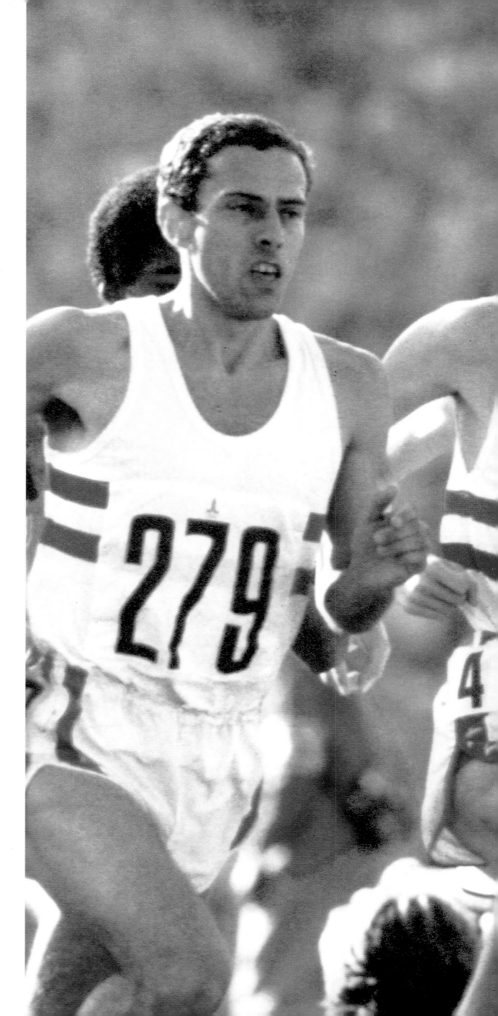

The Daily Telegraph

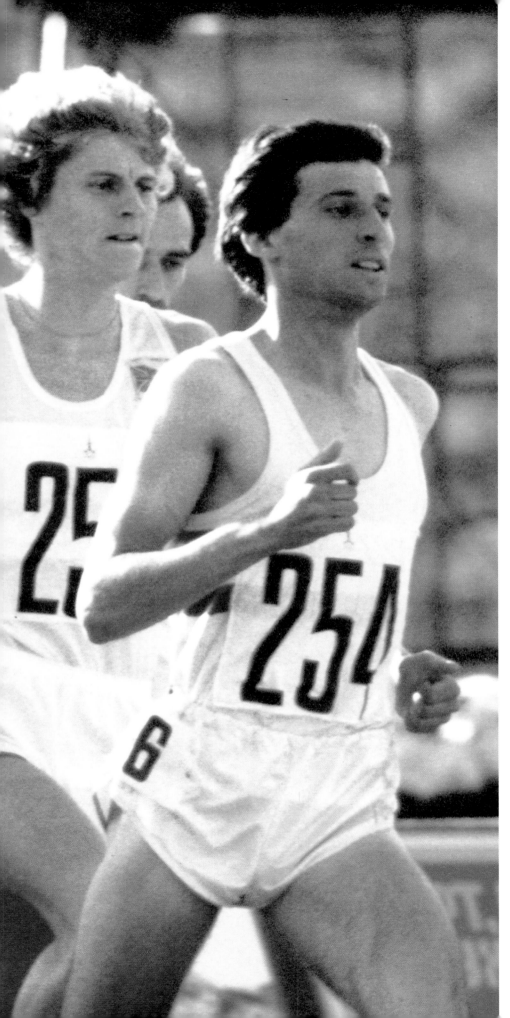

Contents

Acknowledgements

Perhaps more than with most compilations, this has been a collaborative effort and there are many people whom the organisers would like to thank for their help. First among these is Richard Holt, whose enthusiasm and patience, together with his broadly based knowledge of sporting history, have been invaluable aids in the gathering of material. Equally indefatigable, and endlessly cheerful in the face of persistent enquiries has been Paul Prowse of Hulton Getty whose searches have produced many superb images for this exhibition; to him, and to David Allison, we are most grateful. Peter Radford, himself no mean sporting hero, has contributed valuable information on pedestrianism; Peter Lewis and Elinor Clark of the British Golf Museum in St Andrews have kindly written the golfing entries for this book; Wray Vamplew of De Montfort University has answered innumerable questions and helped in particular with horse racing information.

Among many others we would especially like to thank Bill Adcocks (British Athletic Federation), David Barber (Football Association), Dennis Bird (National Ice Skating Association), Hilary Bracegirdle and Graham Snelling (National Horseracing Museum), Dennis Brailsford, Denis Clarebrough, Ian Cook (Arsenal Museum), David Crane, Mark Curthoys (New Dictionary of National Biography), Jon Culverhouse (Burghley House), David Fuller (British Sporting Art Trust), Bobby Furber (Royal Blackheath Golf Club), Tony Gee, Robert Gate, Richard Green Gallery, Stephen Green and Michael Wolton (Marylebone Cricket Club), Jeff Hancock (Surrey County Cricket Club), James Holloway and Susanna Kerr (Scottish National Portrait Gallery), Cilla Jackson (St Andrews University), Lachlan McIntosh (Royal and Ancient Golf Club, St Andrews), Jo Matthews (Public Record Office), Philip Mould, Virginia Murray (John Murray Publishers Limited), Nick Potter, David Roke, John Sheeran, Jed Smith (Museum of Rugby, Twickenham), Valerie Warren (Wimbledon Lawn Tennis Museum) and Caroline Worthington (Royal Albert Memorial Museum and Art Gallery, Exeter).

Our colleagues at the National Portrait Gallery have been unfailingly supportive and we would particularly like to acknowledge contributions from John Cooper on cricket, Robert Carr-Archer, Jacky Colliss Harvey, Lucy Clark, Pallavi Vadhia and Susie Foster for their work on this book, Christine Byron and Martha Brooks for dealing efficiently with an unusually complicated variety of loans, Jill Springall, Antonia Leak and Terence Pepper for helping to locate many elusive images, and Pim Baxter, Emma Marlowe and Ben Rawlingson-Plant for throwing themselves wholeheartedly into publicising the exhibition.

We are particularly grateful to all the lenders to the exhibition:

Allsport
Bob Appleyard
Edgar Astaire
John Austin
Richard Bailey
Trustees of the British Museum
The Burghley House Collection
James Butler/Reg Harris Memorial Fund
C. Capstack Portrait Archive
Michael Carr-Archer
Cheltenham Art Gallery and Museum
Colorsport
Cottesbrooke Hall, Northampton
Gerry Cranham
Andrew Crocker
Carol Djukanovic
Patrick Eagar
Ford Motor Company
Robert Gate Collection
Harris Museum & Art Gallery
Hulton Getty Picture Collection
Jockey Club Estates Ltd
Trevor Jones
Collection of Joseph McGrath
Marylebone Cricket Club
John Murray

National Horseracing Museum
National Portrait Gallery, London
Knightshayes, the Heathcoat-Amory Collection
 (The National Trust)
The Hamilton Collection, Brodick Castle, in care of the National
 Trust for Scotland
Popperfoto
Private Collections
Professional Footballers' Association
Professor Peter F. Radford
Public Record Office
Royal Albert Memorial Museum and Art Gallery, Exeter
Royal and Ancient Golf Club of St Andrews
Royal Blackheath Golf Club
Cowie Collection, St Andrews University Library
Gerald Scarfe
Scottish National Portrait Gallery, Edinburgh
Mark Shearman
Chris Smith
The Earl of Snowdon
Surrey County Cricket Club
Tate Gallery, London
Topham Picture Point
The Wimbledon Lawn Tennis Museum
Yale Center for British Art, Paul Mellon Collection

Director's Foreword

A year and a half ago, Tony Banks, soon after he had been appointed as Minister for Sport, approached the National Portrait Gallery with a suggestion that we ought to consider doing a major exhibition showing the changing fortunes and status of British sport through portraits. It was, not surprisingly, an idea which was received with enthusiasm by everyone in the Gallery. We are unusually well placed to look at the imagery of sport, having collected portraits of sporting heroes since the Gallery was founded in 1856. During the last decade, the Trustees of the Gallery have commissioned portraits of, among others, Sir Bobby Charlton, Ian Botham, Duncan Goodhew and Daley Thompson. And we would like to think that, by holding an exhibition on a subject of such universal appeal, we may encourage a new audience into the Gallery.

In fact, our location makes an exhibition on sport particularly appropriate. The Fives Court was just off Haymarket, John Wisden's bookshop was round the corner near the underground station in Cranbourn Street. And there are at least two pubs nearby – the Hand and Racquet and the Tom Cribb – which are reminders that a passionate, popular interest in sport is nothing new.

As always, the Gallery is very grateful to all those people who have helped us, particularly those many sporting institutions and museums as well as private lenders and photographers who have generously made works available to us. The exhibition's curator and author of most of the entries in this book, James Huntington-Whiteley, has worked exhaustively on the selection and preparation of this exhibition in conjunction with Honor Clerk, Curator of the Twentieth-Century Collection, and other colleagues at the National Portrait Gallery.

We would also like to thank the Hulton Getty Picture Collection, Allsport and the *Daily Telegraph* for their additional support for the exhibition.

Charles Saumarez Smith

Curators' Foreword

The National Portrait Gallery's *Book of British Sporting Heroes* is about winners and champions, but it is also about the heroic losers and eccentric individuals who go to make up the history of sport in Britain from 1750 to the present day. Neither this book, nor the exhibition which accompanies it, attempt to provide a linear history of sport, nor are they in any way definitive. The selection process has been contentious – and enjoyable – and in consultation with sports historians and dozens of experts we have arrived at the names of nearly 250 British sportsmen and women. The emphasis has been on those sports most relevant to the British way of life: athletics, boxing, cricket, football, golf, motor sports, horse racing, rugby and tennis. We all want to have our say when it comes to selection of the national football or cricket team, but books and exhibitions about sport are like sport itself: a general consensus is impossible. The space available in an exhibition gallery, however, made for harsh editing and two words helped us to narrow our focus. The sports had to be truly *competitive* and to enjoy widespread *popularity*. Hunting and field sports, endurance and pioneer sports were reluctantly omitted. While these are undeniably heroic in terms of participation, they lack the immediate audience which creates and then celebrates public heroes. Neither was there space for the many who contribute off the field of play: managers, promoters, trainers, commentators and writers, who are all part of the making of the sporting hero. Whereas in the Sporting Heroes exhibition we have, through electronic means, been able to guess at the great heroes of tomorrow, in this book we have confined our selection to those stars whose position is already firmly fixed in the sporting galaxy.

THE REPRESENTATION OF THE SPORTING HERO

British sporting art took its place in the country house collection, together with Old Masters and ancestral portraits. Equestrian art began to embrace the sporting hero the moment one horse was set to race against another with a jockey in the saddle. Although his features may have been recorded, the jockey's name has often been lost to posterity: he was merely another domestic servant, a useful indicator, in his coloured silks, of the identity of the horse's owner. Along with the horsemen in the country house retinue, there might have been a number of burly outdoor servants and a courier, to run messages from house to house or between town and country residences. Out of these paid occupations developed the competitive sports of prize-fighting and pedestrianism (foot-running): one man's servant being put forward against another. Wherever these riders, fighters or runners became famous, they and their feats may have been recorded, sometimes commissioned from the leading artists of the day, sometimes portrayed by anonymous journeymen painters. As crowds began to gather at the race-track or the prize-ring, or to marvel at feats of endurance, demand grew for images of the protagonists. Engravers and print publishers saw the potential of the sporting print, and within days of an important fight or race,

images were available. Few subjects are as well suited to the rapidity of print production as sport, and the appearance of sporting images in specialist publications from the eighteenth century onwards was the beginning of a media process which evolved, gathering pace, through Victorian illustrated magazines to the saturation coverage of today's tabloid newspapers.

'Sporting Art' – a genre we usually associate with paintings of hunting, shooting and fishing – parted company with the representation of the sporting hero following the rise and codifying of new sports towards the end of the nineteenth century. Cricket, horse racing, boxing, and even to some extent golf, have a strong artistic tradition, but football, rugby and modern athletics have a very different visual history. The images of their heroes were popularised through mass-produced and ephemeral portraits. From the 1890s cigarette and trade cards were a major part of British sporting culture, and it is sometimes only through these that the likenesses of once well-known individuals are preserved. There were, of course, omnipresent faces, and collectors can still readily find the features of W.G. Grace or Fred Archer – the first tabloid heroes – on a host of household objects and bric-a-brac, from plates, pots, pans and furniture through to handkerchiefs, pipes and mugs.

The tradition of the formal painted portrait did not vanish in the twentieth century. As this book shows with paintings of Tom Finney, Henry Cotton, Kitty Godfree and Lennox Lewis, portraits continue to be commissioned up to the present day, but it became increasingly apparent that photography and film were the obvious medium for sport. As early photographers and pioneers of film demonstrated, it was not long before the camera could capture the split-second 'sporting moment'. George Beldam's photograph of Ranji at the crease in 1901 was a forerunner of the boom in photojournalism a generation later. When the lightweight Leica camera replaced the obligatory box of glass plates, the photographer was able to take many more photographs and to respond more quickly to unforeseen opportunities. Resulting multi-page picture spreads became regular features of magazines such as *Picture Post* from the 1930s and many of the finest photographs in this book come from such assignments.

It was television that made spectators and experts of us all. This was the ultimate medium, bringing Wembley or Wimbledon into every home, showing moments of triumph and anguish, making and unmaking heroes as no medium had done before. And yet instead of destroying sports photography, television challenged it to become an art form. The succession of Sports Photographers of the Year – including Gerry Cranham, Eamonn McCabe and Chris Smith, all of whom are represented here – proved the enduring power of the static image. What could be more eloquent of the times, and of the exposure and the vulnerability of the modern hero, than the photograph of Gazza in tears at the 1990 World Cup?

Honor Clerk and James Huntington-Whiteley

Crowd at a Football Cup Tie, Norwich, 1939
Reuben Saidman for the *Daily Herald*

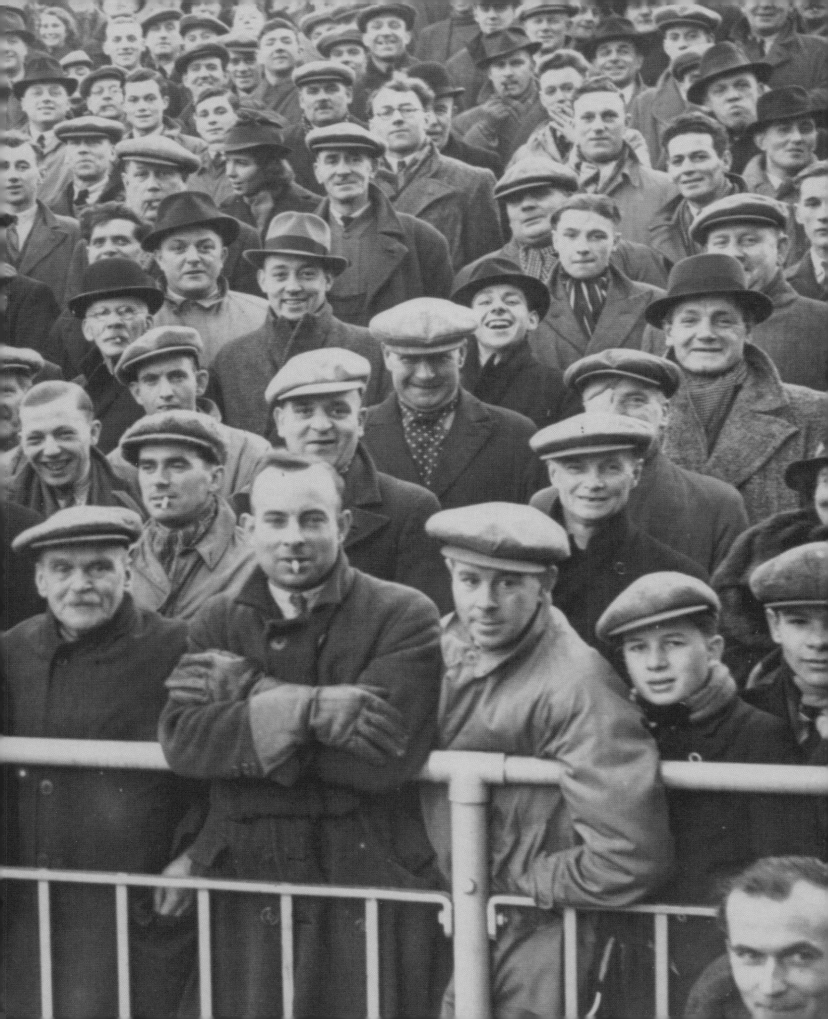

Champions, Heroes and Celebrities: Sporting Greatness and the British Public

Richard Holt

International Centre for Sports History and Culture, De Montfort University

'Excellence in any honourable form, that rarest and most precious of human accomplishments, must be praised.'[1] Stephen J. Gould, whose own excellence as a biologist is beyond doubt, was not writing about science but about sport. Jonathan Swift made the same point slightly differently: 'who'er excels at what we prize appears a hero in our eyes'.[2] Sporting heroes are both universal and particular. They resemble each other and they differ from each other. They have common qualities like courage and will-power but they also have specific national and social characteristics. Heroes change and so does our idea of what is heroic. Both develop in step with general changes in our national life. The National Portrait Gallery's exhibition tries to show how the British sporting hero arose, flourished and evolved as a part of a wider transformation of our economy and culture. Heroes are not just gifted individuals we admire; their lives are woven into stories we tell ourselves about ourselves.

How does the sporting hero resemble or differ from the wider heroic ideal? The British hero from General Wolfe to David Livingstone evolved with the British Empire. Soldiers and explorers were the stuff of Victorian legend, often embellished with Arthurian or Hellenic touches. Tales of brave midshipmen or lieutenants formed a growing body of literature aimed at the newly literate youth of the late nineteenth century and beyond, from Henty to 'Biggles'. A certain idea of the British hero took shape, the fair and modest man, knowledgeable without being academic, loyal and undemonstrative, physically robust and thoroughly decent. These products of the public school élite were supposed to be role models, brave and practical men of action like Scott of the Antarctic, whose qualities were defined by their opposite: the supposed 'latin' type, impetuous, voluble, complex, seductive and unreliable. With an impregnable sense of their own virtue, the British saw themselves as 'good sports' who, unlike most foreigners, 'played the game'. Sporting metaphors increasingly permeated the wider language of national character as military service became the exception rather than the rule. This fixed idea of the male hero dominated British culture until the rise of the confessional biography and an increasing self-consciousness about our stuffiness and national self-importance. Sport has remained one of the few arenas where old-fashioned forms of heroism are still possible, though even here heroes are increasingly expected to be people as well as performers. Hence the recent search for the 'real' Alan Shearer beneath the plain northern exterior.

This history begins with the early champions, the pugilists and pedestrians, the cricketers and jockeys, who took part in the new sports patronised by the nobility in the eighteenth century. Then came the 'golden age' of the gentleman amateur, the public school and imperial sportsmen whose code of fair play dominated the late nineteenth and early twentieth centuries. This period also saw the birth of the modern professional player, a manual worker on fixed wages, the hero as a modest, ordinary man. This quiet suburban figure was a very British creation, who was to supersede the more flamboyant amateur before and after the Second World War. Finally, there is the contemporary sporting hero who exists as performer and celebrity, an ostensibly classless product of market values and the media. These four stages in the history of the sporting hero overlap in unexpected ways and give a fresh perspective on how the British male has defined himself through athletic prowess and the consequences of this for the sporting heroine.

THE HEROIC IN SPORT

What is it that distinguishes the great from the good, the merely admirable from the truly elevated achievement? The fame of the few rests on the failures of the many. Not many of those at a concert or a play ever try to perform themselves. Far more of the sporting crowd have had firsthand experience of what it takes to be good. Many of those who watch football, for example, either still play or will have played and know that 'talking a good game' is one thing, doing it is another. Heroic moments redeem our athletic sins, their talent compensates for our clumsiness, their application our guilt at not working hard enough. We live by the law of diminishing returns which they do not recognise or respect. Their world is both more simple and more testing. A great performance, however, enhances all who are part of it. Not just the performer caught up in the private logic of competition but the spectator vicariously satisfying unrealised dreams and basking in reflected glory. Great artists or inventors seem special creatures, touched by genius beyond our knowing, but sporting heroes are more like us. We can identify with them, especially in childhood, picking up and copying their mannerisms, a shuffle of the feet, a flick of the wrist.

Sport as a contest is unvarying and unique. Played at the same times in the same places, sporting events are both ritualised and spontaneous. Standardised national rules and systems give a routine and structure to the action. Sporting events tend to be made up of periods of strategic inactivity broken by unpredictable moments of high excitement, the best of which linger in the mind and accumulate. After a while – sometimes very quickly – a gifted performer makes a reputation, which acquires a resonance and plausibility in the public mind. Celebrated sports journalists like Neville Cardus, who began writing for the *Manchester Guardian* in the late 1920s and was eventually knighted for his contribution to cricket, have been guardians of the heroic tradition in sports; others, like the stable of venerable BBC broadcasters such as Dan Maskell and David Coleman, have polished the legends of great players. No cricketer could claim his place in the pantheon without the imprimatur of John Arlott, who wrote and broadcast for thirty years after the Second World War.[3] Until the 1960s lapses of virtue went largely unreported. Journalists were interested in performance rather than private life. That Wally Hammond, the supreme batsman and idol of boys in the 1930s, was promiscuous and may have had venereal disease was kept out of the papers. So was the fact that Denis Compton's post-war Middlesex and England partner, Bill Edrich, sometimes had to be carried back drunk to his hotel in the early hours before going out to bat for his country. The official record merely stated 'he lived life to the full'.[4] Today's cricketers can make the front page of the tabloids for chatting up a barmaid. Contemporary sports stars are subjected to media scrutiny of their private lives which earlier generations would have found inconceivable and offensive.

Heroism, of course, does not have to be individual. A brilliant personal performance is a marvellous thing but there are times when teamwork moves and excites us more. The England World Cup team of 1966 had a collective heroism bestowed on them by England fans. The team had plenty of outstanding individuals but it was Alf Ramsey who was honoured for creating such an effective unit. Similarly, for all their different talents, the 'Busby Babes' are remembered by the nation as a team, the doomed youths of Munich, whose promise was never fulfilled. They were martyrs, a symbol of courage and renewal, which won Manchester United many fans beyond Manchester. But this is rare. It's Stanley Matthews we remember, not Blackpool or Stoke.

Group effort is admirable. But there is safety in numbers and heroes are not supposed to be safe. They have to take risks and be brave – courage is a universal characteristic of the hero. Most work alone either by necessity or preference. Hence boxing is such fertile soil for heroes. Defeat itself can be heroic. Think of Tommy Farr going 15 rounds with Joe Louis in 1937 or Henry Cooper

taking on Muhammad Ali and knocking him down in 1963. Winning wasn't the main thing here. Meeting the challenge of a fearsome opponent unaided was more than enough. Cricket, for so long the national sport in England, sets the batsman against the opposing eleven. Small wonder that bowlers, however worthy, are more rarely the heroes. Even pure team sports like football or rugby have special positions for flair and risk-taking, roles filled by the frail genius of a Barry John or a Wilf Mannion, seemingly nerveless and creative under attack from much bigger men.

For teams as for individuals, it is the art of attack which is most highly prized. Bloody-minded backs-to-the-wall resistance can seem heroic at the time – at least, if your team is doing the defending. But defence is not enough. Defending is hard but attacking is harder. A great attacking side breaking forward, sprinting into space, moving with deftness and giddy speed, is a stirring sight. Ideally, it is done with a certain athletic grace. Football can be a dour midfield struggle – not without its fascination for the obsessive fan – or, more rarely, 'the beautiful game', as the Brazilians say, moving to and fro in a kind of half choreographed, half spontaneous dance, set moves combining with moments of inspired improvisation, where creation triumphs over destruction. This brings in the aesthetic dimension where pure aptitude is allied to patient application. Matthews was not just a naturally gifted winger; he never smoked or drank, kept himself exceptionally fit, had his boots specially made and practised a great deal. Sport at the highest level is about getting an edge over other very talented people. This is only acquired by constant effort and perseverance. For all his wayward image, George Best used to take his training seriously. When he stopped practising, he was finished. For the great player knows that 'technique is freedom'.

What the choreographer, Martha Graham, said of the dancer is as true of the batsman, the athlete or the golfer. Fred Astaire developed the point. 'If it don't look easy, you ain't worked hard enough.' Torvill and Dean, masters of a sport that combines the athletic and the aesthetic, understood this. Greatness means making difficult things look simple.

Above and opposite:
Tom Cribb and Tom Molyneux, c.1810–15
Staffordshire portrait figures,
220mm (h)
National Portrait Gallery

Talent has no frontiers but sporting heroes are creatures of historical time like the rest of us. Sport is a barometer of changing values, showing, as Hamlet said of the actor's art, 'virtue her own feature … and the very age and body of the time his form and pressure'. There are obvious risks in choosing a chronological approach which moves from the early champions through the amateur age on to the modern professional and celebrity. The structure is unavoidably schematic, imposing simplicity on a complex process where styles were overlaid, one upon another, and individual lives encompassed different eras. Traces of the aristocratic age survive into the present in horse racing while Gower's languid 'amateur' style stood out in sharp contrast to Gooch's unshaven 'professionalism'.

Clear categories are also blurred by regional and national variations, which are deeply rooted. What features are typically British? What do sporting heroes tell us about being English, Welsh, Scottish or Irish? What was distinctively northern or southern? Cricket apart, English sporting heroes were not normally national symbols in the Welsh and Scottish fashion until quite recently. Hence the hostility when 'English' commentators appropriate a Scottish performance as a 'British' triumph.

Such a rich variety of affiliations made for a wide range of sporting heroes. So, too, did the simple fact that Victorian Britain pioneered or promoted many of the sports which now dominate the world, football and rugby, tennis and golf, cricket and athletics, boxing and rowing, to mention only the most well known. Apart from the English language, sport was Britain's most successful cultural export (except in Ireland, where 'English' sports were rejected as a form of cultural imperialism and only rugby survived the onslaught of Gaelic games). Britain was seen as the home of sport. 'All peoples have their play', wrote a German observer of the British in the 1920s, 'but none of the great modern nations have built it up in quite the same way as a rule of life and national code.'[5] A Frenchman, Baron de Coubertin, based the modern Olympic Games on public school athletics and FIFA still permits the United Kingdom alone among its members to field four teams in recognition of our historic role in the making of the game.

How and why did this sporting revolution take place in Britain? Why was there a rush to create, regulate and administer modern sports on a national level beginning with the founding of the Football Association in 1863, the Rugby Union in 1871 and the Amateur Athletic Association in 1880? Britain was not only 'the first industrial nation', she was the first sporting nation. Industrial and urban growth on an unprecedented scale took hold. The population more than doubled in the first half of the nineteenth century, doubling again to over forty million by the end of the century. Great new industrial cities sprang up in Manchester and Leeds, Birmingham and Glasgow, thickening into vast industrial conurbations linked to each other by the new rail network and to London, the largest city in the world. London itself spread out into the new world of suburbia, from the lawns of Wimbledon to the playing fields of Twickenham in the west and the Crystal Palace in the south where the FA Cup Final, the largest single sporting event of the year, was held until the opening of Wembley Stadium in 1923.

Modern sports were a response to modern British life.[6] The new rhythms of the factory and office, of more repetitive manual labour and more sedentary office work, required new forms of physical 'recreation' as it came to be called. The new sports were restricted in time and space; they were suited to the confines of city life, played on marked-out pitches and mostly of short and precise duration; they were codified to reduce the risk of injury and designed to promote healthy exertion. Just as free trade was at the heart of the new liberal economy, which increasingly dominated world markets in the mid-Victorian boom, so the principle of open competition came to be enshrined in British sports. Foreigners did gymnastics as preparation for military service, the British played games to prepare for economic and imperial expansion. Competitiveness was a cardinal virtue. It was never unrestrained, anarchic individualism. Team games promoted collective struggle and useful co-operation. 'He doesn't play that he may win but that his side may win', muses the master in *Tom Brown's Schooldays*. Those who first promoted modern sports among the public school élite of the 1850s and 1860s sought to re-invent old games in new ways. 'Playing the game' meant knowing both how to win and to lose with dignity.

Collective effort and the competitive principle were what mattered, not the individual or the outcome. All this was part of a wider Victorian reform of the élite associated with the career of Thomas Arnold, the headmaster of Rugby School in the 1830s, who set himself the task of producing a generation of Christian gentlemen. While he did not care for sport himself, his disciples spread through the system applying his values to the sports they found among public schoolboys. In doing so they created national bodies which gave a new shape and structure to older ways of playing.

It was not simply a matter of this amateur sporting élite evangelising the masses. It was rather that millions of working men in the Victorian city took up these new sports themselves; or, more often, paid to watch others play for them. Shorter hours of work, especially the new Saturday half-day, which became standard in the last quarter of the century, combined with rising real wages, the mass press and the tram, created the conditions for the emergence of large-scale professional urban spectator sport. Supply followed demand as spectator sport grew organically from below rather than being provided for profit from above. The centre-piece was the setting up of the professional Football League in 1888 and the creation of test match cricket against Australia in the 1880s. That the two came together was hardly surprising. The 'grey eminence' behind each was the same man: Charles Alcock, son of a Sunderland ship-owner, Harrovian, founder member and Secretary of the Football Association and Secretary of Surrey County Cricket Club. Here was the administrator as hero. When he retired in the 1890s modern British sport was firmly established and on its way to conquering the world.

THE CHAMPION AS HERO

What do we know about the early British sporting champions? The term is instructive, deriving from the medieval tournament where kings and courtiers would appoint or hire others to fight on their behalf. Just as the two best warriors might be chosen to fight for two sides in war, so the best athletes might compete for the honour of their patrons. Hence the use of the term 'patronised'

sports to describe the practice of hiring servants as 'champions' to box – or ride or run – for their noble backers. The demilitarisation of English society from the later seventeenth century with its great country houses and parks shifted sporting endeavour towards less warlike pursuits. Cricket, horse racing, pedestrianism or foot racing (running) emerged as favoured activities.

Pugilism, or bareknuckle fist fighting, may seem ferocious today but it was relatively civilised by the standards of the time. Gentlemen learned what they called 'the noble art' from men like James Figg, who also taught fencing. They sensibly steered clear of the prize ring themselves and let their champions fight it out. Enter Jack Broughton, the founder of modern pugilism and the first sporting hero. He not only defeated all challengers between 1734 and 1750 but laid down rules for the sport which survived for well over a century. By introducing 'rounds' with breaks between them, he hoped to reduce the risk of serious injury to the combatants. Broughton survived, prospered and had a paving stone dedicated to him at Westminster Abbey. He was followed by a Jewish pugilist from London, Daniel Mendoza, 'The Light of Israel', who had three widely publicised fights with Richard Humphries before succumbing to 'Gentleman' John Jackson, at whose 'academy' Byron learned the 'noble art'. Such was the success of pugilism, especially after London journalist Pierce Egan hit upon the idea of publishing a monthly serial work *Boxiana*, or *Sketches of Modern Pugilism*, from 1818, that the best fighters became the first national sporting heroes. 'Gentleman' Jackson organised a bodyguard of pugilists to attend on George IV at his coronation. Pugilism, as Pierce Egan remarked, was 'a national trait'. He had 'no hesitation in declaring that it is wholly – British.'[7]

Pugilists were perhaps the most famous of these early champions but athletes, jockeys, oarsmen and cricketers were also well known. Many were employed as servants to sporting gentlemen. The pedestrians or running footmen were a case in point. Research in the eighteenth-century press has brought to light a whole series of races featuring men such as John Appleby of Nottingham, known as 'The Flying Drawer', Foster Powell and most famously, Captain Barclay, the claimant to a Scottish estate.[8] Barclay achieved remarkable notoriety among 'The Fancy', the exclusive metropolitan sporting and gambling world, and among the general public by

issuing bizarre athletic challenges. On one occasion he bet that he could walk one mile every hour for 1,000 consecutive hours – a feat accomplished in 1809 at Newmarket where Charles II had first patronised horse racing and which became the headquarters of the sport.

A century later jockeys like Sam Chifney were riding – and occasionally cheating – for royalty. John Barham Day was known as 'Honest John', 'either on account of his contemporaries' ignorance or because of their taste for sarcasm.'[9] The honest jockey was a rare thing, a 'Hero of the Turf' – an honour accorded to Frank Buckle and to Nat Flatman, who 'owed his large practice to a steady course of good riding and good conduct, extending over many years, rather than to any more characteristic qualities of jockeyship.'[10] As standards of sporting integrity rose, so the fame of the great jockeys seemed to grow. Tom Cannon and Fred Archer were

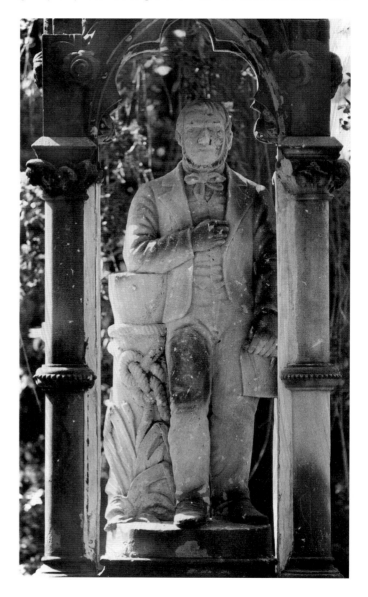

Memorial to Harry Clasper, Tyneside
Photograph by Michael Scott

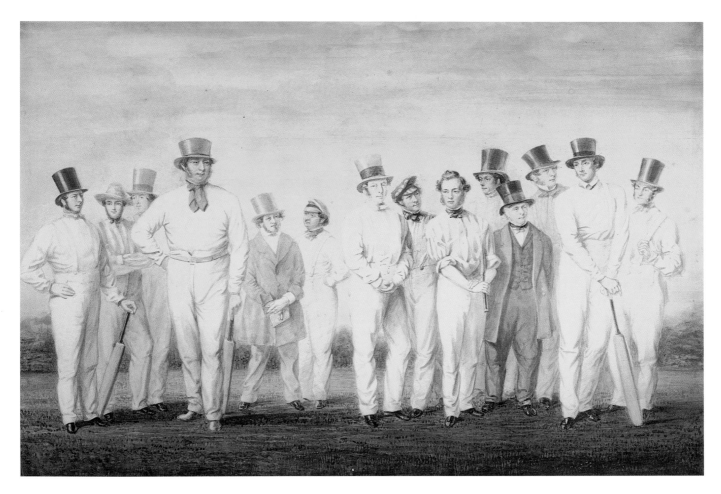

among the best-known men in England in the later nineteenth century. When Archer committed suicide in 1884 *The Times* observed that 'hardly anything could cause a more widespread and painful sensation ... the news of his death has come with a sense of shock and almost personal loss to millions'.[11] Almost as famous were the oarsmen, especially those from the Thames and the Tyne, who attracted vast crowds to the river banks. Harry Clasper's funeral in 1870 was the biggest ever held in Newcastle, attracting tens of thousands. With 'his strong arm and honest heart', wrote the *Newcastle Daily Chronicle*, he 'hewed for himself a pathway to fame and a sepulchre kings might envy'.[12]

Like rowing, cricket was a sport in which the early champions were eventually overtaken by Victorian amateurs. But not before a whole crop of extraordinary players had made their mark, starting with village teams like the Duke of Richmond's Slindon, which drew crowds of up to 10,000 for games in the 1740s. The Hambledon team was formed in 1755 and established itself as the dominant English side until the 1790s, mixing men like the Duke of Dorset with a farmer who would bawl out in broad Hampshire 'That were tedious near you, Sir!' as his 'jerker' shaved the leg stump of the

The All-England XI (l to r): Joseph Guy, George Parr, William Martingell, Alfred Mynn, William Denison, James Dean, William Clarke, Felix, Oliver Claude Pell, Charles Hillyer, William Lillywhite, William Dorrinton, Fuller Pilch, Thomas Sewell
Felix (Nicholas Wanostrocht), 1847
Pencil and watercolour, 463 × 603mm
Marylebone Cricket Club

noble lord.[13] This Hampshire 'village' team took on the might of 'All England' until the formation of the Marylebone Cricket Club (MCC) in 1787 gradually ousted the likes of George Lear, 'as sure as a sand bank' in the field, or John Small, the outstanding batsman of the age, who played until he was 61.

Fortunately Small and the others had John Nyren, whose father Richard Nyren had played for Hambledon and kept the village inn, to record his achievements. Similarly Alfred Mynn, a majestic 20-stone Kentish farmer whose batting delighted the early Victorians, could call on the literary and artistic talents of a cricketing schoolmaster, Nicholas Wanostrocht, better known as 'Felix on the Bat'. Along with 'Felix' there was William Denison, whose *Cricket Companion* (1844–7) and *Sketches of the Players* (1846) were the

first collections of biographical cricket journalism.[14] Heroes need their historians. The nineteenth century obliged with a vastly increased specialist and newspaper press and a mass readership to match. Only a few thousand could go to watch a cricket match, but tens of thousands could read about a great innings or study the scores in *Wisden*, first published in 1864. Sports writing was on its way to becoming a Book of Chronicles and a Book of Numbers.

THE AMATEUR AS HERO

The Victorian public read about one man more than any other: W.G. Grace. 'The Champion' first strode to the wicket as a youth in the 1860s, making 170 in his first senior match at the age of 15. His huge frame and great scruffy beard, his pugnacity and his willingness to share to the full in the material rewards of his success, placed him in the first era of British sporting heroes rather than in the amateur age. Here was a man who learned his cricket in the family's Gloucestershire orchard, not on the playing fields of Eton. He never felt quite at home with the fair play, sportsmanship or personal cleanliness which the amateur represented and required. For all his 40 years at the wicket, he never got the knight-hood so many thought he should have had. He was the 'Grand Old Man' – a founding father, a force of nature, an indomitable national character, the best-known English sportsman of all time.

Grace outlived his age, moving into a world of clean-shaven public schoolboys in immaculate whites, like C.B. Fry, Gilbert Jessop, A.C. Maclaren and Stanley Jackson, not to mention 'Ranji', the Indian prince whose batting made him an English hero. Cardus loved to recount his youthful Edwardian memories of Archie Maclaren, 'dismissing the bowling with a wave of his imperial bat' in what became the 'golden age' of cricket. For others like Harry Altham, the first authoritative historian of the game, C.B. Fry, the Oxford classicist, looked 'alike in form and feature' as if he had 'stepped out of a frieze of the Parthenon'.[15] Fry, the son of a Home Office civil servant from Orpington, was the pure amateur ideal, a brilliant batsman, athlete and footballer. Ever conscious of his role as a model of English manhood, he set up a successful magazine for boys which bore his name.

Amateur purity seized hold of sport, though rowing was the only activity to institutionalise social discrimination by banning 'labourers, mechanics and artisans'. No Thames tradesman was going to walk off with the Silver Goblets at the Henley Royal Regatta, which soon became a part of the social calendar. This was

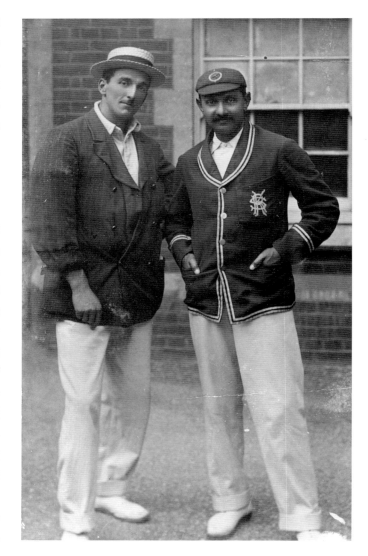

C.B. Fry and K.S. Ranjitsinhji
Charles Hands, 1903
Public Record Office

the province of a new kind of sporting hero, the public school oarsman. Guy Nickalls dominated Henley in the late Victorian and Edwardian years. Jack Beresford, the son of a prominent Victorian amateur, had learned his rowing at Bedford School and took a post in the City of London during which he took part in five consecutive Olympics from 1920 to 1936, winning a gold or silver in each. Here was someone with an absolute claim to sporting greatness. But rowing was too snobbish to have or seek any wider appeal. These men were heroes of the classes, not the masses. There were even two separate amateur rowing associations, the older and more established Amateur Rowing Association, which banned working men, and the National Amateur Rowing Association, which was open to all. The two did not unite until 1956.

Those who wrote about English amateurs in the later nineteenth century required virtue as well as virtuosity in their heroes. When Alfred Gibson and William Pickford published their classic work *Association Football and the Men Who Made It* in 1906, they placed the word hero in inverted commas when used about professional footballers, as if those who were paid could not really be considered heroic. Yet the Victorians were especially fond of the term, extending its use beyond the military sphere of Wellington and Nelson to take in inventors, artists, even politicians like Gladstone, as well as sportsmen. The athletic body was not just a site of power and energy. Nature was turned into culture as the male drives so evident in sport were overlaid with a gloss of decent 'manliness'. Sport was not just about winning and losing; it was a moral and aesthetic endeavour. 'How you played the game' was all-important.

Women were excluded from many sports and barely tolerated in others. Gender distinctions became more sharply focused as middle-class women moved towards greater emancipation. The new amateur hero was part of a wider refashioning of the male ideal. Sporting heroes were supposed to be creatures of action whose power was tempered by a chivalrous concern for those weaker than themselves. The fact that sport was designed to 'make' men meant it was the harder for women to break down the barriers and all the more heroic when they did. There were relatively few women involved in high-performance sport until quite recently. Men firmly closed the door on them. Baron de Coubertin, the founder of the Olympics and for so long the arbiter of international competition, opposed female events, claiming woman's 'fixed destiny' was to be 'the companion of man and the future mother of the family'; in sport her role was 'to crown the victor with laurels'. This was a view with which the majority of British sportsmen probably concurred.[16]

It was not on the track or in team sports that women made their mark despite the success of hockey and the achievements of outstanding players like Majorie Pollard, a railwayman's daughter who triumphed in a strongly middle-class sport. It was in the individual recreational sports like golf and tennis, spreading quickly through suburbia around the turn of the century, that the sporting heroine emerged. The bourgeois life, which anchored women in domestic management, also gave them servants and the leisure to play well. Female sport had some outstanding early competitors. Lottie Dod, 'the Little Wonder', was the most famous, winning Wimbledon at 15 and enjoying a lively rivalry with Blanche Bingley before losing interest after winning five times. Lottie Dod went on to excel in hockey, archery, golf and skating in the classic all-round amateur fashion. Her Wimbledon record was surpassed in the Edwardian years by Dorothea Douglass, later Mrs Lambert Chambers, who won seven Wimbledon singles titles before succumbing to the new French star, Suzanne Lenglen, in the classic 1919 final. Despite the early success of the Renshaws and the Doherty brothers, men's tennis never matched the women's game, with the exception of Fred Perry. No British sportsman has cast so long a shadow. No new hero has taken so long to emerge. The women's game has struggled but kept a place in the top rank until relatively recently with Ann Jones and Virginia Wade. The men's game seeks its new messiah in the shape of Henman or Rusedski.

Britain did rather better in golf, though still yielding for long periods to Australian and American dominance. Women's golf produced some outstanding players. 'Cecil' Leitch, the daughter of a golfing Scottish doctor, hit the headlines when she defeated the former English amateur champion, Harold Hilton, in a one-off challenge in 1910 (with a stroke on alternate holes). Leitch had some superb matches with Joyce Wethered in the 1920s which received wide coverage in the quality press. Women's tennis and golf made the news and Enid Wilson, a top player in the 1930s, worked for the *Daily Telegraph* as a golf correspondent, a job which was eventually to deprive her of amateur status.

Sedentary office work, commuter trains and urban sprawl were the driving forces behind the remarkable spread of suburban golf. Here was a game that not only catered for the middle aged but even permitted them to have heroes in their own likeness. John Ball and Harold Hilton dominated amateur golf from the 1890s to the First World War, playing into their fifties like their professional counterparts, James Braid, Harry Vardon and J.H. Taylor, the best players in the world at the time and known as 'The Triumvirate'. Like tennis, British golf declined in the face of the challenge from the USA. Apart from Henry Cotton's three Opens in 1934, 1938 and 1948, there was very little to cheer about before Tony Jacklin's 'annus mirabilis' of 1969–70 and more recently Nick Faldo's tetchy perfectionism. Faldo is an interesting case, a great player but a seemingly difficult man and consequently not as popular with the press or the public as his achievements merit. Recently, of course, golf has introduced a new kind of hero not found in other sports. As the Ryder Cup has expanded to include European players, we find ourselves cheering Italians, Spaniards, Swedes and Germans alongside British players in the biennial battle with the Americans.

Historically, amateurs were uneasy with adulation. Rugby union in England and Scotland played down individual excellence for team effort. Scotland, run by the amateur purists of Edinburgh's liberal professions, prized their 1925 team as a unit. All players had a public school background and the whole three-quarter line were at Oxford. 'This is a rugby match, not a cattle sale', snapped a Scottish official at George V when he asked why the Scottish players did not have numbers on their shirts.[17] Welsh rugby was keener on heroes from the outset. Men like Arthur 'Monkey' Gould, the brilliant centre three-quarter, who led Wales to victory over England in the 1890s, was the first of many emblematic Welsh rugby players, so important from the 1950s to the 1970s, from Cliff Morgan to Gareth Edwards, Barry John, J.P.R. Williams and the rest. The great Welsh side of the early 1970s still enjoys an extraordinary collective renown in the principality and beyond. Of course, England had its rugby heroes and nowadays even the Scots have succumbed to the cult of the individual player, especially when linked to the British Lions as an international touring team. Heroic feats accomplished far away against the Springboks or the All Blacks are the ultimate test of rugby greatness.

THE PROFESSIONAL AS HERO

Rugby, of course, had two codes and two kinds of hero. Nowhere was the division between amateur and professional more sharply delineated. No public schoolboy ever played in the 'Northern Union', which later became the Rugby League. They split from the amateur Rugby Union in 1895 over the issue of 'broken time' payments. Working men needed to be compensated for time lost from work when playing for club or county whereas students, officers or young middle-class members of the liberal professions required no such payment. This led England's one and only working-class rugby union captain, Dicky Lockwood, 'The Little Tyke', to convert to the Northern Union to the lasting resentment of the Rugby Union, which virtually expunged him from its records. Manual workers were not to be found in the leading union clubs like Harlequins or Wasps. This sharp social cleavage continued to mark the sport profoundly. However, media deals threaten to dissolve the old class structure. English rugby may yet produce a hero who can appeal to both the middle-class traditionalist and the young working-class fan, as Welsh rugby has always done.

Rugby league produced a particular kind of tough local star, wonderfully evoked in David Storey's *This Sporting Life*. Here was the hero as pure northerner, strong, blunt, honest with none of the rough edges knocked off by public school. Joe Ferguson, for example, who played 677 games for Oldham from 1899 to 1924, was a real-life version. Then there were famous rugby families, like the Batten dynasty. Billy was a winger with Hunslet, Hull and Wakefield and his two brothers played professionally before and after the First World War. Billy's three sons all played at the top level with Eric appearing in a record eight Challenge Cup Finals. Then came the Welsh who 'went north', men like Jim Sullivan and Billy Boston. Eddie Waring, the Yorkshire voice of rugby and a gift to every bar-room impressionist, brought all this vividly to life and to a wider public through the BBC. Recent media attention on the winning Wigan side, notably on black players like Ellery Hanley and Martin Offiah, has given the sport a new kind of multi-cultural northern identity.

The professional cricketer was central to the national story, at least in England. Football had its different codes but cricket was played north and south, east and west, by rich and poor. The amateur values — playing with a 'straight bat' or the telling phrase 'that's not cricket' — were increasingly adopted by top professional batsmen, along with the amateur dress code. Batting style was moving from the defensive perfectionism of an Arthur Shrewsbury, Grace's favoured professional partner, to the flowing style of Frank Woolley, whose strokes reminded even the blunt Yorkshire journalist, J.M. Kilburn, of 'sunlit Kentish meadows'.[18] Herbert Sutcliffe and Len Hutton, both from the same small Yorkshire town of Pudsey, played in an orthodox style that pleased the gentlemen of the MCC. Women, however, were often attracted by other features. Sutcliffe, 'the Clark Gable of cricket', and a player throughout the inter-war years, was complimented on his 'glossy black hair' and wore cricket shirts made of silk. Denis Compton's wavy hair adorned post-war Brylcreem adverts and led to a certain cosmetic rivalry with his Australian friend and opponent, Keith Miller.[19]

Jack Hobbs, however, was acknowledged as the supreme figure and in 1953 became the first professional cricketer to be knighted. 'The Master' opened the batting for England from the late Edwardian years to the early thirties, making 197 fluent centuries while calmly remarking that cricket would be a better game without statistics. Hobbs was a professional with all the qualities of

the amateur. He was also a respectable, kindly and ordinary man. Devoted to his wife and children, he drank little, prospered through a sports shop in Fleet Street – a good spot for a popular hero – and said little. Frank Woolley spoke for many when he called Hobbs 'one of the greatest sportsmen England ever had, a perfect gentleman and a good-living fellow'.[20]

Here was the professional as hero in a form that the amateur could understand and appreciate. Hobbs was the son of a Cambridge college servant to whom deference came naturally. Great players who did not fit the template were marginalised. The magnificent Edwardian bowler S.F. Barnes – arguably the best of all time – did not get his full due because he hated amateur captaincy. The Lancashire all-rounder 'Ciss' Parkin, loved by the public for his banter and tricks, was dropped from the England side for daring to criticise his amateur captain in the national press in 1924.[21] Yet this stubborn self-respect that some of the more snobbish amateurs resented appears to our own generation as a virtue.

It took a long time for the professional footballer to move from being a local civic hero to the centre of the national stage. Stanley Matthews was the first footballer to become a national figure, admired throughout England and across the social spectrum, consecrated as a national asset after the 1953 Cup Final when he finally got his winner's medal at nearly 40. A new national audience saw the Cup Final live on televisions bought to watch the Coronation. *The Times* called him 'a superb artist' with 'the power to call souls out of the abyss and into life' and 'to turn nothing into everything'.[22]

Football was the 'People's Game' and the people wanted star players who could score. G.O. Smith, the great Corinthian centre-forward of the late Victorian age, was the only amateur ever to become a football star and even he could not rank alongside Steve Bloomer of Derby, whose sudden low shooting with either foot delighted the Edwardian crowds. Billy Meredith, born just over the Welsh border, was even better known, a winger who was unique, playing around 1,500 games and scoring 470 goals over a 30-year period. He first played for Manchester City, then Manchester United, winning the League in 1907–8 and 1910–11 as well as the Cup in 1909. But Meredith's amazing career was marred by allegations of offering a bribe and he never got the national recognition his exceptional achievements deserved.[23] Nor, for that matter, did Dixie Dean, who scored a record 60 goals in a season for Everton in 1927–8 but was given only 16 games for England. Northern fans were convinced the southern FA selectors were biased against

their heroes, though internationals like Stan Mortensen, Raich Carter, Wilf Mannion and Jackie Milburn were all from the north-east and Tommy Lawton, Tom Finney and Nat Lofthouse from Lancashire.

For its size Scotland had by far the greatest concentration of professional footballers anywhere in the world. Star players achieved national renown sooner in Scotland than in England. The England–Scotland game was always more important north of the border, especially around Glasgow, where crowds could watch Celtic's great trio of Jimmy Quinn, Patsy Gallacher, who somersaulted into the net with the ball between his feet in the 1925 Cup Final, and Jimmy McGrory, a stocky centre-forward deadly in the air. These men were especially prized in Scotland because they stayed there. But many of the best Scottish players came south and being an 'Anglo' was a handicap in the heroism stakes. Scotland resented the haemorrhage of talent down south and preferred national teams made up of those who played in Scotland. But Scotland also desperately wanted to win against England and played 'Anglos' when it suited them. The chance to include men like Hughie Gallacher, who had left Airdrie for Newcastle United, or Alex James from Herbert Chapman's exceptional Arsenal side, was too good to miss. Gallacher was a key player in the side who became known as the 'Wembley Wizards', made famous by their 5–1 thrashing of England in 1928 – an event that has gone down in the annals of Scottish football.[24]

THE CELEBRITY AS HERO

Fame, however, was not translated into fortune. Great footballers added thousands to the gate receipts without any significant benefit to themselves. The market was rigged against the hero by the operation of a maximum wage which was not abolished until 1961. While earlier stars lost the prospect of acquiring substantial wealth, they were able to keep an easy familiarity with their fans. Today's top players are often far removed from their fans, jetting to the Caribbean, hidden behind the tinted windows of a luxury car or cocooned in neo-Georgian mansions. Earlier generations of players – even the best ones – were still part of their community and were paid wages which kept them in touch with ordinary people. Alan Shearer is an icon on Tyneside but not a hero in the old community sense. Shearer never worked a shift before a match or waited for a colliery bus to take him to the game as

Jackie Milburn did in the post-war years as Newcastle United's centre-forward. 'Wor Jackie' – the possessive pronoun says it all – belonged to the region and was loved by it. He also belonged to a remarkable football family with four cousins who were all professionals and a fifth, 'Cissie' Charlton, whose two sons were to make a profound impact. Jack was a tough defender for Leeds and England but became an Irish rather than a British hero for his astute management of their national team. Bobby, his younger brother, took over from Matthews as the most revered figure in English football. He was recently knighted for a career that began in 1953 and spanned 20 years with Manchester United plus 106 games and 49 goals for England. Bobby Charlton became a by-word for club loyalty and good sportsmanship, both qualities that have been in short supply among top players since the end of the Charlton era in the early 1970s.

The World Cup victory was as important to the English as it was galling to the Scots. Being one of 'nature's gentlemen' was not a compliment north of the border, at least not in football. The Scottish football hero was tough and flamboyant, like Billy Bremner from a council estate in Stirling or the diminutive Jimmy Johnstone, drunk in charge of a rowing boat at Largs one night but sober enough to torment England the next.[25] The Scottish football hero was a kind of sporting anarchist, subverting the official values of the game and the sixties English 'system' as practised by 'Ramsey's Robots'. The Scottish hero stood for individualism over consistency, for flair over fitness, for Law's 'Denis the Menace' over Bobby Charlton's 'Roy of the Rovers'. Jim Baxter of Rangers was the supreme exemplar of this tradition, casually juggling the ball at Wembley against England in 1967, 'the slightly hen-toed saunter, the socks crumpled, the florid gallus expression ... his sense of theatre, his exact awareness of how we Scots felt about winning and the English.'[26]

Popular papers now had to compete with television. *Match of the Day* began in 1964 – the same year as the *Sun* replaced the respectable old Labourism of the *Daily Herald*. The *Sun* injected a new chauvinist vehemence into sports reporting, an attitude that was soon taken up by the *Mirror*, the *Star* and other tabloids, spreading to the *Daily Mail* and the *Daily Express*. The tone had changed completely from the fifties when England's defeat by the USA in the World Cup was deemed 'unlucky' and Charles Buchan in the *News Chronicle* concluded 'there can be no complaints, we were outplayed by a great Hungarian side' after England's 6–3 defeat

at Wembley.[27] Britain 'had lost an Empire and was looking for a role'. National defeats in sport became harder to bear for an imperial power buffeted by the 'winds of change' and a French veto on British entry into Europe. Even the economy began to falter as the post-war boom gave way to inflation and a balance of payments crisis. Popular chauvinism was stoked by the popular press which began to take an obsessive interest in the national football team. Winning the World Cup in 1966 created enormous future expectations and woe betide any manager who failed to live up to them, from Ramsey himself to Graham 'Turnip' Taylor, as he was derisively named by the *Sun*, which had called Taylor's predecessor, Bobby Robson, a 'PLONKER'. Sport was becoming a substitute for our former authority in the world and the job of the hero was to give us back our international status as a great power. 'DON'T LET THEM LAUGH AT US' was a telling headline for an England game with Morocco in the run-up to the 1986 World Cup.[28]

Television had greatly increased the visual recognition of players. When Jim Laker took 19 wickets against Australia at Old Trafford in 1956, he stopped at a pub on the way home where the locals were watching the highlights of the game. He joined them, curious to see himself on television and chatted about the game. No-one recognised him and he went on his way. This would have been quite inconceivable 25 years later in the extraordinary 'Botham summer' of 1981, which briefly restored the Ashes to their former glory in English life. After his heroic efforts on the field Botham was an instantly recognised face, his familiarity reinforced by his subsequent appearance on *A Question of Sport*, which became the BBC's most popular quiz with an audience of around ten million. Yet Botham's visibility was never quite translated into the public esteem enjoyed by Bill Beaumont, with whom he shared the show. Beaumont was a quiet leader with a touch of the gentleman-amateur about him. Middle England still liked this and expected such behaviour from their heroes. Hence the success of Gary Lineker, not just as an England striker but as a cheerful, decent family man who has taken to television like a duck to water.

There is plenty of room for the hero as good man, although the press seem ever more obsessed with the self-destructive side of sporting greatness. Heroes are made and unmade in quick succession. This began with George Best, who enjoyed what was the most obsessive and sustained media attention given to any footballer in Britain up to that time. People outside football were almost as fascinated by George Best as they were by his musical

contemporaries, The Beatles. This trend has gathered momentum ever since, culminating in the coverage of Paul Gascoigne, whose wedding was featured in *Hello!* magazine complete with the groom toasting the bride from a gleaming urinal. Accusations of drunkenness and wife-beating followed. This brought sharply into public focus the question of moral character and the English tradition that heroes should be nice people. Should players be dropped if they go off the rails? Should sporting heroes be role models, and what if they aren't? The current England manager, Glenn Hoddle, whose long passing made him a hero to the aesthetes of football in the 1980s, had a problem. Can you drop a player for being disreputable? The press and public love Tony Adams and Paul Merson as reformed sinners who have responded well to the panacea of the nineties: 'counselling'. 'Gazza's' exclusion from England's 1998 World Cup squad seems to prove that he is rather more resistant.

This 'men behaving badly' side of the sporting hero made the women seem all the more admirable. The 1960s had seen the rise of the female athlete as a national star from the 'golden girl', Mary Rand, the daughter of a Somerset window cleaner who got an athletics scholarship to Millfield, winning gold in the 1964 Olympic long jump, to Anne Packer, who won the 800m and fell into the arms of her future husband, Robbie Brightwell. She recalled later 'there was nothing very special about me, except I really wanted to do it.'[29] These were only two of a crop of outstanding female athletes like Dorothy Hyman, the Yorkshire miner's daughter, pitted against the great American Wilma Rudolph in the 100m in Rome in 1960. Lillian Board at just 19 narrowly missed gold in the Olympic 400m at Mexico in 1968. She died tragically young of cancer and came to have as deep and painful a place in the public memory as Duncan Edwards, whose extraordinary football career was cut short in the Munich air crash of 1958. Women emerged as genuinely popular sporting figures during the sixties. Mary Peters, who won the Olympic pentathlon in 1972 and did good works in her native Ulster, had a national profile as a sporting personality that Anita Lonsbrough, the winner of the 200m Olympic breaststroke in Rome in 1960, had not.[30]

If the sixties was the women's decade, the eighties belonged to the men. The nation became absorbed in the intense rivalry of a remarkable trio of middle distance runners, Sebastian Coe, Steve Ovett and Steve Cram. Coe, in particular, summed up for many what was best about British sport, still officially amateur though in reality already professional. Coe's gold and silver in the 1980

Olympics made him a national hero, although his subsequent alliance with Mrs Thatcher rather spoiled his image, at least as far as half of the population was concerned. In 1982 the cover of the *Radio Times* featured 'The Big Showdown' with an artist's impression of Coe and Ovett running side by side, straining every muscle, dressed in plain white shorts and vest, for all the world like the fictionalised images of Harold Abrahams and Eric Liddell in the enormously successful film, *Chariots of Fire*, which came out in the wake of the Moscow Olympics. This film was in part a rumination on the nature of the hero, with a thoughtful script by Colin Welland comparing the idealised gentleman amateur figure of Lord Burghley with the Jewish or Presbyterian seriousness of an Abrahams or a Liddell. Like most fiction, it said as much or more about its own times as the era it was supposed to depict – half celebration of supreme talent, half longing for lost innocence before the era of agents and appearance money.[31]

A vital new factor in the 1980s was the emergence of the black athlete as a British hero. Despite the popularity and success of Tessa Sanderson and Fatima Whitbread, it was a man, Daley Thompson, the winner of two golds in the decathlon, who emerged as a new kind of role model for black and white youth, genial, fashionable, not part of the old amateur tradition. In football, the son of a Jamaican colonel, John Barnes, a stylish player and dignified personality, survived the depressingly widespread racism of the terraces to become Britain's first black international star. Ian Wright at Arsenal, a more pugnacious figure, achieved a kind of cult status among young blacks, especially in south London where he grew up. The number of black professionals had risen from a handful to around one in six within a decade. This was not matched by any equivalent increase in the number of top Asian sportsmen, a sad fact given their talent and enthusiasm for cricket at the grass roots.

The British had changed. They no longer cared how much a hero was paid. Performance was the only thing that mattered. The older generation of professionals had earned relatively little and still enjoyed their sport. Money hadn't been the only or even the main motive. Now there are fortunes to be made and competing for fun or honour isn't an option. Maintaining public dignity is getting harder for the hero. Of course, the public had a soft spot for rowers and swimmers like Steven Redgrave, Duncan Goodhew and David Wilkie but even these formerly underpaid Olympians began to make commercial deals and advertise products on television.

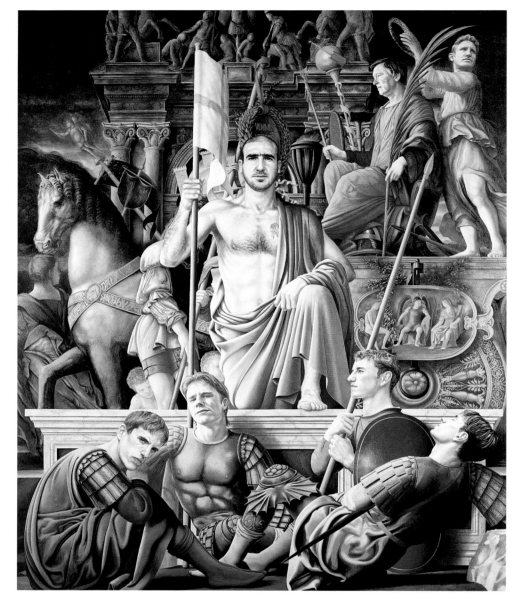

The Art of the Game
(Eric Cantona)
Michael J. Browne, 1997
Oil on canvas,
3048 × 2435.4mm

only one star overseas player per county team – an arrangement which had brought the likes of Viv Richards and Brian Lara to England from the West Indies. So many great foreign stars have played so well in this country, from American and Australian golfers and tennis players to cricketers like Don Bradman and Garfield Sobers, it is impossible to do justice to them here. These 'Heroes of the British' deserve an exhibition of their own.

The pursuit of money, of course, brings today's heroes much closer in spirit, if not in substance, with the champions of earlier times. The wheel has come full circle, revolving from an aristocratic age when sport and gambling went hand in hand to the agents, sponsorship deals and advertising of today. Between their age and ours, there was the long century of the

The money flooding into sport today, especially from satellite television, has brought a host of foreign stars to our shores. In 1997 Chelsea had Zola, di Matteo and Vialli, all top Italian internationals, whilst their neighbours, Arsenal, had two of the best attacking players in the world in the Dutchmen Bergkamp and Overmars. In 1957 Leeds sold John Charles to Italy and a career with Juventus. Twenty-five years later they bought a similarly gifted French centre-forward, Eric Cantona, who went on to become the hero of millions of Manchester United fans. In Scotland Rangers not only dropped the ban on Catholics that had lasted for nearly a century, they even started to sign English players, notably Gascoigne, who were soon to be followed by foreign stars. Cricket, unaffected by the European Union's ruling on free movement of players, continued the tradition of having

gentleman amateur and the working professional, of dispiriting social distinction but decent ethical standards. There have been losses and gains. The amateur ideal running through British sport has certainly been striking and distinctive. Sport defined much of what the British admired about themselves and what others admired about them, before the world media began the process of narrowing national differences. Nowadays British heroes are increasingly international celebrities while foreign stars like Michael Jordan can become cult figures in Britain even if they never play here. Global advertising is taking hold of the sporting hero. How far we go down this road remains unknown. The heroic past, however, is more certain and its qualities are well illustrated in the images collected together for the first time in this book.

NOTES

I am grateful to Honor Clerk for giving me the opportunity to write this essay. She and James Huntington-Whiteley have worked hard to create this exhibition. Lucy Clark collated the comments of other readers and added a useful 'non-sporting' perspective. I would also like to thank Alastair Kinroy and Elizabeth Holt.

1. Stephen J. Gould, 'Good Sports and Bad', *New York Review of Books*, 2 March 1995. I am grateful to Tony Mason for this reference.

2. Cited in R. Holt, J. A. Mangan and P. Lanfranchi (eds.), *European Heroes: Myth, Identity, Sport* (Cass, London, 1996), p.2

3. C. Martin-Jenkins, *Ball by Ball: The Story of Cricket Broadcasting* (Grafton, London, 1990)
 D.R. Allen, *Cricket on the Air* (BBC, London, 1985)

4. C. Martin-Jenkins, *The Complete Who's Who of Test Cricketers* (Queen Anne Press, London, 1987), p.53

5. R. Kircher (trans. R.N. Bradley), *Fair Play: The Games of Merrie England* (London, 1928), p.5

6. For a general historical survey, see R. Holt, *Sport and the British: A Modern History* (Oxford University Press, 1989); on the twentieth century see Tony Mason (ed.), *Sport in Britain: A Social History* (Cambridge University Press, 1989) for excellent essays on individual sports.

7. Cited in J.C. Reid, *Bucks and Bruisers: Pierce Egan and Regency England* (Routledge, London, 1971), p.21

8. I am grateful to Professor Peter Radford of Brunel University for this information.

9. R. Mortimer, R. Onslow, and P. Willett, *The Biographical Encyclopaedia of British Flat Racing* (Macdonald and Jane, London, 1978), p.162

10. *Dictionary of National Biography* (Oxford University Press, Oxford)

11. Cited in R. McKibbin, 'Working Class Gambling in Britain 1880–1939', *Past and Present*, February 1979, p.174

12. Eric Halladay, *Rowing in England: A Social History* (Manchester University Press, Manchester, 1990), p.20

13. Cited in A. Ross (ed.), *The Penguin Cricketers Companion* (Penguin, London, 1981), p.337

14. John Arlott (ed.), *The Middle Ages of Cricket* (Christopher Johnson, London, n.d.)

15. H.S. Altham cited in *The Complete Who's Who of Test Cricketers*, op. cit., p.62

16. Pierre de Coubertin, *Textes Choisies, Vol. 1*, ed. G. Rioux (IOC, Zurich, 1986), p.261; and L. Callebat, *Pierre de Coubertin* (Fayard, Paris, 1988), p.191

17. A.M.C. Thorburn, *The Scottish Rugby Union: The Official History* (Collins, Edinburgh, 1985), p.106

18. J.M. Kilburn, *In Search of Cricket* (Pavilion, London, 1990), p.9

19. Denis Compton, *End of an Innings* (Pavilion, London, 1988), p.105

20. Benny Green (ed.), *The Wisden Book of Cricketers' Lives* (Queen Anne Press, London, 1986), p.436

21. See Arthur Gilligan's foreword to C.H. Parkin, *Cricket Triumphs and Troubles* (Nicholls, London, 1936)

22. Tony Mason, 'Stanley Matthews', *Sport and the Working Class in Modern Britain*, ed. R. Holt (Manchester University Press, Manchester, 1991), p.172

23. For a good biography see John Harding, *Football Wizard: The Life of Billy Meredith* (Robson, London, 1985); Harding has also written well on Alex James and Jack 'Kid' Berg

24. K. McCarra, *Scottish Football: A Pictorial History* (Polygon, Edinburgh, 1984)

25. Stuart Cosgrove, *Hampden Babylon, Sex and Scandal in Scottish Football* (Canongate, Edinburgh, 1991)

26. R. Jenkins, *The Thistle and the Rose*, introduction by Cairns Craig (Polygon, Edinburgh, 1984), p.3

27. Cited in Stephen Kelly, *Back Page Football: A Century of Newspaper Coverage* (Queen Anne Press, London, 1988), p.107

28. S. Wagg, 'Playing the Past: The Media and the England Football Team', *British Football and Social Change*, eds. J. Williams and S. Wagg (Leicester University Press/Pinter, 1991), pp.228–30

29. Anne Packer quoted in N. Duncanson and P. Collins, *Tales of Gold* (Queen Ann Press, London, 1992), p.155; for a general discussion see Greg Moon, *British Female Athletes, 1914–1980*, Roehampton Institute, University of Surrey, 1997 (unpublished PhD dissertation) pp.179–210

30. *Tales of Gold*, op. cit., p.123

31. Garry Whannel, *Fields in Vision: Television, Sport and Cultural Transformation* (Routledge, London, 1992), pp.144–7

SELECT BIBLIOGRAPHY

Sir Derek Birley, *Sport and the making of Britain; Land of Sport and Glory, 1887–1910; Playing the Game, 1910–1945* (Manchester University Press, Manchester; 3 vols.; 1993, 1995, 1995)

D. Brailsford, *Sport, Time and Society: The British at Play* (Routledge, London, 1991)

D. Brailsford, *British Sport: A Social History* (Lutterworth, Cambridge, 1992)

S. Cosgrove, *Hampden Babylon: Sex and Scandal in Scottish Football* (Canongate, Edinburgh, 1991)

E. Halladay, *Rowing in England: A Social History* (Manchester University Press, Manchester, 1990)

J. Hargreaves, *Sporting Females: Critical Issues in the History and Sociology of Women's Sports* (Routledge, London, 1994)

J. Hill and J. Williams (eds.), *Sport and Identity in the North of England* (Keele University Press, Keele, 1996)

R. Holt, *Sport and the British: A Modern History* (Oxford University Press, Oxford, 1989)

R. Holt (ed.), *Sport and the Working Class in Modern Britain* (Manchester University Press, Manchester, 1991)

A. Hopcraft, *The Football Man: People and Passions in Soccer* (Penguin, London, 1968)

G. Jarvie and G. Walker (eds.), *Scottish Sport in the Making of the Nation* (Leicester University Press/Pinter, 1994)

P. Lanfranchi, R. Holt and J.A. Mangan (eds.), *European Heroes: Myth, Identity, Sport* (Cass, London, 1996)

T. Mason, *Association Football and English Society* (Harvester, Brighton, 1979)

T. Mason (ed.), *Sport in Britain: A Social History* (Cambridge University Press, Cambridge, 1989)

G. Moorhouse, *At the George and Other Essays on Rugby League* (Hodder, London, 1989)

M. Polley, *Moving the Goalposts: A History of Sport and Society Since 1945* (Routledge, London, 1998)

K.A. Sandiford, *Cricket and the Victorians* (Scolar Press, Aldershot, 1994)

R. Sissons, *The Players: A Social History of the Professional Cricketer* (Heinemann, London, 1988)

N. Tranter, *Sport, Economy and Society in Britain 1750–1914* (Cambridge University Press, Cambridge, 1998)

G. Whannel, *Fields in Vision: Television, Sport and Cultural Transformation* (Routledge, London, 1992)

G. Williams, *1905 and All That: Rugby Football, Sport and Welsh Society* (Gomer, Llandysul, Dyfed, 1991)

W. Vamplew, *Pay Up and Play the Game: Professional Sport in Britain, 1875–1914* (Cambridge University Press, Cambridge, 1989)

Dictionary of British Sporting Heroes

Over 200 British sporting heroes, from the 1750s to the 1990s, arranged by surname from A–Z. Each entry gives a thumbnail sketch of the individual's personality, biographical information and details of their greatest sporting achievements. Feature boxes throughout the Dictionary give further details of the relevant history and background to specific sports and the men and women who took part in them. Authors are as detailed on page four. Captions to illustrations indicate the collection in which a particular work may be found. In the case of photographs where no source is given, images have been obtained direct from the photographer. Full copyright details are given with the picture credits on p.240.

Fred Perry, Wimbledon Men's Singles Final against Gottfried von Cramm, 5 July 1935

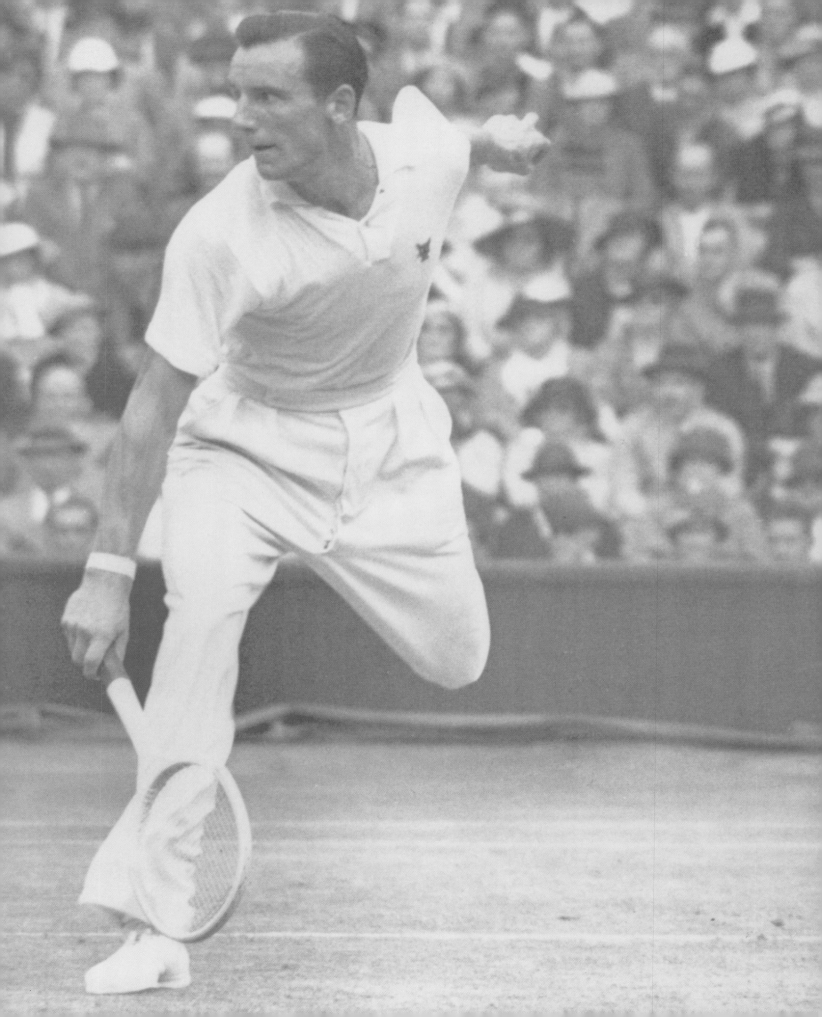

Bobby Abel (1857–1936)
Cricket

A diminutive opening batsman for Surrey and England, 'The Guv'nor' made over 2,000 runs in eight consecutive seasons between 1895 and 1902, and his 357 not out in 1899 is still the highest ever score by a Surrey player. He set a record of 3,309 runs for a season in 1901, which was overtaken by county colleague Tom Hayward five years later. The scores of both players remain among the top ten highest in a single season. Abel scored 74 first-class centuries in his career between 1881 and 1904. He played in 13 test matches, went on two tours to Australia, and retired with a test average of 37. His England colleague **C.B. Fry** recalled in 1898 that Abel stood 'scarcely five feet in his buckskins. His face is ruddy and wrinkled, and suggests premature age or many cares. He has the peculiar serious expression common to grooms and music-hall artistes ... He never smiles even after he has passed his second century. But ... there are no two ways about his batting. He gathers runs like blackberries everywhere he goes.'

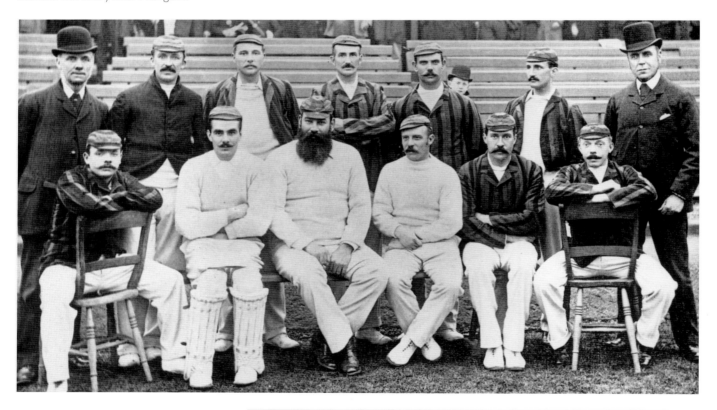

Lord Sheffield's England Team in Australia, 1891 Standing (l to r): R. Carpenter (umpire), William Attewell, George Lohmann, John Read, G. Bean, John Sharpe, R.A. Thomas (umpire). Seated (l to r): Johnny Briggs, Gregor MacGregor, W.G. Grace, Bobby Peel, Andrew Stoddart, Bobby Abel.
C.H. Chandler
Hulton Getty
See also **W.G. Grace**

Harold Abrahams (1899–1978)

Athletics

The 1981 film *Chariots of Fire* posthumously made Abrahams one of Britain's best-known Olympians. Excelling as a student at Cambridge, he was selected for the 1920 Olympic Games, although failed to qualify for either the 100m or the long jump. Returning to dominate domestic competition, he twice set a British long jump record, but dropped this event to concentrate on the sprint races over 100m and 200m. In preparation for the 1924 Paris Olympics, Abrahams hired the professional coach Sam Mussabini, inviting much censure from the Amateur Athletic Association. Together they spent nine months perfecting Abrahams' start, arm action, stride pattern, and the drop finish of the torso onto the tape. At Paris in the 100m he took the gold medal and set a new Olympic record, becoming the first European to win an Olympic 100m title. He was also a member of the silver medal winning 100m relay team, setting a British record which lasted for 28 years, but he finished last in the 200m. In May 1925, by this time a practising barrister, he severely injured a leg, trying to improve on his own long jump record, and retired from active athletics.

Harold Abrahams, Amateur Athletics Association Championships, Stamford Bridge, June 1924
A.R. Coster for Topical Press
Hulton Getty

Jeannette Altwegg (b.1930)

Ice skating

Equally talented at both tennis and skating, the 17-year-old Altwegg became British figure skating champion, finished fifth in the World Skating Championships and was runner-up at junior Wimbledon. She then abandoned tennis to train for the skating events at the 1948 London Olympic Games, where she collected a bronze medal. Her progress towards the next Olympics was exemplary: fourth and fifth in the European and World Championships of 1948; third in both events in 1949, second in both in 1950, and winner in both in 1951. She subsequently went to the Oslo Winter Games as reigning world and European champion, and favourite for the gold medal, which she duly claimed. The newly crowned 22-year-old champion retired immediately after the Games, foregoing many opportunities to turn professional, in order to take up a teaching post at a Swiss orphanage.

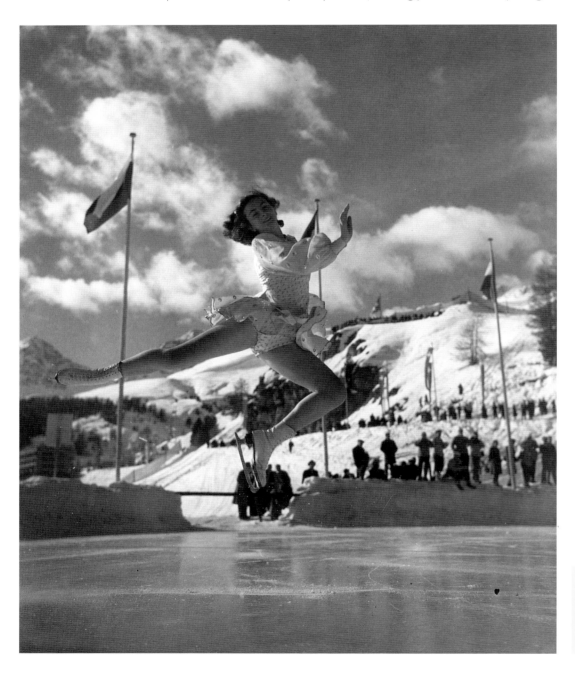

*Jeannette Altwegg,
Winter Olympics,
St Moritz, February 1948*
Chris Ware for Keystone
Hulton Getty

Fred Archer (1857–86)
Horse racing

Fred Archer, heroic, tragic, uniquely successful and universally known, stands alongside **W.G. GRACE** as one of the greatest popular sporting heroes of the nineteenth century. In a career of only 17 years he was Champion Jockey 13 times and rode a total of 2,748 winners including 21 classics. Born in Cheltenham and apprenticed in Newmarket, he rode throughout his career for Matthew Dawson, and was retained by the stable's principal owner, Lord Falmouth. Stories of his racing prowess were legion, but none was more telling than his ride on Bend Or in the 1880 Derby. With one arm seriously injured and strapped to a brace, Archer rode a furious race and beat Robert the Devil by a head. In 1883 he married Matthew Dawson's niece Helen Rose only to lose her two years later in childbirth. Despite such harrowing personal tragedy, his career continued to flourish and his 246 winners for that year remained a record until broken by Gordon Richards in 1933. Archer's health suffered appallingly from wasting and the effects of 'Archer's mixture', a devastating purgative which he took in order to meet ever lighter racing weights. In 1886, having starved for the Houghton races and ridden five winners in one afternoon, he returned ill to Newmarket and on 8 November shot himself in a fit of delirium. HC

Fred Archer
Unknown artist (CWS), 1888
Chalk, 578 × 413mm
National Portrait Gallery

Jockeys and weight

All nineteenth-century flatrace jockeys, apart from those blessed with natural lightness, had to eat little and submit themselves to a regimen of long walks in heavy clothes, Turkish baths and purgatives. Even riders with no apparent weight problems often found themselves trying to sweat off that additional pound, for an ability to ride at a lower weight increased the chances of employment in a competitive profession. Inevitably, such wasting weakened their constitutions – tuberculosis, for instance, was almost an occupational disease. Over time the Jockey Club has raised the minimum weight to its present level of 7st 10lbs in contrast to the 5st 7lbs of 1860. Modern jockeys also benefit from the better understanding of nutrition that we have today. Yet theirs is still a life of fierce self-discipline. At the same time as existing on a starvation diet, they have to keep fit and strong enough to control a thousand pounds of horseflesh. **Frankie DETTORI**'s natural weight is 9st 4lbs, but during the racing season he rides as low as 8st 5lbs. WW

Bunny Austin
Alfred Wolmark, 1938
Oil on board, 1524 × 610mm
John Austin

Bunny Austin
(b.1906)
Tennis

An idol of tennis watchers in the 1930s, Henry Wilfred 'Bunny' Austin reached the men's quarter finals at Wimbledon in nine out of ten years from 1929 to 1939. Twice ranked at world number two, and top seed in 1939, he never managed to lift the trophy, losing in the finals of 1932 and 1938. His consistency as one of the world's top players in the 1930s has been over-shadowed by the hat trick of Wimbledon singles titles won by his contemporary **Fred Perry**. The two men were ever-present in the British Davis Cup team that triumphed in four successive years from 1933 to 1936. Austin was the stalwart of this strongest-ever British team, winning 36 of the 48 matches in which he played. Away from Wimbledon, he was runner-up in the French singles in 1937. In mixed doubles, he narrowly missed out again in the major tournaments, reaching the final at the US Championships in 1929, the French Championships in 1931 and Wimbledon in 1934. It is an irony that Perry, known for the manufacture of tennis clothes, always dressed like a cricketer on court, whereas Austin was the first tennis player to dress in shorts and casual shirts – becoming something of a pin-up in the process.

John Ball Junior (1861–1940)
Golf

The greatest amateur golfer of his era, John Ball Junior won the Amateur Championship a record eight times between 1888 and 1912 and was twice defeated in the finals. He won the Open Championship in 1890, becoming not only the first amateur and the first Englishman to do so, but also the first player to win both the Open and the Amateur in the same year. He also won 149 individual club scratch medals between 1881 and 1927. Ball was born in Hoylake, where his father ran the Royal Hotel, situated conveniently near the Royal Liverpool Golf Club, which Ball joined in 1881. He served as a trooper in the Boer War, missing two years of competition in 1900 and 1901. As a young man, he was very long with his tee shots and his iron clubs and as he grew older, he became noted for his flawless, steady play. A quiet and stoical man, Ball was nevertheless a ferocious competitor, often appearing to play a game of cat and mouse, almost toying with his opponent before ending the match near the home hole. PNL

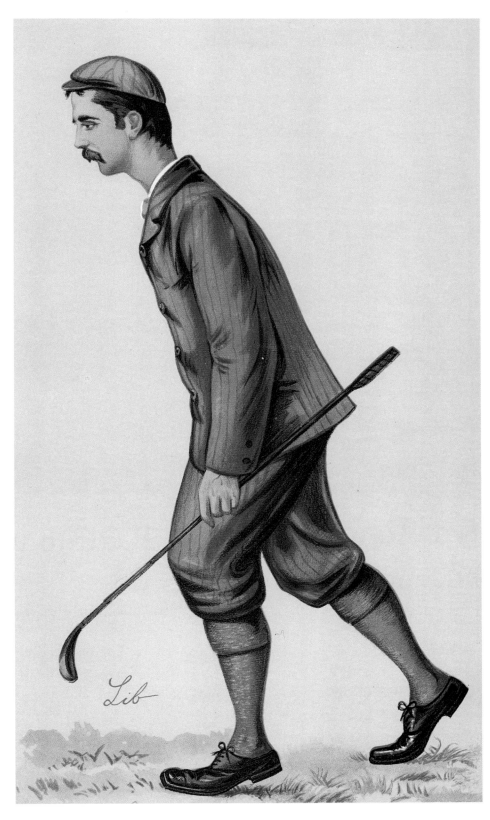

Mr John Ball Jun.
Published in *Vanity Fair*, 1892
Liberio Prosperi (Lib)
Chromolithograph, 321 × 189mm
National Portrait Gallery

Roger Bannister flanked by Christopher Brasher (l) and Christopher Chataway, having broken the four minute mile, Oxford University athletic track, 6 May 1954
Central Press, Hulton Getty

Sir Roger Bannister (b.1929)
Athletics

Bannister achieved immortality in just under four minutes at the Oxford University athletic track. The date, 6 May 1954, has assumed man-on-the-moon significance in athletics, because the desire to complete a mile within four minutes had consumed runners since the days of **Walter GEORGE** in the 1880s. Bannister's record-breaking run was a throwback to the heyday of the Amateur Athletic Association. Dressed from top to toe in white (running for the AAA against the University), Bannister was accompanied by Christopher Brasher and Christopher Chataway. It was they who set the pace to allow the tall, skinny medical student to make his long loping strides towards glory. This most celebrated of all records – the mile in 3:59.4 minutes – lasted only six weeks, beaten by the Australian John Landy. But Bannister proved his was no one-off achievement when he beat Landy in the Commonwealth Games 1500m final in Vancouver. He never triumphed on an Olympic stage, however, having turned down the chance to compete in 1948, and finishing fourth in 1952 in the 1500m; his disappointment at this was immense, and he was pushed to the brink of retirement. By the time of the 1956 Olympics, Bannister had sidelined running to pursue his distinguished medical career.

'Captain' Barclay (1779-1854)
Pedestrianism

A tall and well-built man, Robert Barclay Allardice was renowned for great physical strength, inexhaustible endurance and for lasting days with little or no sleep. He was an extraordinarily versatile athlete who won races from 440yds to 90 miles, once lifted 1,204lbs, and could raise, one-handed, an 18-stone man from the floor onto a table. At the age of 22, Barclay successfully walked 90 miles in 21½ hours, for a wager of £10,500, the largest sum won by a pedestrian up to that time. However, the event for which he is best remembered was his wager to go on foot one mile every hour for 1,000 consecutive hours (only eight hours short of six weeks), which he completed on Newmarket Heath in the summer of 1809, and which won him £16,000.

Barclay also became a famous boxing coach. He trained **Tom CRIBB** for his return fight for 'The Championship' against Tom Molyneux in 1811, winning £10,000 when Cribb won with ease. Unfortunately, not all Barclay's fighters prospered and when one died in the ring he was forced into hiding. This event was just one among many in Barclay's diverse life; others included him petitioning for an earldom, breeding prize-winning cattle and his involvement in a duel. PR

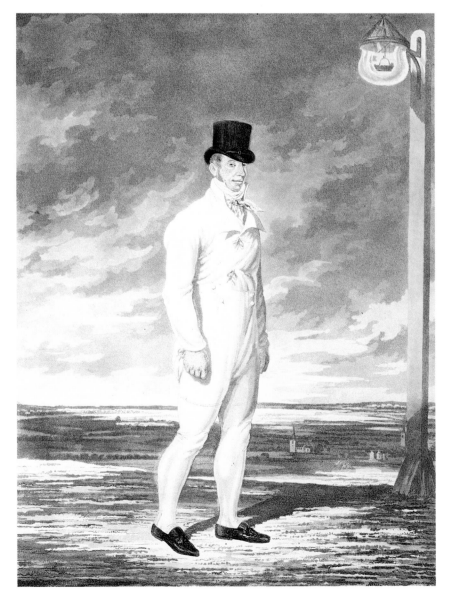

Robert Barclay Allardice ('Captain' Barclay) on Newmarket Heath
Williams, 1809
Colour aquatint, 420 x 295mm
Trustees of the British Museum

Pedestrianism

Throughout the eighteenth and most of the nineteenth century, and probably earlier, men and women in Britain raced for money and for wagers. Because those involved went on foot, they were known as pedestrians, and their sport, pedestrianism. Anyone could take part: men, women, fat, thin, rich, poor, young and old. Many of the events they competed in were over long distances; in the eighteenth century, for example, 50 per cent of all races recorded were over 12 miles, 25 per cent over 30 miles, and 10 per cent over 300 miles.

In the second half of the nineteenth century pedestrianism began to lose favour with the public, partly because it attracted the lowest social classes whose presence led to an increasing number of accusations of 'race fixing'. This coincided with the rise of amateur athletics, which eventually replaced pedestrianism, except in some areas of Scotland and the North of England.

The Powderhall Sprint in Edinburgh, which, traditionally, was a handicap sprint race over 120yds, held at New Year, still survives, in a slightly modified form, even today, and is a reminder of this old professional sport of pedestrianism. PR

S.F. Barnes (1873-1967)
Cricket

A hostile and moody fast bowler, Sydney Barnes was rated the quickest in the world during the Edwardian era. Preferring to play northern league cricket to the county game, his professionalism stood him at odds with the amateur ethos of the 'golden age' of English cricket. When he was selected to tour Australia in 1901–02, he was an unknown quantity, with only 13 first-class wickets to his name. He proved a revelation, taking 19 wickets in his first two test matches. Aloof, blunt and opinionated, he would argue with his captain, **A.C. MACLAREN**, if he was not bowling, and – if things weren't going his way – would argue when he was; it was hardly suprising that he was selected only sporadically at test level. On the 1907–08 Australian tour, his bowling was the exceptional success of an otherwise disappointing visit, in which the series was lost 1–4. Back in Australia in 1911–12, he took 34 wickets in five tests, and on the 1913 South African tour, he took 49 wickets, including a return of 17 for 159, the best bowling figures in a test match until **Jim LAKER**'s heroic 19 for 90 in 1956. Standing gaunt and erect, Barnes was a menacing presence: he saw every batsman as his enemy, and thought every ball bowled should be the batsman's last.

S.F. Barnes
Topical Press, c.1910
Hulton Getty

Cliff Bastin (1912-91)
Football

A prolific goal-scorer with Arsenal in the 1930s, Bastin's partnership with midfielder **Alex JAMES** was the inspiration at the heart of the London club's glory years under manager Herbert Chapman. Bastin was the scorer and James the provider. He joined Arsenal from Exeter City in 1929, at the age of 17. In his first season, he became the youngest ever FA Cup medal winner. The following season, having scored 28 league goals, he was selected for the first of his 21 England caps, still aged only 19. His precocity earned him the nickname 'The Boy Bastin'. From 1929 to 1938, he helped Arsenal to win five league titles and two FA Cup Finals, and won a runners-up medal in a third final. In Arsenal's 1935–6 FA Cup run he scored six goals in seven games. Arsenal were champions again in the 1937–8 season, with Bastin scoring 15 goals. He played in 244 wartime games, in which he scored 71 goals. Bastin's name was forgotten by all but the most diehard Arsenal fans until 1997, when his record of 176 league and cup goals for the club was at last overtaken by **Ian WRIGHT**.
(Illustrated under **Alex JAMES**)

Billy Batten (1889–1959)
Rugby league

One of the first stars of the sport, Batten scored twice in Great Britain's inaugural test match against Australia in 1908. He made his name with Hull, for whom he signed from Hunslet in 1913. His £600 transfer fee was sensational, double the previous record, as was his pay of £14 a game, about five times the going rate. As a centre he was powerful and pacey, with a trademark style of hurdling over tacklers as they prepared to stop him. Never a record-breaking try-scorer, he was an attacking provider, and great handler of the ball, creating opportunities for his team-mates. He and Huddersfield's **Harold WAGSTAFF** became the most popular players of the day, and Batten was the idol of the Hull crowd until 1924, when he moved, playing out his last three seasons with Wakefield Trinity. Injury and his refusal to play in trial matches cost him a place on two Australian tours but he still won 25 international caps. On his retirement, he left behind a rugby league dynasty: three sons, a nephew, and a grandson all played the game at first-class level, with son Eric the most effective, scoring 435 tries, mainly playing with Bradford Northern.

Billy Batten, c.1913
Robert Gate Collection

Jim Baxter (b.1939)
Football

Rangers and Scotland player Jim Baxter was obliged to have two separate 'auld enemies': Celtic and England. In 18 'old firm' league and cup games against Celtic from 1960 to 1965, 'Slim Jim' finished on the losing side only twice, becoming a Rangers icon. He was soon elevated to national idol, when he twice engineered wins against England at Wembley: in 1963 he scored both goals in the 2–1 victory, and in 1967, orchestrated the proceedings when the Scots won 3–2. This was the sweetest Scottish victory of all, as the opposition had

just won the World Cup. **Jimmy GREAVES** had been recalled for England, prompting Billy Bremner to remark 'that England were strengthening their world championship side to face the mighty Scots'. Baxter was the key to Rangers' success in the early 1960s, playing 254 games, during which time the club won three league titles, three Scottish FA cups, and four Scottish league cups. Sometimes wayward, often arrogant and opinionated, Baxter was a consummate ball player, highly skilful and much prone to showing off, especially against England.

Jim Baxter scoring from the penalty spot against Gordon Banks, England vs. Scotland, Wembley, 6 April 1963
Colorsport

Bill Beaumont (b.1952)
Rugby union

Beaumont led England to the Grand Slam in 1980, a feat that had eluded every English captain but one since 1928. A broad-shouldered lock and a good jumper from the lineout, Beaumont made his England début in 1975, and his first match for the British Lions followed two years later. He was never the prettiest or most subtle rugby player – his backside was once referred to as his 'outboard motor' – but he was a formidable and committed scrummager. Fellow Lancastrian Richard Trickey once told him: 'no side-stepping or selling dummies or trying to drop a goal…just remember you are a donkey and behave like one.' Beaumont won 34 England caps, 21 as captain. His best season was the one in which England won the Grand Slam, as he also captained a North of England side to a 21–9 win over New Zealand and led Lancashire to the county championship. In addition, he became the first Englishman to lead the British Lions for 50 years. His retirement on medical advice, in 1982, only enhanced his great popularity with the sporting public: his battle-worn face, walrus moustache and jovial demeanour became familiar through his television appearances, especially as a team captain on the BBC's *A Question of Sport*.

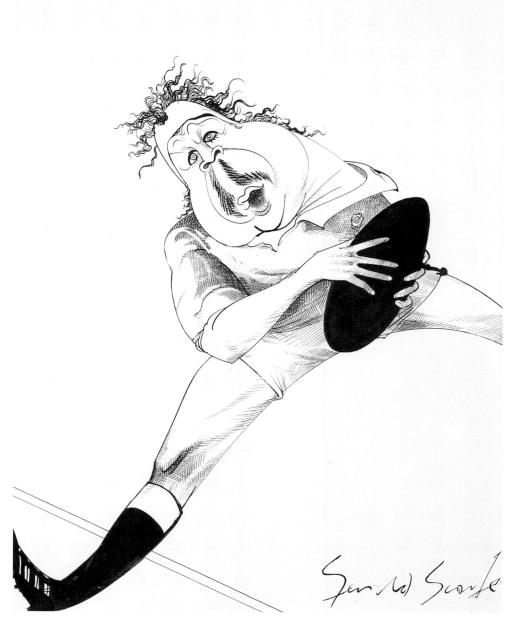

Bill Beaumont
Gerald Scarfe, 1970s
Pen and ink with white,
840 × 590mm
The Artist

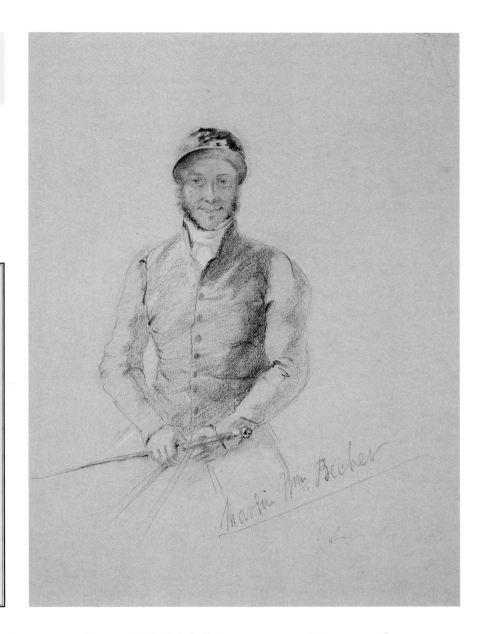

'Captain' Martin William Becher
Bryan Edward Duppa, c.1840s
Coloured chalks, 348 × 255mm
The Trustees of the British Museum

Steeplechasing

It is commonly held that the first steeplechase was a match in 1752 in Ireland between Messrs O'Callaghan and Blake, who raced several miles from Buttevant Church to the steeple of St Leger Church. Similar matches were occasionally held in England before the end of the eighteenth century. The first recorded race with more than two runners was held in Leicestershire in 1792. In the early days of the sport, both horses and riders were hunters. Indeed many of the cross-country races were promoted by hunts who saw such racing as a means of improving the breed of hunting horses. During the 1830s, steeplechasing developed throughout Britain as a spectator sport thanks to the successful pioneering efforts of two sporting entrepreneurs: Thomas Coleman, who organised the St Albans Steeplechase over four miles of 'decent hunting county' in 1830, and William Lynn who began steeplechasing at Liverpool in 1836 on the Aintree course. The good prizes offered attracted specially trained horses and professional jockeys, such as **Jem MASON**, to ride them. WV

'Captain' Martin William Becher
(1794–1864)
Horse racing

It is one of the ironies of racing history that a man once described as 'the best steeplechase rider in England' is now only known for a fall. The son of a Norfolk farmer, 'Captain' Becher joined the army, serving in the Storekeeper General's Department and as an officer in the Buckinghamshire Yeomanry before making his name and living riding over fences in the 1830s. He won the Northampton steeplechase in 1834 and the St Albans steeplechase in 1835 and in 1836, when his mount Grimaldi collapsed on the finishing line. His name is forever associated, however, with the Grand National at Aintree. In the first running of the race in 1839, his mount Conrad hit a fence, throwing Becher into an eight-foot-wide brook. Undeterred, he waited for the rest of the field to pass and remounted, only to fall again two fences later. The race was won by **Jem MASON** on Lottery, but Becher's Brook is to this day the most famous obstacle on the National course. HC

Sir Alec Bedser (b.1918)
Cricket

A lionhearted medium-pace bowler, Bedser's harvest of 236 test wickets in the decade after the Second World War was one of the main reasons behind England's test match success during this period. He made an impact in international cricket in 1946, taking 11 wickets in each of his first two games against India. A consistent test bowler, with a bowling average of 24.89 from 51 matches, he took a total of 1,924 first-class wickets from 1939 to 1960, at an average of 20.41. Against Australia in 1950–1, Bedser took 69 wickets at an average of 16.8. Two years later he was the architect of England's 1953 recapture of the Ashes, with 39 wickets in the five test matches. As a county cricketer, Bedser's contribution was the key to Surrey's run of championship titles from 1952 to 1958. Built like a yeoman, with huge hands and big flat feet, he could work indefinitely, coping with any number of overs in a day. He could swing the ball both ways, and was considered by Don Bradman – on some wickets – to be the most effective bowler he ever faced.

Alec Bedser
David Wynne, 1953
Bronze, 699mm (h)
Marylebone Cricket Club

Jem Belcher (1781–1811)
Pugilism

Of pugilistic stock, his grandfather Jack Slack having conquered **Jack BROUGHTON**, Belcher was one of the many Bristolian prize-fighters who learned to fight in the boxing booths of local fairs. When he arrived in London he was regarded as something of a phenomenon: elegant and modest out of the ring, quick, courageous and clever in it. A contemporary recalled that 'you heard his blows, but you did not see them'. From 1798 to 1803, Belcher was Champion of England, defeating all-comers, and winning many admirers and patrons. In July 1803, at the peak of his powers, Belcher lost an eye, ironically not in the prize ring but while playing rackets. Although he fought bravely and skilfully against his former pupil Hen 'game chicken' Pearce in 1805, and against **Tom CRIBB** in 1807 and 1809, his almost legendary speed and courage could not offset the disadvantage of fighting with one eye: he lost these fights and never fought again. He became landlord of the 'Jolly Brewers' pub in London's West End, thanks to the generosity of his many patrons, one of whom, Lord Camelford, left Belcher his bulldog Trusty on his death.

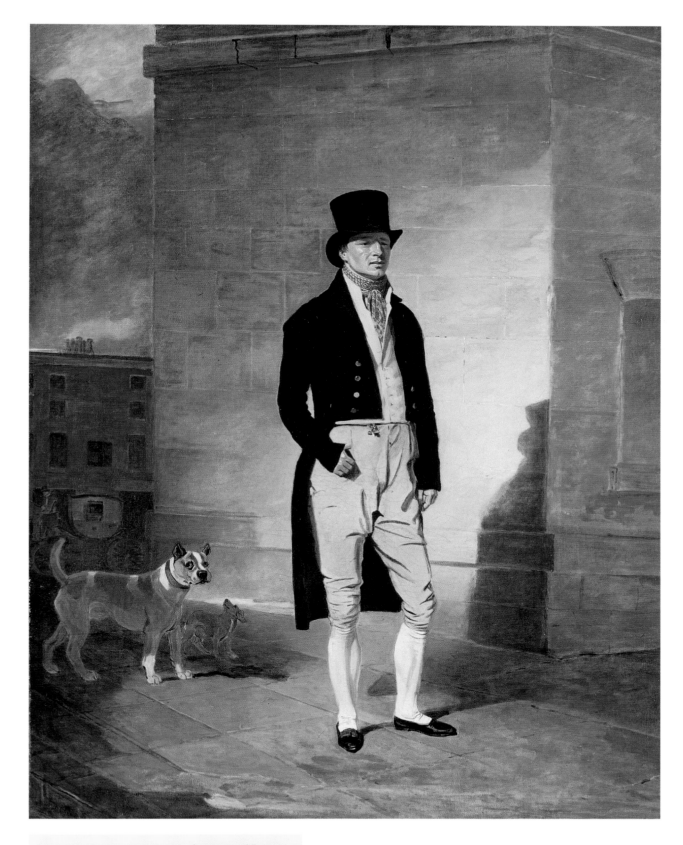

James 'Jem' Belcher, Bare-knuckle Champion of England
Ben Marshall, *c.*1803
Oil on canvas, 906 × 702mm
Tate Gallery, London

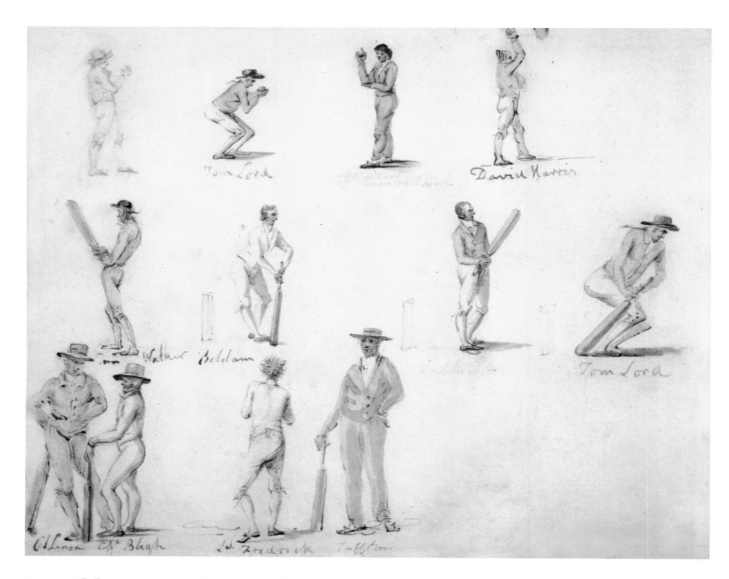

William Beldham (1766-1862)
Cricket

Even when a sideshow of English bucolic life rather than a sporting contest, cricket still had its heroes and one of these was William Beldham. He was a player with the Hambledon Club, the cradle of English cricket. It was in this small Hampshire village on the green near the pub that many of cricket's idiosyncratic rules were devised and the modern game was developed. Grey-haired 'Silver Billy' Beldham first played for Hambledon in 1787, aged 21. For over 30 years, he was the finest batsman of the day, playing in many important matches including some at Lord's, and he also bowled a deceptive underarm ball which swerved through the air, and could bounce either way off the grass. John Nyren, cricket chronicler and player with the Hambledon Club, said of Beldham that 'he was safer than the Bank ... and yet a most brilliant hitter.' The Reverend John Mitford recalled Beldham as he struck the ball: 'the grandeur of the attitude, the settled composure of the look, the piercing lightning of the eye, the rapid glance of the bat...Michelangelo should have painted him. Beldham was great in every hit, but his peculiar glory was the cut. His wrist seemed to turn on springs of finest steel.'

Twelve cricketers in characteristic attitudes, members of the Hambledon cricket team, including William Beldham, (centre row, second left) George Shepheard, c.1795 Ink and watercolour, 230 x 254mm Marylebone Cricket Club

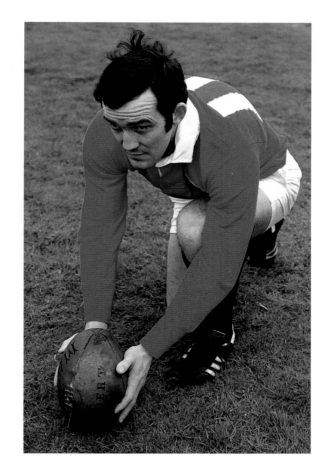

Phil Bennett (b.1948)
Rugby union

An impish fly-half, Llanelli's Phil Bennett had the unenviable task of succeeding **Barry JOHN** in the Welsh national side and for the British Lions. In 29 Welsh internationals from 1972 until 1978, he stood alongside **Gareth EDWARDS** at scrum-half, forming probably the most potent half-back pairing ever produced by a British team. Edwards said of him that 'he could catch the worst rubbish you might throw at him, he could almost bewitch opponents with his footwork.' Bennett was also an elusive runner, an inventive distributor of the ball and an accurate kicker. He was idolised by Welsh fans, one of whom claimed that his shingles had been cured by touching Bennett's boot – the one that had just kicked three goals against England. When Bennett played with the British Lions in South Africa on the 1974 tour, team-captain **Willie John MCBRIDE** considered him the most influential member of the team; the Lions won 21 out of 22 matches. Playing in Wales' glory years of the 1970s, Bennett helped his country to three successive Triple Crown wins from 1976 to 1978.

Phil Bennett, Llanelli
Gerry Cranham,
c.1975

Jack Beresford (1899–1977)
Rowing

Three gold and two silver medals over five consecutive Games make oarsman Jack Beresford one of the greatest Olympians of all time. He was Britain's most decorated rower this century until **Steven REDGRAVE**. But for the Second World War, Beresford would have extended his Olympic appearances to six from 1920 until 1940, and would no doubt have added to his collection of silverware. Winning his third gold at the Berlin Olympic Games in 1936 was Beresford's finest hour; at 37, he was the only non-German winner in the rowing events. His Olympic titles came in three different disciplines, single sculls, coxless fours and double sculls. He proved equally versatile in domestic competition, was champion sculler of Britain from 1920 to 1926, and outstanding at numerous Henley regattas and with the Thames Rowing Club. He set new standards in the sport, and as sculler or oarsman was considered out of range of any of his contemporaries. Sportsmanlike and well-mannered, he was for many years an adept ambassador for his sport.

Jack Beresford
Central Press, 1923
Hulton Getty

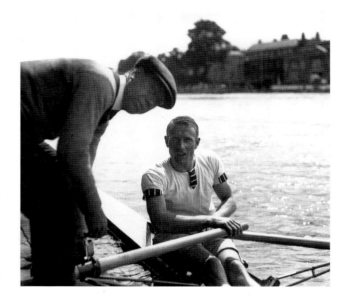

George Best (b.1946)
Football

Arriving in Manchester as a skinny 15-year-old hopeful, Belfast-born George Best soon became the highest profile British footballer in history. Established as a winger with Manchester United, he helped his team to the Championship title in 1965 and 1967. In 1968, aged 22, and at his peak, Best won an even greater prize, a European Cup winner's medal, when Manchester United beat Benfica 4–1. Scoring a prodigious solo goal in the match, Best confirmed his reputation as the most talented player in Britain. With dazzling skills and immaculate ball control, Best mocked the strongest defences in the world, was joint top scorer in the league, and was voted both British and European Footballer of the Year. Off the pitch, his fame spread quickly and he was dubbed 'the fifth Beatle'. As the trappings of his success became more ostentatious – driving sports cars, drinking and nightclubbing – the media began to take an interest in his private life: 'BEST AND HIS BIRDS' roared the headline in the *People* in January 1971. By 1972, as his controversial lifestyle began to infringe on his training, Best left Manchester United aged 27, having scored 137 goals in 361 games. Brief spells playing in America and for Fulham and Hibernian were followed by alcohol-fuelled problems in his personal life; he was even driven to attempt suicide and served a prison sentence. Although Best now only comments occasionally on the game, he still remains a footballing legend.

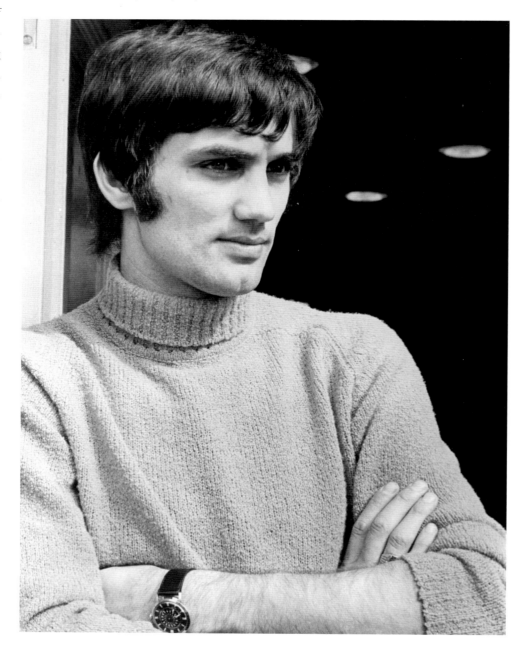

George Best
Sefton Samuels, 1968
National Portrait Gallery

Danny Blanchflower (1926–93)
Football

An inspirational captain for Northern Ireland, Blanchflower led his country to victory over England at Wembley in 1957, and the following year to the World Cup quarter finals. The Wembley win was Northern Ireland's first against England in 27 years, although the always witty Blanchflower remarked that all the previous matches had been 'moral' defeats for England. His achievement at the World Cup in 1958 won him the title of Footballer of the Year. In 1949, Blanchflower signed for Barnsley from Irish league side Glentoran. Two years later he moved to Aston Villa, and in 1954 signed for Tottenham Hotspur for £30,000. At White Hart Lane, he matured into the creative playmaker at the heart of Spurs' greatest-ever side, managed by Bill Nicholson. Blanchflower enjoyed an exalted few seasons in London, captaining the 1961 team that won a league and cup double for the first time this century. Voted Footballer of the Year for the second time in 1961, he won another FA Cup winner's medal in 1962, and led Spurs to European Cup victory in 1963. His vision, close control, and cultured long passes were equally influential for Northern Ireland in his record number of 56 international appearances.

Tottenham Hotspur
Standing (l to r): Peter Baker, Maurice Norman, Roy Brown, Bobby Smith, Ron Henry, Dave Mackay;
seated (l to r): Terry Medwin, Jimmy Greaves, Danny Blanchflower, John White, Cliff Jones
Peter Blake, 1962
Gouache on card, 508 × 762mm
Collection of Joseph McGrath
See also **Jimmy GREAVES**

Steve Bloomer (1874-1938)
Football

England's first great striker, Bloomer scored 28 times in only 23 internationals between 1895 and 1907: his goal tally stood as a record until broken by **Nat LOFTHOUSE** in 1956. Signing for his hometown club Derby County in 1892, he played for the 'Rams' – except for four years with Middlesborough – until he retired at 40 in 1914. He was Derby's leading marksman for 13 seasons, scoring 293 goals in 474 league games, and 38 in 50 cup ties. Bloomer was, like all instinctive goal-scorers, criticised for being too selfish and always looking for glory himself. Short, frail and sickly-looking, he earned himself the nickname 'Paleface'. A contemporary said he was 'as crafty as an Oriental and as slippery as an eel and much given to dealing out electric-like shocks to goalkeepers at the end of a sinuous run'. In 1914, he went to coach in Germany and was interned during the First World War. Returning to Derby, he served on the club staff as coach and general assistant. When his health began to fail in 1938, the club raised money to send him on a world cruise; he died three weeks after his return.

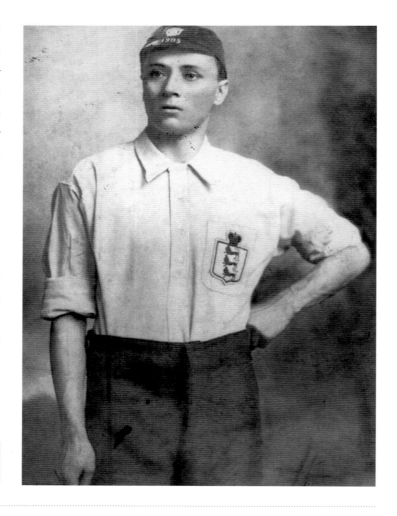

Steve Bloomer, c.1905
Derby Evening Telegraph

Lillian Board (1948-70)
Athletics

The smiling 400m silver medallist at the 1968 Olympic Games, Lillian Board was heralded as the new 'Golden Girl' of British sport; instead, she became its tragic heroine two years later, the victim of cancer at the age of 22. Coached by her father and later encouraged by club-mate **Mary RAND**, Board was a versatile teenager, and was the British schools long jump champion at the age of 14. Establishing the 400m as her chief event, she finished fifth in the 1966 Commonwealth Games, and in 1967 became the British national champion. Later in the year, running for the Commonwealth in a meeting versus the USA in Los Angeles, she won a prestigious 400m race: the event was televised and she was beginning to gain widespread recognition. Tipped by many as a gold medal winner at the 1968 Olympics, she was narrowly beaten into silver medal place by Colette Besson of France. A year later she won the European 800m title, but her health was rapidly deteriorating, and she was training less frequently. Immensely courageous and determined, she was forced to spend increasingly longer periods in hospital, while few knew the extent of her life-threatening condition. She died at a clinic in Munich, ironically the venue for the 1972 Olympics, on which she had set her sights.

(l to r): Lillian Board, Lynn Davies and Mary Rand, London, 9 October 1967
Dennis Oulds for Central Press
Hulton Getty
See also **Lynn Davies** and **Mary Rand**

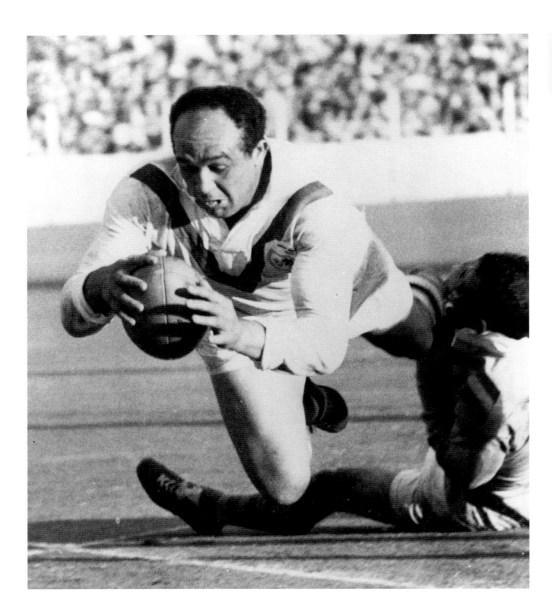

Billy Boston, Great Britain vs. Australia, June 1962
Central Press, Hulton Getty

Billy Boston (b. 1934)
Rugby league

The most exciting player of his generation, Boston was an unstoppable scorer whose haul of 571 first-class tries from 565 games has only ever been beaten by the Australian Brian Bevan. Initially, he was an outstanding rugby union player in South Wales but, lured by the financial rewards rugby league offered, Boston signed for Wigan in 1953. Only six games into his league career, he was selected for the 1954 Great Britain touring side to Australia. Boston was the youngest and most inexperienced team-member ever to tour, and also the first black player to represent Great Britain. He was a sensation, scoring 36 tries in 18 games. On the domestic front, in his famous cherry-and-white hooped shirt, 'The Peer of Wigan' scored 477 tries between 1953 and 1968, the first 100 coming in only 68 matches. He and Eric Ashton formed a potent partnership at Wigan and their visits to Wembley for the Challenge Cup Final became virtually an annual outing. Despite Boston's stocky build, he had electrifying pace and power, great determination, and his trademark swerve fooled many an opposition until he retired in 1970. His devastating hand-off was compared to the kick of a mule, and until the appearance of **Ellery Hanley**, he was the greatest crowd pleaser in the sport.

Ian Botham (b.1955)
Cricket

There has never been a matchwinner in cricket like Ian Botham: if he had any shortcomings they were brushed aside by his complete self-confidence and voracious appetite for the game. He raised his game for international matches, and consistently made the headlines through his heroics on the pitch. His antics away from cricket also appealed to the tabloid newspapers, making him one of the highest profile sportsmen of the century. When his cricket powers were waning, he walked the length of the country for charity, and marched an elephant across the Alps. Botham was a sensation from the outset, taking five wickets on the first day of his first test match, and 5 for 21 in the next match. Between 1977 and 1980 he could do no wrong, taking 8 for 34 and scoring two centuries against Pakistan, becoming the youngest player ever to reach 1,000 runs and 100 wickets, and the first player to score a century and take ten wickets in a test match. He then accepted the job as England captain, a mistake as the side lost all 12 tests under his leadership. His own form dipped too, most dramatically when he was out for a humiliating pair at Lord's against Australia in 1981. Mike Brearley was subsequently recalled as England's captain, and Botham flourished in the remainder of the Ashes series. Throughout the 1980s, particularly in one-day cricket, Botham's flamboyant play continued to translate into both county and test success.

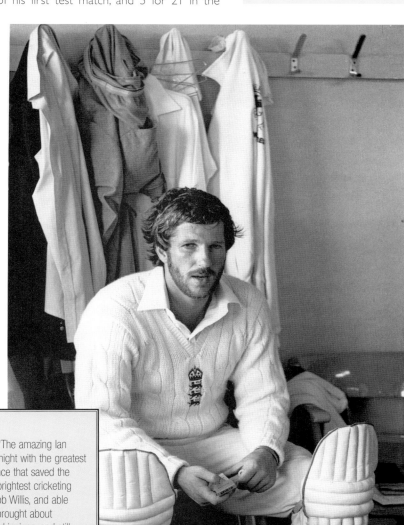

Ian Botham in the dressing room after scoring 149 not out, England vs. Australia, Headingley, 1981
Patrick Eagar

Headingley, 1981

'Botham's a miracle!' claimed the *Daily Express* on 21 July 1981. 'The amazing Ian Botham had the mourners dancing in the aisles at Headingley last night with the greatest comeback since Lazarus.' In an all-round match winning performance that saved the Ashes for England, Botham cemented his reputation as England's brightest cricketing star. Although helped by a devastating spell of fast bowling from Bob Willis, and able batting support from Graham Dilley, Botham was the catalyst who brought about England's change in fortunes. With England 105 for 5 in the second innings, and still 122 runs behind, the odds were on an innings defeat. Enter Botham. At 135 for 7, England were still 92 runs behind. Botham's unbeaten 149, helped by sensible tail end batting, gave England the narrowest chance of success. Australia still only needed 130 to win, and at 56 for 1, they appeared to be cruising to victory. Then it was the turn of Bob Willis to work miracles, taking 8 wickets for 43. In the following test, Botham took 5 wickets for 11 runs, and then scored a century. In the final match, he took ten wickets to secure a draw.

Geoffrey Boycott (b.1940)

Cricket

One of England's greatest opening batsmen, Boycott has been admired and censured in equal measure. With Yorkshire from 1962 to 1986 and playing in 108 test matches for England, he scored 48,426 runs (including 151 centuries), the highest number of runs for a post-war batsmen to date. In 1971 and 1979, his batting average was over 100. Of the 112 batsmen to have topped 25,000 first-class runs, only the Australian Don Bradman has a higher average: hence the admiration. But Boycott also acquired a reputation for being tetchy and incurred criticism for the monomaniacal way he accumulated his runs, often oblivious to the situation of the match or the needs of the team. His defensive technique was immaculate and he protected his stumps as if they were made of the finest crystal. Defending his actions, he always held that putting runs beside his name was the best contribution he could make for England. Boycott was desperate to captain the national side; overlooked for the appointment in 1974, he made himself unavailable for selection for the next three years. To make his point, when he returned to play against Australia in 1977, he scored 107, 80 and 191 in his first three innings. Since retiring, his considerable knowledge of the sport has been put to good use in his erudite media commentaries.

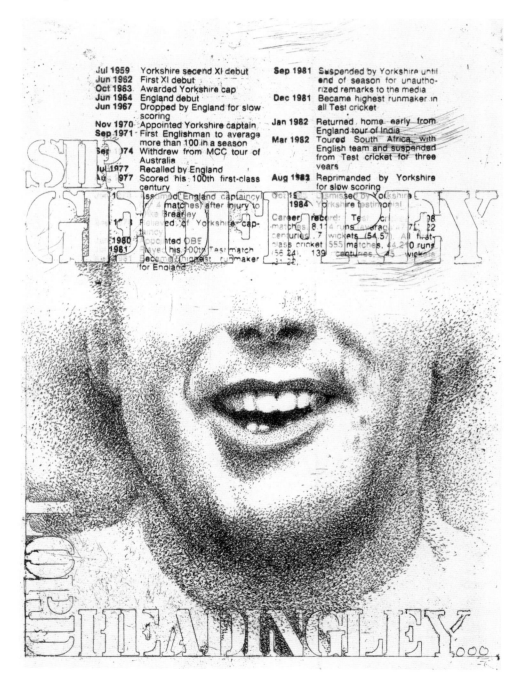

Geoffrey Boycott
Tom Phillips, 1986
Etching, 178 × 127mm
National Portrait Gallery

James Braid (1870–1950)
Golf

The third member of 'The Triumvirate' alongside fellow professionals **Harry Vardon** and **J.H. Taylor**, James Braid won the Open Championship five times in 1901, 1905, 1906, 1908 and 1910. He also won the *News of the World* Tournament four times, the French Open once, and between 1894 and 1914 took the prize at 34 of the 147 tournaments in which he played. Born in Earlsferry, Fife, Braid left school at 13 to become an apprentice joiner. He went to London in 1893 to become a clubmaker for the Army and Navy Stores and three years later became Romford Golf Club's professional, moving in 1904 to Walton Heath where he stayed for the rest of his career. Braid, who had an excellent match temperament, was an extremely long and accurate driver, hitting the ball with such force that he used to knock the gutta percha ball out of shape within a few rounds. He began having eye problems around 1910 and was never quite the same player again. A prolific golf course architect, he designed or worked on over 160 golf courses, mainly in Britain as he disliked sea travel. PNL

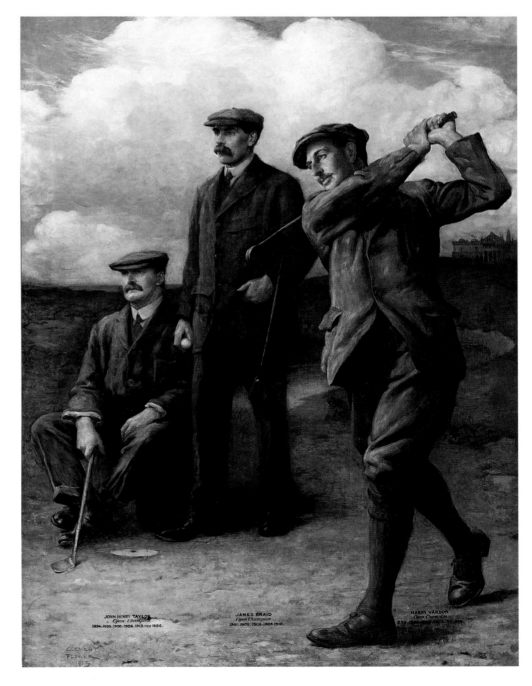

The Triumvirate
(l to r): J.H. Taylor, James Braid, Harry Vardon
Clement Flower, 1913
Oil on canvas, 1880 ×1372mm
Royal and Ancient Golf Club of St Andrews
See also **J.H. Taylor** and **Harry Vardon**

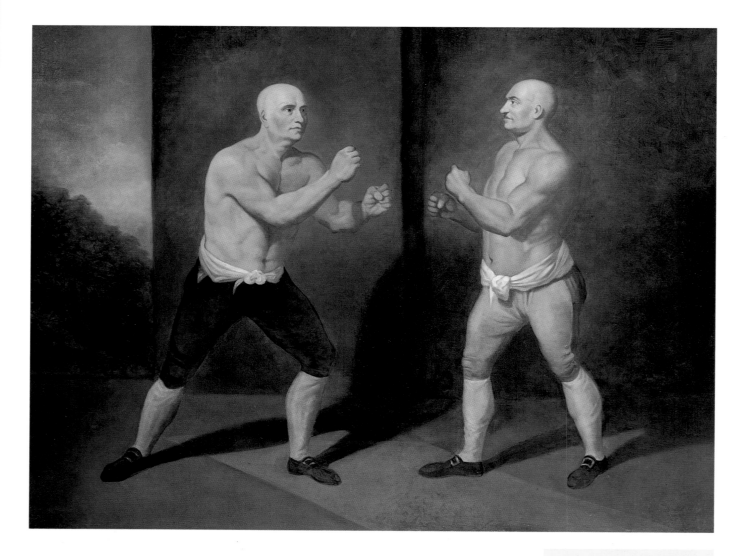

Jack Broughton (1705–89)
Pugilism

The Set-to, the fight between
Jack Broughton (l) and George
Stevenson, 24 April 1741
John Hamilton Mortimer
Oil on canvas, 635 × 762mm
Private Collection

A Thames waterman by trade, Broughton is considered the father of English pugilism. Fighting from a boxing booth in Tottenham Court Road, London, his most famous fight was against Yorkshire coachman George Stevenson, the outcome of which changed the course of pugilism. The defeated Stevenson died from wounds sustained in the ring several days later, and the repentant Broughton then devised the prize-ring's first set of safety rules, to prevent such tragedy from recurring. 'Broughton's Rules' became the basis of all prize-fighting for almost a century, and he was also responsible for the introduction of mufflers (gloves) for sparring purposes. Broughton found a munificent patron in the Duke of Cumberland, but when, in 1750, the Duke backed his man to the tune of £10,000 and Broughton lost, temporarily blinded by the marauding Jack Slack, he thought he had been double-crossed and never forgave his protégé. Using his considerable royal influence Cumberland tried to outlaw pugilism, and punished Broughton by ordering the closure of his boxing academy. The fighter's active ring career was over, but other influential friends rallied round and Broughton continued to thrive as an instructor, eventually building himself his own theatre off Oxford Street. Here he gave lessons in the fistic arts to the gentry, held performances and gloved sparring matches, while amassing a small fortune. After his death a paving stone was dedicated to him in Westminster Abbey.

Frank Bruno (b.1961)
Boxing

Frank Bruno is the most popular British boxer since **Henry Cooper**, and one of Britain's best-known sporting celebrities. 'Know what I mean, 'Arry' became his much-imitated ring side catchphrase, and even years after the retirement of the BBC's boxing doyen Harry Carpenter, Bruno delighted his fans by continuing to ask 'Where's 'Arry?' Although sometimes exposed within the ropes, Bruno never disgraced himself against the world's most dangerous heavyweights. He turned professional in 1982, having won the British amateur title at the age of 18. His first 21 bouts were won inside the distance, but he was knocked out in 1984 by James 'Bonecrusher' Smith. The following year he gained the European heavyweight crown, and began to challenge for the world title. In 1986 he lasted 11 rounds against Tim Witherspoon, and in 1989 was defeated by Mike Tyson. A win was never expected against the American, but Bruno's resistance for five rounds surprised many observers, and he returned home a hero: 'Arise Sir Frank' implored the *Sun's* front-page headline. He challenged for the title against **Lennox Lewis** in 1993, and two years later became the WBC World Heavyweight Champion defeating Oliver McCall. In retirement he has been as much of a light entertainer as a sportsman, his hearty 'Ho, Ho, Ho' and thoroughly likeable manner having been used to great effect in television game shows and pantomime.

Frank Bruno
Tom Wood, 1983
Coloured etching,
524 x 524mm
National Portrait
Gallery

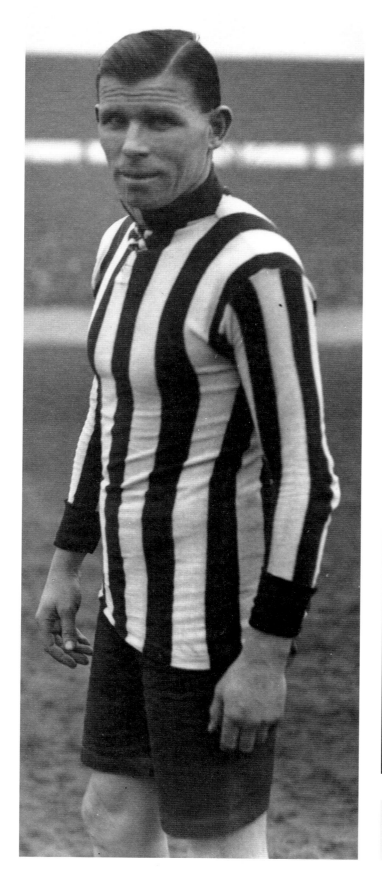

Charles Buchan
Central Press, 1925
Hulton Getty

Charles Buchan
(1891–1960)
Football

Buchan left Arsenal for Sunderland in 1909, having played just four games for the reserves, and returned to the London club as a senior player in 1925. In the intervening years he scored 209 goals in 307 games. Between 1911 and 1914, he was the best-known player in England, inspiring Sunderland to the league title in the 1912–13 season and becoming the club's leading goalscorer six seasons running, three before the First World War and three after. In the 1922–3 season he was the top scorer in the first division. Herbert Chapman, needing an experienced player around whom he could build a new team, re-signed Buchan for Arsenal in 1925. Sunderland put a price of £4,000 on Buchan, but Chapman refused to pay so much for a 34-year-old, offering instead the unusual sum of £2,000 plus £100 for every goal scored in his first season. During three seasons in London he scored 49 goals in 102 games, and led the team to its first FA Cup victory in 1927. He later became a distinguished football journalist, and from 1951 until his death edited *Charles Buchan's Football Monthly*.

Arsenal Football Club in the 1930s:
The Power of a Good Manager

Modern football management began with Herbert Chapman. A Yorkshire mining engineer by trade, Chapman managed Huddersfield between 1921 and 1925, uniquely taking the club to three successive league titles, and FA Cup Final victory in 1922. This impressive background made him an obvious choice for Arsenal, whom he joined as manager in 1925.

A struggling London club in need of a new lease of life, the Gunners were transformed by Chapman into the best team in the league. He sought out talented players from around the country, and was the first man prepared to pay huge sums to bring players to north London, securing the signatures of **David JACK**, **Alex JAMES** and Charles Buchan. He was the forefather of today's big-spending managers, and the biggest innovator the game had seen, introducing floodlights and all-weather pitches. He even managed to persuade the London Passenger Transport Board to change the name of the Gillespie Road Underground station to Arsenal. He won three Championship titles at Arsenal, plus the FA Cup Final in 1930. He died in the middle of the 1933–4 season, but the team he created continued to be the best in England until the outbreak of the Second World War.

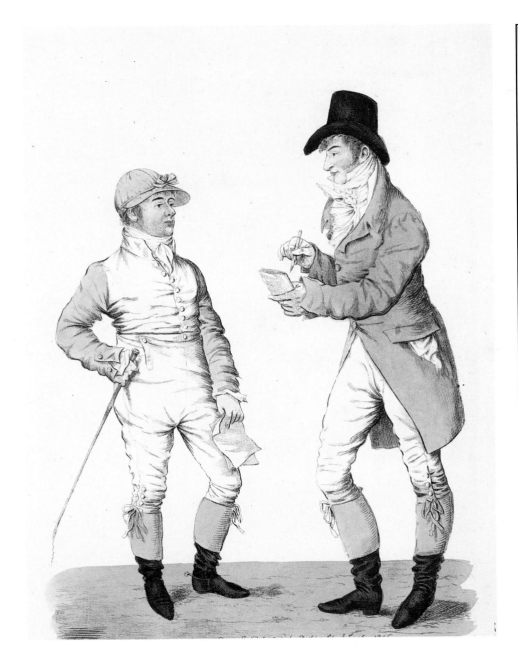

A D E F G H I J K L M N O P Q R S T U V W X Y

Flat Racing

Horse racing emerged from an environment in which horses were seen as status symbols, their quality an overt display of their owner's wealth. Ownership inevitably engendered rivalry that led to the organisation of races, initially matches between two horses but later formalised races with several entrants. Match races continued well into the nineteenth century, the most famous being Flying Dutchman's defeat of Voltigeur over two miles at York in 1851. By this time, however, most thoroughbred racing was open to allcomers and individual owners no longer made wagers against each other, but paid a sweepstakes entry into a prize fund instead. Three major types of races emerged: handicaps, in which all horses theoretically had an equal chance because the allotted weights they carried were determined by their perceived ability; weight-for-age events in which older animals carried heavier weights to compensate for their increased maturity; and racing where all horses carried the same weight in which the best horse should emerge victorious, gaining not only kudos and prize money but also the seal of approval for breeding. WV

A Hero of the Turf and his Agent Frank Buckle (l) and Colonel Henry Mellish
Robert Dighton, 1806
Hand-coloured etching,
365 × 257mm
National Portrait Gallery

Frank Buckle (1766–1832)

Horse racing

When **Lester PIGGOTT** won the St Leger in 1984, he broke a record which had stood unchallenged for over 150 years: Frank Buckle's 27 classic wins. The son of a Newmarket saddler, Buckle rode his first Derby winner, John Bull, for the Earl of Grosvenor in 1792. From 1802 he rode for the Newmarket trainer Robert Robson and together they won the 2,000 Guineas four times and the 1,000 Guineas five times for the fourth Duke of Grafton. Known as the 'pocket Hercules', he was particularly good with lazy and difficult horses, his familiar upright profile often seen swooping to deliver a perfectly timed late challenge. In an era of rampant corruption Buckle was famous for his honesty, riding out winners even against horses on which he had placed bets. He was a master of hounds and bred greyhounds, fighting cocks and bull-dogs on his farm near Peterborough. He died only months after retiring from racing in 1832.

HC

David, Lord Burghley (1905–81)
Athletics

Correctly addressed as David George Brownlow Cecil, sixth Marquess of Exeter and Baron Burghley, and informally known as 'his hurdling lordship', this elegant, aquiline blond was one of the world's pre-eminent hurdlers between the two world wars. In later life, as long-serving president of the Amateur Athletic Association, his AAA1 car number plate was a familiar sight beside the track. At the age of 19, he competed at the Paris Olympics of 1924, but failed to qualify for the 110m hurdles final. He was back in Olympic garb four years later as one of the favourites having broken the 400m hurdles world record in 1927. He lived up to expectations in the Olympic final of the event, taking the gold medal and becoming the first European to win the event. He continued to compete in track events at the highest level after the 1928 Games. In all, he won eight AAA titles, three gold medals at the Empire Games and, at his third Olympics in 1932, a silver medal with the 4 x 400m relay team. In the two individual hurdles events at these Games, he narrowly missed out on a medal, finishing fourth in the 400m and fifth in the 110m. The 1981 film *Chariots of Fire* showed Burghley balancing champagne glasses on the hurdles to test his accuracy in training: in reality he used matchboxes. In addition, it was Burghley, not **Harold ABRAHAMS** as the film suggested, who raced against the clock in circumnavigating the Great Court of Trinity College, Cambridge.

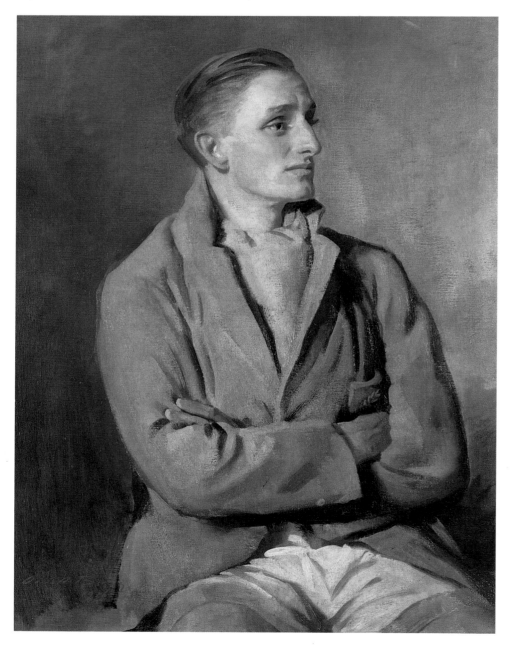

David, Lord Burghley
(as a Cambridge Blue)
Sir Oswald Birley, 1926
Oil on canvas, 1010 x 749mm
The Burghley House Collection

Beryl Burton (1937-96)
Cycling

Britain's greatest-ever female cyclist, Burton was the world's best time trialist in the early 1960s, and was virtually unbeatable in competitive cycling. She was the first woman to compete at the top level against men in the Grand Prix des Nations, being the equal of most male cyclists of her generation. At the World Championships between 1959 and 1967, she won five gold, three silver and three bronze medals in the individual pursuit, plus two more golds and a silver in the road race. Her haul of domestic titles and records was unprecedented: time trial champion for 25 years from 1959 to 1983, winning 72 individual titles, as well as 14 track pursuits and 12 road races. In 1967, her distance of 446km in 12 hours was 9km further than the British men's record, and the following year she recorded a time of three hours and 55 minutes for the 100-mile ride, only 12 years after the first British man had broken the four-hour barrier at that distance. She continued as a serious competitor until just short of her fiftieth birthday, and rode alongside her daughter Denise at the 1972 World Championships.

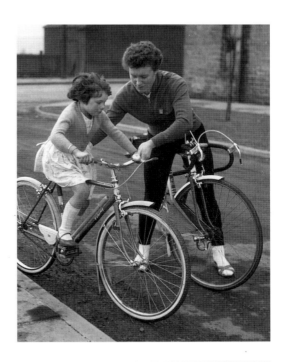

Beryl Burton with her daughter Denise
John Pratt for Keystone, c.1962
Hulton Getty

Abraham Cann (1794-1864)
Wrestling

Abraham Cann
Unknown artist, c.1850
Oil on canvas, 930 × 810mm
Royal Albert Memorial Museum
and Art Gallery, Exeter

The son of a Devonshire farmer and wrestler, Cann himself was soon defeating the best wrestlers in the county and winning prizes wherever he fought. Devon enjoyed a rich tradition of wrestling, although the county style differed from that seen in other parts of the country. The Devonian sport consisted of competitors wearing heavy shoes, endeavouring to disable an adversary by violent kicking in the leg. In December 1826, at the Eagle Tavern in City Road, London, Cann won a major bout without shoes against James Warren of Redruth. Long the champion of Devon, Cann then challenged the champion of Cornwall, a publican called James Polkinghorn, at Devonport. In this, his greatest fight, the much lighter and shorter Cann was more than a match for his opponent, but in front of 12,000 spectators the match was declared a draw, amid a great deal of argument between contestants and crowd, many of whom had wagered heavily on the outcome. At the end of Cann's career, Lord Palmerston headed a subscription of West Country gentlemen who presented the wrestler with a pension of £200. Cann then became an innkeeper at Crediton, not far from his place of birth.

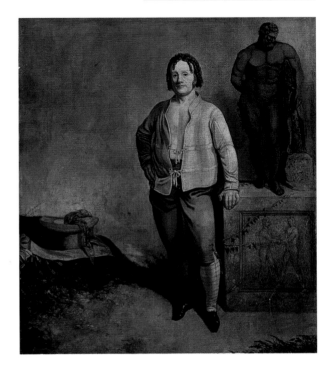

Tom Cannon (1846-1917)
Horse racing

With **Fred ARCHER** and **George FORDHAM**, Tom Cannon made up the great trio of later nineteenth-century jockeys. Like George Fordham, with whom he rode for John Day (son of **John Barham DAY**) at Danebury, he was particularly good with young horses and rarely used his whip. Born in Eton, the son of a Windsor livery stable-keeper, he rode his first winner in 1860, had his first classic success with Repulse in the 1866 1,000 Guineas, and went on to add another dozen classics in a career total of 1,544 winners. In 1872 he was Champion Jockey with 87 winners. Cannon was married to John Day's daughter Catherine and, before his riding career ended, took over the running of the Danebury training stables from his father-in-law. Successful as a trainer of both flat-race horses and jumpers, he was also renowned as a trainer of jockeys. His sons Mornington and Kempton were both leading jockeys and his daughter Margaret married the steeplechase jockey Ernest Piggott, grandfather of **Lester PIGGOTT**. Cannon retired from training in 1892 and acted as Clerk of the Course at Stockbridge for six years before purchasing the Stockbridge pub the 'Grosvenor Arms' where he spent the remaining years of his life. HC

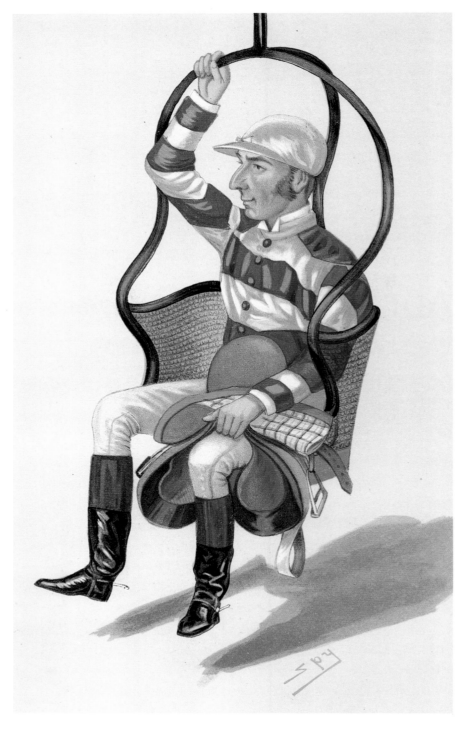

Tom Cannon
Published in *Vanity Fair*, 1885
Sir Leslie Ward (Spy)
Chromolithograph, 317 x 189mm
National Portrait Gallery

Will Carling (b.1965)
Rugby union

Will Carling, England vs.
Argentina, 3 November 1990
David Cannon/Allsport

England's longest-serving captain, Carling was also the most successful, leading England to 44 victories in his 59 games in charge. England having narrowly lost the Grand Slam to Scotland in 1990, he steered the team to the highly sought prize in 1991, 1992, 1995 and 1996. England had only won the Five Nations Championship twice since the 1920s. Carling also led the side to the 1991 World Cup Final, and scored two tries in the 1995 losing semi-final against New Zealand. Showing maturity beyond his years, he had been appointed to the post of captain aged 22 after only seven of his 72 caps. A strong and stocky centre, with a deceptive change of pace and a streak of arrogance, Carling's playing days co-incided with the huge rise in rugby's popularity, as world cups, sponsorship money and professionalism entered the game. He became one of the highest profile players ever, as much for his behaviour off the pitch as for his play on it, and in 1995 his public remarks about the Rugby Football Union executive led to his sacking and somewhat clumsy subsequent reinstatement as captain.

Willie Carson (b.1942)
Horse racing

Unusually among the great jockeys, Scottish-born Willie Carson's rise to the top was slow. Apprenticed in 1958, it was not until 1962 that he rode his first modest winner at Catterick Bridge, and another decade before High Top's success in the 2,000 Guineas brought Carson the first of his 17 classics. From then on his progress was inexorable, and over 30 years his toughness and dedication won him the affectionate title of 'the punter's friend'. It was with the trainer Major Dick Hern that Carson forged the most important alliance of his career, and their partnership was one of the most powerful in modern racing. Among the great horses ridden by Carson and trained by Hern were the 200th Derby hero Troy, in 1979, and Nashwan, effortless winner of the 2,000 Guineas and the Derby in 1989. Carson was famous for overcoming injury and adversity, but a kick from a horse in the Newbury paddock in 1996 finally hastened the end of a long and distinguished career. In retirement he has become a much-appreciated commentator. HC

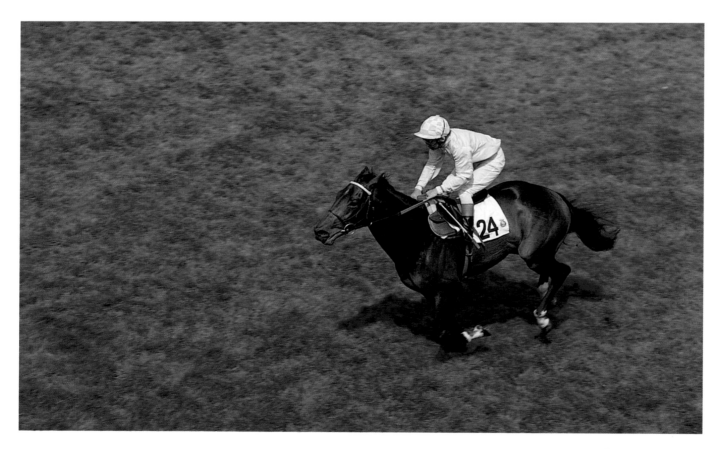

Willie Carson on Troy, winner of the 200th Derby, 6 June 1979
Gerry Cranham

Horse racing Injuries

All workers run the risk of industrial injury though for most it is unlikely. For jockeys, however, serious injury at work is not a possibility, or even a probability, it is inevitable. For those who ride over hurdles and especially jumps, falls are an accepted part of the business. The fall rate for jump and hurdle jockeys is roughly 1 in 14 mounts, with about 1 in 80 rides resulting in an injury sufficient to prevent riding without medical clearance. Every leading National Hunt jockey has suffered serious injury during their years of riding. During his 15-year career Terry Biddlecombe, champion National Hunt jockey on three occasions, broke a shoulder blade six times, his wrists five times, bones in his left hand five times, his left collar bone, elbow, forearm and ankle once each, as well as cracking two vertebrae, dislocating his right ankle, breaking a rib, and chipping a bone in his shin; he also suffered over 100 cases of concussion. Today's leading National Hunt rider, **Tony McCoy**, maintains simply that 'Any time you walk to your car at the end of the day: that's not a bad day.' WV

Raich Carter (1913-94)
Football

One of only three players to win a full England cap either side of the Second World War (**Tommy LAWTON** and **Stanley MATTHEWS** being the others), Horatio 'Raich' Carter signed for his hometown club, Sunderland, in 1931, and captained the team to the league title in 1936, and the FA Cup in 1937. He signed for Derby in 1945, and linking with Irishman Peter Doherty, guided the team to a 4–1 FA Cup Final win in 1946. A gifted passer, he was a provider for others as well as a consistent scorer himself.

Carter won his first England cap in 1934, and scored seven goals in his 13 matches, including England's first post-war goal. With Sunderland, he scored 118 goals in 246 league games, and at Derby, for whom he played well into his thirties, he scored 34 goals in 63 league games, and 16 in 20 cup games. In 1948, he moved to Hull City as player-manager, playing 150 games until he retired, although he continued to manage the side, and was later manager at Leeds and Middlesborough.

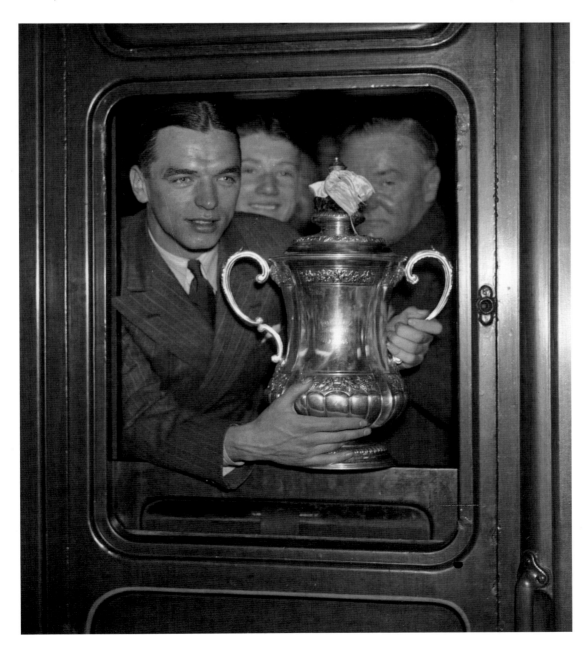

Raich Carter with the FA Cup after Sunderland's 3–1 victory over Preston, 3 May 1937
Topical Press
Hulton Getty

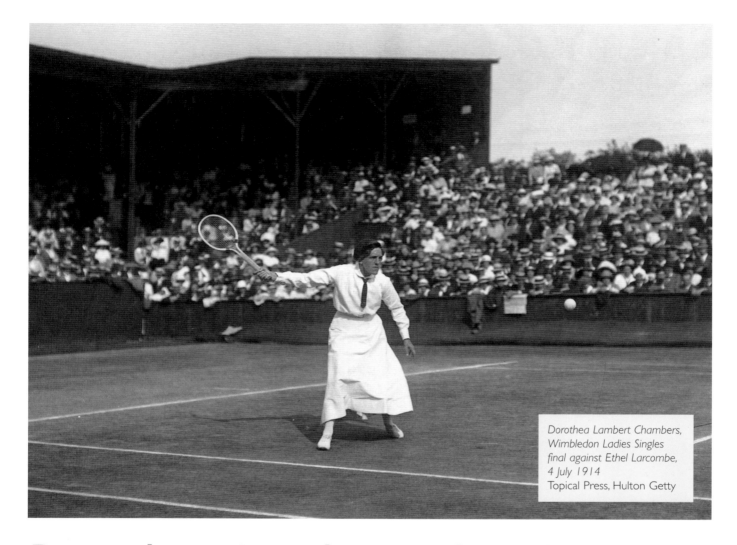

Dorothea Lambert Chambers, Wimbledon Ladies Singles final against Ethel Larcombe, 4 July 1914
Topical Press, Hulton Getty

Dorothea Lambert Chambers
(1878–1960)
Tennis

The sporty daughter of an Ealing clergyman, Chambers was well set to fit the stereotype of the Edwardian vicarage lawn player. But instead she became the best British player of her day, winning Wimbledon seven times between 1903 and 1914, and contesting a further four finals. The epic match that she lost to Suzanne Lenglen in 1919 is still regarded as one of the best women's finals ever. Never has the Centre Court witnessed such a clash of youth versus experience as when the 40-year-old mother of two met the rising star of the game. Chambers looked every inch the Edwardian white-stockinged matron, while Lenglen – young enough to be her daughter – shocked the tennis world, as much by the length of her skirt as through her play. The final score went in favour of Lenglen 10–8, 4–6, 9–7, with Chambers having spurned two match points. She was Lenglen's victim again in the 1920 final, at the age of 41, still the record age for a female Wimbledon finalist. Despite the interruption of the First World War, only Blanche Bingley and Martina Navratilova have played in more finals. Tall, dour and lantern-jawed, Chambers was a formidable figure on court. With her competitive style and unrelenting power, she rejected out of hand the garden party ethos attached to tennis. In her book, *Lawn Tennis for Ladies*, she removed much of the stigma associated with a woman's right to take exercise.

Bob Champion (b.1948)
Horse racing

Like **'Captain'** BECHER of Becher's Brook fame, Bob Champion's heroic status rests on just one race, the 1981 Grand National, and is linked with just one horse, Aldaniti. In July 1979 Champion was diagnosed as having cancer and given just eight months to live. At the same time Aldaniti was almost put down after suffering a badly strained tendon. As the horse was slowly nursed back to health it became the goal of his owner Nick Embiricos and his trainer Josh Gifford, himself a former Champion Jockey, to achieve the apparently impossible and win the Grand National with Bob

Champion in the saddle. After treatment at the Royal Marsden Hospital in Surrey, Champion spent the spring and summer of 1980 convalescing and regaining his riding confidence in America. With only one preparation race for horse and jockey in February, they took on the National: not since **Fred WINTER** had won on Sundew in 1957 had a horse led throughout the final circuit. Although tiring towards the end, they beat Spartan Missile by four lengths. The victory was greeted with an outpouring of popular emotion and the story of the dual comeback became the subject of the full-length feature film *Champions* (1983). HC

Grand National winner
Bob Champion with Aldaniti,
Covent Garden,
14 September 1981
Ray Moreton for Keystone
Hulton Getty

John Charles (b.1931)
Football

Most footballing exports – from **Denis Law** and **Jimmy Greaves** to **Ian Rush** and **Paul Gascoigne** – have experienced torrid times playing for Continental clubs. The Welshman John Charles is the exception to the rule, as no British player has enjoyed such acclaim on foreign soil. Making his name with Leeds, Charles scored 27 goals in 30 matches during his first season, and 42 more the following year. In 1956 he finished as the first division's top scorer. The Italian scouts were taking note, and Turin team Juventus rocked British football in 1957 by doubling the record transfer fee to get their man. Charles continued his goal-scoring feats in Italy, with 29 goals in his first season, and was voted Footballer of the Year, a great compliment to an overseas player. In his time in Turin, he scored 93 goals in 155 league games, and Juventus won three Italian league championships, plus two cup finals. Built like a guardsman at 6ft 2in and 14st, Charles was much loved by the Italians who called him 'The Gentle Giant'. He was perhaps the most important Welsh international since **Billy Meredith**, and in 1958, at the only World Cup Finals where all the home nations joined the party, Charles was as inspirational for the Welsh as **Danny Blanchflower** was for Northern Ireland. Wales drew all their group games, and then beat Hungary in a play-off. But, against Pele's Brazil, Charles was injured, and Wales lost 1–0. In 38 internationals, he scored 15 goals, but he was equally effective playing at centre-half as at centre-forward.

John Charles (r) playing shove halfpenny with a Leeds colleague in the dressing room, c.1954
Hulton Getty

Sir Bobby Charlton (b.1937)
Football

Some are born great, some achieve greatness and some have greatness thrust upon them. Bobby Charlton, one of British football's greatest ambassadors and a national sporting institution, came from a family steeped in football (**Jackie MILBURN** was his uncle). He achieved greatness in his own right, and an unlooked-for greatness was forced upon him as a survivor of the 1958 Munich Air Crash: he quickly became one of Manchester United's senior players, back in action only three weeks after the disaster. At first a precocious scorer of goals, Charlton developed into a classic midfielder, with pace, balance and calm authority alongside a great temperament. At Manchester United in the 1960s, with the likes of **George BEST** and **Denis LAW** gradually replacing the memory of the 'Busby Babes', he won two further league titles, the FA Cup and the coveted European Cup in 1968, in which he scored twice in the final. He scored 247 goals in 752 games for the club. In 1966 Charlton was voted both English and European Footballer of the Year. For England, he is the most distinguished player of all time, winning 106 caps and scoring 49 goals, still a record. He played in three World Cups between 1962 and 1970, scoring three important goals in 1966, and setting the country on its way to World Cup-winning glory.

Bobby Charlton, 1959
Popperfoto

Samuel Chifney Senior (1753/4–1807)
Horse racing

Samuel Chifney Senior was founder of a dynasty of great racing figures – his elder son William was a trainer and his younger son Samuel and grandson Frank Butler were both celebrated jockeys. Born in Norfolk, he grew to be 5ft 5in, but kept his weight within 7st 12lb, cultivating a dandified, foppish image. He won both the Derby and the Oaks in 1789, one of four successes in the fillies' classic, the last-minute 'Chifney rush' becoming his trademark. However, a scandal in 1791 made him infamous. Riding the Prince of Wales' horse Escape at Newmarket, he came last in a field of four despite being odds-on favourite. The following day he reversed the form, winning on Escape at odds of 5 to 1, with a wager of 20 guineas on himself. His claim that the horse had needed the exercise of the first race to put him right was not accepted by the Jockey Club and the affair brought to an end the Prince's racing involvement at Newmarket and Chifney's pre-eminence, though his self-esteem remained undented. In his latter years he ran into financial difficulties over his invention of a racing bridle with the 'Chifney bit', and died a debtor at the age of 53. HC

Baronet, with Sam Chifney up, in the Prince of Wales' colours
George Townly Stubbs, after George Stubbs, 1794
Colour stipple engraving with etching, 387 × 550mm
The Trustees of the British Museum

Corruption and Horse racing

Honest was a rare word in nineteenth-century racing parlance. It was used deliberately about jockeys such as **Nat FLATMAN**, Tommy Lye and **George FORDHAM** with the implicit assumption that it was not applicable to the bulk of riders. Horse racing was a sport which was dependent upon gambling, but too frequently corruption followed in the wake of betting, particularly among jockeys who were insider traders par excellence. Under the leadership of Admiral Rous, the Jockey Club took steps in the 1860s to give local stewards the power to suspend jockeys and not just fine them. More of a deterrent to misconduct was the introduction of revocable licences in 1879 for all jockeys who wished to ride at authorised meetings. Yet many jockeys continued to gamble, arguing that they were forced to bet as owners often refused to pay their riding fees. In 1880 the Jockey Club ruled that all fees must be deposited with the clerk of the course before any race took place. However gambling by jockeys did not cease and, annoyed by this and by rumours of race fixing, in 1884 the Jockey Club made betting by jockeys an offence punishable by loss of licence. WV

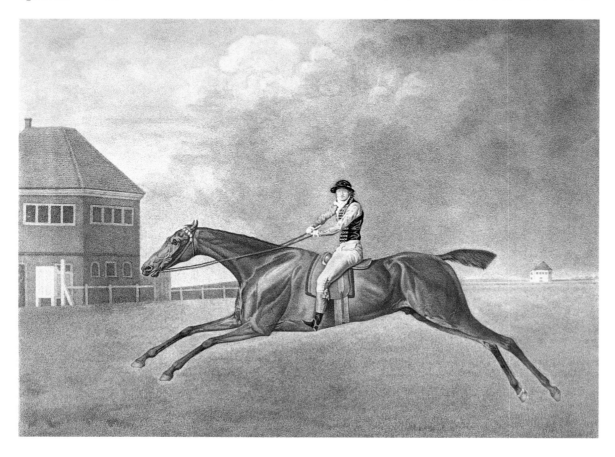

Linford Christie (b.1960)
Athletics

Britain's greatest sprinter, Christie trained in the West London stadium which since 1993 has borne his name. Narrowly missing selection for the 1984 Olympic Games, by 1986 he had become Britain's brightest hope, and won the 100m at the European Championships. He was fourth at the World Championships, and his Olympic bronze medal in 1988 became silver following the disqualification of the Canadian Ben Johnson. An obsessive competitor, Christie triumphed at the Barcelona Olympics of 1992, taking the 100m gold medal in a time of 9.96 seconds. Renowned for his trance-like state and staring eyes at the start of his races he had become, at 32, the oldest 100m champion of all time. The following year, he beat the American Carl Lewis in a 100m race at Gateshead, and added the world title to his Olympic one in the 1993 World Championships, running the second fastest time ever at 9.87 seconds. In 1994, he won the European Championships 100m title for a third time, and secured the gold medal at the Commonwealth Games. But Christie's Olympic exit in 1996 was a sorry one, marred by two false starts, for which he was disqualified.

Linford Christie (r) and Colin Jackson
Jillian Edelstein, 1993
National Portrait Gallery

Jim Clark (1936–68)
Motor racing

Clark's death in 1968 at the age of 32 was the most significant loss to Formula One until the Brazilian Ayrton Senna was killed in 1994. His record of wins – 25 out of 72 Grands Prix – would alone have raised him to greatness, but it was his brilliance on the track that made this shy Scotsman a motor racing legend. Progressing from local trials racing and rallying in 1956 to mastery of Formula One by 1960, his potential was recognised by Colin Chapman at Lotus, to whom Clark remained faithful throughout his driving career. By 1962, in the newly constructed monocoque Lotus 25, Clark won three Grands Prix, but narrowly lost the Drivers' Championship to Graham Hill. The following season Clark won seven out of ten starts to win the title and establish himself as motor racing's star attraction. Second in 1964, way ahead of the rest of the field in 1965, he had a poor year in 1966; but by 1967 he was back to his best, winning four out of eleven Grands Prix. 1968 looked to be Clark's year again: overtaking Juan Manuel Fangio's record of victories, he won the first Grand Prix of the season. But it was also to be his last. On 6 April 1968, in a meaningless Formula Two race at Hockenheim, he was killed instantly as his car spun off the track into the trees. The motor racing world scarcely believed it possible. The finest exponent of their sport was dead.

Jim Clark with Jean Shrimpton and Ford Corsair
David Bailey, 1965
Ford Motor Company

Don Cockell (1928–83)
Boxing

In what sounds like a tale of a nineteenth-century prizefighter, Cockell worked as a blacksmith, and boxed for money in fairground booths on Saturday nights, in order to earn enough money to get married. Proving a popular success in the ring, he left his job to box full time, turning professional in 1946. A strong puncher, he won the British light-heavyweight title in 1951 and added the European title, later losing them both to **Randolph TURPIN**. He then moved up to heavyweight, beating an out-of-condition **Tommy FARR** to take the British and Commonwealth titles. Cockell then defeated the Americans Harry Matthews and Roland La Starza to earn himself a fight against Rocky Marciano, in the first British world heavyweight title challenge since Tommy Farr fought Joe Louis in 1937. In front of a partisan San Francisco crowd, Cockell bravely stood up to a barrage of blows from the all-punching Marciano, some of which were clearly illegal, and might have been disallowed by another referee. Cockell retired after nine rounds, and his career was virtually over.

Don Cockell
Derek Hill, *c*.1950
Oil on canvas, 545 × 635mm
Private Collection

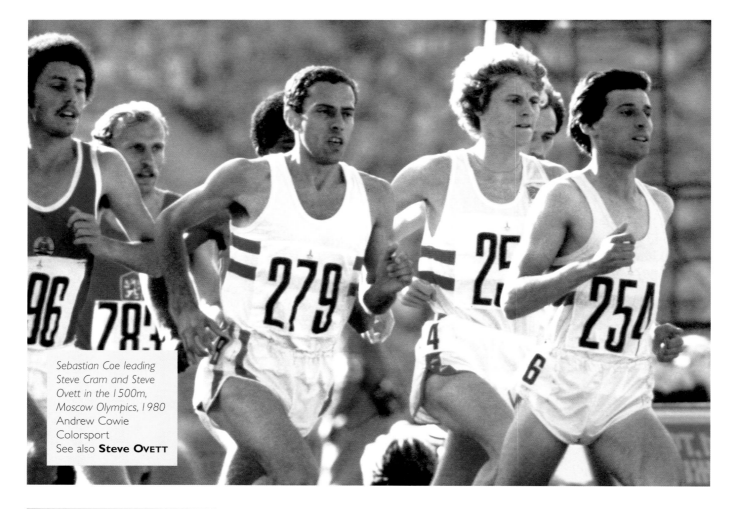

Sebastian Coe leading
Steve Cram and Steve
Ovett in the 1500m,
Moscow Olympics, 1980
Andrew Cowie
Colorsport
See also **Steve OVETT**

Showdown in Moscow: Coe vs. Ovett

With Steve Ovett and Sebastian Coe in their prime, Britain ruled middle-distance running for over a decade. Their own private competition for medals in the 800m and the 1500m at the 1980 Moscow Olympics was the most eagerly awaited duel in British athletics. Most were in favour of the urbane media-friendly Coe, whereas Ovett's tetchiness extended to his refusal to talk to the press. Ovett was unbeaten over 45 successive 1500m races, so was expected to win that event. Coe, the world record holder at 800m, was the likelier to win the shorter distance. Yet in the 800m, Ovett shocked the nation by taking the gold while Coe picked up the silver. A dejected Coe attracted criticism for his sullen performance on the medallists' podium. Revenge soon followed in the 1500m. Ovett, the favourite, took the bronze, while Coe became the Olympic champion in what was supposed to be his reserve event.

Sebastian Coe (b. 1956)
Athletics

Drawing physical and mental strength from his father's coaching, Coe was the world's pre-eminent middle distance runner from 1978 to 1984. Between 1977 and 1981, he lowered nine 800m and 1500m world records (many already his own), breaking three within six weeks in 1979. The following year, he faced his biggest test at the Moscow Olympics. In preparation for the 1984 Olympics, Coe was set back by injury and began to lose ground to the likes of Steve Cram and Peter Elliott. He showed great sporting reserves, however, rising to the occasion at the 1984 Games, and repeating his medal haul from the 1980 Olympics: the 800m silver came first, then the 1500m gold, the latter setting a new Olympic record. But he had to wait until the 1986 European Championships to achieve a gold medal in the 800m. It is possible that he might have won another gold medal in the 1988 Olympics, thus creating Olympic history in defending his track title twice, but he retired from the sport amid controversy: failure in the official British trials was followed by a 'wild card' invitation from the International Olympic Committee to compete in the Games in recognition of his stature. A sporting *cause célèbre* followed, debating the ethics of this offer, and eventually Coe stood down, departing from athletics altogether to enter politics.

Cecilia Colledge (b.1920)

Ice skating

In 1932, at 11 years and 82 days old, Colledge became the youngest-ever female Olympic competitor in any sport. As a seven-year old, she was taken to the World Championships in London, where she was enthralled by the Norwegian ice skating champion Sonja Henie, who was 15. Colledge decided to emulate Henie, and three years later, in 1931, finished third in the British Championships. Later that year, she competed in the British Olympic trials alongside Megan Taylor, her great rival throughout the 1930s. In 1932, Colledge finished eighth in both the Olympics and the World Championships. Domestically, she was runner-up to Taylor from 1932 to 1934: but between 1935 and 1938 she won five British Championships (two Championships were held in 1937). She finished second to her inspiration Sonja Henie at both the 1935 World Championships and the 1936 Olympics, eventually becoming world champion in 1937, and European champion from 1937 to 1939. By this time Henie had turned professional, and Colledge and Megan Taylor were the dominant names in the amateur sport. After the Second World War, during which she was a driver in the transport corps, Colledge returned to become British champion again. She then turned professional, and emigrated to America five years later.

Cecilia Colledge
Bassano and Vandyk, 1938
National Portrait Gallery

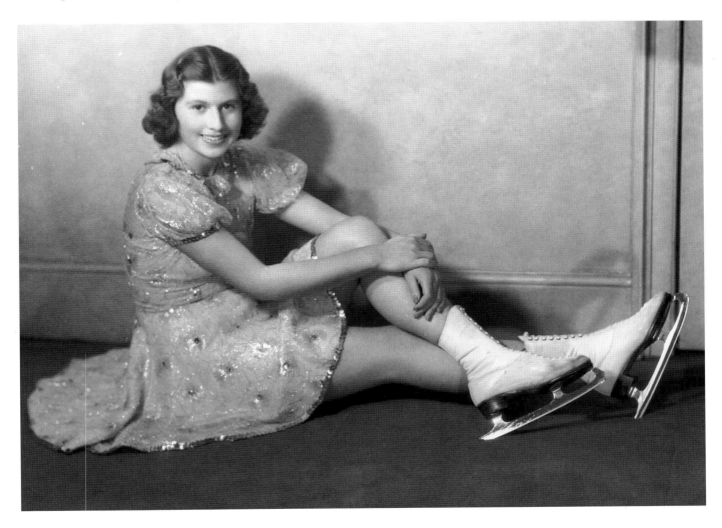

Denis Compton (1918-97)
Cricket

Compton was the supreme entertainer of English cricket, and his majestic batting, combined with his natural *élan* and film star looks helped to raise British morale in the years of post-war austerity. As the 'Brylcreem Boy' of the national advertising campaign, his face was known to hordes of people who never watched the game. The 1947 season was his zenith, playing for Middlesex and in the test match series against South Africa. During that summer, he totalled 3,816 runs, with 18 centuries, averaging 90.85. Carefree and imperious at the same time, sweeping arrogantly, driving and cutting with authority or cheekily caressing the ball down the leg side, Compton was an endless improviser, daring to play the unplayable. He played for England 78 times between 1938 and 1956, and his first-class batting average from nearly three decades of cricket was 51.85. He made 1,000 runs a season 17 times, and was also a useful bowler taking 622 wickets in his career. In addition, Compton was one of the last double England internationals at football and cricket. In 1950, within a few days of returning from England's tour of South Africa, where he averaged 84.80 and struck a triple century, Compton collected an FA Cup winner's medal with Arsenal.

Denis Compton dancing with Anna Neagle, Empress Hall 1 October 1949 Monty Fresco for Topical Press Hulton Getty

Henry Cooper (b.1934)
Boxing

Henry Cooper, 'Our 'Enry', was Britain's best heavyweight since the Second World War, but despite his devastating left hook, known as 'Enry's 'Ammer', he was rarely a world beater in the ring; he even quipped that his suspect right hand was strictly for 'writing cheques'. As a teenager, Cooper competed at the Olympic Games in 1952, turning professional in 1954. His first big test was in 1957, when he lost a European title fight to Ingemar Johansson. In 1959 he beat Brian London, gaining the British title which he held until 1970. Ironically, his greatest moment came in defeat, when he gave a courageous performance against Cassius Clay in 1963. A return match took place in 1966, by which time Clay fought as Muhammad Ali. This time, Cooper hardly got a look in. However, he continued to dominate the British scene until 1971 when, at 37, he lost his British and Commonwealth titles to Joe Bugner, and retired on the spot. A regular on *A Question of Sport* and other television panel games, he became a marketable media personality, even entering the pop charts with his single *Knock Me Down With a Feather*. He also attracted a much larger audience than ever saw him fight when he appeared in the celebrated television commercials for the men's fragrance, *Brut*.

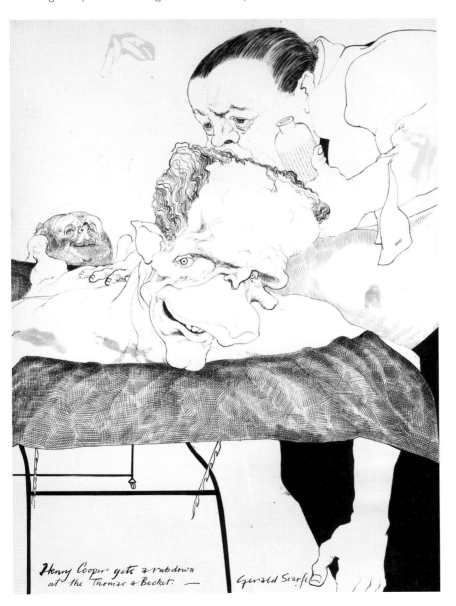

Henry Cooper gets a rubdown at the Thomas à Becket. — Gerald Scarfe

Henry Cooper gets a rubdown at the Thomas à Becket
Gerald Scarfe, c.1967
Pen and ink, 775 × 560mm
National Portrait Gallery

Henry Cooper vs. Cassius Clay

Controversy still surrounds one of the greatest nights in British boxing history, Cassius Clay's meeting with Henry Cooper. Four seconds short of the bell at the end of round four, Cooper floored the American with a blow from his left glove. Clay stumbled back into his corner, relieved that the round was over. During the break, Clay's manager, Angelo Dundee, claimed that his glove had split and that it would have to be changed, so doubling the break to two minutes. The extra minute, and the use of smelling salts, allowed Clay a fuller recovery, giving him the opportunity in the next round to set to work on Cooper's highly vulnerable cut above the eye. Cooper's subsequent defeat denied Britain's finest heavyweight of the day his greatest victory.

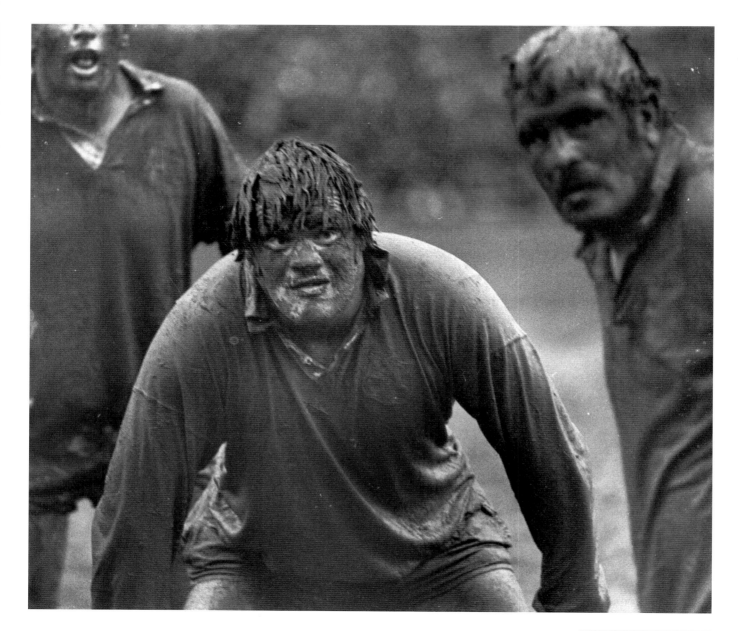

Fran Cotton (b.1947)
Rugby union

Fran Cotton, British Lions, New Zealand 1977
Colin Elsey
Colorsport

Big of heart and square of jaw, Cotton was an influential and versatile prop-forward. Growing up in Wigan, Cotton's boyhood heroes were the rugby league players **Billy Boston** and Bev Risman. He took up rugby union while training as a PE teacher at Loughborough. At 6ft 2in, and weighing 17st, Cotton was a tough scrummager, and fearless in loose play. He won 31 caps for England and 7 for the British Lions, with whom he toured to South Africa in 1974, and to New Zealand in 1977 as the senior scrum player. A fitness fanatic, and using his PE experience, Cotton organised the training sessions on both tours. In 1980, he was the cornerstone of the forwards as England won the Grand Slam, led by **Bill Beaumont**. Later in the year, he was stretchered off the pitch during a match, having suffered a minor heart attack. He bravely returned to rugby in 1981, but sustained a leg injury in a match against Wales, which forced him to retire from the game. Later as a businessman, he set up Cotton Traders, a company supplying sportswear around the world. He was appointed British Lions tour manager in 1997.

Sir Henry Cotton (1907-87)
Golf

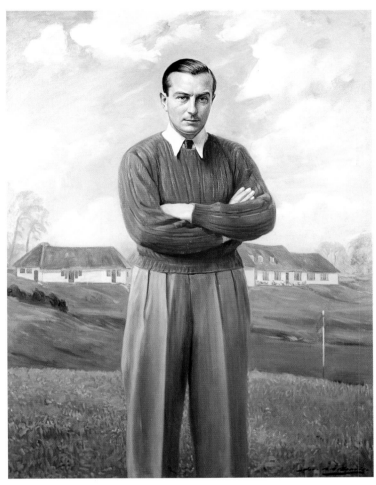

Henry Cotton
J.A.A. Berrie, 1938
Oil on canvas, 1510 x 1150mm
Royal and Ancient Golf Club
of St Andrews

Henry Cotton was the dominant British golfer just before and after the Second World War, winning the Open Championship three times, in 1934, 1937 and 1948. He also won the *News of the World* Tournament three times, the Belgian and German Opens three times and the French Open twice. In addition, on two occasions Cotton was captain of the Ryder Cup team. Cotton did much to raise the status of British professionals. He came from a middle-class background and he insisted on having honorary membership of the clubs to which he was attached. After receiving much encouragement from professional golfer **J.H.TAYLOR**, Cotton turned professional himself at the age of 17. His round of 65 in the 1934 Open caused such a sensation that Dunlop named a golf ball after it and the score stood as the joint lowest round in an Open Championship until 1980. So great was his contribution to the game as a player, teacher, writer and course designer that in 1988, having already been awarded an MBE for his charity work during the war, Cotton was awarded a knighthood for his services to golf. Unfortunately, he died before the honour was publicly announced. PNL

Robin Cousins (b.1957)
Ice skating

An outstanding free skater and ice dancer, Cousins worked his way from British junior champion in 1972 to Olympic champion in 1980. Following in the wake of **John CURRY**, he was part of a sequence of British skating success which was crowned by **Jayne TORVILL** and **Christopher DEAN**. Where Curry was more balletic, Cousins was more athletic. When the former made his bow after his Olympic gold medal in 1976, it became Cousins' turn to dominate the British skating scene, which he did as national champion from 1976 to 1980. In the build-up to the 1980 Olympic Games, he won a total of four bronzes and a silver in European and World Championships. When Olympic year arrived, the stage was set for Cousins to repeat Curry's 1976 trio of gold medals at the Olympics, World and European Championships. The Olympic and World titles won, he was foiled at the European Championships, however, and had to settle for a silver medal. He retired from amateur competition at the end of the year, but continued to skate professionally at galas and exhibitions.

(Illustrated under **John CURRY**)

Colin Cowdrey, Lord Cowdrey
(b.1932)
Cricket

The popular Kent and England player Michael Colin Cowdrey may not be as much of an institution as the MCC with which he shares his initials, but he did become its president and his stature in the game stands as solid as the Pavilion at Lord's. He was England captain 27 times, and also led Kent from 1957 until 1971. Cowdrey was a powerful stroke-player and timer of the ball, who never looked flustered by either fast or spin bowling, and his cover drive was a delight to watch. He averaged 44.06 from 188 test innings, including 22 centuries. Altogether in first-class cricket he made 107 centuries. Cowdrey went on six England tours to Australia, where he enjoyed huge popularity and is still greatly respected. His 114 test match appearances set a record and his maiden test innings, also one of his best, was a match-saving 102 out of 191 at Melbourne in 1955. Twenty years later he was recalled at the age of 41 to halt England's perilous decline against the bowling of Australians Dennis Lillee and Geoff Thomson.

Sir Colin Cowdrey
Bryan Organ, 1996
Acrylic on canvas, 610 x 914mm
Marylebone Cricket Club

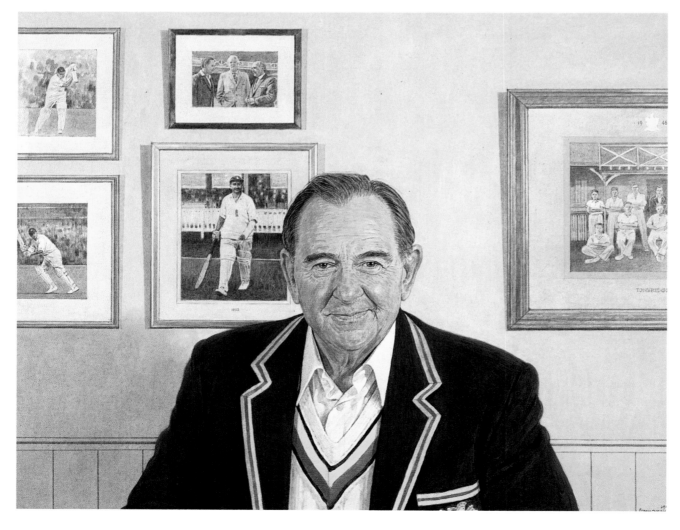

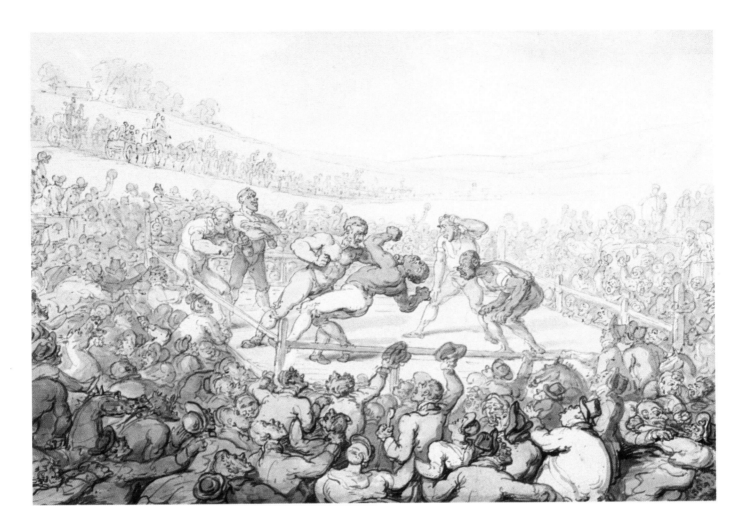

Tom Cribb (1781–1848)

Pugilism

In 1807, the sometime bellhanger and coal porter Tom Cribb met the famous Scottish landowner and pedestrian **Captain BARCLAY**, who became his patron. He took Cribb in hand, trained him and then backed him for 200 guineas against **Jem BELCHER**. In an epic 41-round bareknuckle encounter, Cribb emerged the victor. He became Champion of England in 1808 after a close, punishing and exhausting contest over 23 rounds with the Lancastrian Bob Gregson. In 1810, a challenge came from the American Tom Molyneux, an ex-slave who had made a name for himself in England. The honour of England was deemed to be at stake and the fight attracted huge interest. Cribb was lucky to emerge the victor after 33 rounds, having been second-best for much of the contest. Cribb triumphed again over Molyneux nine months later, this time convincingly, breaking the American's jaw in the ninth round. Cheered through the streets as he returned to London a national hero, Cribb earned 200 guineas in prize money and at least £400 in side bets, while his crafty patron Barclay pocketed nearer £10,000. Cribb's many supporters then found him a pub, the passage from pugilism to publican being *de rigeur* for successful retired fighters. Out of respect for his sense of fairplay and integrity, Cribb was allowed to retain the title of Champion of England until he resigned it in May 1822.

The fight between Tom Cribb and Tom Molyneux, 1811
Thomas Rowlandson
Ink and watercolour,
285 x 381mm
The Hamilton Collection,
Brodick Castle, in the care of
the National Trust for Scotland

Bob Crompton (1879-1941)
Football

From 1902 to 1914, Blackburn's Bob Crompton was the best full-back in the country. With 41 appearances, he was England's most capped player until **Billy Wright** and was in the first national team to travel abroad in 1908, to Hungary, Austria and Bohemia. A keen swimmer and water-polo player, he joined Blackburn in 1896, but delayed signing a professional contract as it would have jeopardised his amateur swimming status. He became Blackburn's greatest ever footballer and he captained the side in many of his 576 appearances. Under his leadership Blackburn won two league titles. He was also captain of England, where he formed a legendary defensive partnership with Jesse Pennington. An opposing forward remembered that: 'you could not be sure of ever having beaten Crompton. Though he seemed safely out of the way his speed in turning and getting back was most deceptive. He never spared himself or opponents. In fact, I should say that Crompton was the finest exponent of the square shoulder charge I ever played against. When he charged you went over.' A sound tactician and thinker on the game, Crompton became Blackburn's manager once his playing career was over.

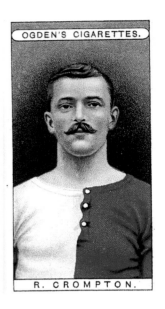

Bob Crompton
Ogden's Famous Footballers,
cigarette card series, 1908
The Trustees of the British
Museum

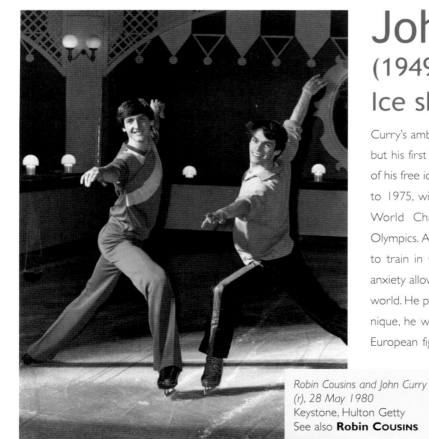

*Robin Cousins and John Curry
(r), 28 May 1980*
Keystone, Hulton Getty
See also **Robin Cousins**

John Curry
(1949–1994)
Ice skating

Curry's ambition to be a ballet dancer was thwarted by his father, but his first love was always evident in the refinement and fluency of his free ice-dance routine. He was national champion from 1970 to 1975, winning a silver and two bronzes at the European and World Championships, and finishing eleventh at the 1972 Olympics. A generous sponsor, seeing his potential, paid for Curry to train in Colorado, where facilities and freedom from financial anxiety allowed him to develop into the undisputed ice king of the world. He proved it in 1976: with a combination of grace and technique, he won the Olympic gold medal, and both the World and European figure skating titles. He became only the fourth man to hold all three titles in one year. Not since **Jeannette Altwegg** in 1952 had Britain won an Olympic ice skating title, and no British male had ever won a medal before. To crown the year he was nominated for BBC Sports Personality of the Year, the first skater to be thus honoured.

Kenny Dalglish (b.1951)
Football

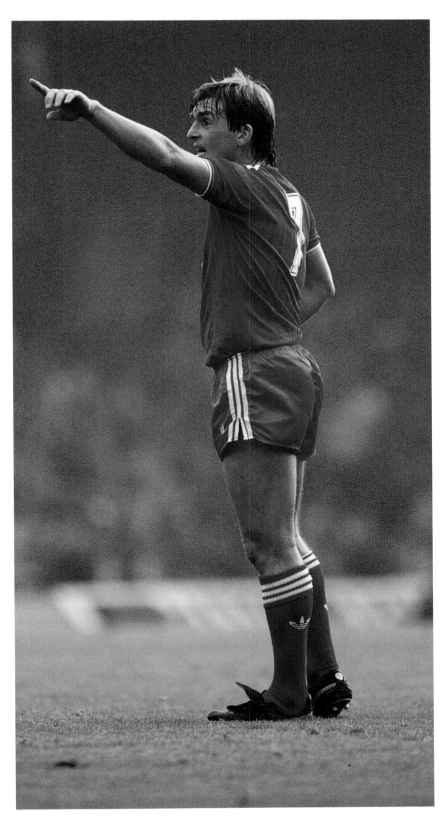

The most decorated player in British football, Dalglish is the only one to have scored more than 100 league goals in both England and Scotland, and has been idolised on both sides of the border. His 102 Scottish caps are a record, and his 30 goals matched **Denis Law**'s tally. Equally a provider of goals, he was a master of close control with uncanny awareness and sense of anticipation. Dalglish signed as a schoolboy for Celtic in 1968, and having secured nine major trophies including the league and cup double in 1972, moved to Liverpool in 1977 for a British record fee of £440,000. His presence did much to prolong Liverpool's pre-eminence as the most efficient team in Britain. Between 1978 and 1985, the team won three European Cup Finals, five league titles, and four consecutive league cup finals. In 1985, Dalglish became player-manager and extended the run of success by guiding the club to a league and FA Cup double in 1986, plus two further league titles in 1988 and 1990. His shock resignation in 1991 was followed by a managerial appointment at Blackburn: here he transformed a first division club to a premiership title-winning side by 1995. In 1997 Dalglish was on the move again, becoming manager of Newcastle United. However, his stay in the north-east was brief — in August 1998 Dalglish resigned as manager.

Kenny Dalglish, Liverpool vs. Luton Town, 26 October 1985
Bob Thomas
Popperfoto

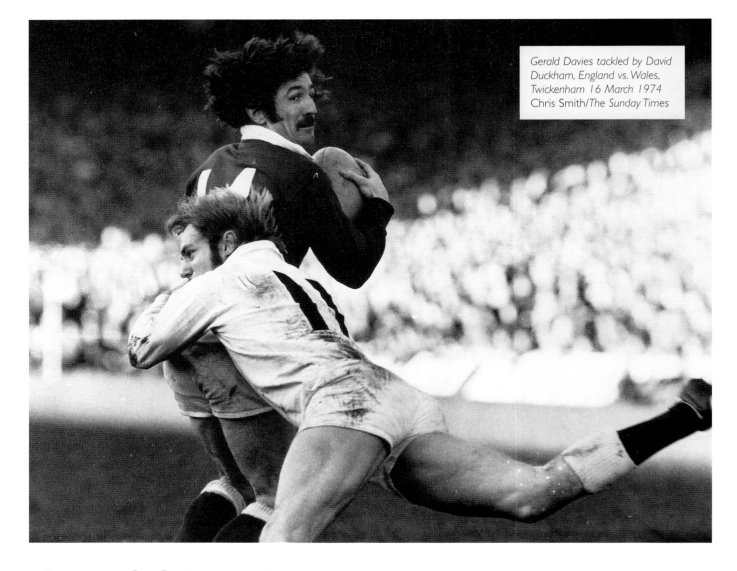

Gerald Davies tackled by David Duckham, England vs. Wales, Twickenham 16 March 1974 Chris Smith/The Sunday Times

Gerald Davies (b.1945)

Rugby union

Davies was one of the greatest of Welsh wingers, and epitomised the glory of the running game. The Welsh back division of the 1970s, including Davies, **Gareth Edwards**, **Phil Bennett**, J.J.Williams and **J.P.R.Williams**, was probably the most effective ever seen in British rugby. Davies was an exciting entertainer as well as a scorer of tries. He had pace and adventure, with a deceptive side-step and body swerve. Also an impressive chaser of the ball, he was able to create room for himself among a crowd of players. Having made his début in 1966, he proved one of the highlights of the 1971 British Lions tour of New Zealand, particularly when he thrilled the crowd with four tries against the club side Hawke's Bay. He played his club rugby with London Welsh, from which team seven of his club colleagues went with him on the 1971 Lions tour. Business commitments ruled him out of the 1974 and 1977 Lions tours, and he was much missed. After 44 caps, he retired in 1978 as Wales' most capped three-quarter, and also the country's leading try-scorer with 20 to his name.

Welsh rugby in the 1970s

In the 1970s the world rugby stage belonged to Wales. The Welsh team had pace and power, style and guile, and with television coverage of rugby beginning seriously in the early 1970s, the world took note of the principality as a sporting force. It was unusual for so many good players to play together for so long. **J.P.R. Williams** won 55 caps, **Gareth Edwards** won 53 consecutively and Gerald Davies won 46. The most effective unit ever seen in British rugby, the team won or shared the Five Nations Championship eight times in ten seasons. What's more, no nation managed to beat Wales at Cardiff Arms Park.

Laura Davies (b.1963)

Golf

As a young amateur Davies was selected for the Curtis Cup tournament in 1984 and won her singles match over a much more experienced player. She then turned professional, initially financed by a £1,000 loan from her mother. This she paid back after her first win and finished the season top of the money list. In 1986 Davies won the British Women's Open at Royal Birkdale and the following year she added the US Women's Open to her conquests. Since then she has topped the European Order of Merit a further three times and the American Ladies Professional Golf Association (LPGA)

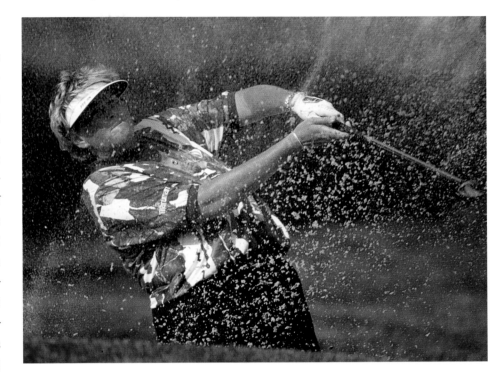

Laura Davies, JAL Big Apple Classic, July 1995
Simon Bruty/Allsport

money list once. In 1996 she became the first woman to win over £1 million world-wide. Throughout her professional career Davies has constantly been a leading contender, with over 50 world-wide victories so far. Of these 27 were in Europe and 15 in the USA, an amazing transatlantic record. This includes four 'Majors', with the addition of the LPGA Championships of 1994 and 1996. In 1994 she was the first person to win on five different tours in one calendar year. The Solheim Cup, since its inception in 1990, has added to her reputation with 9 wins out of 14 matches. ERC

Lynn Davies (b.1942)

Long jump

The son of a Welsh miner, Lynn Davies was spotted at a schools' athletics meeting by Ron Pickering, who coached him to become one of the world's best long jumpers, and guided him to a gold medal at the 1964 Olympics in Tokyo. Davies only just managed to scrape through to the final, but on the day itself, the wet and windy weather being exactly what he was used to, Davies became the first British athlete to win a field event since 1908. Back in South Wales, the population of Nant-y-Moel began preparing for the return of their now famous son, 'Lynn the Leap'. Following a reception at Buckingham Palace, 4,000 people met him off the

train at Cardiff station and a motorcade saw him home, where the streets were decorated with flags and streamers. In 1966, in the space of two weeks, he became Commonwealth and European Champion. He was back for the 1968 Mexico Olympics, but his confidence was shattered by Bob Beaman's legendary jump. He retained his Commonwealth title in 1970, then captained the British team, without competing himself, at the Munich Olympic Games of 1972.

(Illustrated under **Lillian Board**)

Joe Davis (1901–78)

Billiards and snooker

In both billiards and snooker, Joe Davis was the nonpareil of the green baize until the emergence of his namesake **Steve Davis** in the 1980s. The man who made snooker into a world game learned to play as a child by shutting himself away in the billiard room above his father's pub in Derbyshire. He claimed his first billiards world title in 1928, and retained it until defeated by the Australian Walter Lindrum in 1933. His personal feats and records at billiards were prodigious, his highest break being 2,501, but he made hundreds of breaks of over 1,000. As manager of several billiard halls around Chesterfield, Davis soon noticed that billiards was being eclipsed as a popular game by snooker. He persuaded the sport's governing body to sanction a professional snooker championship, which they inaugurated in 1926, the title inevitably being won by Davis. The following year he made the first of his 687 snooker breaks of over 100, including the first maximum 147 break. His technique and positional play set the standard for today's highly paid players. He was World Snooker Champion every year from 1927 to 1946, when he relinquished the title to his younger brother, Fred (1913–98), the only person ever to beat him.

Joe Davis
John Capstack, c.1939
C. Capstack Portrait Archive

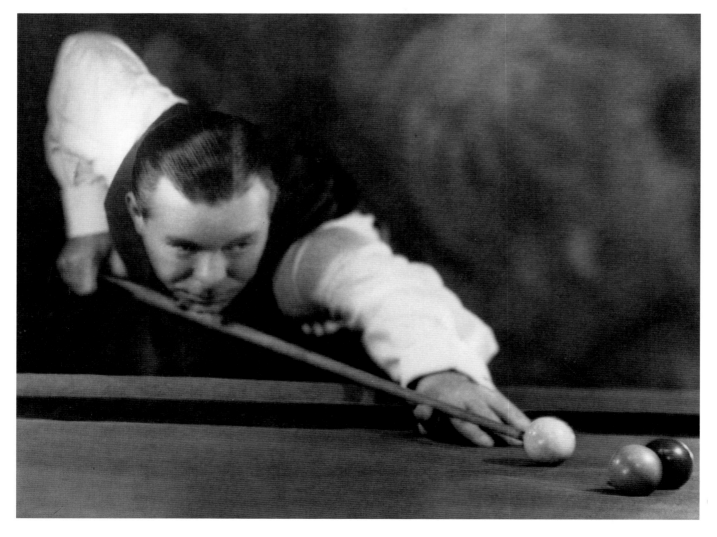

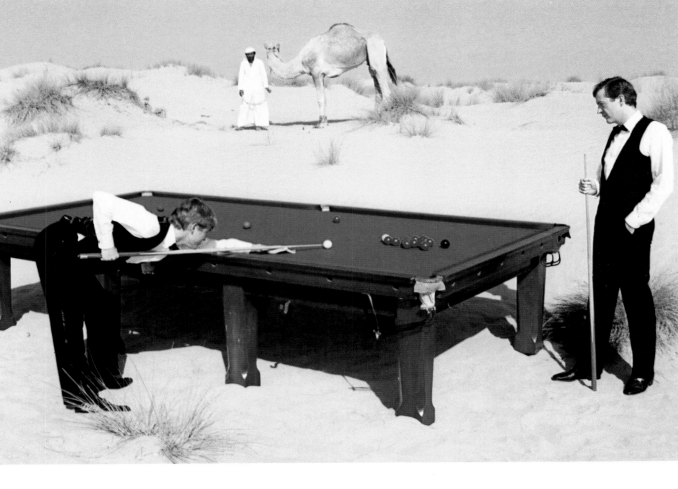

Steve Davis (b.1957)

Snooker

While **Joe DAVIS** turned snooker into a competitive world sport, albeit with largely British competitors, his namesake Steve Davis was the first to get rich through it. No sport is as suited to colour television as snooker, and appearing in seven successive Embassy world title finals in the 1980s, with the sport at its zenith, Davis became a household name and one of the highest profile sportsmen of the decade. When the satirical television show *Spitting Image* created a latex figure sarcastically christened Steve 'Interesting' Davis, cult status was conferred on this unassuming 'boy-next-door' from East London. Instead of shunning the public's perception of him as a bore, Davis milked the image, thus becoming highly popular. He was World Champion in 1981, 1983 and 1984, and again from 1987 to 1989. Since then he has progressed to the semi-finals on four occasions, but younger players, attracted to the game by the example of Davis and the rewards on offer, have replaced him in the world's top ten. Davis' epic final against Dennis Taylor in 1985, which he lost 17–18, kept 18.5 million television viewers (BBC2's largest ever audience) gripped until past midnight. Taylor's victory on the final black became one of the classic television moments in modern British sport.

Stephen Hendry and Steve Davis (r), promoting the Dubai Classic, 1990s
Allsport
See also **Stephen HENDRY**

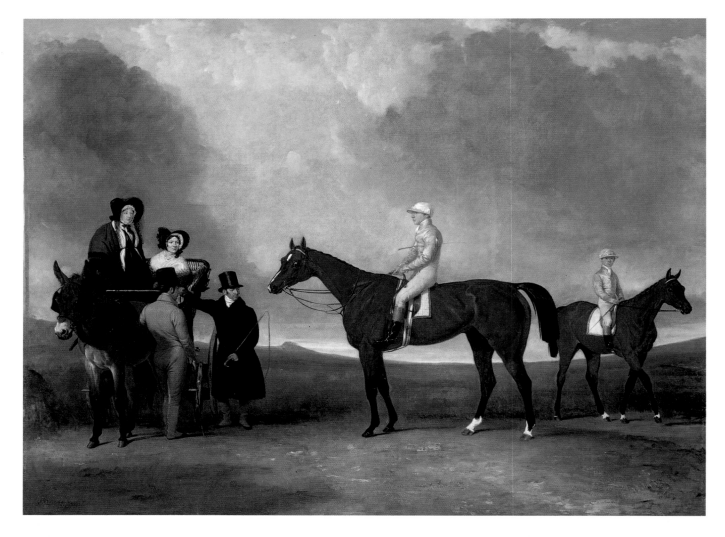

John Barham Day (1793/4–1860)
Horse racing

Hampshire-born John Barham Day was the son of a trainer and the brother of four jockeys. Four of his own sons also followed him into the racing business. A regular churchgoer and a moral tyrant to the jockeys in his stables, his notorious lack of scruple in his every association with the turf earned him the ironic title of 'Honest John Day'. In the late 1820s he rode for the fourth Duke of Grafton, winning both the 2,000 and 1,000 Guineas for him in 1826, the first of his 16 classic victories as a jockey. Some ten years later he took up training at Danebury near Stockbridge, and between 1837 and 1840 sent out five classic winners which he rode himself. As a trainer he had the reputation of schooling his horses hard. Two of his major patrons were Lord George Bentinck, one of the most ambitious and influential owners in racing, and a solicitor, Mr Henry Padwick. In due course Day fell out with both, behaving particularly badly over Mr Padwick's colt St Hubert, which Day arranged should lose the 2,000 Guineas in 1855 to Lord of the Isles, trained by his son William. HC

The Day Family (l to r): Mrs Anne Day, Mrs Day, John Day Junior, John Barham Day (whip in hand), Venison with Sam Day up, Chapeau d'Espagne with William Day up
Abraham Cooper, 1838
Oil on canvas, 968 × 1273mm
Tate Gallery, London

'Dixie' Dean (1907–80)
Football

Although the name was chanted everywhere he went, William Ralph Dean hated being known as 'Dixie'. He will be forever remembered for the 1927–8 season, in which as a 21-year old, he created a record of 60 goals in one season, including seven hat tricks. Seventy years later, this record seems likely to remain unbeaten. But this season was not a one-off; Dean was a consistent scorer at Everton for 13 years, and became the club's greatest idol. His final total was 377 league and cup goals in 431 games. After scoring 33 goals in his first full season, he never looked back: year after year his instinct for goal and mastery of heading the ball kept him at the top of the scoring charts. However, despite scoring twice on his debut against Wales in 1927, he was much underused at international level. In only 16 games for England, he scored 18 times. In 1936 he overtook **Steve BLOOMER**'s league scoring record of 352 goals, but injury was beginning to restrict him, and he played mainly for the reserves in 1937–8. In 1938, he was transferred from Everton, amid much shock and sorrow, to third division Notts County.

'Dixie' Dean leading Everton out against Arsenal, Highbury, 29 August 1936
Barker for Central Press
Hulton Getty

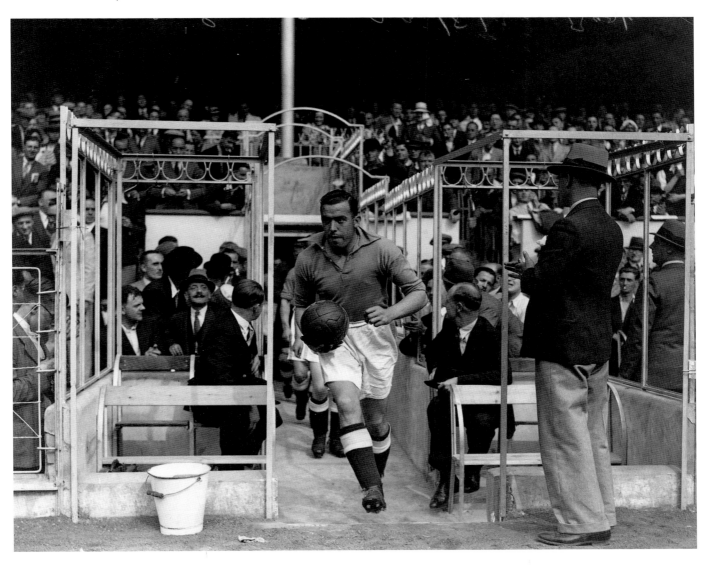

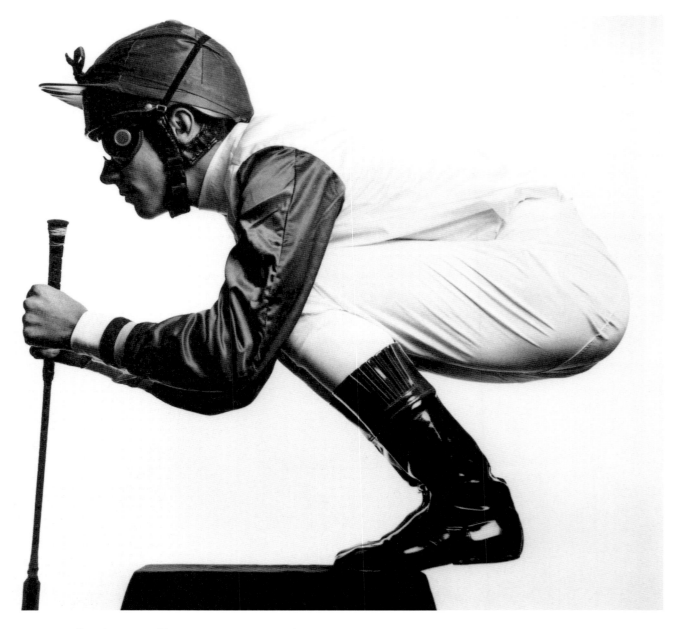

Frankie Dettori (b.1970)
Horse racing

Frankie Dettori
Alistair Morrison, 1997
National Portrait Gallery

When Fujiyama Crest crossed the line in first place in the seventh race at Ascot on 28 September 1996, racegoers ran to the winner's enclosure to salute the jockey who had just won every race of the afternoon, and bookmakers ran for cover. Past records – **George FORDHAM**'s six and a dead-heat in an eight-race card at Stockbridge in 1867 and **Gordon RICHARDS**' 12 successive wins over three days in 1933 – seemed to lack the completeness of Dettori's achievement. Suave and cocky, the Italian-born son of a jockey has become an important figure in recent racing history, popularising the stuffy image of the turf and delighting crowds with his trademark leaping dismount after a big win. Riding for a number of powerful Arab owners, Dettori is currently first jockey to the Godolphin stable of Sheikh Mohammed, for whom he won the 2,000 Guineas in 1996 on Mark of Esteem. Among other notable victories have been the King George and Queen Elizabeth Diamond Stakes and the Prix de L'Arc de Triomphe on the unbeaten Lamtarra in 1995. HC

Ted Dexter (b.1935)
Cricket

The stylish Dexter had the relative misfortune of playing for England in the 1960s, at a time when English cricket was in the doldrums, after the glorious era of the previous decade: thus his exciting batting was often in a losing cause. He came to prominence during England's 1959–60 tour to the West Indies, where he headed the averages and scored two centuries. He played in 62 test matches, and was captain from 1961 to 1964. His test batting average was 47.89, and his 66 test wickets as a medium-pace bowler were often vital. He also captained Sussex from 1960 to 1965. Dexter was a popular figure off the pitch, and in the 'swinging sixties' was cricket's closest equivalent of a pop star. His off-the-field interests embraced modelling men's clothes, flying private aeroplanes, riding motorbikes, dabbling in the turf and greyhound racing, and playing top-level golf with celebrities. He could often be seen in the outfield practising his golf shots. In 1964, he missed the England tour to India, because he was standing as a Conservative candidate against future Prime Minister James Callaghan. A commanding batsman at his best, and a little autocratic in his captaincy, he earned himself the nickname 'Lord Ted'.

Ted Dexter
Henri Cartier-Bresson, 1961
National Portrait Gallery

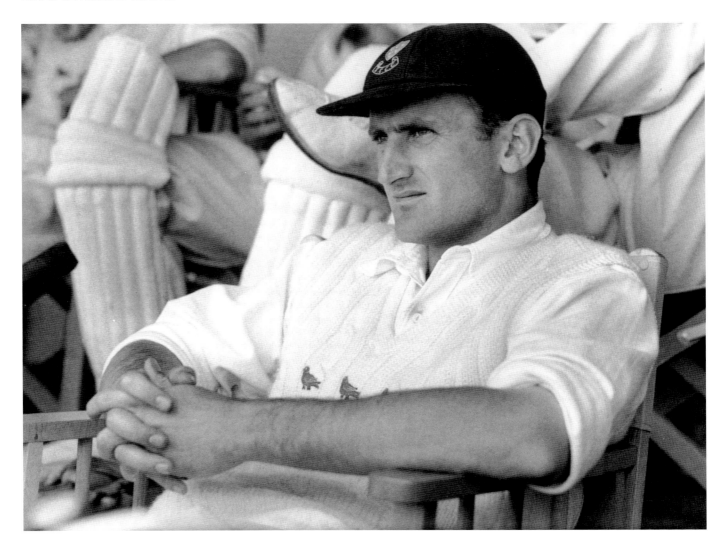

Lottie Dod (1871-1960)
Tennis

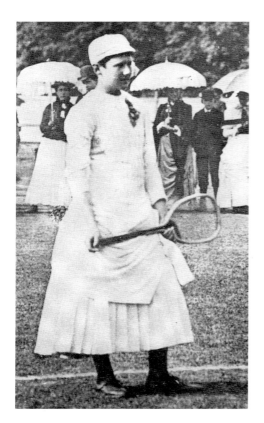

Lottie Dod at the West of England Championships, Bath
Unknown photographer, 1886
The Wimbledon Lawn Tennis Museum
(Tom Todd Collection)

'The Little Wonder' was the female sporting equivalent of her contemporary **C.B. FRY**. Tennis was the game in which she found fame, but for a decade either side of 1900, she was the outstanding sportswoman in Britain, representing her country at hockey, winning the Ladies Open Golf Championship, competing on the Cresta Run, and skating at international level against men as well as women. She then won an Olympic silver medal in archery at the 1908 Games. All these feats were achieved after she had retired from tennis at the age of 21. At 15 years and 285 days, she is still the youngest woman ever to win a Wimbledon title (Martina Hingis was three days her senior when she won the women's doubles in 1996). The first of Dod's five singles titles came in 1887, and four of her finals were against Blanche Bingley, who later went on to win six times herself. Lottie Dod never lost a match at the All England Club from 1887 to 1893, and the absence of her name on the 1889 winners' board is only because she was abroad at the time on a yachting cruise.

> ### Lottie Dod on Tennis
> In the early days of lawn tennis many doubted the game, believing it to have a negative influence over the moral fibre of the participants. Lottie Dod rejected these perceptions and urged the doubters to watch 'a men's five setter played under a broiling sun. For ladies, too, it is decidedly a very athletic exercise, always supposing that they go in for it heartily and do not merely frivol at garden parties.' She went on to add that 'the blessings of our sex would be heaped upon anyone who could invent a practical, comfortable and withal becoming costume', and she admitted with regret that 'if the skirt must be endured, it is important to have it somewhat short, reaching to the ankles.'

Reggie Doherty (1872-1910) and Laurie Doherty (1875-1919)
Tennis

The Doherty brothers dominated Wimbledon at the turn of the century. Not only did their heroics and success revive national interest in the game, but their modesty, style and sportsmanship did much to establish tennis as a way of life in upper-class Edwardian England. Born within a cross-court volley of the All England Club, the brothers shared nine singles titles, and but for Arthur Wentworth Gore's victory over Reggie in 1901, the Doherty name would have been on the cup for ten years running. Reggie was the elder and won Wimbledon in four successive years from 1897 to 1900. Laurie went one better, winning five times between 1902 and 1906; he also notably won the US Championships in 1903, the only foreign player to win it in 44 years. The brothers hated playing against each other, and only once met in a Wimbledon final, in 1898. In the 1902 US Championships, Laurie withdrew from the semi-final to allow Reggie through to the final. The following year, the favour was returned and Laurie went on to win. But they relished playing together, winning eight Wimbledon doubles titles between 1897 and 1905, and two US titles in 1902 and 1903. Between them – in singles and doubles – they also won five Olympic gold medals, four in 1900, and one in 1908.

Steve Donoghue (1884–1945)
Horse racing

Unlike so many of his fellow professionals, Steve Donoghue was not born to the racing life. With none of the usual contacts available to him, it was only his determination that enabled the young Donoghue to become a jockey. After brief spells at stables in Kingsclere, Middleham and Newmarket, he rode in France and in Ireland before returning to England and H.S. Persse's Stockbridge stable. For Persse in 1913 he rode The Tetrarch, a two-year-old known as 'The Spotted Wonder' which remained unbeaten and brought Donoghue's name into the public arena. From then on, 'Come on Steve' was a cry that reverberated around racecourses for the rest of his career. In spite of the obligations of various retainers, he would, like **Lester Piggott** 50 years later, relentlessly search for the best possible mounts in the classics – a single-mindedness that brought him 14 victories. He won the Derby six times, was Champion Jockey every year from 1914 to 1923 and was the only jockey to complete the Triple Crown twice. In later years his already enormous popularity further grew through his association with the much-loved Brown Jack, which won the Queen Alexandra Stakes at Royal Ascot six years running from 1929 to 1934. HC

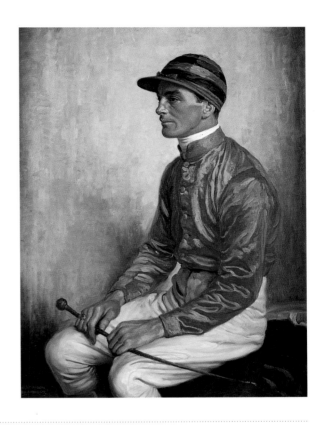

Steve Donoghue in the colours of H.E. Morris, owner of Manna, 1925 Derby winner
W. Smithson Broadhead, 1925
Oil on canvas, 1170 × 920mm
National Horseracing Museum

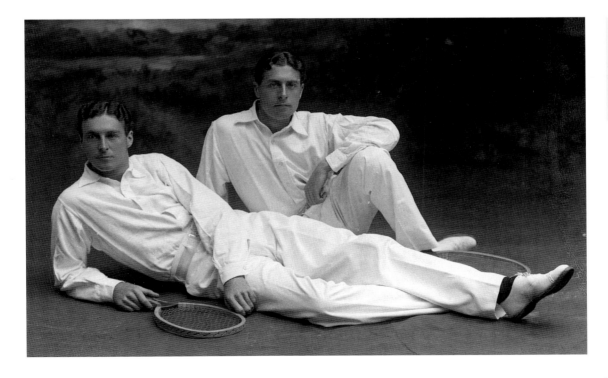

Reggie (l) and Laurie Doherty
London Stereoscopic Company, c.1903
Hulton Getty

Jim Driscoll (1880–1925)
Boxing

Driscoll learned to fight by wrapping his hands in wastepaper, while working for a newspaper office in Cardiff. From such rudimentary beginnings, he became a classic British boxer, with his upright stance and lethal left lead. He was a favourite at the National Sporting Club (NSC), where he gained the British featherweight title in 1907. Defeating all challengers in London to become Empire and European titleholder, he crossed the Atlantic, where he achieved great popularity, his impressive displays earning him the name 'Peerless Jim'. In 1909, he easily outboxed world featherweight champion Abe Attell at the National Athletic Club of New York, but because he had failed to knock out his opponent, the Americans refused to recognise him as champion. Instead, a 'no decision' verdict was announced. Back in Britain, Driscoll was hailed as world champion, and soon claimed one of the first Lonsdale Belts by defeating three challengers in quick succession. Against his will, he took on his countryman **Freddie WELSH** in a much vaunted fight. It was a heated affair, Driscoll eventually being disqualified for headbutting. He retired soon afterwards, but the NSC invited him back six years later for his final and unsuccessful fight in 1919 against the much younger Charles Ledoux.

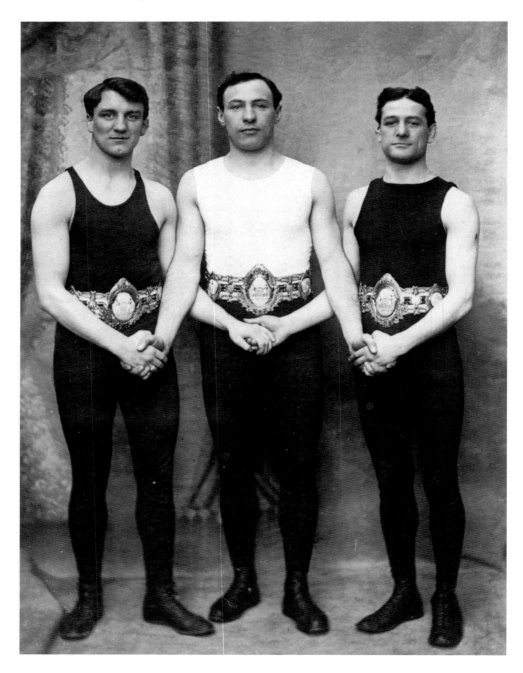

(l to r): Freddie Welsh, Tom Thomas and Jim Driscoll wearing Lonsdale Belts
John Gronow, 1910
Public Record Office
See also **Freddie WELSH**

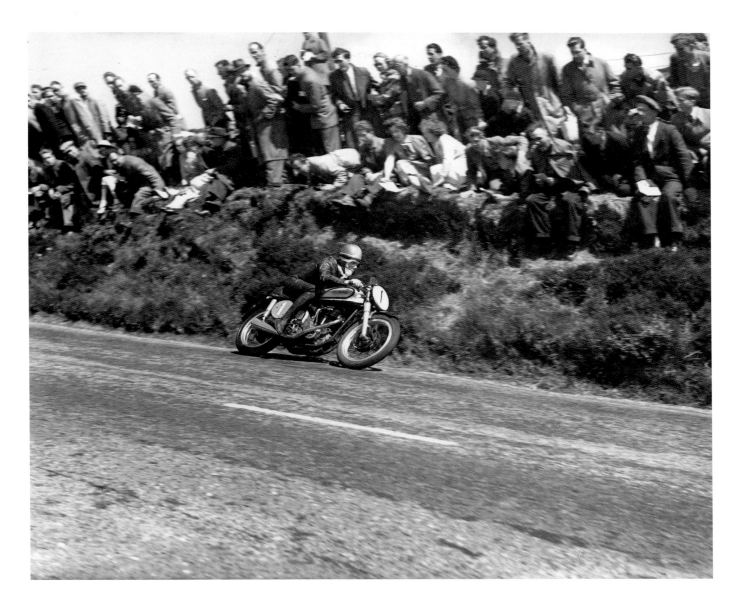

Geoff Duke (b.1923)
Motorcycling

The first British motorcyclist to emerge after the Second World War, Duke won 33 Grands Prix, 11 at 350cc, and 22 at 500cc. From 1952 to 1955, he won world titles in one or other of these classes, having won both in 1951. He also won a total of six Isle of Man TT races. With his good looks and all-in-one leather outfits, he brought considerable style to motorcycling, and attracted huge crowds wherever he rode. He began his career riding for Norton in 1948, where he remained until the end of 1952. He then moved to Gilera, with whom he won three successive world titles. He missed much of the 1956 season, as he was suspended for his support of the riders' strike during the Dutch TT. Most of the following season was also missed through injury, but Duke returned in 1958 to win two more Grands Prix. He retired in 1960 but made a brief return in 1963, leading his own team, Suderia Duke. His influence on the sport was far reaching, and he inspired many future riders, in particular **Mike HAILWOOD**.

Geoff Duke, Senior TT, Isle of Man, 9 June 1951
Price for Fox Photos
Hulton Getty

George Duncan (1883–1964)
Golf

George Duncan, who won the Open Championship in 1920, was a player in his prime when the First World War broke out. He had already won the *News of the World* Tournament in 1913, which ranked as the second most important professional event after the Open, as well as the Belgian Open in 1912 and the French Open the following year. Duncan was born near Aberdeen and started his career as a caddie. His policeman father was aghast when he learned that his own son wanted to caddie, fearing that it would bring him in contact with his regular customers, but young George stood his ground. Noted for the speed of his play, Duncan later titled his autobiography *Golf at the Gallop*. Golf writer Bernard Darwin stated that he had never met anyone who combined Duncan's astonishing dash, rapidity and naturalness with such an acute consciousness of what he was doing. He won numerous tournaments in the 1920s and played in the inaugural Ryder Cup match against the USA in 1927. He captained the team in 1929 and played a final time in 1931.

PNL

George Duncan on the first tee, Old Course, St Andrews
Central Press, 1927
Hulton Getty

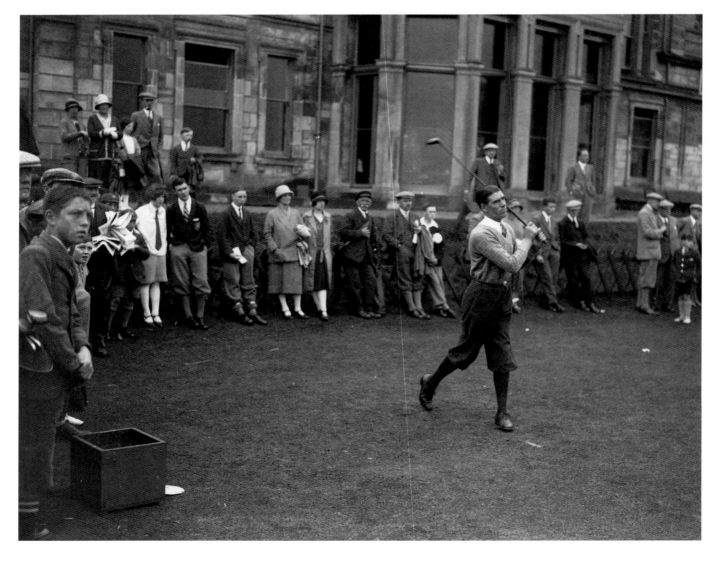

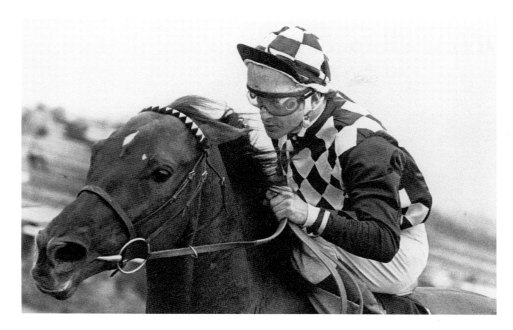

Pat Eddery, racing at Lingfield, 1984
Chris Smith/The Sunday Times

Pat Eddery (b.1952)
Horse racing

The figure of **Lester Piggott** has cast such a long shadow over modern racing that it is possible to underestimate the achievements of **Willie Carson** and Pat Eddery. Between 1972 and 1993 they amassed 13 jockeys' titles between them, the Scottish Willie Carson winning five and Irish Pat Eddery eight. At 22 years old Eddery was the youngest Champion Jockey since **Gordon Richards** in 1925. Apprenticed initially to Frenchie Nicholson at Cheltenham, Eddery became first jockey to Peter Walwyn in 1972, and it was on the Walwyn-trained Grundy that he won his first Derby in 1975 and the King George and Queen Elizabeth Diamond Stakes at Ascot against Bustino in what many still regard as the race of the century. A stylish jockey with a strong and idiosyncratic finish, Eddery has since been associated with some of the greatest horses of the day, including Dancing Brave, perhaps the most brilliant recent winner of the Prix de L'Arc de Triomphe. In 1997 Eddery became only the third jockey (after Sir Gordon Richards and Lester Piggott) in British racing to ride 4,000 winners, a milestone reached with Silver Patriarch's victory in the St Leger.

HC

Duncan Edwards (1936–58)
Football

Duncan Edwards died at the age of 21, a victim of the 1958 Munich air disaster in which seven of his Manchester United team colleagues were also killed. In four seasons, he had won two league championships, played in an FA Cup final, and won 18 caps for England. His club and international career was set certainly to equal, if not surpass, that of his team-mate **Bobby Charlton**. Three months before his death, he was voted the third best player in Europe after Alfredo di Stefano and **Billy Wright**. No future could have looked brighter, and anyone who witnessed his ball control, passing, tackling, shooting, and heading knew that here was a great player in the making. He was powerful and versatile, the young engine of the Manchester United side, a brave tackler and intelligent passer. But it was his perfect temperament that hinted at a great future. Moreover, he was fanatically enthusiastic about the game, and would practise for hours on end. He died before his prime, and is memorialised in a stained glass window in his parish church at Dudley in the West Midlands.

(Illustrated under **Sir Stanley Matthews**)

Gareth Edwards (b.1947)
Rugby union

Winning his first cap as a teenager, Edwards made a record 53 consecutive appearances for Wales, and went on three British Lions tours in 1968, 1971 and on the unbeaten 1974 tour to South Africa. The complete scrum-half, with pace, guile, power, passion and skill, Edwards was the key to the great Welsh team of the 1970s, when the country won three Grand Slams, five Triple Crowns, and seven Five Nations Championships. Unusually for a scrum-half, Edwards scored 20 international tries, mostly ten-yard bursts over the line. But his great asset was in setting up try-scoring chances for the three-quarters, using his trademark spin pass to his fly-half partner (initially **Barry John**, and later **Phil Bennett**). When Edwards was first picked to play alongside John, he contacted the senior man to suggest a training session so they could get used to playing together. 'Don't worry, you throw it, I'll catch it' was John's reply. Born in the local mining community, Edwards played for 12 seasons with Cardiff. He became a national Welsh hero, immortalised as the subject of a song by Max Boyce, and selected recently by *Rugby Magazine* as number one in their list of top 100 individual players.

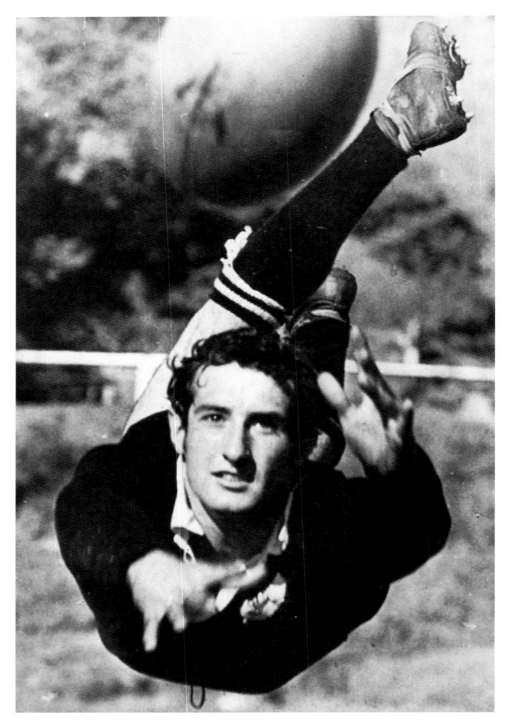

Gareth Edwards, 9 July 1969
Popperfoto

Nick Faldo (b.1957)
Golf

Inspired to play golf after seeing Jack Nicklaus winning the 1972 US Masters tournament on television, Faldo won the English Amateur Championship at the age of 18 and turned professional the following year. By the mid-1980s, Faldo was well established, with a series of victories behind him. He felt, however, that his game lacked the consistency to reach the very top, so he turned to the coach David Leadbetter. It took two hard years to remodel his swing. In 1987 the effort repaid him: Faldo won the Spanish Open and then the Open Championship. The latter he won with an incredible final round of 18 consecutive pars. In 1988 he lost the US Open in a play-off, but the following year won the US Masters trophy, after a play-off against Scott Hoch. He took his second US Masters prize in 1990, narrowly lost the US Open, and won the Open at St Andrews. In 1992 he won his third Open and was the first to win over £1 million in a European season. He added a third US Masters to his 'Major' titles in 1996. His international career to date includes ten Ryder Cups, in which he has won a total of 23 points. ERC

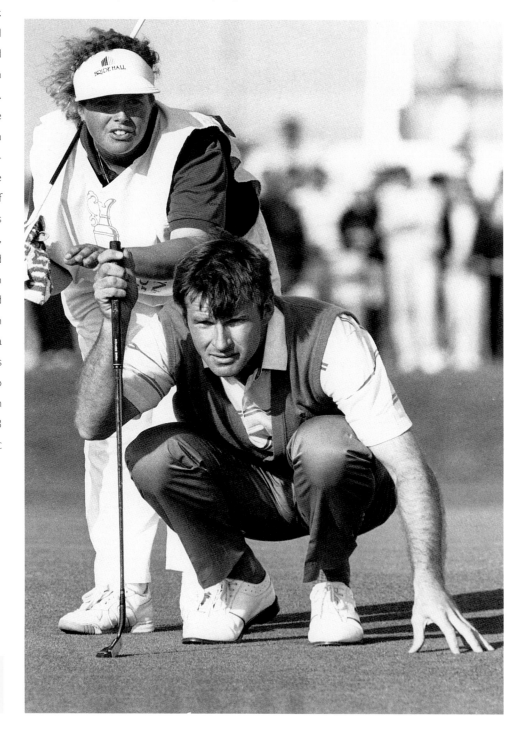

Nick Faldo with his caddie, Fanny, Sunesson, St Andrews, 1990
Chris Smith/The Sunday Times

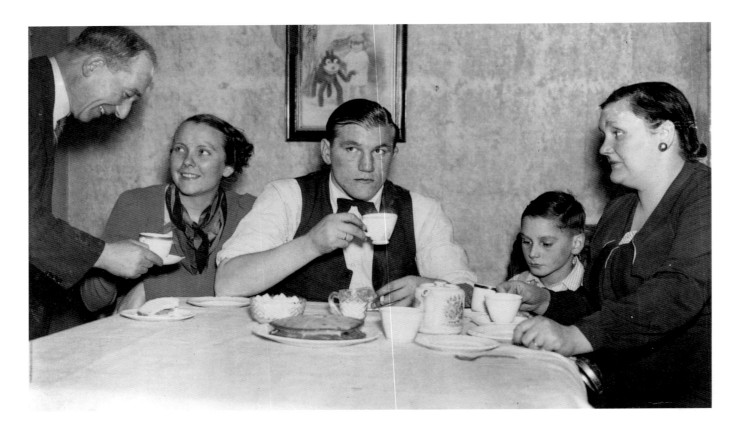

Tommy Farr (1914-1986)
Boxing

Welsh miner Tommy Farr went from boxing in a booth on Saturday nights at the age of 13, to giving the American Joe Louis the biggest challenge of his career in 1937. Aside from **Randolph TURPIN**'s victory over Sugar Ray Robinson in 1951, Farr's performance against 'The Brown Bomber' was the greatest British showing against an American this century. Although he narrowly lost on points, Farr became a Welsh folk hero overnight. Having claimed the British and Empire heavyweight titles, he achieved wider fame in 1937, outpointing former world champion Max Baer, and knocking out the German Walter Neusel. It was Farr's victory over Neusel that brought him up against Joe Louis. Farr's other fights in America were in a losing cause, and he returned to London just as the Second World War intervened. In September 1950, ten years after his previous fight, 36-year old Farr contested the British heavyweight title again, but his surprise comeback was stopped in seven rounds by **Don COCKELL**.

Tommy Farr, recently home from his world title fight against Joe Louis, having tea with his sisters and nephew, 11 October 1937
Sayers for the *Daily Herald*
National Portrait Gallery

Tommy Farr vs. Joe Louis

Louis enjoyed the highest profile of any boxer in the world until the arrival of Cassius Clay (Muhammed Ali). Tommy Farr's challenge for the world heavyweight crown was the first by a British fighter, and the 37,000-strong New York crowd gave him little support. But Farr's spirit never waned, he ducked and dodged the American's punches, fearlessly smiling at him. By the third round, Farr was suffering from cuts to both eyes, but he lasted until the end of the contest; one of Louis' few opponents to avoid being knocked out. Despite losing on points, Farr had been a credit to British sport, and to Wales in particular. In his home town of Clydach Vale, the spirit of hope had been overwhelming. The streets were festooned with streamers and flags and those households with radios opened their doors to the whole community, others crammed into public assembly rooms to listen to the commentary – five thousand people stood outside the Town Hall. As the decision in favour of the American was announced, the sound of hisses and boos was soon drowned out by a hearty rendition of 'Land of My Fathers'. Farr later told the listeners, 'I done my best…we, I showed 'em I got plenty of guts.'

Sir Tom Finney (b.1922)
Football

A one-club man with Preston North End from 1946 to 1960, Finney was a model of loyalty and good sports-manship. In 1952, he rejected a £10,000 transfer to Palermo, which would have given him £130 a week plus bonuses and a villa. At the outset of his career, his father, insisting that Finney learn a trade, had refused to let his son sign for Preston. Finney took heed of the advice and 'The Preston Plumber' still runs a highly successful business. With 217 goals in 507 matches, most of which he scored as a winger, Finney was probably the most complete British forward of all, as he could also play at centre-forward. Despite his goals and all round contribution to the team, he won no honours at club level, but in an England shirt, he played in two World Cups in the 1950s, and won 76 caps over 12 years. Only three of these were played at centre-forward, and he remains the only winger to have scored 30 goals for England. Often compared to fellow player **Stanley MATTHEWS**, Finney combined skill, exhilarating pace, and great determination, so much so that he initially kept Matthews out of the national side. Finney was twice voted Footballer of the Year, and was knighted in 1998.

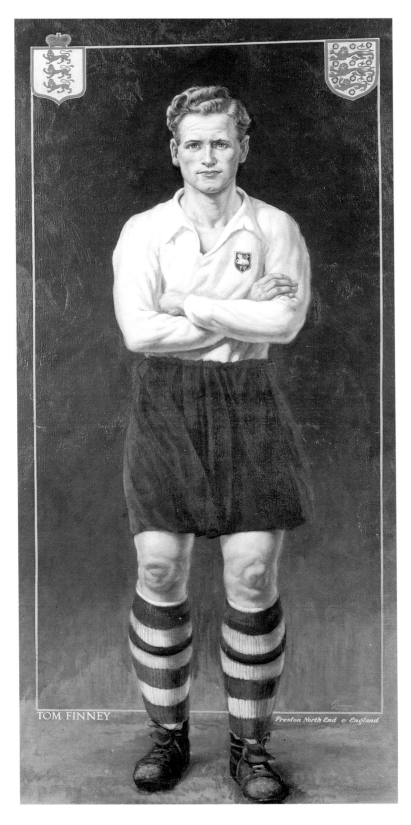

Tom Finney, Preston North End and England
Edward Robinson, 1951
Oil on canvas, 1222 x 611mm
Harris Museum & Art Gallery

Elnathan (Nat) Flatman (1810–60)
Horse racing

When in 1846 the first record was published of jockeys' wins for the season, Nat Flatman headed the table with 81 successes, a position he maintained for the next six years. In 1848, his best season, he had 104 winners. Born in Suffolk, Flatman was apprenticed to the trainer William Cooper at Newmarket in 1825, although he did not have his first professional ride until he was 19, a relatively late age for a jockey. He won his first classic, the 1,000 Guineas, on Charles Greville's Preserve in 1829, but it was another ten years before he established his reputation in the dead-heat between his mount, Gibraltar, and Crucifix. His only Derby win came in 1844 on Orlando, which came second but won on the disqualification of Running Rein. His greatest moment was his victory on Lord Zetland's Voltigeur over the previously unbeaten Flying Dutchman in the Doncaster Cup of 1850. A modest man with a reputation for scrupulous honesty, Flatman was much favoured by a wide variety of owners from the Earl of Chesterfield and Lord George Bentinck to the formidable turf administrator Admiral Rous. Flatman's death in 1860 was probably due to the after-effects of two heavy falls. HC

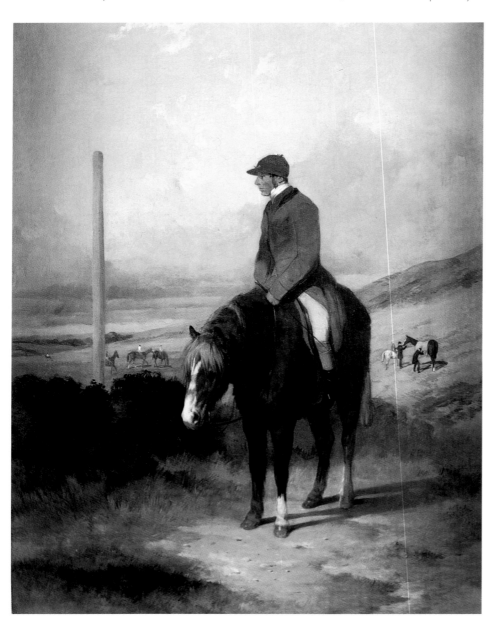

Nat Flatman on his pony before the start of the 1844 Chesterfield Sales
Harry Hall
Oil on canvas, 760 × 501mm
National Horseracing Museum

George Fordham (1837–87)
Horse racing

Between 1855 and 1871 George Fordham was Champion Jockey on 14 separate occasions, enjoying his best season in 1862 with 166 victories. After an apprenticeship at stables in Middleham, he rode successfully for an American owner, Mr Richard Ten Broeck, but was particularly associated with the trainer John Day (son of **John Barham Day**) at Danebury, for whom he rode a number of horses owned by the Marquess of Hastings. Blessed with a fine and instinctive tactical sense, he rode with shorter stirrups than most of the jockeys of his day and his gentle touch was particularly successful with two-year-olds. He was known as 'The Demon', famous for pretending that his mount was in difficulties but then finishing with a late rush. Scrupulously honest, he refused to ride again either for William Day or for Captain Machell when they accused him of not trying. Having earned a large sum he retired in 1876, but all his subsequent business ventures failed, driving him to drink. Found by Sir George Chetwynd in a distressed condition the following year, he was persuaded to resume his racing career and returned to enjoy another six years at the top of his profession, winning his only Derby, and bringing his tally in all to 16 classic victories. HC

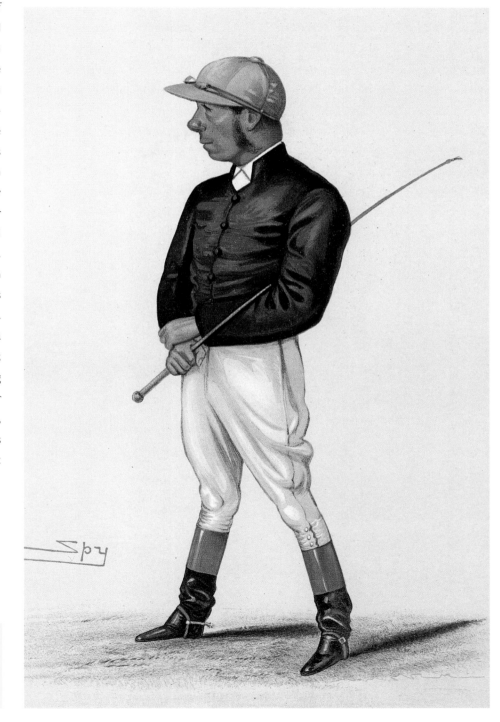

The Demon (George Fordham)
Published in *Vanity Fair*, 1882
Sir Leslie Ward (Spy), 1882
Chromolithograph, 305 × 181mm
National Portrait Gallery

Marjorie Foster (1893–1974)
Rifle shooting

The daughter of an ex-serviceman, by the age of eight Marjorie Foster was proficient enough with the small-bore rifle to be accepted as a junior member of the Camberley Rifle Club. It was not, however, until the mid-1920s that this erstwhile sculptor turned poultry farmer started to shoot seriously with the South London Rifle Club based at the home of the National Rifle Association at Bisley. In 1929, encouraged by former champion shot George Fulton, she competed in the Imperial Meeting, earning her first qualification for the Sovereign's Prize, the most coveted trophy in rifle shooting. The following year she won it in front of a huge crowd, beating off the challenge of nearly 1,000 other entrants, and taking the final shoot-off against Lieutenant Sandy Eccles with a bullseye and a score of 280 against his 279. She was the first woman to win the prize and was cheered, chaired and toasted in champagne, and then carried home to Frimley in Surrey by the local fire engine and given a car with money raised by public subscription. After 1930 she continued to compete at the highest level, reaching the Sovereign's Prize finals another seven times, the last in 1961 when she was 68. During the Second World War she trained young riflemen and was a senior commander in the Auxiliary Territorial Service. HC

'It is no occasion, when a woman wins after so stern a test, for men to say that they must look to their laurels; it is rather a moment, as indeed it was at Bisley on Saturday, for generous and whole-hearted rejoicing that the "undescribable" – as it was to generations before the present – has been "done". There is, so far as memory seems able to reckon, no real parallel to women like Miss Foster and her compeers in other fields… It may be said to mark off the twentieth century from the nineteenth as decisively as anything that has happened in the last thirty years. It is certain that the first emancipators of women had no idea of what lay in store for their granddaughters. Could they have foreseen it they might have disarmed much opposition by pointing to the possiblities, not only of freedom but of equality and fraternity also.'
(From *The Times* leader, 21 July 1930.)

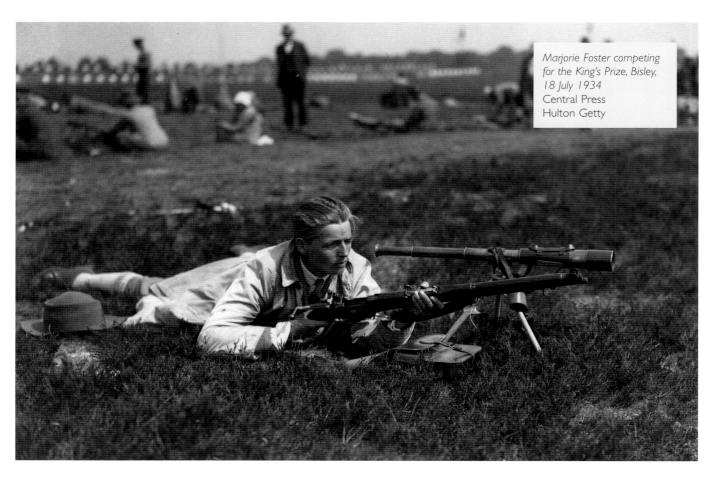

Marjorie Foster competing for the King's Prize, Bisley, 18 July 1934
Central Press
Hulton Getty

Neil Fox (b.1939)
Rugby league

Neil Fox, Wakefield's man of the match, resting after victory in the Challenge Cup final, 1962
Daily Express
Hulton Getty

Fox is the highest point-scorer in the history of the game, and his total of 6,220 points – from 358 tries and 2,575 goals – is unlikely ever to be bettered. The metronomic accuracy of his left kicking boot earned him the nickname 'The Points Machine'. A strong and intelligent centre, he was at the heart of the great 1960s Wakefield Trinity side, which won three Challenge Cups and two Championship titles. Fox's impact on the club was immediate: in his first full season – 1957–8, he scored 32 touchdowns and kicked 124 goals, setting up a new club record in both departments. By the time he left the Yorkshire side in 1974, his conveniently short name was inked all over the record books and gold-lettered on the clubhouse boards. In addition, he played in every position except hooker and open side prop. His presence in Great Britain's colours was automatic, and no-one playing at centre has yet matched his 29 tests.

John Francome (b.1952)
Horse racing

There have been few better horsemen than John Francome. After a successful grounding in showjumping he joined **Fred WINTER**'s stable in 1969, becoming Winter's first jockey in 1975. Together they forged one of the most formidable partnerships in National Hunt racing. Francome was a stylish and intelligent rider from the outset, whose strength in a finish came with experience, making him the complete jockey. Of the major races only the Grand National eluded him, as it did **Peter SCUDAMORE**; his victories include the Cheltenham Gold Cup on Midnight Court in 1978 and a characteristically insouciant triumph on Sea Pigeon in the 1981 Champion Hurdle. Among the other great horses he rode was Burrough Hill Lad, trained by Jenny Pitman. Only the second jockey after Stan Mellor to ride 1,000 winners over fences, he was Champion Jockey on seven occasions. In 1982 Peter Scudamore was well ahead in the jockey's table when he sustained a bad injury, putting him out for the rest of the season. When Francome reached Scudamore's total he stopped riding in order that they could share the title. In retirement, following a brief period as a trainer, he has earned a reputation as an astute and entertaining racing commentator. HC

John Francome
Miriam Reik, 1987
National Portrait Gallery

Charles Burgess Fry (1872–1956)
Cricket

C.B. Fry was the quintessential Edwardian all-round sportsman. He looked like a Greek god, and performed like one too. Famed primarily as a cricketer, he was also an outstanding athlete, whose world long jump record stood for 21 years. He played football for England and rugby for the Barbarians. He created *Fry's Magazine*, wrote a novel and an autobiography, as well as authoritative books and articles on cricket. He stood as a Liberal candidate for Parliament and, most bizarrely of all, was offered the throne of Albania, a deputation from that country recognising his extraordinarily statesmanlike demeanour. As a county cricketer for Sussex, Fry was a peerless run-maker, scoring 92 centuries for the county, at an average of 50.22. Each season between 1899 and 1905, he scored over 2,000 runs and in 1901 he scored 3,147 runs, including 13 centuries, six of them in successive innings. His next visit to the crease was in April 1902, where he scored another 100, two days after playing football for Southampton in the FA Cup Final. His 26 test matches were comparatively disappointing, as he only made two centuries for England. When once criticised for having only one decent shot, Fry replied: 'true, but I can send it in twenty-two places'.

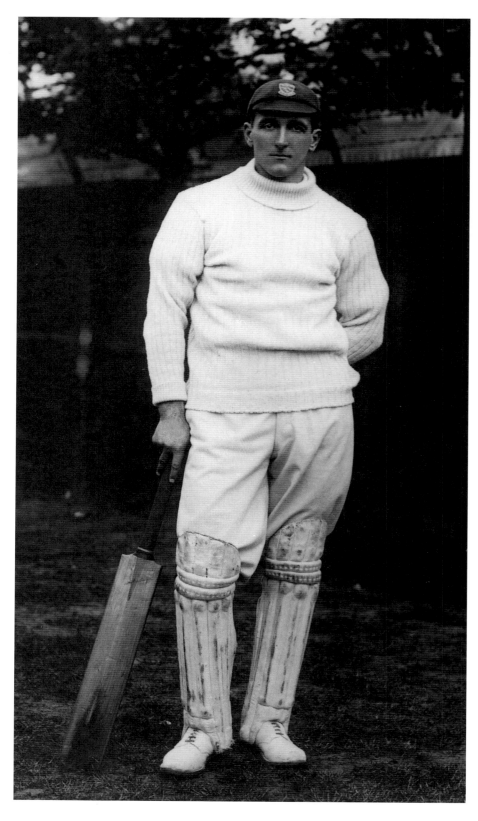

C.B. Fry
Thomas Henry Bolland, 1905
Public Record Office

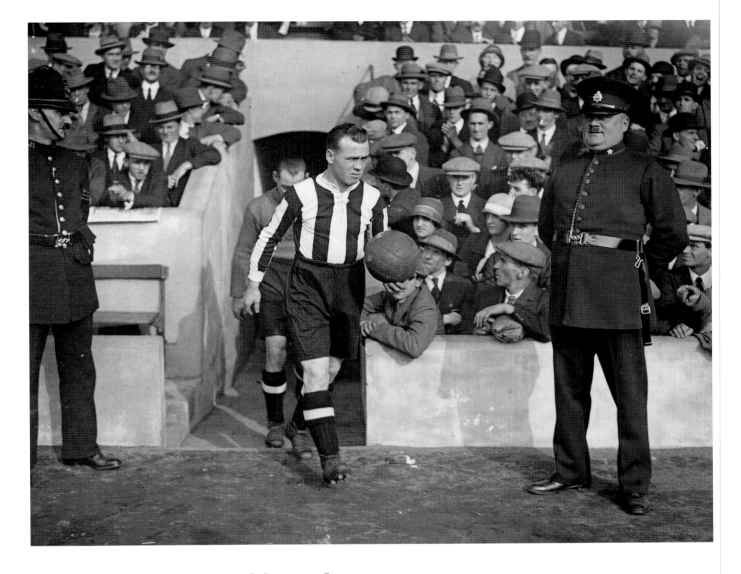

Hughie Gallacher (1903-57)
Football

Hughie Gallacher was still working in a colliery when he began his playing career with Airdrie, minnows of the Scottish league. His 33 goals in the 1923–4 season attracted a host of clubs after his signature, and his huge £6,500 eventual transfer south to Newcastle in 1925 incensed Scottish fans to such a degree that they threatened to burn down the stadium. Gallacher steered Newcastle to the league championship in 1927, breaking the club scoring record in a season with 36 goals in 38 games. His five seasons yielded 133 goals, making him an idol in the north-east. He signed for Chelsea in 1930 for £10,000, but although continuing to find the back of the net with 125 league goals, he never settled in London. Having left Chelsea, and with his price tag dropping each time, he played for several clubs in the lower divisions until the Second World War. As an 'Anglo'– a Scot who played club football in England – he was frequently excluded by the patriotic Scottish team selectors, and won only 20 Scottish caps. His goal-scoring record of 387 league goals in 543 matches was outstanding, especially considering his many personal and domestic problems, which led to his suicide in 1957.

Hughie Gallacher leading Newcastle out against Arsenal, Highbury, 2 October 1926
Kirby for Topical Press
Hulton Getty

Paul Gascoigne
(b.1967)
Football

For good reasons and bad, Gascoigne is the most talked-about sportsman of the 1990s. His promise was evident from his début in 1985 for Newcastle, but perhaps too much happened too soon. He was lured to Tottenham Hotspur for £2 million, then transferred to Lazio for £5.5 million, returned to Britain with Glasgow Rangers and in 1998 moved to Middlesborough. During this time the equivalent of three seasons had been lost to injury. At times, he has been unquestionably brilliant; but indiscipline, injury (mainly of his own making) and his off pitch antics have blighted this most gilded of talents. England boss, Bobby Robson, once famously described Gascoigne as 'daft as a brush', but he could also be as deft as the finest. He was the player who could dribble, pass and exploit gaps in defences; he scored spectacular goals and took clever free kicks. But the most famous thing he ever did was cry. His tearful face during the World Cup semi-final was the sporting image of 1990. Sadly, neither television nor the print media have let up on Gascoigne ever since those tears. He was England's most inventive player at that World Cup, and until his much discussed omission from Glenn Hoddle's 1998 World Cup squad, was the player to whom England looked for inspiration.

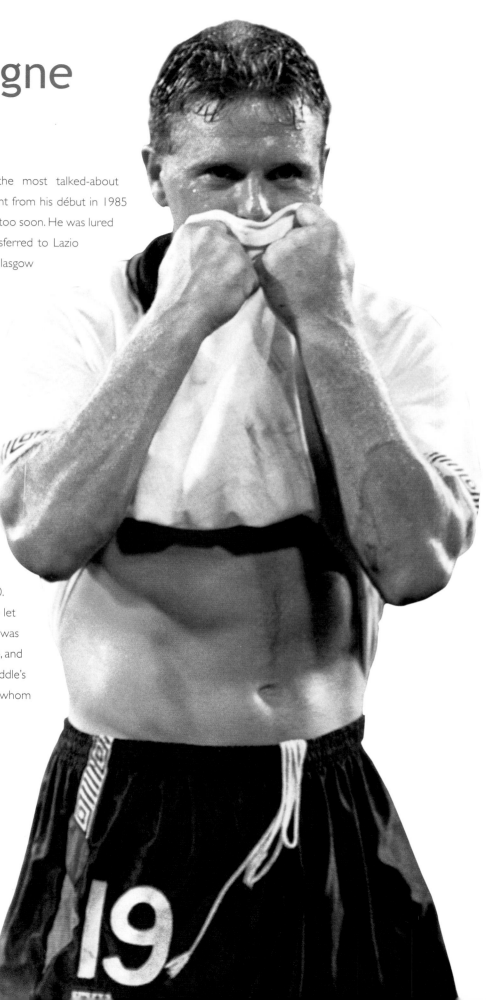

*Paul Gascoigne, World Cup semi final,
England vs. West Germany, Turin, 1 July 1990*
David Cannon/Allsport

Walter Goodall George (1858–1943)
Athletics

Britain's first great track athlete, George dominated the meetings of the Amateur Athletic Association in the 1880s. The AAA as a governing body was a model for the world. It codified the basic track and field programme, and its meetings were the Olympics of their day: George was its first star. From 1879 until 1885, he was virtually unchallenged, setting records at every distance from 1,000yds to 12 miles. Tall and gaunt, dressed from neck to knee in black, he won more than 1,000 cups and prizes. The four-minute mile was a psychological sporting barrier for many years before **Roger BANNISTER** broke the record, and Walter George was the first to come close, establishing the world's fastest recorded mile at 4 minutes and 12 seconds in 1886. His time was unbeaten for 28 years, and remained a British record until broken by **Sydney WOODERSON** in 1935. By 1886 he had turned professional and, running for money, he beat the Scotsman William Cummings over a mile, in front of nearly 30,000 people. He toured the USA five times, where he continued to prove himself the world's greatest middle-distance runner of the day.

Walter George, c.1884
Topical Press
Hulton Getty

Mike Gibson (b.1942)

Rugby union

New Zealand's rugby hero Colin Meads once said that this modest Belfast solicitor was 'as near to the perfect rugby player as I have ever seen'. Gibson's international career lasted 16 years from his début for Ireland while still a student at Cambridge in 1964. He played at fly-half until 1969, then moved to centre for 40 games and finished with four games on the wing. When he retired in 1979, his 69 international appearances stood as a world record. His career co-incided with that of fellow Ulsterman **Willie John McBride**; these two giants of Irish rugby were the backbone of the British Lions successes in 1971 and 1974, and they share the record of having travelled on five tours. Gibson alone was the acknowledged hero of the victorious 1971 side. Despite an often furrowed brow, he loved the game that he graced for so long; balance, technique, determination, and positional flair made him one of the key players of his era, and the best Irish back since **Jackie Kyle**, whose decisive distribution and quick ball-handling he emulated.

Mike Gibson challenged by Gareth Edwards (tackling), Mervyn Davies (with headband) and J.P.R. Williams (r), Ireland vs. Wales, Cardiff Arms Park, 10 March 1973
Colin Elsey
Colorsport
See also **Gareth Edwards** and **J.P.R. Williams**

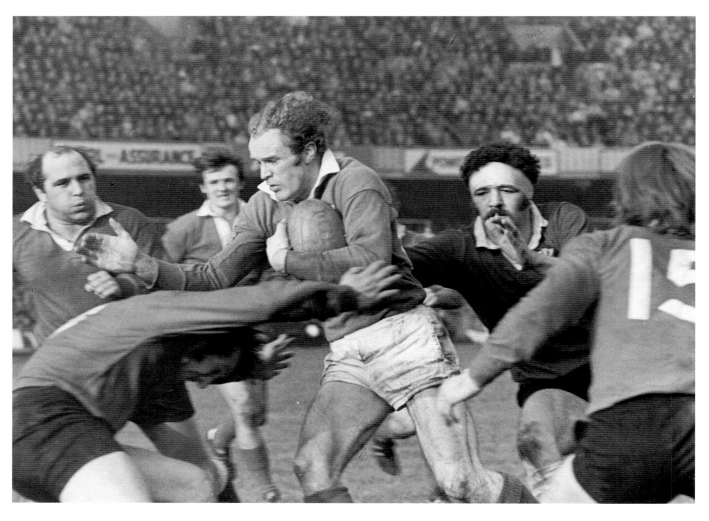

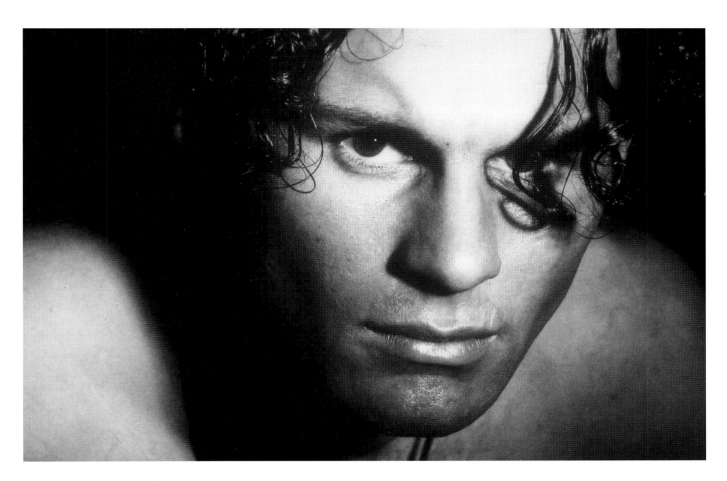

Ryan Giggs (b.1973)
Football

The emergence of Ryan Giggs co-incided with the renaissance of Manchester United's fortunes under manager Alex Ferguson. His youth and ability encapsulate the spirit of the team, built largely around young players, and sometimes referred to, in comparison to the 'Busby Babes', as 'Fergie's Fledgelings'. Born Ryan Wilson in Cardiff, Giggs took his mother's maiden name after his parents' separation. He made his first-team début aged 17, and over the next two seasons established himself as a Welsh 'wunderkind'. Immediately compared to his antecedent at Manchester United, **George Best**, Giggs was wisely shielded from the intrusive media by Ferguson. Waif-like and elusive, Giggs glides his way past defences on the field, deceiving the opposition with frequent changes of pace and direction. A clever crosser of the ball, he also contributes a number of notable goals each season. Young Player of the Year in 1992 and 1993, and a key member of the Manchester United team that won the league championship in 1993, 1994, 1996 and 1997, Giggs also received an FA Cup winner's medal in 1994 and 1996. In 1991, Giggs became the youngest-ever Welsh international, but, like **Ian Rush**, has been denied the chance to shine on the world stage as Wales have perennially failed to qualify for the major tournaments.

Ryan Giggs
Tim O'Sullivan, 1994
National Portrait Gallery

George Glennie (1818–86)
Golf

A Glasgow iron-master and engineer, George Glennie was already a member of the Royal and Ancient (R&A) Golf Club when he came to manage his company's office in London and joined the Blackheath Golf Club in 1853. One of the best-known amateur golfers of his time, he created a sensation at the Royal and Ancient Golf Club's Autumn Meeting in 1855 when he scored 88, the first member to achieve a score better than 90 in the competition for the Royal Medal, presented by William IV. This record was not tied until 1879 and not broken until 1884. His real love was match play, particularly by foursomes. In 1857, he and Lt John Campbell Stewart represented the Blackheath Golf Club in the first known team championship, the Grand National Tournament,

held at St Andrews. The Black-heath pair won the trophy, defeating the R&A team by seven holes in the final. The club became known as the Royal Blackheath Golf Club after their victory. Glennie was Blackheath's Club Captain in 1862 and 1863 and then the Honorary Secretary and Treasurer from 1868 until his death. He won 18 medals there between 1854 and 1967 and another ten medals at the R&A, Prestwick, Edinburgh Burgess and Royal North Devon between 1851 and 1872. He was also Captain at Prestwick in 1876 and at the R&A in 1884. FRF

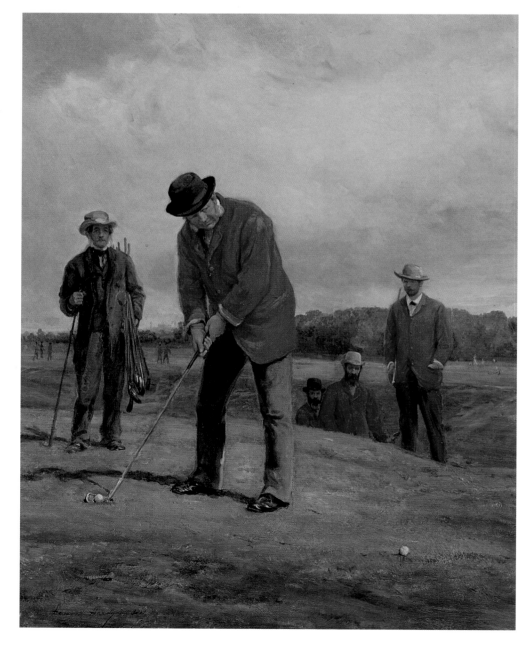

Golf on Blackheath
George Glennie with caddie
Dick Steer on the first green, in
a foursomes match with (l to r):
Francis Gilbert, William
McCandlish and John Penn
Heywood Hardy, 1881
Oil on canvas, 510 x 405mm
Royal Blackheath Golf Club

Kitty Godfree (1897–1992)
Tennis

The best British player since **Dorothea Lambert CHAMBERS**, Godfree shared with **Dorothy ROUND** the distinction of winning the Wimbledon ladies' singles twice, in 1924 and 1926. Had her career not co-incided with those of two of the all-time greats, Suzanne Lenglen and Helen Wills Moody, her collection of trophies would have increased considerably. In 1923, she was the losing finalist to Lenglen; the following year they were drawn together in the semi-final. Lenglen withdrew through injury, but Wills Moody was awaiting Godfree in the final. In an epic match, Godfree started badly but recovered from what seemed an impossible position, to win 6–4 in the third set, inflicting the only defeat on the American in her nine visits to Wimbledon. Lenglen was back in 1925, and in devastating form: Kitty Godfree met her in the French final where she lost 6–1, 6–2. Worse was to come at Wimbledon, as the French player beat her again, 6–0, 6–0 in the semi-finals. The following year, with Wills Moody and Lenglen both absent from Wimbledon, Godfree took her chance and won the title again. In the same year, history was made in the mixed doubles, as Kitty and her husband Leslie became the only married couple ever to have won the event. Playing singles, ladies and mixed doubles, she also won five Olympic gold medals in 1920 and 1924.

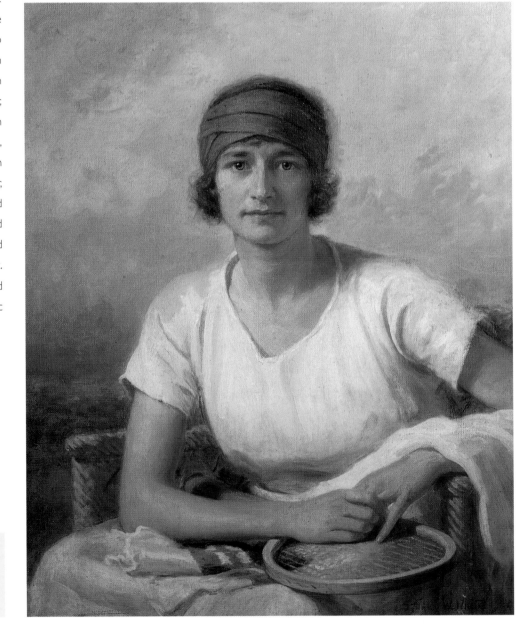

Kitty Godfree
Sidney White, 1924
Oil on canvas, 865 x 690mm
The Wimbledon Lawn Tennis Museum

Graham Gooch (b.1953)
Cricket

Gooch's international baptism embodied the batsman's worst fear: 'a pair' (nought in each innings), against Australia in 1975. But from such an acorn-like début grew the oak tree of English batting throughout the 1980s: not only did Gooch stand at the crease with enormous authority, he could also strike the ball with majestic confidence. At his best against fast bowling, Gooch often rescued England at a time when the West Indian pacemen were terrorising the world's batsmen. A consistent high scorer for Essex in over 25 seasons, he was devoted to training and physical fitness, though not all of the England team which he captained in 34 matches appreciated his dumb-bells and press-ups routine. But exercise served Gooch well, and when he retired from test cricket aged 42, there were many who wished he had continued playing. He scored 128 first-class centuries, 94 of which were for Essex. He is England's leading scorer in test matches with 8,900 runs, and the most capped player with 118. His 333 against India at Lord's in 1990 is the highest ever score by an England captain: in the second innings his contribution of 123 makes his score the highest aggregate in one test match. Essex's greatest ever player and most prolific scorer, Gooch was the inspiration behind six county championship titles, as well as numerous one-day trophies.

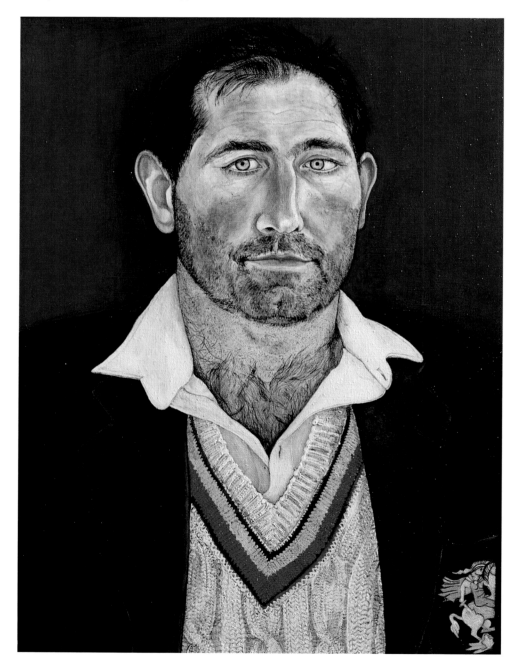

Graham Gooch
Ishbel Myerscough, 1992
Oil on canvas, 457 x 356mm
Marylebone Cricket Club

Duncan Goodhew (b.1957)

Swimming

Goodhew's unmistakable bald pate has greatly endeared him to the British sporting public and made him an instantly recognisable celebrity. He discovered his talent for swimming at an early age and as a highly promising 18-year-old won a sports scholarship to the North Carolina State University. He was selected for the British Olympic team to go to the 1976 Montreal Games, where he finished seventh in the 100m breaststroke. Thanks to superior American training facilities, he was able to improve on this, winning three silver medals at the 1978 Commonwealth Games in both 100m and 200m breaststroke and in the medley relay. At the World Championships, he finished fourth in the breaststroke events, and third in the medley relay. Finally, in 1980, he won the Olympic 100m gold medal, beating both the world record holder and the reigning champion. He added a bronze medal in the 100m medley relay.

(l to r): Duncan Goodhew, Adrian Moorhouse, David Wilkie
Alistair Morrison, 1996
National Portrait Gallery
See also **Adrian MOORHOUSE** and **David WILKIE**

Arthur Gould (1864-1919)

Rugby union

Gould helped make rugby the national sport for Wales, and established himself as the game's first star player. When he made his début in 1885, Wales had only played eight international matches, winning two. By the time he retired, the principality had won the Triple Crown for the first time in 1893, and club sides from Wales were beating opposition from the other home countries. With 27 caps, Gould played an important role in developing the game, particularly initiating the change from three to four three-quarters. Known as 'Monkey', Gould was a teenage sprint champion, and always elected to run with the ball instead of kicking to safety. He became Newport's finest player, and the side lost only four out of 55 games between 1893 and 1895. In 1896, in recognition of his status, a public subscription was opened in his honour. The sport's amateur status precluded gifts of money: Gould was offered a house instead, but the rugby community was still thrown into turmoil, horrified at any thought of material reward. The other home nations broke off all fixtures with Wales, and the country was only re-admitted to the fold on Gould's retirement in 1897.

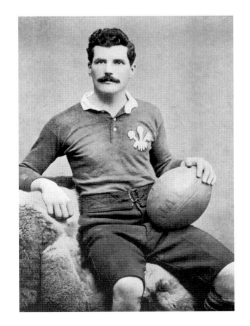

Arthur Gould
Unknown photographer, c.1896

David Gower (b.1957)
Cricket

The left-handed Gower was the most stylish batsman England had seen for decades, ever graceful, and timing his shots to perfection. But while his artistry was never in question, his attitude sometimes was. His style could be wrongly interpreted as uncompetitive, and his wristy stroke-play as laziness, especially when with a loose shot he gave his wicket away. Gower abandoned law studies to play cricket for Leicestershire in 1975. Three years later he was playing test cricket, pulling his first delivery for four. In 117 tests he scored 8,231 runs – averaging 44.25 – and was briefly (until eclipsed by **Graham Gooch**) England's highest scorer in test matches and most capped player. He became captain in 1982, but despite his series average of 90.75, England failed to win a test against Pakistan in 1982–3. He was again helpless as the West Indians humiliated England with two successive whitewashes (5–0 test series losses). In 1988 he became, by four years, the youngest player to reach 100 test caps. Popular with cricket lovers and revered by aficionados, Gower's omission from the 1992–3 tour party to India threw the MCC membership into internal dispute, and *The Times* letters page was overwhelmed with comment and opinion.

David Gower, England vs. India, The Oval, 1990
Patrick Eagar

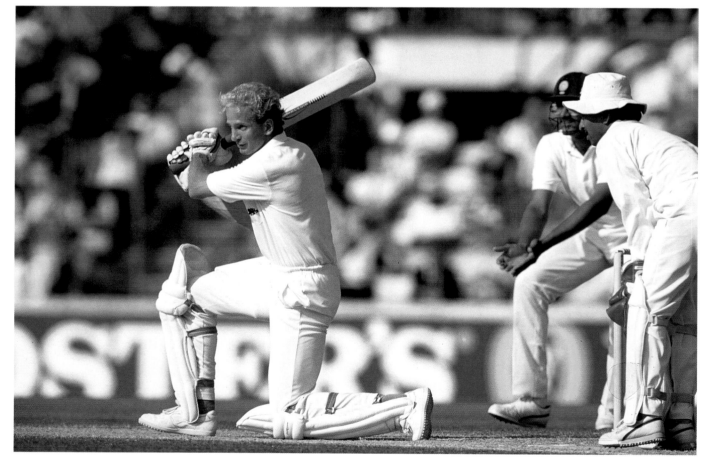

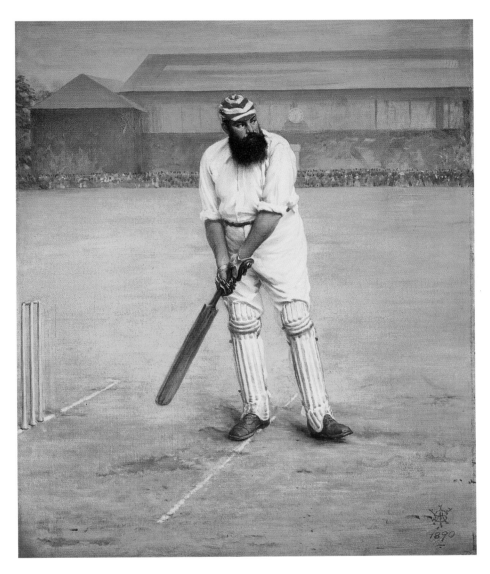

W. G. Grace at the Wicket
Archibald Stuart-Wortley, 1890
Oil on canvas, 1220 x 864mm
Marylebone Cricket Club

W.G. Grace (1848–1915)
Cricket

Wherever the game is played, W.G. Grace's unmistakable bearded face is still the best-known in world cricket. He saw cricket develop from a provincial pastime to the national sport. His England colleague **K. S. Ranjitsinhji** said of his batting: 'he turned it from an accomplishment into a science…turned the old one-stringed instrument into a many-chorded lyre'. A major celebrity of the late Victorian era, Grace is Britain's best-known sporting son. Known both as 'The Doctor', because of his profession, and 'The Champion', for his sporting accomplishments, he created and re-set most of the cricketing records available. He was the first player to reach 2,000 runs in a season and the first to do the double (1,000 runs and 100 wickets in a season), which he repeated seven times. He played sporadically for the Gentlemen against the Players for 41 years, during which time they only lost four games, and toured Australia twice and America once. He hit the first test century and led a variety of England XIs in 22 games from 1880 to 1899, when he retired because 'the ground was getting too far away'. Grace played for Gloucestershire and the side have never won the county championship since his playing days. He was always a star attraction: at some matches, there were signs outside the ground saying 'Entrance 6d, if Grace plays, one shilling.' Once, on being ruled 'out', he stood in his crease and declared: 'They've come to see me bat, not you umpire. Play ON!'

Jimmy Greaves (b.1940)
Football

Greaves was a Cockney boy wonder, whose goal-scoring feats illuminated football in London for nearly 15 years. Making his league début for Chelsea in 1957, he scored 124 league goals for the club, including a club record of 41 in the 1960–1 season. After a brief and unhappy six-month stay with AC Milan, he signed for Spurs in 1961 for £99,999, manager Bill Nicholson being unwilling to break the £100,000 barrier. The season before, Spurs had completed the league and cup double, and Greaves shared in the club's subsequent glory years, playing in the team that won the FA Cup in 1962 and 1967, and the European Cup in 1963. His 306 goals for the team were the work of a cunning poacher, with immaculate balance and positional flair: his finishing from close range was lethal. In six seasons, he was the first division's top scorer, including three seasons in a row from 1962 to 1965. His England career was no less distinguished, playing in the 1962 and 1966 World Cups and scoring 44 goals in 57 matches for his country. He endured wretched bad luck to be suffering from hepatitis in 1966, thus missing the latter stages of the World Cup final. A period of alcoholism followed his retirement, but Greaves recovered and re-invented himself as a television personality, presenting the popular *Saint and Greavsie* show with Ian St John.
(Illustrated under **Danny BLANCHFLOWER**)

Lucinda Green (b.1953)
Equestrianism

Green's record six wins at Badminton, the world's major horse trial, is all the more remarkable given that her victories were achieved on six different horses. Her first win, at the age of 19, was on Be Fair, a horse she was given on her fifteenth birthday. Her second win, in 1976, became her best known when her horse, Wideawake, collapsed and died during the prize-giving. She won in the 1977 season on George, and her additional victory at Burghley Horse Trials meant that she became the first person to claim both prizes in the same year. Subsequent wins at Badminton were achieved on Killaire in 1979, on Regal Realm in 1983 and Beagle Bay in 1984. She competed at two Olympic Games; the first, in 1976, ended in sadness as Be Fair was badly injured in the final stages. A team silver medal at Los Angeles in 1984 was her Olympic best, but she won the World Championships in 1982 on Regal Realm, and two European titles in 1975 and 1977. Initially competing under her maiden name of Prior-Palmer, Lucinda Green was known for her immaculate care and preparation of her horses, and in retirement remains involved in the running of equestrianism in Britain.

*Virginia Leng and Lucinda Green (r),
Badminton, 1980s*
Srdja Djukanovic
See also **Virginia LENG**

Tanni Grey (b.1969)
Paralympics

Tanni Grey's four gold medals from four events at the 1992 Paralympics made her one of the world's most distinguished disabled athletes. In the wheelchair track events, she won the 100m and 400m with new world records, while her 200m and 800m gold medals set new Paralympic records. Two years later, at the World Championships in Berlin, she repeated her four-medal haul, triumphing in the 100m, 200m, 400m and 800m, adding a bronze medal in the 10,000m. She was also the first disabled athlete to cross the line in the 1994 London Marathon. Born with spina bifida, Grey has been a wheelchair user since the age of eight. Before specialising in track athletics, she competed in basketball, and also enjoyed scuba diving and horseriding. A politics graduate from Loughborough University, Grey's research into disability sports made such an impact that she was awarded a second honorary degree. Ever since, using her high profile to fight prejudice, Grey has also worked to gain equal rights for people with disabilities. Like fellow Welsh Paralympian **Chris HALLAM**, Tanni Grey is honoured in the Welsh Sporting Hall of Fame.

Tanni Grey
Richard Bailey, 1996

Judy Grinham (b.1939)
Swimming

At the 1956 Melbourne Olympic Games, Grinham became Britain's first swimming champion for 32 years, winning the 100m backstroke final with a new world record. It was something of a heyday for national swimming, as she was one of three British swimmers in the Olympic final. After the Olympics she flirted with the freestyle events but, reverting to backstroke, she broke another world record to win the Empire title, and also won the European title to add to her Olympic gold. A second Empire Games gold in the 4 × 110yds medley relay gave Grinham more pleasure than her individual gold, because the team had defeated the highly rated Australian team, in which the great Dawn Fraser was swimming. On Grinham's retirement from competitive swimming at the age of 20, she made a brief foray into acting and modelling.

Judy Grinham, Elstree Studios
3 December 1958
Popperfoto

Sally Gunnell (b.1966)
Athletics

Britain's most popular sportswoman of the 1990s, solicitor's clerk Sally Gunnell began competing in the pentathlon, but later switched events, becoming Commonwealth champion in the 100m hurdles in 1986. In 1988 she competed in the 400m hurdles too, finishing fifth in the Olympic final. In 1990, she won the Commonwealth title in the 400m hurdles and won a silver medal in the 100m hurdles. She came second again in the 1991 World Championships, and broke the British and Commonwealth records in the same year. At the 1992 Barcelona Games she achieved Olympic glory, becoming the 400m champion. Her successes were consolidated in 1993 when she became world champion and the world record holder in the 400m hurdles. In 1994, retaining her Commonwealth Games 400m hurdle title, and adding the European title, Gunnell became the only female athlete to simultaneously hold Olympic, World, Commonwealth and European titles. A farmer's daughter from Essex, Gunnell was unaffected by her fame and, retaining her down-to-earth demeanour, became a great favourite with the public. After her world 400m hurdles domination from 1992 until 1994, she was restricted by injury, culminating in her failures at the 1996 Olympics: she retired in 1997. Away from competitive athletics, Gunnell has designed and developed her own sportsbra, created a chain of fitness centres, raised money for charity, and worked extensively in the media.

Sally Gunnell
Tim O'Sullivan, 1992
National Portrait Gallery

Mike Hailwood (1940-81)
Motorcycling

Britain's most successful motorcyclist, Mike Hailwood came to the fore in 1961, when he won three Isle of Man TT races in a week. Still only 21, he then claimed the first of his nine world championships, on a Honda at 250cc. From 1962 to 1965, he won four successive world titles at 500cc, riding for MV Augusta. Re-joining Honda in 1966 his 19 wins in the season (the number **Barry SHEENE** had in his entire career), ensured that he took the world title at both 250cc and 350cc. He defended them in 1967 with 16 wins, and in both these years also finished as runner-up to Giacomo Agostino in the 500cc title race. His total of Grands Prix wins stands at 76. He continued to rule on the Isle of Man, winning five senior TT titles among others between 1963 and 1967, when he abandoned motorcycling.

In 1968, Hailwood turned to Formula One racing, in which he had driven sporadically since 1963. He was not successful, however, and emigrated to New Zealand. In 1978, returning to the Isle of Man 11 years after his last victory, he won two races, taking his total number of TT wins to 14. Having retired for good he was killed in a road accident in 1981.

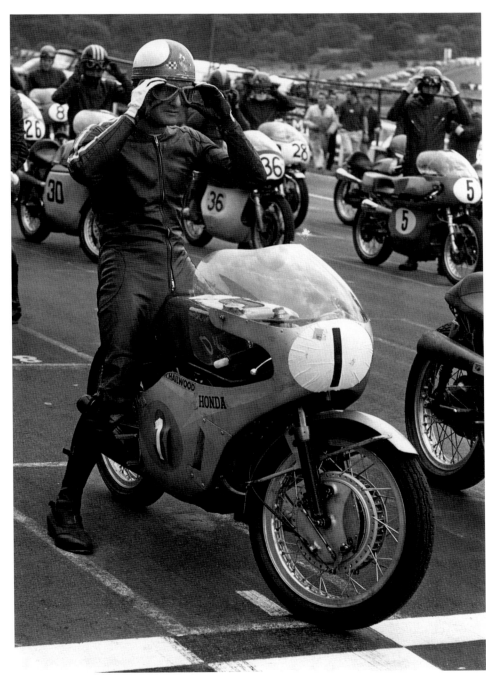

Mike Hailwood, Brands Hatch,
13 August 1967
R. Dumont for the *Daily Express*
Hulton Getty

Chris Hallam (b.1962)
Paralympics

Chris Hallam
Richard Bailey, 1996

Two days before he was due to compete in the Welsh national swimming trials in 1980, Chris Hallam was paralysed from below the chest following a motorcycle accident. In 1982, he relaunched his career as a disabled athlete, and as such became Britain's most distinguished and successful competitor. From 1982 to 1985, he was the 50m breaststroke world champion and record holder. He was a regular winner of full and half-marathons, finishing first in the 1985 and 1987 London Marathon. A diverse athlete, he also competed as the British cross country ski champion in the World Championships in Oslo in 1986. At the Seoul Paralympics in 1988, he won a silver medal in the 50m breaststroke, and finished third in the 400m track event. In 1991, he broke world records in the 100m and 200m track events, and won a bronze in the 100m at the 1992 Paralympics. He competed in his third Paralympics in 1996, and despite a serious kidney complaint, reached the 100m and 200m track semi finals. Off the track, Hallam was chairman of the British Wheelchair Racing Association from 1990 to 1992. In 1987 he set up the charity PvsH (People versus Handicap), to raise money for the Welsh Sports Centre for the Disabled. In 1997, he was inaugurated into the Welsh Sporting Hall of Fame, which counts Paralympian **Tanni Grey** among its 40 members.

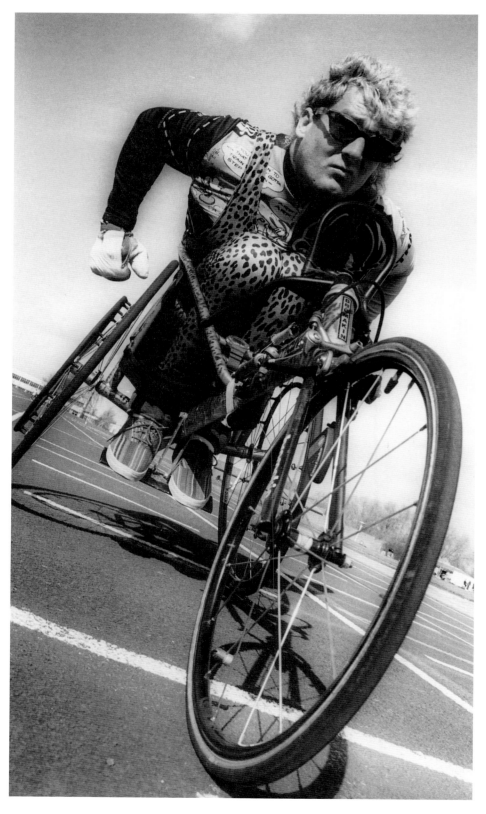

Chris Hallam
Richard Bailey, 1996

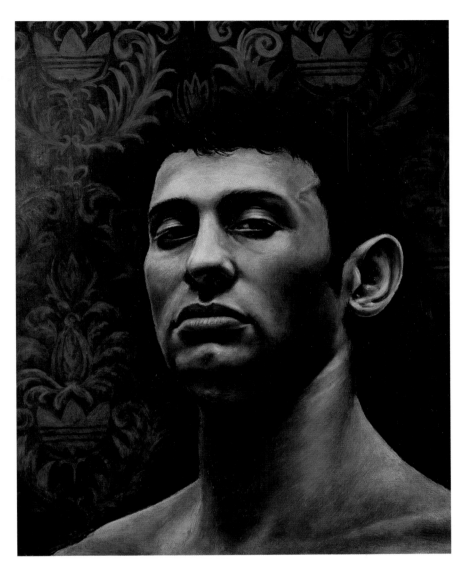

Naseem Hamed
Andrew Crocker, 1996
Oil on copper, 432 × 380mm
The Artist

Naseem Hamed (b.1974)

Boxing

Hamed's Yemeni father took his seven-year-old son to Brendan Ingle's Sheffield gym to help the youngster equip himself against the racist bullying he encountered at school. Five years later, the precocious 12-year-old met the editor of *Boxing News* and told him: 'You ought to write about me. I'm going to be World Champion.' Such self-confidence has been Hamed's stock-in-trade ever since, especially since he fulfilled his prediction, becoming world featherweight champion in September 1995, defeating Wales' Steve Robinson. A string of challengers, mostly South American, have been seen off by Hamed in defence of his title. The self-styled Prince Naseem, known to his army of admirers as 'Naz', became Britain's best boxing prospect in 1992. With rare talent and charisma, he has thrilled boxing fans with his lightning-fast hands, devastating punches, agility, and co-ordination. A provocative fighter, Hamed sways back and forth in the ring, almost defying his opponent to punch him. Hamed has never lost a professional bout, and 29 of his 31 fights have ended in a knockout. Many of his fights have taken less time to complete than his spectacular entrances, which are always finished off with a trademark backflip over the ropes into the ring. A non-smoking, non-drinking committed family man, Hamed is intelligent and highly articulate. Religious and fiercely proud of his origins, he is revered in Arabic countries: 'In Yemen, the entire country prays for me night and day. How can I lose?'

Walter Hammond (1903–65)
Cricket

Only **W.G. GRACE** and **Jack HOBBS** come before Walter Hammond in the English batting pantheon. Emerging as an all-rounder with Gloucestershire, in the 1925 season he made 1,818 runs, including 250 not out, took 68 wickets and 65 catches. In 1927, he scored 1,000 runs in the month of May. He was then selected to join the England team touring South Africa in the winter of 1927 and was a fixture of England's batting for the next 20 years. From 1933 until he retired he topped the batting averages in every season but one. He was at his best against the Australians: in his first Ashes series in 1928–9, he averaged 113.12 with 905 runs, including two double centuries. His finest test innings – though not his highest score – was against Australia at Lord's in 1938: he made 240 runs, coming in with the score at 31 for 3. Hammond's test aggregate of 7,249 runs stood as a record for 25 years, and his average was 58.45. A commanding figure at the crease, he made 167 career centuries, 36 of which passed 200. He led the first post-war tour to Australia in 1946–7, but with little success. By this time he was fighting illness, and became increasingly withdrawn. He then retired and emigrated to South Africa, where he lived, sad and virtually forgotten, until his death.

Walter Hammond padding up in the Gloucestershire dressing room, 3 August 1946
Charles Hewitt for *Picture Post*
Hulton Getty

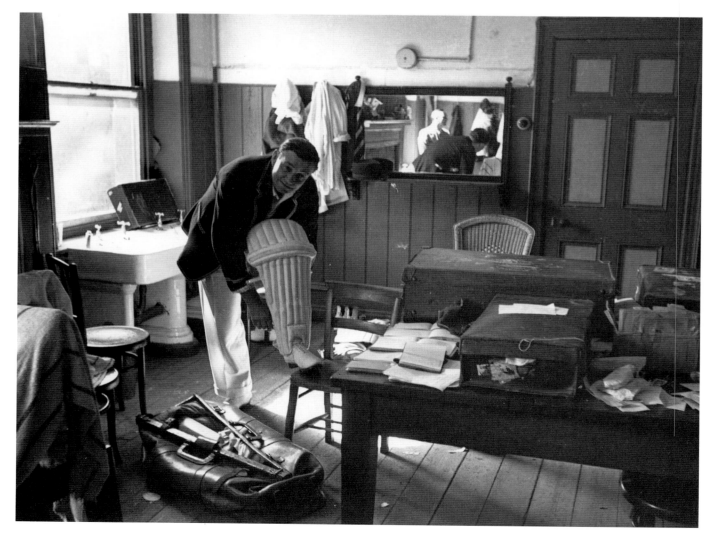

Ellery Hanley (b.1961)
Rugby league

The most exciting rugby league player of the last 20 years, Hanley is a devastating try-scorer, who combines pace and power with immaculate handling. Establishing himself with Bradford Northern in 1981, he began setting many of the sport's records. In the 1984–5 season, his total of 55 tries was the highest ever for a non-winger. Following his record-breaking transfer to Wigan in 1985 for £150,000, he scored 63 tries in his first season. He won 35 Great Britain caps playing in four different positions, forward, stand-off, centre and wing. On the tour to Australia in 1984, he scored 12 tries in 17 matches, and in 1988 became the first black player to captain Great Britain, recording the team's first win over Australia for ten seasons. He also won rugby league's Man of Steel award in 1985, 1987, and 1989. He led Wigan to three successive Challenge Cup wins from 1989 to 1991. At the end of the 1991 season, Hanley moved to Leeds as player-coach, and led his new club against Wigan in two Challenge Cup finals. In 1993 he retired from international rugby league and was appointed Great Britain team coach the following year.

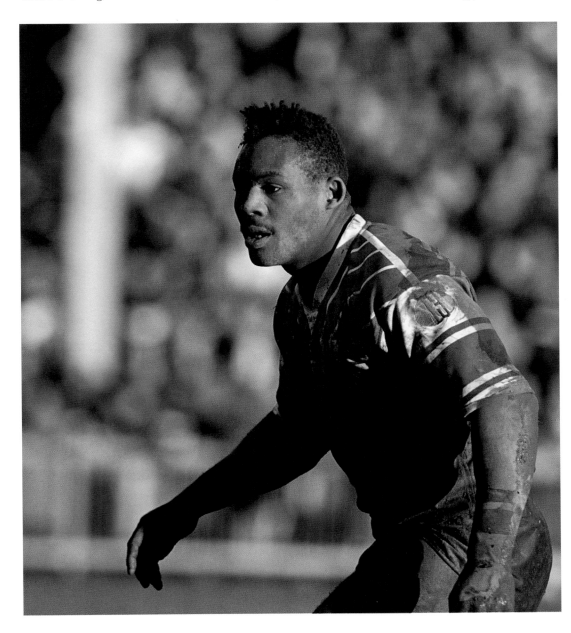

Ellery Hanley, Wigan, 1980s
Allsport

Eddie Hapgood (1908-73)
Football

Hapgood was never known as 'Steady Eddie' but he could have been, for he was the imperturbable left-back with Arsenal from 1928 to 1945. Including wartime games, he played 645 times for the north London club, but because he was a defender, and not a freescoring striker, he was never given his due credit. He captained England 34 times in 43 games (13 of which were wartime internationals), and was known in his day as the 'ambassador of football', an honour usually granted a player only on his retirement. Signing for Arsenal in 1927, he soon became the **Bobby Moore** of the 1930s, showing the same attributes – anticipation, authority, calmness and poise on the ball. Hapgood was also brave and never shirked a tackle. He and George Male were the defensive rock behind Arsenal's five league championships and three FA Cup Final appearances between 1930 and 1938.

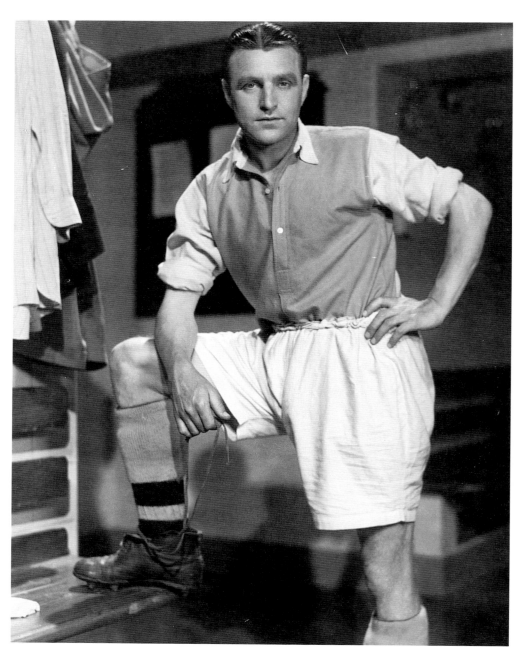

Eddie Hapgood
Fred Daniels, 1939
National Portrait Gallery

Reg Harris (1920-92)
Cycling

Britain's greatest sprint cyclist is still revered more on the Continent than in his homeland. Denied five years of competitive cycling by the Second World War, Harris won a gold medal at the 1947 World Championships in Paris, the first British winner since Bill Bailey in 1914. During 1948 he broke his neck in a car crash, recovered only to fracture an arm cycling, and was omitted from the British Olympic team for refusing to train with them in London, preferring to remain in Manchester instead. A public outcry led to his re-instatement, and despite racing with

a broken arm he won two silver medals, in the 1000m sprint and the 2000m tandem sprint at the 1948 London Olympics. Harris then turned professional and spent most of his time abroad. He won the gold at the professional sprint title in his début season, and was voted British Sportsman of the Year, despite his self-imposed exile. His mastery of the event in the 1950s was unprecedented, winning four world professional sprint titles, plus a silver and a bronze. Two of his world speed records (set in 1952 and 1957) stood until 1973. Their being broken prompted Harris into a sensational comeback 17 years after he had retired. To the amazement of his colleagues, this 54-year old veteran regained the 1974 British sprint title, and reached the final again a year later.

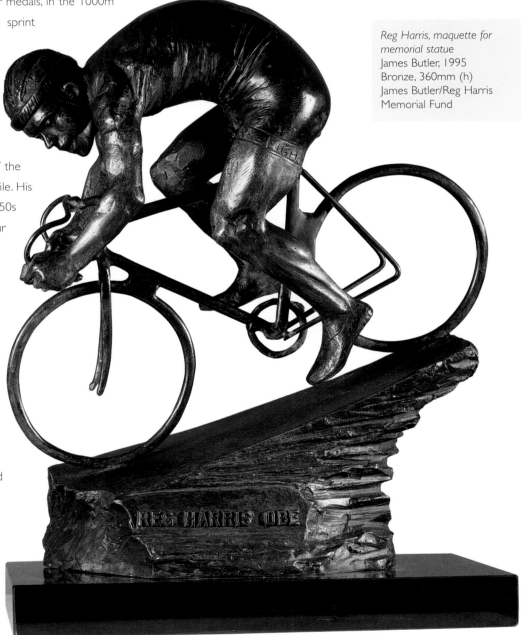

Reg Harris, maquette for memorial statue
James Butler, 1995
Bronze, 360mm (h)
James Butler/Reg Harris Memorial Fund

Len Harvey arriving at Jack Straw's gym, London, 24 February 1938
Davies for Topical Press
Hulton Getty

Len Harvey (1907-76)
Boxing

Harvey boxed at every division from flyweight to heavyweight, and is the only man to have held three British titles simultaneously, at middle-, light-heavy- and heavyweight. A model of good sportsmanship, Harvey was among the most popular British idols of the 1930s. He showed a sound defence, and was a highly tactical fighter, better at close quarters than as a heavy puncher. Having won his first middleweight title in 1929, he then fought off six challengers until losing the title to Jock McAvoy in 1933. Later that year, Harvey won instead the light-heavy- and heavyweight titles; the latter was perhaps his greatest win, outpointing the previously unbeaten Jack Peterson. Peterson took it back in 1934, only to cede it to Harvey again in 1938. As a world title contender, he failed on two occasions, against Marcel Thil in the middleweight division in 1932 and to the light-heavyweight John Henry Lewis in 1936. Harvey's last appearance in the ring was his most anti-climactic, as the aggressive newcomer **Freddie Mills** knocked him out in only two rounds – Harvey's first knockout in a long career.

Gavin Hastings (b.1962)
Rugby union

Broad-shouldered, authoritative and articulate, Hastings was the core of the Scottish rugby team for a decade. Over 6ft tall, he was an orthodox full-back, secure under the high ball, and a solid defender who linked with the three-quarter line to great effect. A powerful runner, he made up what he lacked in pace with strength and intelligence. He was highly skilful kicking into touch and a great kicker of conversions, scoring a record 667 points for Scotland in 61 games, and 66 for the British Lions. In his début match in 1986, he scored all Scotland's points with his boot in an 18–17 victory over France at Murrayfield. He later inspired Scotland to the country's first win over France at the Parc des Princes. One of the country's finest full-backs, he heroically captained the team to a victorious Grand Slam in 1990, having also inspired the British Lions to victory over Australia in 1989. He played for Scotland in three World Cups, and retired from international rugby after Scotland's exit from the 1995 tournament.

Gavin Hastings
David Mach, 1996
Postcard and photograph collage, 1810 × 1810mm
Scottish National Portrait Gallery, Edinburgh

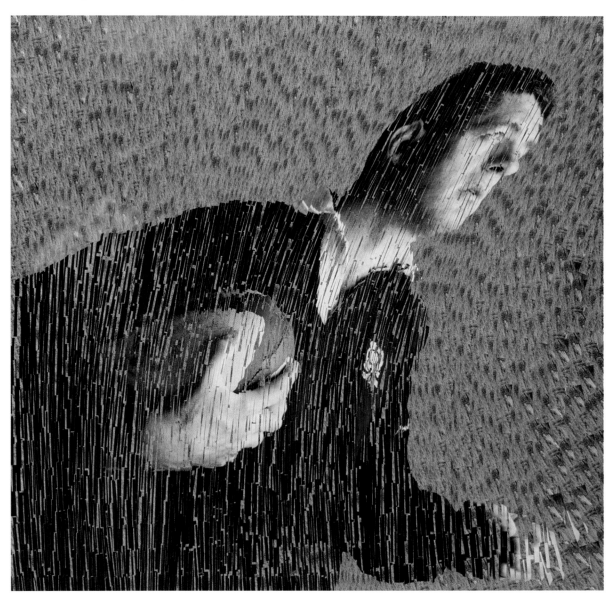

Mike Hawthorn (1929-59)

Motor racing

Britain's first Formula One champion, Hawthorn was handsome and debonair, often racing wearing a bow-tie. He made his début in 1952, finishing fourth in the Spa Grand Prix. The following year Hawthorn joined Ferrari and with a wheel-to-wheel victory against Juan Manuel Fangio in the French Grand Prix, Hawthorn became the first Briton to win the event since Henry Segrave in 1923. Hawthorn finished fourth in the Drivers' Championship, improving to third in 1954. The next two seasons were marred by injury and a difficult partnership with Vanwall. Back to his best, he returned to the Ferrari team for the 1957 season. In 1958, on Fangio's retirement, **Stirling Moss** had become clear favourite for the drivers' crown. Hawthorn was not really in the same class, and his career yielded but three victories in 45 races; nevertheless he beat the luckless Moss to the Drivers' Championship by one point, having taken five second places. His joy was clouded, however, by three deaths on the track, notably that of his best friend Peter Collins. Hawthorn's retirement to oversee his family garage business was short-lived as he himself was killed in a road accident, three months short of his thirtieth birthday.

Mike Hawthorn, Oulton Park, 25 August 1955
Barham for the *Daily Herald*
National Portrait Gallery

Formula One

As soon as speed became integral to car design, motor racing was inevitable. The first official race was held in France in 1894, with the first Grand Prix following ten years later. Grands Prix races were held continuously until the Second World War, and then in 1948, Formula One was inaugurated. The Drivers' World Championship started in 1950, with British drivers prominent from the start. Reg Parnell and John Whitehead finished in the top ten in 1950, with Mike Hawthorn and **Stirling Moss** emerging between 1952 and 1956. Then from 1957 until 1968, British drivers virtually monopolised the Drivers' Championship. **Jackie STEWART** won in 1969, 1971 and 1973, and **James HUNT** took the title in 1976. Despite the efforts of John Watson, Britain had to wait for 16 years for the next winner – **Nigel MANSELL** in 1992.

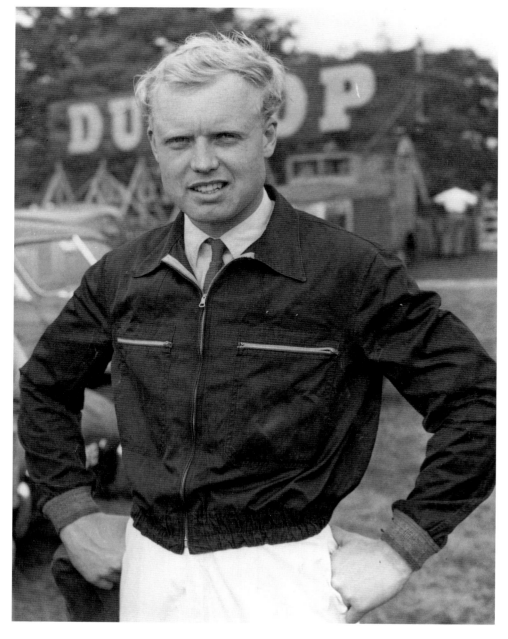

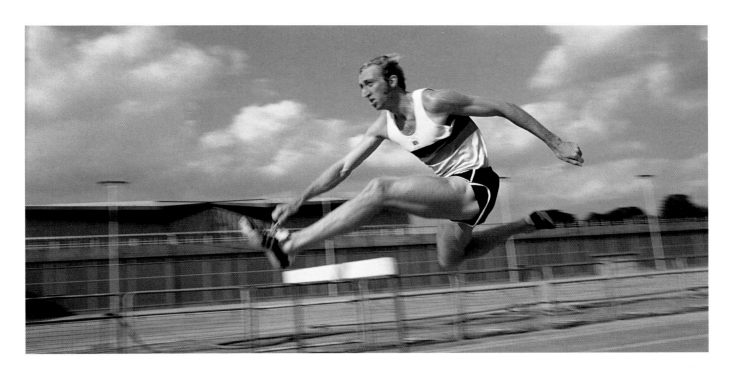

David Hemery (b.1944)
Athletics

David Hemery
Mark Shearman, 1967

In the altitude of Mexico City, Hemery's 1968 Olympic gold medal in the 400m hurdles ranks as one of the greatest of all British athletic triumphs. He clipped 0.7 seconds off the world record, winning with the biggest margin of victory in the event since 1924. His Olympic record stood for four years, and his British record for 22 years, when it was broken by Kriss Akabusi. To cap the year, he was voted BBC Sports Personality of the Year, and was awarded an MBE in 1969. Hemery began to train seriously while studying at Boston University and in 1966 he won the 110m hurdles Commonwealth title, which he retained four years later in 1970. He proved his versatility in both the sprint and 400m hurdles races, winning the silver medal in the 110m hurdles at the European Championships of 1969. Returning to defend his Olympic title in Munich in 1972, he finished in third place. To complete his hat trick of medals, he won a silver as a member of the British 4 × 400m relay team – the culmination of his career.

Stephen Hendry (b.1969)
Snooker

The world's number one player for eight years until supplanted by fellow Scot John Higgins in May 1998, Hendry replaced **Steve Davis** as the world's best snooker player at the beginning of the 1990s. At the age of 21, and looking five years younger, Hendry beat Jimmy White in the 1990 final of the World Snooker Championships. Worse was to come for White, as the ever-popular Londoner, a perennial runner-up, was beaten by Hendry in three successive World Snooker Finals from 1992 to 1994. In the 1992 final, White led Hendry 14–8, but Hendry recovered to take ten frames in a row, and won the final 18–14. In 1994, Hendry won by a single frame. Hendry was World Champion again in 1995 and 1996, losing out in the 1997 final to Ken Doherty. In his 12-year professional career, Hendry has won 64 titles, and broken most of the records, including scoring over 400 century breaks.

(Illustrated under **Steve Davis**)

Albert Hill (1889-1969)
Athletics

Despite taking two gold medals and a silver in a single Games, Hill is a largely forgotten Olympian. By the time of the 1920 Olympics, he was over 30, robbed of one such event by injury, and another by war. Age proved no barrier, however, and he still remains the oldest gold medal winner in both the 800m and the 1500m – a unique double record that is unlikely to be broken. A railway guard by profession, he was known to his sporting colleagues as 'The Sleeper', a name he lived up to, it being his custom to doze off for a few hours before his races. Before the First World War, Hill had joined the country's leading athletic club, the Polytechnic Harriers, where he trained with the coach Sam Mussabini (mentor to **Harold ABRAHAMS**). After the war, in which he served as a wireless operator in France, he immediately returned to athletics, and in 1919 won the Polytechnic's half mile, 880yds, mile and medley relay all in one afternoon. After his notable success at the 1920 Olympics, he returned to domestic competition, winning the Amateur Athletic Association mile in 1921, and slicing more than three seconds off the British record. He then turned to coaching where he occupies an exalted place as trainer of **Sydney WOODERSON**.

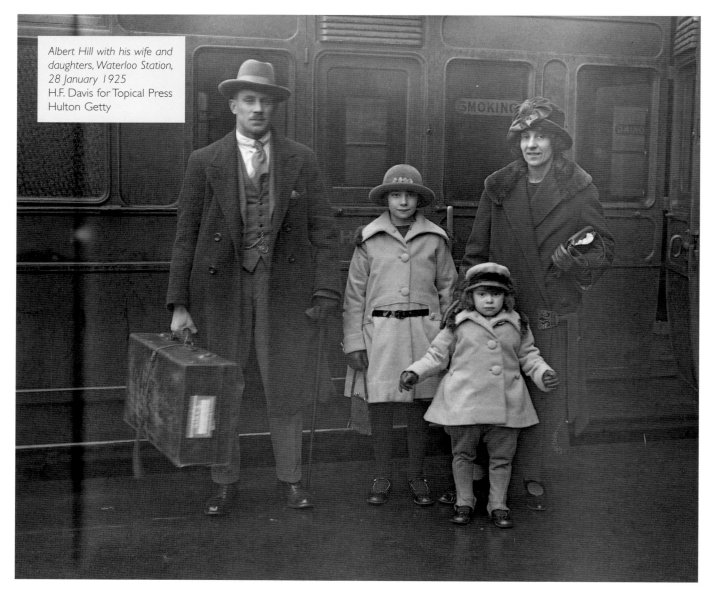

Albert Hill with his wife and daughters, Waterloo Station, 28 January 1925
H.F. Davis for Topical Press
Hulton Getty

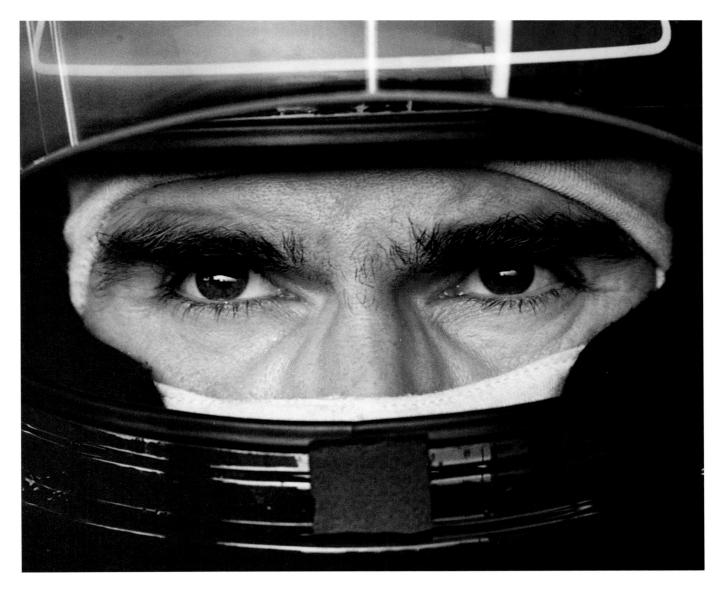

Damon Hill (b.1960)
Motor racing

Like his father (twice World Champion **Graham Hill**) Damon Hill was late coming to Formula One; but in the space of four seasons from 1993 to 1996, he won 21 Grands Prix, and became one of Britain's highest-profile sportsmen. He was 33 in his first full season, driving for Williams Renault, alongside thrice world champion Alain Prost: Hill won three Grands Prix, and finished third in the Drivers' Championship. In 1994, his new team-mate Ayrton Senna died three races into the season, leaving Hill with the task of rebuilding morale at Williams. He went on to win six Grands Prix, finished in second place in the Drivers' Championship, and was voted BBC Sports Personality of the Year. He came second again in 1995, thwarted by Michael Schumacher, but his eight Grands Prix in 1996 guaranteed him the World Drivers' title. 1997 was a disappointing year, as he finished in twelfth place driving for Arrows Yamaha, before moving to Jordan for the 1998 season. He and Graham Hill are the first British father and son to have both won a Grand Prix.

Damon Hill, Argentine Grand Prix, 9 April 1995
Mike Hewitt/Allsport

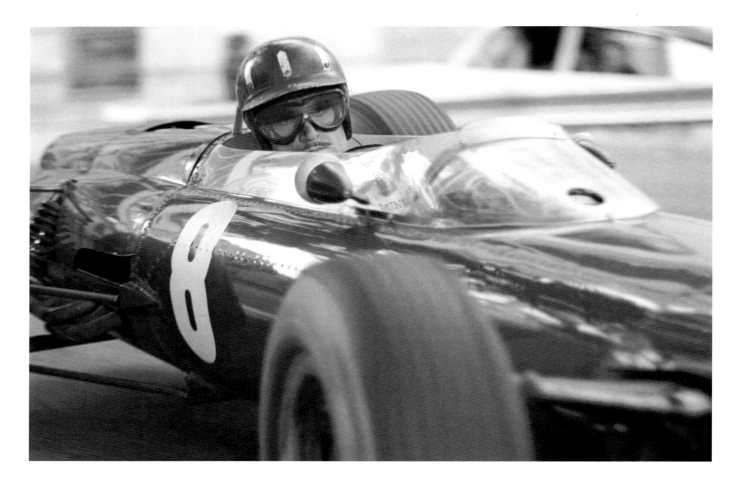

Graham Hill (1929-75)
Motor racing

Never a natural like **Jim CLARK** or **Stirling Moss**, Graham Hill's 176 races over 18 years were the result of dedication and single-minded hard work. His 14 Grand Prix wins came in seven seasons. In 1954, hitching a lift from Brands Hatch to London with Lotus boss Colin Chapman, Hill talked his way into a job as a mechanic on the Lotus team, hoping to get an occasional drive. He made his full début with Lotus in 1958, but after two poor seasons, and two more with BRM, he had only achieved seven points from 30 races. His luck changed in 1962, however, when he won four Grands Prix and finished first in the Drivers' Championship. Following three consecutive years as runner-up, he rejoined Lotus in 1967, teaming up with Jim Clark. After Clark's death in 1968, Hill went on to win the Drivers' Championship again, to huge popular acclaim. The following year, having won the Monaco Grand Prix for a record fifth time in seven years, he sustained serious injuries from which he never completely recovered. But he remained a favourite sporting son, and great was the sadness when he was killed, piloting his own aircraft in 1975.

Graham Hill, Monaco Grand Prix, 10 May 1964
Colin Waldeck
National Portrait Gallery

Harold Hilton (1869-1942)
Golf

Harold Hilton won the Amateur Championship four times, in 1900, 1901, 1911 and 1913, and won the Open Championship twice, in 1892 and 1897. He was the first British player to have won the British and American Amateur Championships in the same year, accomplishing this feat in 1911. Many of his contemporaries felt that he was better in stroke play than in match play and he took both his Open titles before any of his Amateur titles, winning his first Amateur Championship only on his thirteenth attempt. A small man at 5ft 6in, he still played with great power, which, combined with superior skill and attention to detail, made him a formidable opponent. He was especially good at playing in windy conditions, and he generally had great control of his full range of shots. Commentators at the time described how Hilton rose up onto his toes at the top of his swing, an action considered most detrimental to the majority of players. Hilton used his shrewd powers of observation to great effect as a writer on golf and was editor of *Golf Monthly* and then *Golf Illustrated*. PNL

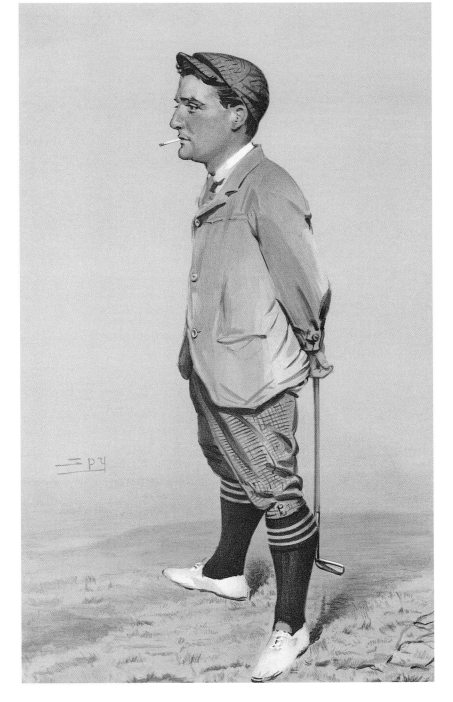

Hoylake (Harold Hilton)
Published in *Vanity Fair*, 1903
Sir Leslie Ward (Spy)
Chromolithograph, 319 × 189mm
National Portrait Gallery

Amateur Golf

In 1457 golf was sufficiently popular in Scotland to be interfering with archery practice, causing it to be banned by an Act of Parliament. This was unsuccessful, but there are no surviving rules or records of golfing societies before 1744. These early records belong to the Honourable Company of Edinburgh Golfers and their first Annual Challenge for the Silver Club. Other clubs, including the Society of St Andrews Golfers, soon followed, and these form the basis of organised club golf today. The early 'challenges' were to select a captain, but as the captain became elected, these were replaced by medal competitions. The first championship, the Grand National Tournament of 1857, was played at St Andrews between pairs from 11 clubs. The following year a similar event was played, but between individuals, and was repeated in 1859. However, these events drew competitors away from the more important club medals, and were therefore discontinued. It was not until 1885 that the first Amateur Championship was played. It followed a match-play format and was won by A.F. Macfie. From its early days, the Amateur Championship has grown greatly in size and prestige, based upon the solid foundation of expanding recreational and club golf and competitions on all levels, but it is now largely eclipsed in the public eye by the professional game. ERC

George Hirst (1871–1954)
Cricket

One of Yorkshire's great cricketers, Hirst will always be linked with his county colleague, **Wilfred Rhodes**, since they played together in over 400 matches. Hirst passed 1,000 runs in 19 seasons, took 100 wickets in 15 seasons, achieving the 100 wicket/1,000 run double 14 times. Only Rhodes did better, and their combined talent was the main reason behind Yorkshire's hat trick of championship victories between 1900 and 1902. In 1906, Hirst created a Yorkshire record of 2,385 runs (at an average of 45.86), and 208 wickets (at an average of 16.50) in a season: this and his 341 for Yorkshire in 1905 are both still unbeaten county records. Although his test match feats never equalled those for Yorkshire, he toured Australia twice, and reserved his best performances for the matches against the Australians in 1902. He took five wickets for nine runs for Yorkshire as Australia were bowled out for 23. In the Oval Test Match in the same season, he and Rhodes bowled the tourists out for 36: they then contributed the 15 runs needed for victory, in a last-wicket partnership that has become the stuff of cricketing legend. A popular and loyal cricketer, Hirst's benefit match in 1904 raised £3,703, a figure only topped once before the Second World War.

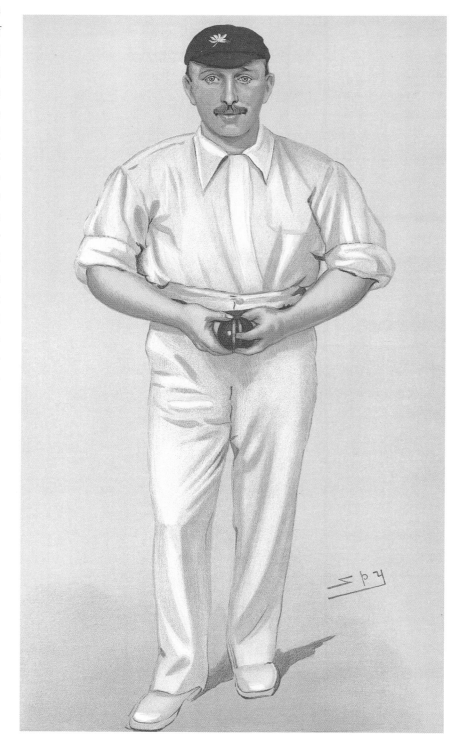

Yorkshire (George Hirst)
Published in *Vanity Fair*, 1903
Sir Leslie Ward (Spy)
Chromolithograph, 355 × 209mm
National Portrait Gallery

Sir Jack Hobbs (1882-1963)
Cricket

A model and modest sportsman, Hobbs was the most respected cricketer in the British Empire, not only for his batting, but because he symbolised honesty, loyalty, and devotion to the job. He was knighted in 1953, but was known as 'The Master' long before. No fast bowler was too hostile for him, no spinner too wily. From his first tour to Australia in 1907–08, he opened the England innings until 1930. On the South Africa tour of 1913–14, he made 1,489 runs, 700 more than the next highest scorer. The following season, Surrey were county champions for the only time in Hobbs' career: he made 11 centuries for the county, three of them double 100s. A cricketing legend before the First World War, he was even more illustrious in the twenties, scoring 98 centuries after his fortieth birthday. He scored a career 61,237 runs at an average of 50, and his 197 centuries dwarfed **W.G. GRACE**'s record of 126. Hobbs overtook it in 1925, hitting ten 100s in his first 12 games. In 1926, he made the highest score at Lord's with 316 not out, and, batting with **Herbert SUTCLIFFE** against Australia that summer, he helped recover the Ashes. For Surrey and England he shared in 166 opening century partnerships, and topped 1,000 runs in 26 seasons.

Jack Hobbs
W. Smithson Broadhead, 1920s
Oil on canvas, 1020 × 770mm
Surrey County Cricket Club

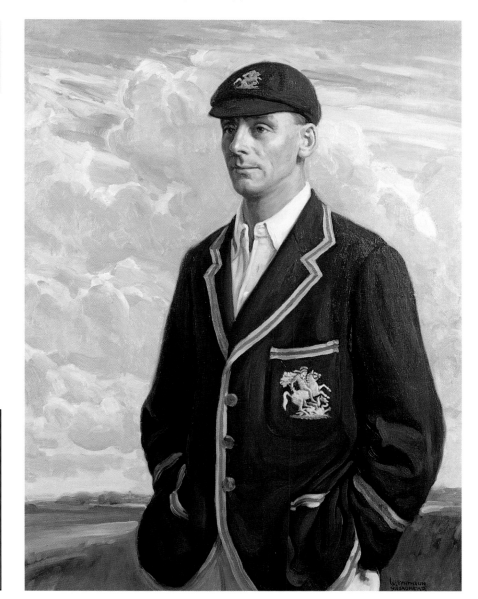

He made every innings a text-book of batting with illustrations entirely his own. Nothing in post-war cricket has revealed more grandeur than the autumn of this man's career. From the brilliance of his classical foundation grew the safety and power of his on-side play. No longer was his bat a lance, pennant flying, eagerly routing the foe, the lance became a wand, charming the enemy to impotence and bringing success through calm and assurance.

(J.M.Kilburn, *Hail and Farewell*, 1934)

James Hunt (1947-93)
Motor racing

Early in his career, Hunt's capacity to crash earned him the nickname 'Hunt the Shunt'. He finally proved himself in 1975, winning the Dutch Grand Prix, and picking up three second places. Patronised by Lord Hesketh, who formed a race team around him, 'Young Master James' (a blond-haired playboy off the track) quickly became a media favourite. When Hesketh pulled out of racing, Hunt joined the leading constructor Maclaren, and it proved a worthwhile move. Hunt and his main rival, the Austrian Niki Lauda, contested every race of the 1976 season, and in the final Grand Prix in Japan, either could have won the championship. In treacherous wet conditions, Hunt proved the braver as he forced his way round the flooded track to finish third. The points were enough to put him ahead of the Austrian for the title. Hunt was back in 1977 to win three Grands Prix, but his motivation was beginning to wane, and he retired in mid-season in 1979. His private life continued to prove newsworthy: Hunt's first wife left him for Richard Burton, and he then enjoyed a relationship with Jane Birkin. Outspoken and amusing, he was a good foil for sports commentator Murray Walker with the BBC, before his premature death at 45 from a heart attack. (Illustrated under **Stirling Moss**)

Sir Geoff Hurst (b.1941)
Football

Geoff Hurst's historic hat trick in the 1966 World Cup Final brought football's greatest prize to the country that invented the game. It transformed Hurst from a successful club player with West Ham United into a legendary figure in world football. He started the World Cup campaign on the substitute's bench, but luckless marksman **Jimmy Greaves** fell ill, and Hurst took maximum advantage while playing in his stead. Club manager Ron Greenwood had initially converted Hurst into a striker from a deeper midfield position: the switch immediately paid dividends for West Ham, and Hurst became the club's second highest scorer of all time, with 180 league goals. He was the first division's leading scorer with 40 goals in 1965–6, and in 1966–7 he scored 41 goals. For club as for country, Hurst rose to the big occasion, as he was a prodigious scorer in cup competitions, with 46 goals in the League Cup, and 23 in the FA Cup, including the winning goal in the 1964 Cup Final. (Illustrated under **Bobby Moore**)

Sir Leonard (Len) Hutton (1916-90)
Cricket

The first professional player to captain England, and as such not allowed to captain his county, Hutton remains one the most exalted of all England's batsmen. He made his Yorkshire début in 1934, and four years later announced himself on the international stage, with 364 runs against Australia at the Oval, a score which remained a record in international cricket for over 20 years. For the best part of two war-interrupted decades he was, alongside **Denis Compton**, the leading English batsman. His average in the 1938 Ashes series was 118.25, and against the West Indies the following year, his average was 96. Appointed captain against India in 1952, he led England to success in 23 matches. His greatest achievement was in winning back the Ashes in 1953. He led by example, averaging 55.37 for the series, and his innings of 145 at Lord's was rated as one of his best. Under his captaincy, England retained the Ashes in 1954 in Australia. In his career, he scored 129 centuries, made 1,000 runs a season 17 times and passed 2,000 in eight seasons. His average in test cricket was 56.67 from 79 matches. He retired in 1955 and received a knighthood the following year, the second cricketer to be thus honoured after **Jack Hobbs**.

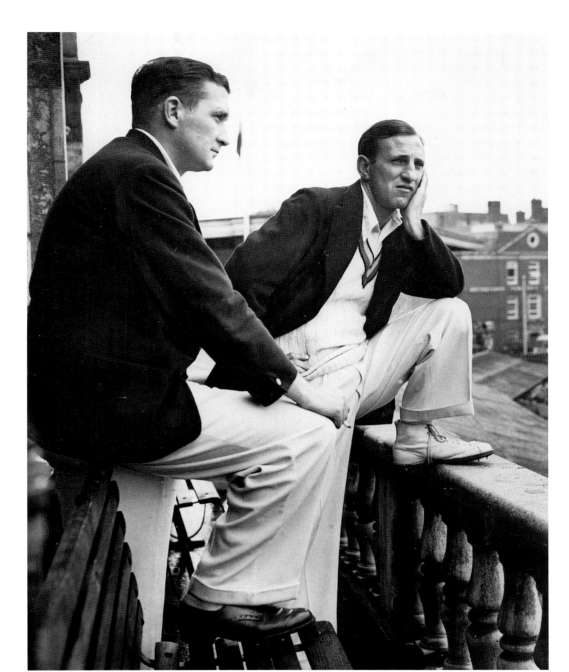

*Jim Laker and Len Hutton
(r) on the players' balcony,
England vs. India, The
Oval, August 1952*
Popperfoto
See also **Jim LAKER**

A Winning Side: England's Cricket Team in the 1950s

The 1950s was a decade of success for English test cricket, with the Ashes regained at The Oval in 1953, retained in Australia in 1954–5 and at home in 1956. The West Indies were victorious in England in 1950, but lost heavily in 1957; India and New Zealand provided unchallenging opposition, although Pakistan recorded their first defeat of England in 1954, and in the hot English summer of 1955, South Africa and England played out an epic series with the home side winning 3–2. The basis of this success was a well-balanced team of talented individuals. Len Hutton led the batting from the top of the order, supported by his successor **Peter MAY** and **Denis COMPTON** and **Colin COWDREY**; the robust Godfrey Evans was both a technically-sound and spectacular wicket-keeper; Trevor Bailey a fine all rounder; Lock and **Jim LAKER**, the Surrey spinners, confused those batsmen not already dismissed by fast bowlers **Fred TRUEMAN**, Brian Statham and Frank Tyson.

Hutton, the first of the modern era to captain England, was a *professional*, his successor, May, an *amateur*; in 1962 this outdated distinction was abolished and all became cricketers. JC

Andy Irvine (b.1951)

Rugby union

An adventurous attacking full-back of great flair and invention, Irvine had the misfortune to be in direct competition with the great Welsh full-back **J.P.R. WILLIAMS**, but still managed to add nine British Lions caps to his 51 for Scotland. He made his Scottish début in 1972 against the New Zealand All Blacks, and remained a member of the national team for 11 years. His pace was initially used on the wing, before he dropped to full-back, from where he continued to score tries. He and J.P.R. Williams transformed the position from a defensive tackling and kicking role into an attacking one. Both were great runners with the ball, frequently joining the three-quarter line in attack. Irvine's most memorable match was in 1980 against France. With 12 minutes left to play, and Scotland trailing 4–14, Irvine briefly took over Murrayfield as he scored 18 points, including two tries, to win the game 22–14. Irvine toured with the British Lions on the unbeaten visit to South Africa in 1974, and again in 1977 and 1980. He retired in 1983 as the highest point-scorer in test rugby, and Scotland's most capped player.

Andy Irvine, British Lions, New Zealand, 7 July 1977
Wellington Evening Post
Hulton Getty

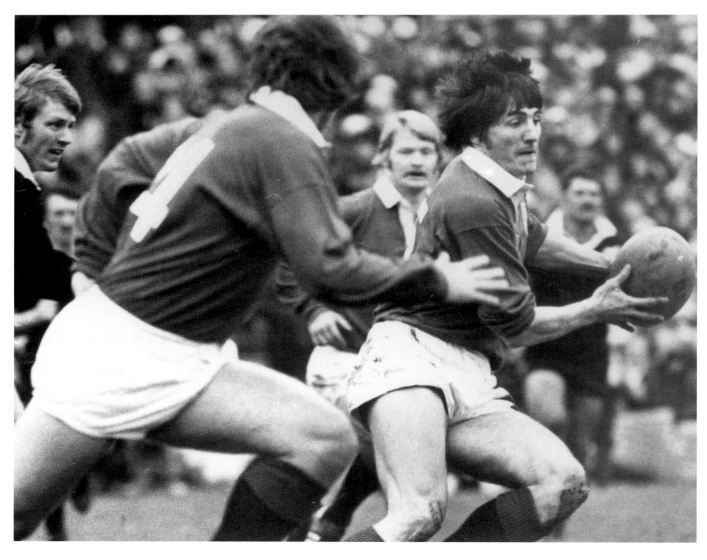

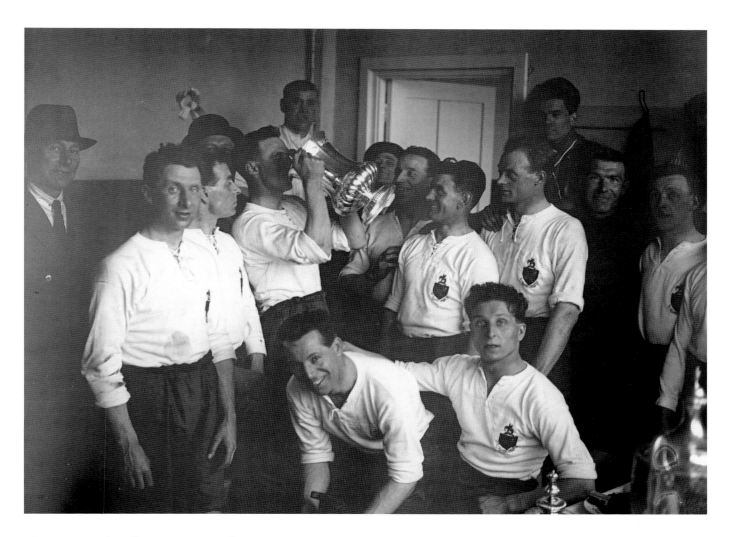

David Jack (1899-1958)
Football

Jack was the first player to be transferred for five figures, when the high-spending Herbert Chapman paid £10,000 to take him from Bolton to Arsenal in 1928. In 1930 he was in the Arsenal team that won the FA Cup, and thus became the only man to win the prize with two different clubs, having won with Bolton in 1923. In his early career as the Lancashire team's leading scorer for five seasons, he contributed a total of 145 goals in 295 games. As well as his Cup Final goal in 1923 (which was the first to be scored at the newly built Wembley Stadium), he scored the only goal when Bolton lifted the Cup again in 1926. At the beginning of the 1928–9 season, Bolton transfer-listed most of the regular first team. Naturally, Jack was not on the list, but when Arsenal manager Chapman met with the Bolton board at a London hotel, he told the barman: 'I will drink gin and tonic…see that our guests are given doubles of everything…and my gin and tonic contain no gin.' Jack was duly signed for Arsenal to replace **Charles BUCHAN**, and scored 25 goals in his début season. In the 1930–1 season, he contributed 31 more as Arsenal won the first of five league titles in the 1930s.

David Jack, scorer of the winning goal for Bolton in the 1926 FA Cup Final, toasting victory with his team-mates, 24 April 1926
Kirby/Davis for Topical Press
Hulton Getty

Tony Jacklin (b.1944)
Golf

From an early age, Tony Jacklin wanted to be the best in golf and in 1970 his wish came true: as holder of the Open Championship, won at Royal Lytham and St Annes in 1969, he also won the US Open at Hazeltine, Minnesota. It was a time of great hope and promise for British and European golf. Unfortunately, Jacklin's reign at the top was shortlived. Later in 1970, at the Open Championship, he started playing excellent golf, but after a break of play due to rain, the spark seemed to have gone. Open victory once again seemed in sight in 1972, but Lee Trevino holed two shots from off the green to snatch the Championship from Jacklin's grasp. To many, this loss marked the end of Jacklin's top form, but he returned to prominence as an inspirational Ryder Cup captain in 1983. That year saw a narrow defeat at the PGA National in Florida, but the team, with Jacklin as captain, won the two succeeding Ryder Cups at the Belfry, Sutton Coldfield, in 1985 and at Muirfield Village, Ohio, in 1987. In 1989 the Ryder Cup tournament was drawn and Europe therefore retained the Cup. Jacklin's contribution to golf was recognised when he was made Honorary Life President of the Professional Golfers' Association. ERC

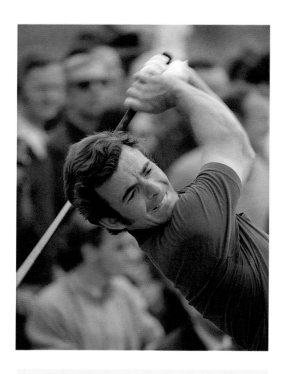

Tony Jacklin, the Open, Royal Lytham and St Annes
Gerry Cranham, 1969

F.S. Jackson (1870–1947)
(Sir Stanley Jackson)
Cricket

Captain of Yorkshire and England, Colonel the Honourable Sir Stanley Jackson was always known by his colleagues as 'Jacker'. The best all-rounder since **W.G. GRACE**, Jackson was called up to play for England while still a Cambridge undergraduate. He scored 91 in his maiden test innings and 103 in the following match, making himself an indispensable part of the team. His business commitments sometimes prevented him from taking time off to tour Australia. However in 1905 he enjoyed a charmed summer as the Ashes-winning England captain, heading both the batting and bowling averages, and scoring five centuries, where the previous record for a test series had been two. A lively medium-fast bowler, and a stylish batsman, Jackson retired from cricket in 1906 to pursue a career in politics.

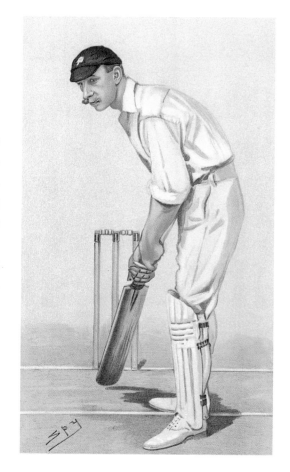

A Flannelled Fighter (F.S. Jackson)
Published in *Vanity Fair*, 1902
Sir Leslie Ward (Spy)
Chromolithograph, 344 × 239mm
Private Collection

John Jackson (1769-1845)
Pugilism

Despite only three appearances in the prize-ring, 'Gentleman' John Jackson achieved widespread fame as an instructor in sparring and self-defence. His school in Bond Street was attended by London's nobility, and his most famous customer was Lord Byron, a passionate devotee of fisticuffs, and the poet and pugilist became close friends. When Byron's Cambridge tutor suggested that he should spend more time with persons of his own lordly rank, the poet replied that Jackson's manners were 'infinitely superior to those of the fellows of the college whom I meet at the high table'. Byron even incorporated an advertising slogan for his friend in one of his verses: 'Men unpractised in exchanging knocks/Must go to Jackson ere they dare to box'.

Jackson was once called upon to organise a pugilistic fête for the benefit of the Emperor of Russia, the King of Prussia and a number of dukes and princes. The Prince of Wales was present at his first fight, and ascending to the throne as George IV in 1821, he put Jackson in charge of organising 'security' at Westminster Abbey for his coronation. Jackson's third and final fight was against **Daniel MENDOZA** in Hornchurch in 1795. It was one of the key bouts of the era, setting Jackson up as Champion of England until **Jem BELCHER** took the title in 1798.

John Jackson (detail from Lord Byron's boxing screen), c.1811–16
Collaged screen, 4 panels, 1830 x 590mm each
John Murray, on loan to Newstead Abbey, Nottingham

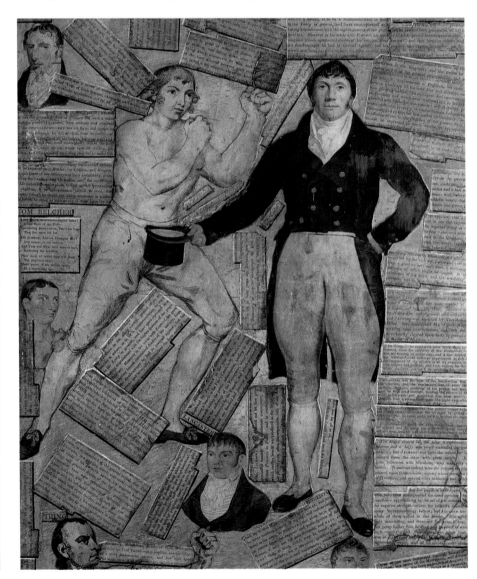

Byron's Boxing Screen

Lord Byron was passionate about pugilism. Although largely illegal, the fistic arts had a huge following in Regency London, especially among the rich gambling classes. But Byron was no mere casual spectator or follower of 'the fancy'. Between 1811 and 1814, during which time he was taking boxing lessons from 'Gentleman' John Jackson, he created a shrine to his passion on a large four fold decoupage screen. Using engravings and text from newspapers and Pierce Egan's *Boxiana* magazine, he pasted together a document of contemporary prize-fighting, with all the leading names represented: Jackson himself, John Gully, Richard Humphreys, **Daniel MENDOZA**. He also featured the founding figures of pugilism, James Figg and **Jack BROUGHTON**. On the other side of the screen, Byron indulged in another of his passions, the theatre – over 100 engravings of actors appear on the screen. In 1816, following the break-up of the poet's marriage, the screen was sold at auction, advertised as 'the property of a Nobleman about to leave England on tour'. It was bought by John Murray, Byron's publisher.
(See also illustration on p.240)

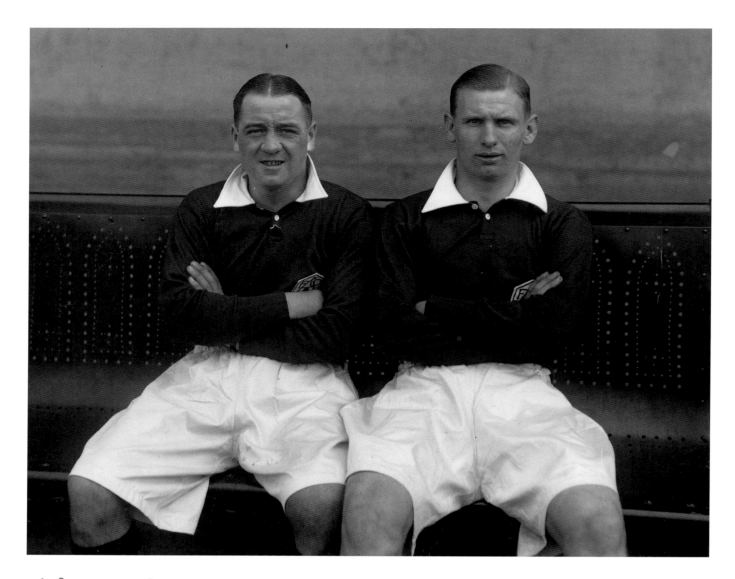

Alex James (1901–53)
Football

The diminutive Scotsman Alex James was an unmistakable 1930s figure in his trademark baggy shorts flapping around the knees, and his sleeves buttoned down at the wrist. After two seasons for Raith Rovers he moved to Preston North End in 1925. There his goal-scoring reputation quickly spread, and a move from the struggling second division club became inevitable. Arsenal manager Herbert Chapman was prepared to part with £9,000, the second-highest price ever paid for a player. James' signature proved the turning point for Arsenal, as during his eight seasons at Highbury, the Gunners enjoyed their greatest ever period, winning four league titles and two FA Cup Finals. As the midfield lieutenant and the playmaker of the team, he initiated the attacks with skilful dribbling and distribution, building a telepathic understanding with **Cliff BASTIN**. Arsenal won the league with 66 points out of a possible 84 in James' first season, a record that stood for 30 years. Successive titles followed, and James became an Arsenal legend. As a snub for his London affiliation he was only asked to make eight appearances for Scotland but he did score twice in Scotland's finest hour, when the so-called 'Wembley Wizards' beat England 5–1 at Wembley in 1928.

Alex James (l) and Cliff Bastin
The Daily Express,
c.1935
Hulton Getty
See also **Cliff BASTIN**

Gilbert Jessop (1874–1955)
Cricket

Born in Cheltenham, Jessop made his first appearance for Gloucestershire while still at Cambridge in 1894, playing alongside **W.G. GRACE**. In 1899, he made his début for England, and the following year replaced Grace as county captain, a position he held for 13 years. He made his name at The Oval Test Match in 1902 against Australia. He came in to bat with England on 48 for 5 in their second innings, when they needed 215 runs to win. With an 'apocalyptic blend of high art and controlled violence', he scored 104 runs in just 75 minutes, setting up an unlikely England victory. Not only was Jessop the biggest hitter of his day, he was also the fastest scorer, notching up 53 first-class 100s (12 in under 60 minutes) and averaging nearly 80 runs an hour. His 286 against Sussex in 1903 was the quickest double century on record, taking him under three hours. On an England tour to America, a Philadelphian newspaper called Gilbert Jessop 'the human catapult who wrecks the roofs of distant towns when set in his assault'. Standing at 5ft 7in, Jessop's unusual posture earned him the nickname of 'The Croucher'. A brilliant fielder with a throw like a rocket, he scored over 1,000 runs in 14 seasons, and took 851 wickets in his career.

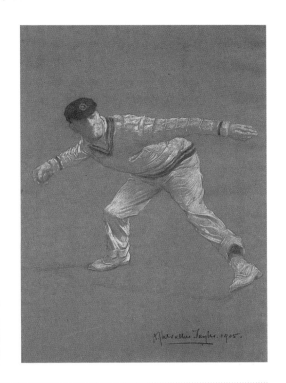

Gilbert Jessop
Albert Chevallier Tayler, 1905
Chalk, 529 × 364mm
Cheltenham Art Gallery and Museum

Barry John (b.1945)
Rugby union

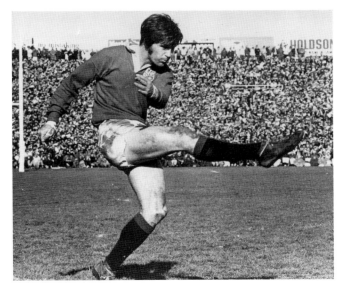

Barry John, British Lions vs. the All Blacks, Auckland,
14 August 1971
Wellington Evening Post
Hulton Getty

John is revered throughout Wales, a figure of national status like Dylan Thomas or Richard Burton. He was christened 'King John' by the All Blacks in 1971; on the British Lions visit to New Zealand he was considered the outstanding player of the tour. His speed of thought and distribution were unmatched by his contemporaries: he was a classic fly-half, with pace and great handling skills, and proved a canny tactical kicker, especially of dropped goals. On the 1971 tour, he broke the record with 180 points for the British Lions. British television cameras were covering a rugby tour properly for the first time, and Barry John in his prime was introduced to a national audience: his name soon became synonymous with great rugby. He illuminated the Welsh national team for six years from 1966, and in the years 1970 to 1972, he was the best player in the world. Wales won the Triple Crown in 1969, and the Grand Slam in 1971. John's early retirement at the age of 27 in 1972 stunned the Welsh in particular and the sporting world in general. Despite only 25 internationals and five Lions tests, John had become one of the great attractions of the sport.

Tom Johnson (1750-97)
Pugilism

Yorkshireman Tom Johnson did much to re-instate the respectability of pugilism following a series of mediocre and corrupt champions in the era following **Jack BROUGHTON**. His upright behaviour and good sportsmanship attracted many new patrons, including the Prince of Wales (the future George IV) who became a connoisseur of the fistic arts. From 1783 to 1790, Johnson was the undisputed champion, defeating all comers, some in a matter of minutes, some in over two hours. His greatest win was over 'the Birmingham Goliath' Isaac Perrins on 22 November 1789. Johnson conceded 70 pounds and six inches to his opponent, but wore the bigger man down with clever defence and greater mobility. The bout lasted an hour and a quarter, and the prize was 400 guineas. The publication *Pugilistica* described Johnson's 'strength and science' which gave him 'rank superior to all his contemporaries, but his greatest excellence was his surprising coolness and judgement'. He was noted for his generosity, no more so than when as a corn porter he doubled his own working hours to ensure that a sick colleague received his pay.

The fight between Tom Johnson (l) and Isaac Perrins, Banbury, 22 November 1789
Unknown artist
Watercolour, 475 × 635mm
Collection of Edgar Astaire

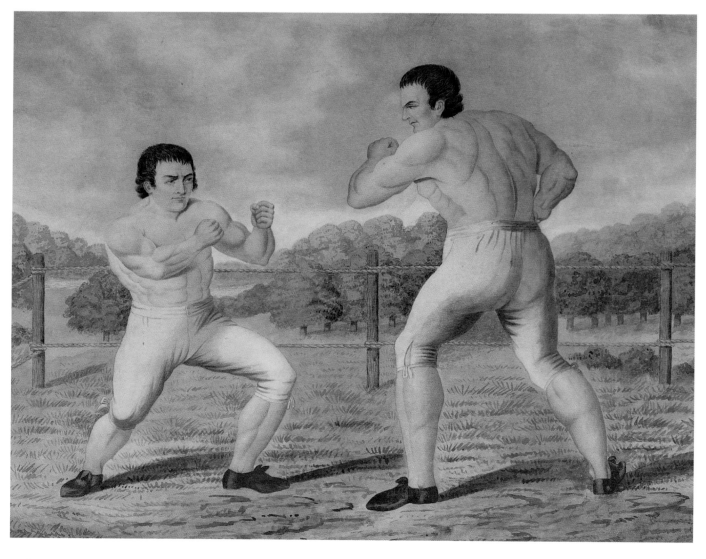

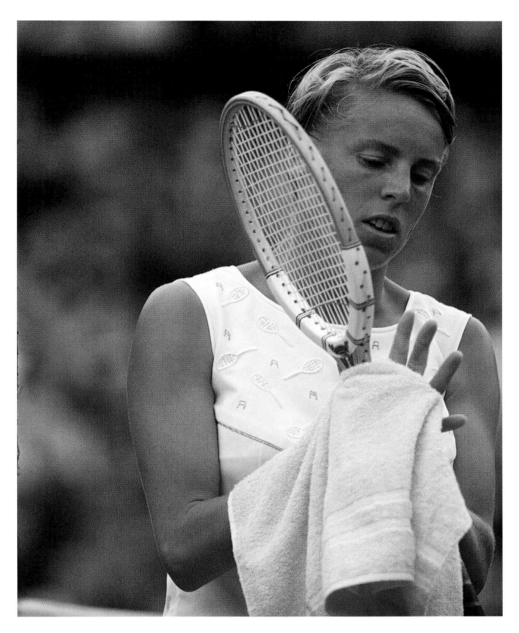

Ann Jones, runner-up to Billie Jean King, Ladies Singles Final, Wimbledon, 1967
Gerry Cranham

Ann Jones (b.1938)

Tennis

The darling of the British tennis world in the 1960s, Ann Jones — like **Fred PERRY** before her — began as a table tennis player, representing England at the age of 14. She simultaneously excelled at the two sports in the 1950s, winning junior Wimbledon twice and finishing second in the World Table Tennis Championships. In the senior game, she was at her best on clay courts, and her record on this surface in the French Open is unparalleled by a British player. Jones won her first singles title in Paris in 1961, her second in 1966, and was then runner-up on three further occasions: 1963, 1968 and 1969. She also won the ladies doubles consecutively in 1968 and 1969, reaching the singles and doubles semi-finals at the Australian Open in the latter year.

At home, although she had reached the semi-final stage in 1958, the British crowd had to wait until 1969 for her Wimbledon victory. Her path to glory meant having to beat the world's two best players, Margaret Court in the semi-final, and Billie Jean King in the final. It was her fourteenth attempt, and she added the Wimbledon mixed doubles title a few days later, playing with Fred Stolle.

A B C D E F G H I J K L M N O P Q R S T U V W X Y Z

Kevin Keegan (b.1951)
Football

The face of English soccer in the 1970s, and a much respected figure in the game, Kevin Keegan won a record five titles as Footballer of the Year: twice European, twice English and once German. He was a regular England player from 1974 to 1982, and frequently captain in his 63 appearances. Under manager Bill Shankly, Keegan became part of the Liverpool legend, scoring spectacular goals and creating many more. With Keegan on board Liverpool won the league in 1973, 1976, and 1977, and the FA Cup in 1974. They also won the UEFA Cup in 1973 and again in 1976, adding the European Cup in 1977. The treble beckoned in 1977, but they lost in the FA Cup Final to arch-rivals Manchester United. Keegan then left to play for SV Hamburg, with whom he won the German league in 1979. He returned to England in 1980, where he rejuvenated Southampton and then Newcastle, retiring as a player in 1984. He was out of football for eight years until he returned to a hero's welcome at Newcastle as manager, taking the club from the first division to serious premiership championship contenders. In 1997, he departed acrimoniously from Newcastle and became manager of Fulham in 1998.

Kevin Keegan,
12 December 1972
Popperfoto

Alan Knott (b.1946)
Cricket

If wicketkeepers are on occasion renowned for their eccentricity, Kent's Alan Knott was a credit to his profession. Ever bobbing around behind the stumps, he was like a jack-in-a-box diving towards seemingly impossible catches, and launching himself into saving byes. His batting record made him one of the greatest ever batsman-wicketkeepers and ensured his place with England in 95 matches from 1967 until 1981. Despite his unorthodox stance, batting as if he were playing French cricket, his test average was 33.66, and he scored five centuries; against the pace attack of the Australians Geoff Thomson and Dennis Lillee in 1974, he was England's second-highest scorer. But he will be mostly remembered for his wicketkeeping: making his début at the age of 21 he claimed 269 test victims. Knott was instantly recognisable, a small, bony man, fit and nimble, usually in a floppy white hat. His partnership with Derek Underwood was one of the most effective wicket-taking double acts in world cricket, and prompted a constant entry in both the Kent and England scorebooks: 'caught Knott bowled Underwood'.

Alan Knott (r) and bowler Derek Underwood appeal for lbw, England vs. Australia, Headingley, 1972
Patrick Eagar

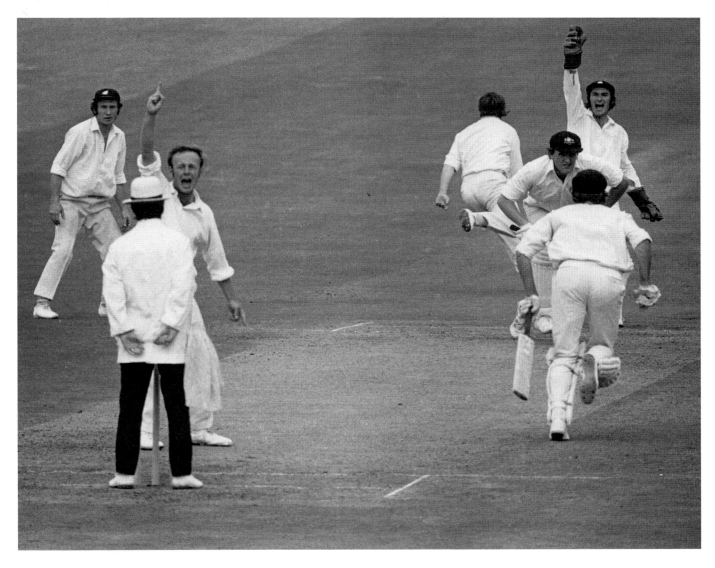

Jackie Kyle (b.1926)

Rugby union

Kyle was one of Britain's most celebrated rugby players from 1945 until the end of the 1950s. He played in every Irish international from the end of the Second World War until 1958, winning 46 caps and so setting a world record for international appearances. In the Five Nations Championship in 1948, he was the inspiration behind Ireland's only ever Grand Slam win, which was followed by the Triple Crown in 1949. He played in six tests for the British Lions in 1950, and although Kyle finished on the losing side against Australia and New Zealand, he was still regarded as the best fly-half in the world. Endowed with exceptional ball-handling skills, Kyle was both a matchwinner setting up tries and a matchsaver in the tackle. A deceptive and elusive runner with an accurate kick into touch, he was the inspiration to the future Welsh fly-halfs **Cliff Morgan** and **Barry John**. He was less revered by the Scots, as in his ten international games against them, Ireland won on each occasion. The embodiment of good sportsmanship on and off the pitch, Kyle was an ambassador for the sport and highly respected by the sporting world in general.

Jackie Kyle, 17 March 1951
William Vanderson for *Picture Post*
Hulton Getty

Jim Laker (1922–86)
Cricket

If Jim Laker had achieved nothing else, his return of 19 wickets for 90 runs against Australia in 1956 would have been enough to raise him to the status of cricket legend. A Yorkshireman who played for Surrey from 1946 to 1959, Laker was a tall and strong off-spinner who took over 100 wickets in a season on 11 occasions. His action was both economical and classical, and he was a clever reader of the wicket and conditions. In Surrey's championship-winning years between 1952 and 1958, he was a key member of the bowling attack, which also included his 'spin-twin' Tony Lock, and **Alec BEDSER**. Laker's personal wicket tally for the county was 327 at an average of 15.62. He had won a first test cap in 1947, but was not given a regular place with the England team until the 1956 Ashes series, when he was 34. However, he proved a point to the selectors, taking 46 Australian wickets at an average of less than ten. Then in the Old Trafford Test in July, he came closer than anyone before or since to achieving the elusive target of 20 wickets in a test match.

(Illustrated under **Sir Leonard (Len) HUTTON**)

Harold Larwood
Howard Coster, 1930s
National Portrait Gallery

Harold Larwood (1904–95)
Cricket

Ex-miner Harold Larwood was considered by the batsmen who faced him to be the most menacing fast bowler in the world. But his name has become synonymous with the infamous Bodyline affair, which took place during England's tour to Australia in 1932–3. England captain Douglas Jardine had asked his bowlers, including Larwood and his Nottinghamshire colleague Bill Voce, to aim short-pitched balls towards the batsman and not the stumps. The tour became acrimonious, telegrams went back and forth between the Australian authorities and the MCC; even Australia's allegiance to the Commonwealth came under serious threat. Bodyline was considered to be not only highly dangerous, but most assuredly 'not cricket', and something of a national disgrace for Britain. Although his captain Jardine also became highly unpopular, Larwood was made chief scapegoat. The statistics tell a different story however, as 16 of his 33 victims were in fact clean bowled and Larwood was also largely responsible for limiting the irrepressible Australian Don Bradman to a series average of 56.57. England took the series, winning four out of five tests, but instead of returning to a hero's welcome, Larwood was grilled by the MCC, and never played test cricket again. He continued to play for Nottinghamshire, taking 1,427 wickets in first-class cricket at an average of 17.51, but his sport was not kind to him, and he emigrated to Australia after the Second World War.

Denis Law (b.1940)
Football

When the spindly and bespectacled redhead Denis Law signed for Huddersfield in 1955, then manager Bill Shankly described the Aberdonian as looking like a plucked chicken. Law went on to ruffle many feathers as a hot-tempered and free-scoring centre-forward. He made his international début at 18, the youngest Scottish cap this century: 33 goals came in his 55 internationals. He joined Manchester City in 1960; after two years there and an unsettled season with Torino in Italy, he returned to Manchester, this time playing with Manchester United, where he made his name. Despite the presence of **Bobby CHARLTON** and **George BEST**, Law – 'The King' – was the toast of Old Trafford, with 160 goals for United in 222 games: each was celebrated by his raised-arm trademark salute. He shared in two league titles and the 1963 FA Cup Final victory, but was unlucky to miss the European Cup success in 1968 through injury. He returned to Manchester City for his final season in 1974. His last game was his most controversial, as he back-heeled a cheeky goal in the Manchester derby, consigning his former employers to the second division: it was a bittersweet experience for Law, but will be forever cherished by the blue half of Manchester.

Denis Law (l) and Billy McNeill, Heathrow, arriving for Scotland's match with England, 8 April 1965
Central Press
Hulton Getty
See also **Billy McNEILL**

Tommy Lawton (1919-96)
Football

The model centre-forward of his day and a sporting star of the 1940s, Lawton was a prodigious goal-scorer, known especially for his spectacular headed goals. Aged 17, he scored three goals for Burnley against Tottenham, becoming the youngest player ever to score a hat trick in the football league. Quickly moving to Everton for £6,500, he scored 62 goals in his first two seasons, helping the club to the league title in 1939. He finished as the first division's top scorer in the two seasons 1938 and 1939. He made his England début in 1938, and in an international career badly affected by the Second World War, he had scored 22 goals in 23 games by 1948. He signed for Chelsea in 1945, for another big fee, £11,500, and in his one full season in London, scored 26 goals in 34 games, before his surprise move to the lowly third division club Notts County. The club's home gate trebled after Lawton had signed, and he helped them win promotion to the second division in the 1949–50 season, with 31 goals. The scorer of 231 goals in a total of 390 league games, Lawton was a player who knew his market value and capitalised on his success, writing a weekly newspaper column, and appearing in poster advertisements.

The England Football Team, prior to a training session at Highbury, 1948.
(l to r): Frank Swift, John Aston, Alf Ramsey, John Howe, Billy Wright, Neil Franklin, Bill Nicholson, Henry Cockburn, Tom Finney, Tommy Lawton, Wilf Mannion, Bobby Langton, Stan Mortensen, Stan Pearson, Stanley Matthews, Laurie Scott
Reg Birkett for Keystone
Hulton Getty
See also **Billy WRIGHT**, **Sir Tom FINNEY** and **Sir Stanley MATTHEWS**

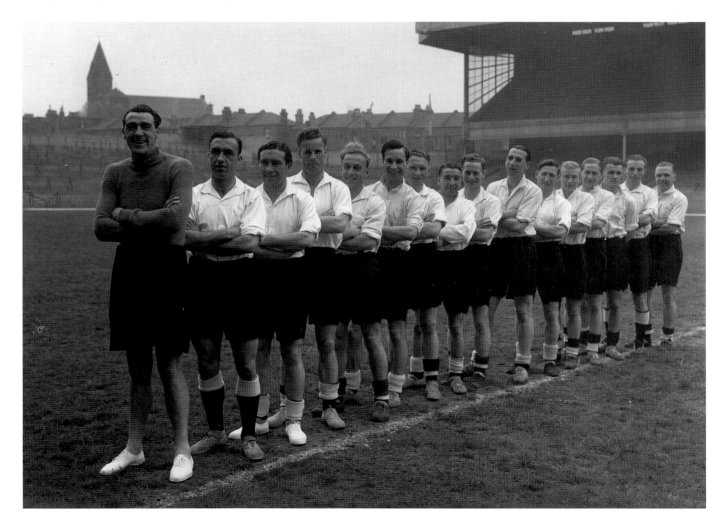

'Cecil' Leitch (1891–1977)
Golf

From her first appearance in a ladies' competition in 1908, it was obvious to many that 'Cecil' Leitch would be a champion one day. She took part in matches with many of the leading men of the time; the most celebrated of these matches was in 1910 against **Harold Hilton**, great Open and Amateur Champion. The match was over 72 holes and Leitch was given a stroke on every second hole. She beat Hilton two holes up with one to play; she also later played five-time Open Champion **J.H. Taylor** and *News of the World* Champion Tom Ball on the same basis, and won both times. Her championship record was excellent: winner of the British Ladies title in 1914, 1920, 1921 and 1926, she also won two English, five French and one Canadian championships. An England international 12 times, she held over 20 course records at her peak. She dominated the field until **Joyce Wethered** entered the scene and their rivalry was a feature of the 1920s. Ground-breaking in her aggressive style of play, Leitch also took an active part in the organisation of the game throughout her life. ERC

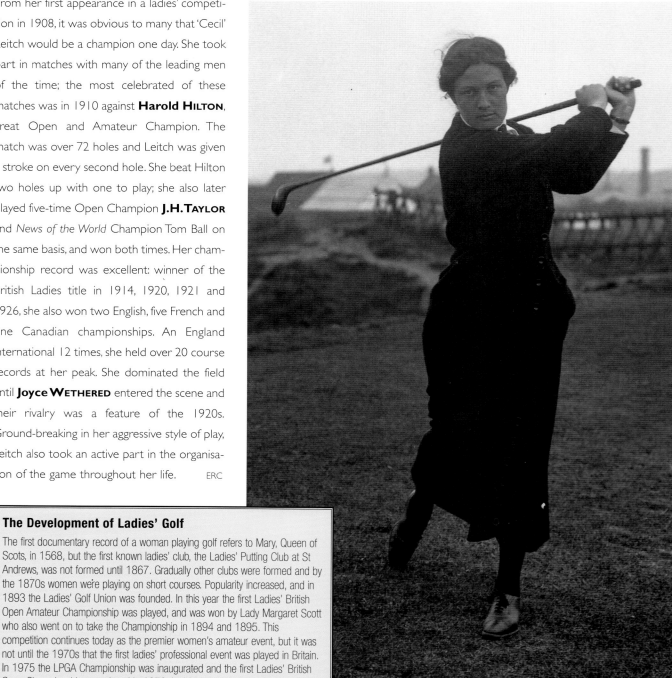

'Cecil' Leitch, Ladies Golf Championship, Hunstanton, 13 May 1914
Topical Press
Hulton Getty

The Development of Ladies' Golf

The first documentary record of a woman playing golf refers to Mary, Queen of Scots, in 1568, but the first known ladies' club, the Ladies' Putting Club at St Andrews, was not formed until 1867. Gradually other clubs were formed and by the 1870s women were playing on short courses. Popularity increased, and in 1893 the Ladies' Golf Union was founded. In this year the first Ladies' British Open Amateur Championship was played, and was won by Lady Margaret Scott who also went on to take the Championship in 1894 and 1895. This competition continues today as the premier women's amateur event, but it was not until the 1970s that the first ladies' professional event was played in Britain. In 1975 the LPGA Championship was inaugurated and the first Ladies' British Open Championship was played in 1976. In 1978 the Women's Professional Golfers Association was launched, closely followed in 1979 by the WPG Tour. Since then, due to increasing television coverage and growing interest of sponsors, the tour has grown in size and popularity. Today media coverage concentrates on the top professionals on the tour, renamed in 1998 as the European Ladies' Professional Golf Tour. This top competition, like with many sports, is sustained by the enthusiasm of amateur players at all levels. ERC

Virginia Leng (b.1955)
Equestrianism

Leng's career co-incided with that of **Lucinda GREEN**, and the pair brought prominence, not to mention glamour, to equestrianism in the 1970s and 1980s. The daughter of a Royal Marine serving abroad, 'Ginny's' family lived outside England until she was 16, which meant she missed out on the conventional country pony club route to competitive eventing. But in 1973, she became European junior champion, the springboard for her career. Four years later, she nearly suffered an amputation when she broke her arm in 23 places in a serious fall. Having recovered, between 1981 and 1993 Leng enjoyed a career at the top of her profession. She won a team silver medal at the European Championships in 1981, followed by a team gold at the World Championships in 1982. She won Burghley Horse Trials in 1983, 1984 and 1986, and she won Badminton three times in 1985, 1987 and 1993. She was British national champion in 1987 and 1993. Since retirement from competitive riding, Leng has become an author of thrillers set in the equestrian world.
(Illustrated under **Lucinda GREEN**)

Lennox Lewis (b.1965)
Boxing

At the age of 12, London-born Lennox Lewis moved to Ontario, Canada. A ferocious amateur boxer, he became world junior champion at 17 and in 1984 represented Canada at the Olympic Games, losing to the eventual gold medallist. He refused a lucrative offer to turn professional, rejecting it in order to continue his quest for an Olympic gold medal; this he achieved in 1988, when he beat the American Riddick Bowe to the prize. He returned to Britain in 1989, signed as a professional, and soon went on to win British, Commonwealth and European heavyweight titles. In 1992 he knocked out Razor Ruddock, the world's most dangerous heavyweight after Mike Tyson. In the following year, Lewis became the first British heavyweight world champion this century. Defending his title, he defeated a number of challengers, including **Frank BRUNO**, before losing it to American Oliver McCall at Wembley. In 1997, before 80 million television viewers worldwide, he regained the title from McCall in Las Vegas, staking his claim as one of Britain's most effective punchers this century. Subsequent bouts against Henry Akinwande and Andrew Golota have confirmed his status.

Lennox Lewis
Ray Richardson, 1993
Oil on canvas, 248 × 911mm
National Portrait Gallery, given
by the *Telegraph Magazine*

Ted 'Kid' Lewis (1894–1970)
Boxing

Born Gershon Mendaloff in London's East End, Lewis was, with 283 contests under his belt, the most indefatigable modern British fighter. In 1911 alone, he stood in 48 fights, 13 more than **Barry McGuigan** in his whole career. In 20 years Lewis won nine titles at a variety of weights from featherweight to middleweight, and until the 1970s, he was still the only British boxer to have won a world title fight in America. He began boxing professionally at 14, under the name Kid Lewis, and won the British featherweight title in 1913, adding the European crown four months later. In 1914 he went to Australia, where he kept up his prodigious fight schedule. From there, Lewis moved to America, added 'Ted' to his name and fought as a welterweight. Between 1915 and 1919, he fought Jack Britton 19 times, winning the welterweight title from him twice and losing it twice too. He returned to Britain in 1920, but in May 1922, was knocked out by Georges Carpentier in the first round: as Lewis was turning to make a protest to the referee, the French champion unsportingly floored him. Lewis boxed until 1929, never refusing a fight when money was available. On occasions, he was known to drive through the East End streets where he had grown up, scattering banknotes to the amazement of passers-by.

Ted 'Kid' Lewis sparring with his son
Central Press, c.1923
Hulton Getty

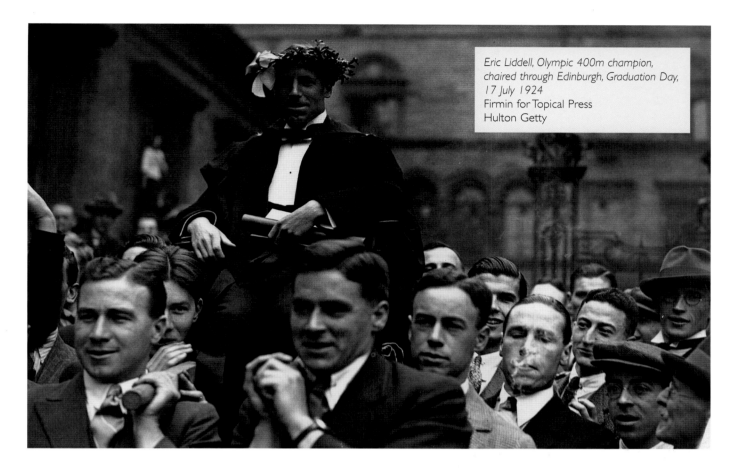

Eric Liddell, Olympic 400m champion,
chaired through Edinburgh, Graduation Day,
17 July 1924
Firmin for Topical Press
Hulton Getty

Eric Liddell (1902–45)

Athletics

Eric Liddell is the most famous Sabbatarian in British sporting history. He denied himself the chance to compete in both the 100m and the 4 x 400m relay at the 1924 Olympics, as heats for these events fell on a Sunday. His sporting prowess was evident as a record-breaking student at Edinburgh University, and he dominated domestic athletics. An unrivalled sprinter for 35 years, his pace made him a fine rugby player, a sport in which he won seven Scottish international caps as a winger. At the 1924 Paris Olympic Games, Liddell fought his way to the bronze medal in the 200m, leaving **Harold ABRAHAMS** in last place. Then, displaying his characteristic running style of head held back and arms flapping, he won the 400m gold with ease, setting a new Olympic record of 47.6 seconds. The one gold medal proved enough for Liddell, and he returned to China to continue the missionary work started by his father. His refusal to compete in the Olympics of 1928 and 1932 was a great loss to athletics. He would have only been 26 and 30 at the respective events, and would surely have won more medals. Ironically, it was his Christian zeal that drove him to success, but also denied him the chance to have been one of Britain's greatest Olympians. He remained in China for the rest of his short life, and died there in a Japanese prisoner-of-war camp, forgotten until the film *Chariots of Fire* resurrected his reputation.

Graduation Day Celebrations

On 17 July 1924, Olympic 400m gold medallist Eric Liddell returned to Edinburgh for University Graduation Day. The university's greatest sporting son, he was crowned with a laurel wreath, the reward for the victor in the ancient Olympic Games. The graduation ceremony over, Liddell was chaired through the streets to St Giles Cathedral. A celebratory poem was given to Liddell. Written in Greek, it translates thus:

Happy the man who the wreathed games essaying
Returns with laurelled brow
Thrice happy victor, thou, such speed displaying
As none hath showed till now;
We joy, and Alma Mater, *for thy merit*
Proffers to thee this crown:
Take it, Olympic Victor. While you wear it
May Heaven never frown.

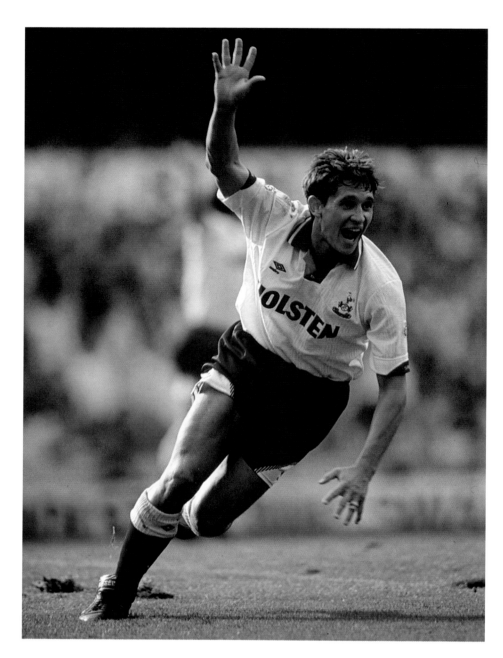

Gary Lineker, Tottenham Hotspur vs.
Queens Park Rangers, White Hart Lane,
14 September 1991
Bob Martin/Allsport

Gary Lineker (b.1960)
Football

Combining intelligence, timing and marksmanship, Lineker's career record of 332 goals in 631 games proclaims him as a great scorer of goals, but in fact he was never a classic goal-scorer. His goals were poached, side-footed and poked into the net: always swift of thought and positionally aware, only Lineker could so successfully outfox a goalkeeper in his own six-yard box. Domestically he won few honours with Leicester, Everton (for whom he scored 40 goals in one season) and Tottenham Hotspur. Playing with Barcelona from 1986 to 1989, he won the Spanish league and the European Cup. But he saved his heroics for the games in which he wore an England shirt. His 48 goals were one short of **Bobby CHARLTON**'s record, and they always came when England needed them most: in 1986, he transformed England's presence in the World Cup in Mexico from non-entities to contenders. His total of six goals earned him the Golden Boot award, and he scored four more World Cup goals in 1990, becoming the darling of the sports pages.

Nat Lofthouse (b.1925)
Football

A Bolton man to the core, Lofthouse's odyssey took him from 14-year-old apprentice, via outstanding player, goal-scorer and captain, to coach, manager and chief scout, before finally becoming club president in 1986. He won 33 caps for England between 1950 and 1958 and scored 30 goals, equalling **Tom FINNEY**'s record. Lofthouse's most famous international goal was the winner in England's 3–2 victory over Austria, earning him the nickname of 'The Lion of Vienna': in a morale-boosting performance for an off-form national team, Lofthouse collected the ball in his own half and ran through the Austrian defence. As he and the goalkeeper collided, Lofthouse slid the ball goalwards before being carried off on a stretcher. He played in two classic FA Cup Finals. In the so-called Matthews Final of 1953, Bolton lost against Blackpool, although Lofthouse scored in every round to the final, and was voted Footballer of the Year. In 1958, he was back at Wembley, scoring both goals as Bolton beat Manchester United 2–0, but was remembered for controversially barging United's goalkeeper and the ball into the net simultaneously. In 1955–6, he was the league's top scorer with 33 goals.

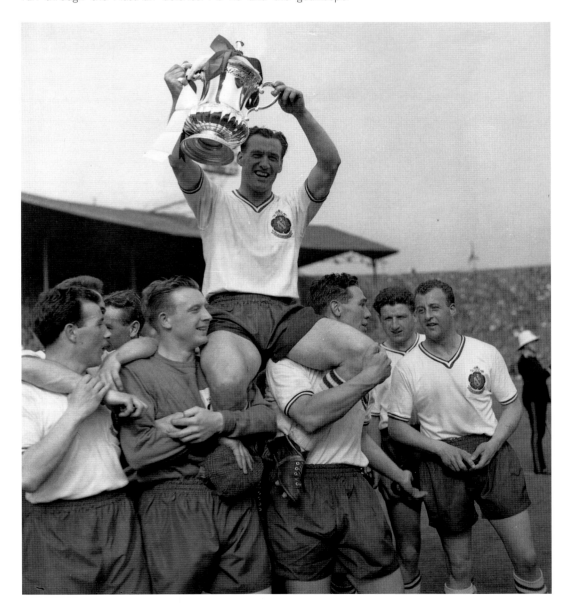

Nat Lofthouse chaired by Bolton team-mates after winning the FA Cup Final, Wembley, 3 May 1958
Ron Burton for Keystone
Hulton Getty

Anita Lonsbrough (b.1941)
Swimming

Until Anita Lonsbrough appeared on the scene, Huddersfield had enjoyed mere crumbs of sporting success since the heady days of its great football and rugby league teams of the 1920s. Then, in 1960, local corporation worker Lonsbrough brought considerable tonic to the town, winning an Olympic gold medal in the 200m breaststroke in Rome. By the age of 17, she was the country's best swimmer, and between 1958 and 1962 she became the most decorated female swimmer in British history. Lonsbrough won a total of seven gold, three silver and two bronze medals at the Olympics, the Commonwealth and European Championships, in events including breast-

stroke, the relay and the medley. She set four world records, one of which came in her 200m breaststroke final: it was the only new record set in the women's individual events. On her return from Rome in 1960, and again in 1962, she was voted Sportswoman of the Year. In 1964, at the Tokyo Olympics, she became the first woman to carry the flag for the British team.

Anita Lonsbrough, British Swimming Championships, Blackpool, 1959
Gerry Cranham

Douglas Lowe (1902–81)
Athletics

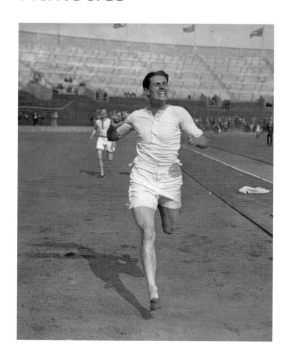

Douglas Lowe winning the half mile, Oxford and Cambridge vs. Harvard and Yale, London, July 1923
Topical Press
Hulton Getty

The first man successfully to defend an Olympic 800m title, Lowe was the **Sebastian COE** of his day, and a great inspiration to the later runner. With his immaculate centre parting and matinée-idol looks, it is surprising that the posthumous glory granted to **Harold ABRAHAMS** and **Eric LIDDELL** by the film *Chariots of Fire* was not extended to Lowe. His gold medal at the 1924 Paris Olympic Games was every bit as noteworthy as theirs, especially considering that Lowe had yet to prove himself on the domestic front and had only gone to Paris as a second-string runner. Following his 800m triumph, he narrowly missed third place in the 1500m final. In the following few years he showed his class on the British track, with five Amateur Athletic Association titles. At the 1928 Olympic Games, his second 800m triumph was even greater than his first as the field was much stronger, and he set a new Olympic record. He then ran in the 4 × 400m relay team finishing in fifth place. At the end of the year he retired, but served as AAA secretary until the outbreak of the Second World War.

Sandy Lyle (b.1958)
Golf

As the son of Scotsman Alex Lyle, a respected teaching professional, Sandy Lyle had an early start in golf. It is said that at the age of three he could hit a ball 80yds. At 14 he was junior champion and he won the English Amateur Stroke-play aged 17 and again at 19. After playing in the 1977 Walker Cup Lyle turned professional, and in 1985 at Royal St George's he became the first Scot in over 60 years to win the Open, and the first Briton since **Tony Jacklin**. A popular man, he celebrated with a party for press and friends. In 1988 he became the first Briton to win the US Masters, securing victory with a stirring birdie finish. His career victories include 17 European and 4 US events, not including his two 'Majors'. He was top of the European Order of Merit on three occasions, in 1979, 1980 and 1985 and has played in the Ryder Cup five times. As a player who relies on his natural gifts, Lyle's career has been plagued by inconsistency. Despite working with his father and others on his swing, top form has eluded him for several years. ERC

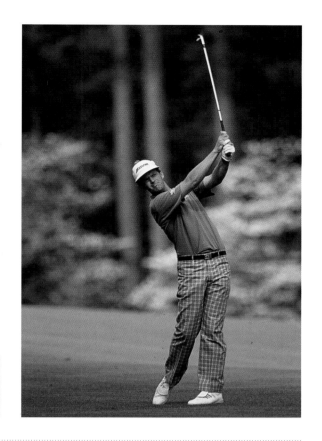

Sandy Lyle, US Masters, Augusta, 1988
David Cannon/Allsport

Benny Lynch (1913–46)
Boxing

At 20, the devastating Benny Lynch was considered the best 'wee man' in Glasgow. In his prime, his bouts were seen by packed audiences at Scottish football stadia. In 1935, he became the country's first world boxing champion, overcoming defending champion Jackie Brown, who was floored ten times in the first two rounds. In 1937, a points defeat versus the American champion Small Montana made him the undisputed flyweight champion of the world. He had pluck and artistry in equal measure, great balance and a fierce punch for a man of his size. Defending his title in 1937, he met Peter Kane in one of the classic encounters of British boxing, certainly the most exciting flyweight bout ever seen. Kane was knocked out in the thirteenth round in front of an ecstatic 40,000-strong crowd. It was Lynch's last fight: by the time of his next defence, alcohol had taken its toll and he was stripped of his title, weighing in over the limit. His licence to box was taken away on medical grounds in 1939, and he left boxing for good aged 25. Within three years he degenerated from being Scotland's pride to an alcoholic wreck, and a few years after that, died of malnutrition at the age of 33.

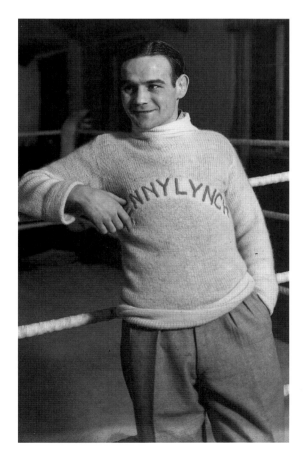

Benny Lynch, 19 January 1937
Hulton Getty

Willie John McBride, British Lions' captain,
South Africa, 1974
Allsport

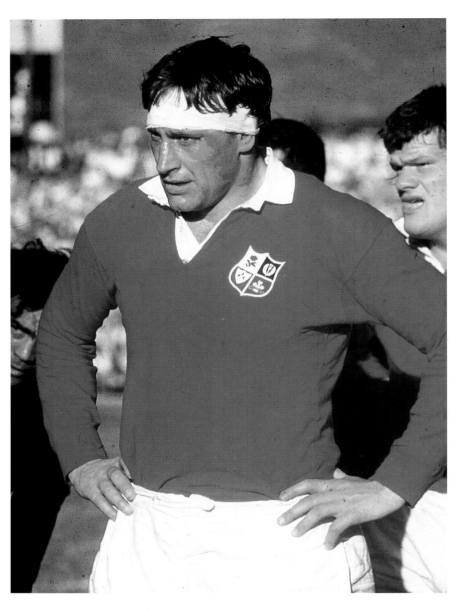

The British Lions play
New Zealand, 1974

According to All Black John Gainsford, the British
Lions team of 1974 were,

...mentally tougher, physically harder, superbly
drilled and coached, disciplined and united. They
were dedicated fellows who were trained to peak
fitness, who were prepared like professionals and
who were ready to die on the field for victory.
They were rugged, even ruthless competitors who
played their rugby to win and who were not
squeamish about resorting to obstruction,
gamesmanship and even the use of their fists and
boots to achieve their end.

(*My Greatest Game,* 1995)

Willie John McBride (b.1940)
Rugby union

McBride was the key figure in British rugby in the early 1970s: his 17 test match caps from five British Lions tours set a record, as did his 63 international appearances for Ireland. Both records were later overtaken by fellow Ulsterman Mike GIBSON. On the 1974 British Lions tour to South Africa, McBride eclipsed the All Black Colin Meads as the world's best forward, and also became the most respected leader ever of a touring British rugby team. In the eyes of the southern hemisphere's rugby-playing nations, the British Lions traditionally lacked a competitive edge in the scrum: that was the widely held view until the emergence of McBride, whose bravery, aggression and commitment brought a new passion to the British Lions. Confidence was high following the successful 1971 tour to New Zealand, but few had predicted that the 1974 British Lions would dominate to such an extent in South Africa. Much of the credit, as the team won 21 out of 22 games, was due to McBride's inspired leadership. Scoring the most points and the most tries ever on a South African tour, the Lions' 28–9 defeat of South Africa was the biggest margin of victory ever, and only a controversial 13–13 draw in the final test halted a 22-match whitewash. McBride retired in 1975, one of the most respected players in the game.

Tony McCoy (b.1974)
Horse racing

It is normally unwise to judge a sporting career before its conclusion, but in the case of Irish-born Tony McCoy such caution is unnecessary. Still in his early twenties, he has already shattered records that had seemed unassailable, and with the continued backing of Martin Pipe's stable and that element of luck essential to any jump jockey, there would seem to be no bounds to his achievements. Experienced judges are already speaking of him as the greatest jump jockey of all time, and a fine sense of pace, immense strength in a finish, and an insatiable appetite for work and success have brought McCoy the fastest 100 and 200 winners in a season. His major wins include the great Cheltenham double in 1997, on the Martin Pipe-trained Make a Stand in the Champion Hurdle, and Mr Mulligan in the Gold Cup. He has been Champion Jockey for the last three years.

HC

Tony McCoy on Mr Mulligan, winner of the Cheltenham Gold Cup, 13 March 1997
Trevor Jones

Jimmy McGrory (1904–82)
Football

The most prolific goal-scorer in British football, McGrory and his 550 goals have become a legend at Celtic, for whom most of the goals were scored. He played just seven times for Scotland, but he did score three times in his two games against England. He made his début for Celtic in 1922, and averaged more than a goal a game in 15 years with the club. In one match against Dunfermline in 1928 he scored a Scottish record of eight goals, and he scored the fastest hat trick in Scottish football in a three-minute spell against Motherwell in 1936. An old-fashioned centre-forward, most of McGrory's goals were headers, as he rose to meet crosses from the wing provided by team-mate Paddy Connolly. McGrory's outstanding scoring feats helped keep Celtic in contention for the championship, and the club won the league in 1926 and 1936: Celtic also won the Scottish FA Cup in 1925, 1931, 1933, and 1937, finishing as runners-up in 1926 and 1928. From 1937 until the Second World War, McGrory was manager of Kilmarnock. In 1945, he returned to Celtic as manager, staying until he was replaced by Jock Stein in 1965.

Jimmy McGrory
Famous Footballers
cigarette card, 1934

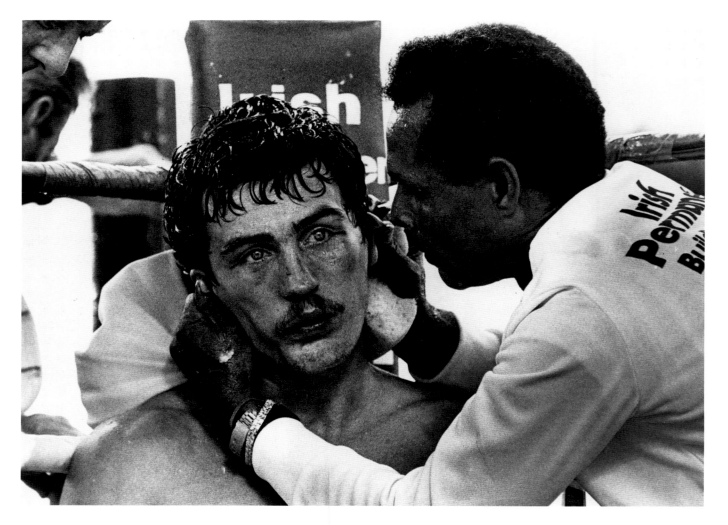

Barry McGuigan (b.1961)
Boxing

A hugely popular figure on both sides of the Irish Sea, McGuigan initially boxed as an amateur for the Republic of Ireland, then for Northern Ireland in the 1978 Commonwealth Games. He began professional boxing in 1981, and apart from a points defeat in his third outing, remained unbeaten until his last important fight in 1986. An obsessive trainer and an aggressive two-fisted body puncher, he was a great box-office draw, especially at the King's Hall in Belfast. He was a Catholic married to a Protestant, a fact that the media was quick to champion: his stirring fights temporarily brought unity to strife-torn Ireland, with the whole island behind him.

McGuigan became British and European Featherweight Champion in 1983, and his greatest fight was against Panamanian Eusebio Pedroza in June 1985, at the Queens Park Rangers football ground in West London. Pedroza had reigned as world featherweight champion since 1978, with 19 successful defences. McGuigan outpointed him over 15 absorbing rounds, and 25,000 fans and a huge television audience rejoiced. He then beat off two challengers until outpointed by Steve Cruz in Las Vegas in 1986. Managerial problems followed and McGuigan was out of action for a year, returning for three fights, before he retired.

Barry McGuigan in his corner, world featherweight fight vs. Steve Cruz, Las Vegas, 1986 Chris Smith/The Sunday Times

A.C. Maclaren (1871-1944)
Cricket

The son of a Manchester businessman, Maclaren announced himself as a teenager by scoring 55 and 67 runs for Harrow School in the annual match versus Eton at Lord's. In his first game for Lancashire a month later, he made 108 runs, remaining the foundation of Lancashire's batting until the First World War, and captaining the county for over ten years. Aged 22, he was selected to join the England tour of Australia in 1894, where he made scores of 228 and 120. Returning to county cricket, he scored 424 runs for Lancashire against Somerset in 1895, a record score which stood for 99 years. He toured again to Australia in 1897–8, and as captain of the side in 1901–02. On the 1897–8 tour he and **K. S. RANJITSINHJI** became the first batsmen to score 1,000 runs in Australia. Maclaren was a controversial captain, often pompous and at odds with the selectors, and sometimes too busy to play cricket if his business interests conflicted with his sporting ones.

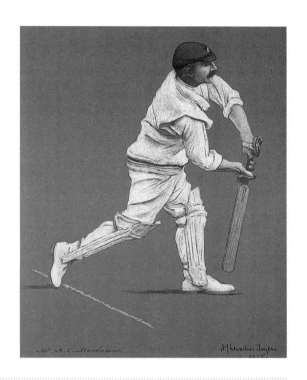

A.C. Maclaren
Albert Chevallier Tayler, 1905
Chromolithograph, 381 × 254mm
National Portrait Gallery

Billy McNeill (b.1940)
Football

At the heart of Celtic's tenure as the most successful club in Britain from 1965 to 1975 was the inspirational player and captain Billy McNeill. He made the first of his 486 league appearances for the club in 1958. Including domestic and European cup competition, McNeill played 787 matches for Celtic. Of these, none was more significant than the 1967 European Cup Final in which Celtic, the outsiders, beat Inter Milan 2–1 to become the first British holders of the European Cup. McNeill was a competitive and commanding defender, incisive in the tackle and rarely beaten to the ball in the air. He could also score goals, contributing one in the 1965, 1969 and 1972 Scottish Cup Finals. The 1965 victory was the club's first trophy under the revered Jock Stein's period as manager. With Stein at the helm and McNeill his on-field general, an avalanche of cups and titles followed. In 1966, Celtic won the first of nine successive league titles. McNeill's authoritative leadership and strict marshalling of the team earned him the nickname 'Caesar'. A model but tough player on the pitch, a gentleman and sporting ambassador off it, he won 29 caps for Scotland, but experienced an unfortunate début in 1961 when Scotland lost to England 9–3. McNeill returned to manage Celtic on two occasions, the first following Stein's retirement in 1978. As manager, he won four league championships and three Scottish Cups. (Illustrated under **Dennis LAW**)

The Lisbon Lions: Celtic win the European Cup, 1967

In 1967, Celtic became the first British club to conquer Europe, beating the mighty Inter Milan in the European Cup Final in Lisbon. Hugh McIlvanney was there and wrote of 'that magical hour-and-a-half under the hot sun in the breathtaking, tree-fringed atmosphere of the national stadium.' He remembered the 'exhilarating speed and the bewildering variety of skills that destroyed Inter – the unshakeable assurance of Clark, the murderously swift overlapping of the full-backs, the creative energy of Auld in midfield, the endless virtuosity of Johnstone, the intelligent and ceaseless running of Chalmers…the massive heart of this Celtic side.' The 2-1 result announced to the world that British domestic football was a force to be reckoned with.

Nigel Mansell (b.1953)
Motor racing

Nigel Mansell, Phoenix,
Arizona, 1993
Terry O'Neill
National Portrait Gallery

Mansell was one of Britain's highest-profile sportsmen of the 1980s and early 1990s, winning 31 out of 185 Grands Prix: yet in the television age where a man is judged by his style and interviews, Mansell was not a great performer, appearing dull and sounding monotonous. His early years took him nowhere, and he entered more than 50 Grands Prix before registering his first win. Success came in 1985 when he left the declining Lotus team and joined Williams. In the 1986 and 1987 seasons, he had five and six successes respectively, finishing second in the Drivers' Championship each time. After three wins in the next three seasons, two of them with Ferrari alongside Alain Prost, he rejoined Williams in 1991. Despite five wins in mid-season, he failed to overhaul Ayrton Senna, the greatest driver of the period, and earned his third second place. The following year was his, as he won nine Grands Prix out of 16, including the first five of the season, and became World Champion. Falling out with the Williams team he then spent a season driving Indy cars in America. In 1994 he returned to Britain for just four more races before retiring.

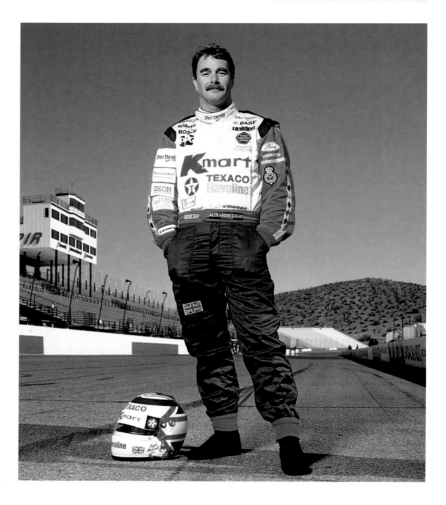

James (Jem) Mason (1816–66)
Horse racing

Jem Mason was the son of a dealer and breeder of hunters. After grammar school in Huntingdon, he became a rough-rider riding untrained horses for a Mr Tilbury at Pinner, and had his first race-ride in 1833. The following year he won the St Albans steeple-chase on The Poet and three years later the Leamington steeplechase on Jerry owned by John Elmore of Harrow, the father of his first wife. It was with another horse of Elmore's, Lottery, however, that Mason was most closely associated in the public mind. It was said in his obituary that he was 'as much iden-tified with Lottery as Dick Turpin with Black Bess' and it was on Lottery that he won a number of steeplechases, including the Cheltenham in 1839 and 1840, the Leamington Grand Annual in 1840 and, most notably, the first ever Grand National, run at Aintree on 26 February 1839. As much the dandy as any of his flat-racing counterparts, Mason was always impeccably dressed and jumped Lottery over a 5ft 6in gate on a stone road in pref-erence to the adjacent hedge saying, 'I'll be hanged if I am going to scratch my face, for I am going to the opera tonight.' HC

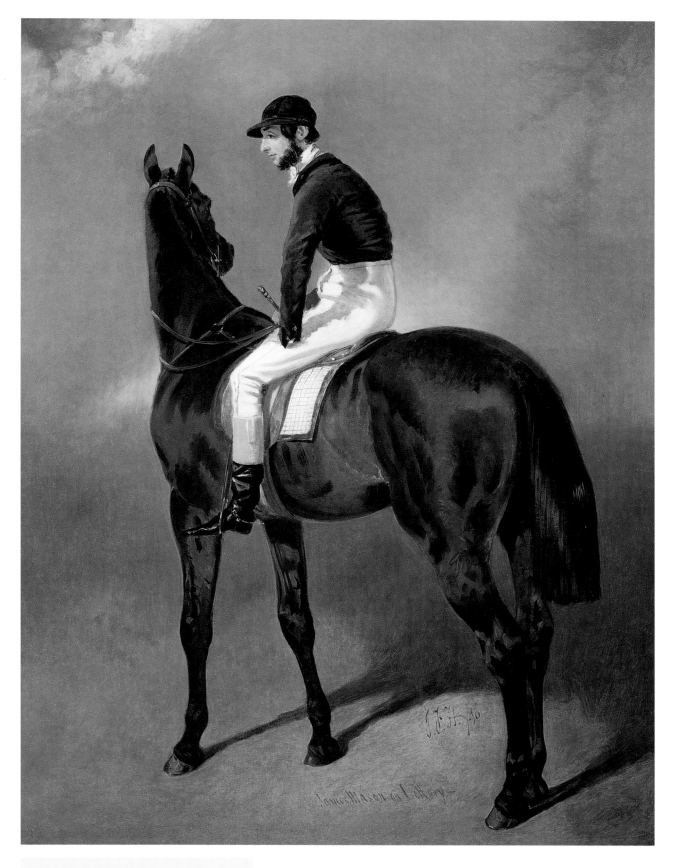

Mr John Elmore's Lottery with Jem Mason up
John Frederick Herring Senior, 1846
Oil on canvas, 605 x 450mm
Cottesbrooke Hall, Northampton

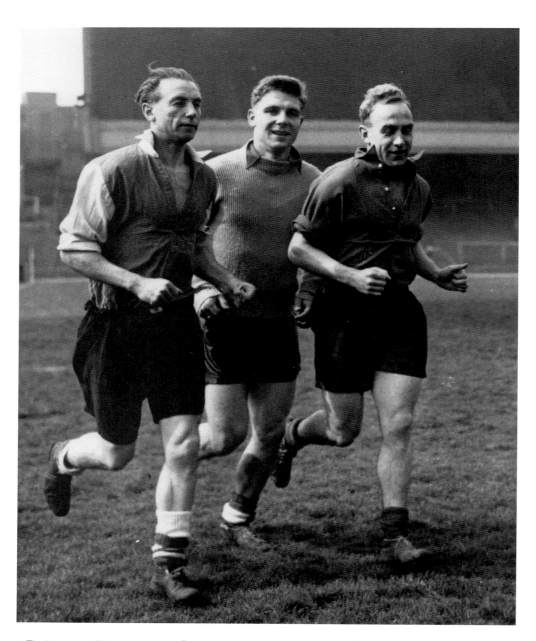

Stanley Matthews (l), Duncan
Edwards and Billy Wright (r)
training at Highbury before
England's match against
Scotland, 3 April 1957
Douglas Miller for Keystone
Hulton Getty
See also **Duncan EDWARDS**
and **Billy WRIGHT**

Sir Stanley Matthews (b.1915)
Football

There is magic in the name of Stanley Matthews. Ever a provider, rather than a goal-scorer, he was known as 'the wizard of dribble' as he danced and skipped past defenders with the ball apparently stuck to the end of his boot. He made his début for Stoke in 1932, and the first of his 54 England caps soon followed in 1934. After the Second World War, 'The Potters' were dismayed when he was transferred to Blackpool, to link up with prolific striker Stan Mortensen. Their partnership came to fruition in the so-called Matthews Final of the 1953 FA Cup, when the two players engineered a 4–3 win over Bolton. An out-and-out right winger, Matthews' longevity at the top of his profession stood him apart from his contemporaries. He played his last game for England in 1957, aged 42. He returned to play for Stoke at the age of 47, adding 27,000 on the gate with his first game back: he inspired Stoke to promotion from division two in 1962. He retired aged 50 in 1965, the year in which he was knighted, having played 701 league games alone, plus internationals (including two World Cups) and wartime matches.

Peter May (1929-94)
Cricket

'Salute Miracle Man Peter May!' urged the *Daily Sketch* in June 1957, in recognition of his record-breaking 411 partnership with **Colin COWDREY** for the fourth wicket against the West Indies. May's own match-saving contribution of 285 not out was the pinnacle of an illustrious batting career. Tall, handsome and fastidious, May was the first great batsman to emerge after the Second World War. A prolific run-scorer at school and for Cambridge, May made his début for Surrey in 1950, and was part of the team that enjoyed supremacy in the County Championship from 1952 to 1958. As a student, he scored a century in his test début against South Africa in 1951. He went on to play in a further 65 test matches, captaining the side 41 times. He was at his best against the Australians, scoring 1,566 runs in 21 Ashes matches, and captaining the 1956 side that retained the Ashes trophy. During the 1950s no-one in world cricket was a better driver of the ball than May. With immaculate timing and footwork he frequently struck the ball over the bowler's head or majestically through the covers. He passed 1,000 runs in a season 14 times and exceeded 2,000 runs five times: he was top of the national batting averages in three seasons. By 1963, his love for county cricket had waned, and to the regret of many, he retired, aged 33, to pursue a career in insurance.

Peter May (r) and Colin Cowdrey leaving the field after a record 411 partnership against the West Indies, Edgbaston, 1957
Central Press
Hulton Getty
See also **Colin COWDREY**

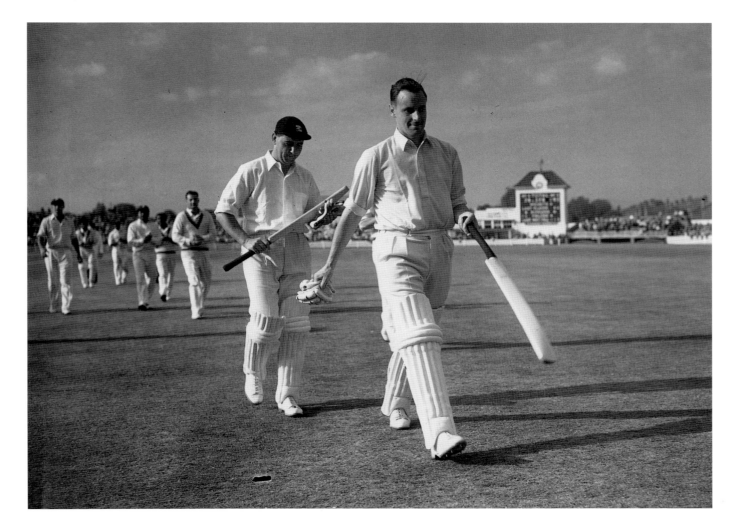

Richard Meade (b.1938)
Equestrianism

The winner of three gold medals, ex-army officer Richard Meade is Britain's greatest three-day-eventer in Olympic history. He took part in four successive Games between 1964 and 1976, his medals coming in 1968 and 1972. He is still the only Briton to have won gold in the individual event, and his tally of medals in the World and European Championships from 1965 to 1982 is no less impressive: two silvers in the individual events, and five gold, one silver and two bronze medals in the team events. In 1964, he won the Burghley Horse Trials on Barberry, also his mount at the Tokyo Games, where he finished eighth. Four years later, he rode Cornishman V and, helped by a winning performance by Derek Allhusen, 'the galloping major', the British team won gold, while Meade narrowly finished outside the medals in the individual event. The peak of his career came four years later in the Munich Olympics in 1972, in which he won both the individual and team gold medals, on Laurieston. This was the last of his Olympic medals, as he finished in fourth place in Montreal in 1976. At home he won the Badminton Horse Trials twice in 1970 and 1982.

Richard Meade, Badminton, 1975
Srdja Djukanovic

Daniel Mendoza (1764–1836)
Pugilism

A mere 5ft 7in tall, the Jewish fighter Daniel Mendoza was the forerunner of today's guileful boxers who compete at weights from fly to welter. Not only dextrous, quick, and extremely courageous, Mendoza also used his brain to great effect both in and out of the ring, being the first man to manage himself and help promote his own contests. He claimed the Championship of England in 1787, having been instructed in fisticuffs by the gentleman fighter Richard Humphreys. The three contests from 1788 to 1790 between the master and his ex-pupil were the greatest pugilistic events of their time, witnessed by huge crowds. The last was held in Doncaster where a stage was erected in an inn-yard and an admission fee charged for the first time.

The victorious Mendoza reigned as champion until 1795, when over 3,000 spectators saw him bow before **John JACKSON** at Hornchurch in Essex. According to contemporary witnesses, Mendoza's long hair was 'pulled with one hand while he was pounded into insensibility with the other'. He retired, but continued to organise sparring matches, give lessons and write his memoirs.

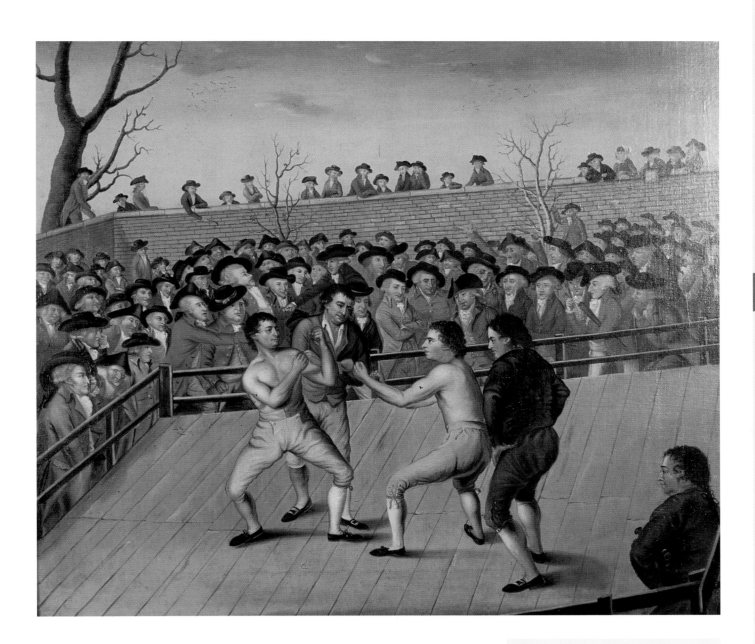

The fight between John Jackson and
Daniel Mendoza (r) at Hornchurch, 1795
Unknown artist
Oil on canvas, 788 × 915mm
The Hamilton Collection, Brodick Castle,
in care of The National Trust for Scotland
See also **John JACKSON**

A
B
C
D
E
F
G
H
I
J
K
L
M
N
O
P
Q
R
S
T
U
V
W
X
Y

Billy Meredith (1874–1958)
Football

Tall, bony and forever chewing on a match, this former Welsh miner was one of the first pin-ups of the terraces. The most famous player of the Edwardian period, he featured in advertisements to endorse Oxo gravy, and the Great Central Railway had a poster urging travellers to 'see Billy Meredith secure the cup'. He joined Manchester City in 1894, and the following year won the first of his record 48 caps for Wales. In 1906, Meredith was banned for a season for his involvement in a match-fixing scandal. He was transferred to Manchester United, with whom he won a Cup winner's medal (having already won the Cup with Manchester City) and two league titles in 1908 and 1911. After the First World War, he returned to Manchester City for three seasons, before retiring in 1924 at the age of 50. Although a winger, he was a prolific goal-scorer, and he is said to have scored 470 goals in his career, including wartime games and friendlies. He played 670 league games, a record until 1963. Meredith is remembered for his role in setting up the Player's Union (later the Professional Footballer's Association) in 1907 to tackle issues such as the maximum wage and transfer fees. He became popular with other players, whose causes he championed, but rarely saw eye-to-eye with officials, who considered him a socialist radical.

Billy Meredith
Francis Fielding, 1904
Public Record Office

Jackie Milburn (1924–88)
Football

Jackie Milburn, with broken arm, shaking hands with Field Marshal Montgomery, Newcastle vs. Portsmouth, Fratton Park, 2 September 1950
Popperfoto

Tyneside's most idolised footballer, J.E.T. Milburn scored 177 goals in 353 league games for Newcastle and helped the team to three FA Cup Final victories in the 1950s. A player of great flair and a flamboyant goal-scorer, he lived up to his initials as one of the fastest centre-forwards of his day. Known as 'Wor Jackie', he saved his best strikes for the FA Cup, and won Cup winner's medals in 1951, 1952 and 1955. In the first of these, Milburn scored in every round, including both goals in the final. He used pace and ability to outwit defences; his ball control was extraordinary and he had a deadly shot from either foot. He won only 13 international caps, but his appearances yielded 10 goals. Uniquely, Milburn was once kidnapped on the morning of a match: in what was an unusual method of rag-week fundraising, Newcastle medical students held Milburn until the club met their ransom demands in time for the afternoon's match. Fortunately unaffected by the adventure, Milburn scored the goal to defeat Liverpool 1–0. When he left Newcastle in 1957, he surprisingly signed for the Irish league club, Linfield. He later worked in football management and as a journalist.

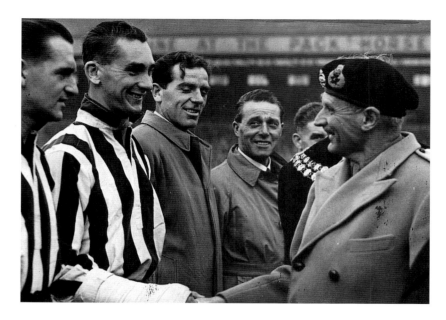

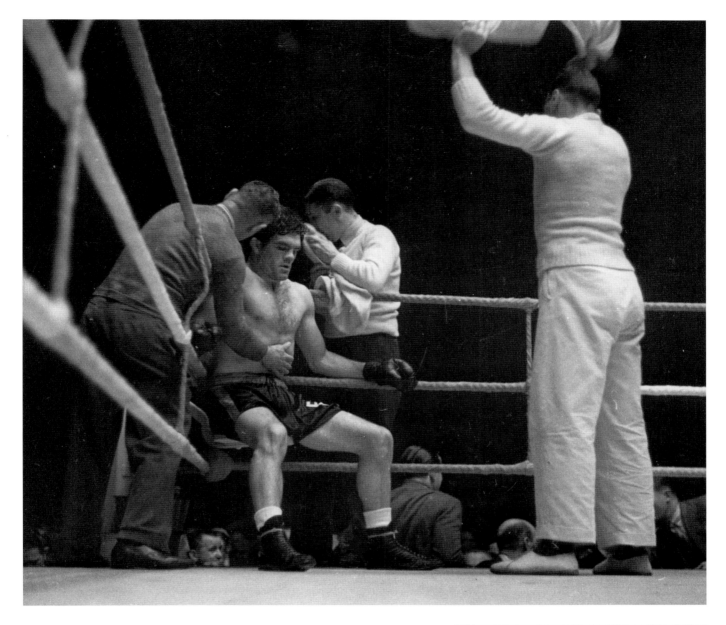

Freddie Mills (1919–65)
Boxing

Freddie Mills, British heavyweight title fight vs. Jack London, Belle Vue, Manchester, 30 September 1944
Felix Man for *Picture Post*
Hulton Getty

Like many of the best prize-fighters a century earlier, the pugnacious Mills learned to box the hard way in the fairground boxing booth. He developed into a two-fisted, aggressive puncher, never afraid to take on heavier opponents, and over half of his victories were knockouts. While serving in the RAF, he sensationally floored middleweight champion Jock McAvoy in the first round, and then accounted for the hugely popular **Len Harvey** in 1942, punching him over the ropes in round two. This victory took the boxing world by surprise, as Harvey had never previously suffered a knockout. An out-of-practice Mills lost his world lightweight crown to Gus Lesnevich in 1946; two years later, however, moving up a weight, he outpointed the American in his finest fight, to become the first British light-heavyweight champion since 1903. In addition, he now held British, European and Empire crowns. In the absence of any decent opponents, Mills twice challenged for the British heavyweight title, losing to Jack London in 1944 and Bruce Woodcock in 1946. His last fight was in 1950, after which he retired. Fifteen years later he was found shot dead in his car outside his Soho nightclub. Although suicide was suspected, the incident was never fully resolved.

A B C D E F G H I J K L M N O P Q R S T U V W X Y Z

Colin Montgomerie (b.1963)
Golf

To date, Colin Montgomerie's career has proved him to be the player with the most consistent game in Europe. In 1997 he topped the European Order of Merit for a record fifth year in succession with winnings totalling £1,583,904. The previous record holder was Peter Oosterhuis, who won four years running between 1971 and 1974 with total winnings of £77,375. In 1993 alone Montgomerie won £798,145, more than ten times Oosterhuis' total figure, and overall his career winnings exceed £6.7m. By the end of 1997 Montgomerie had won 14 events on the European Tour, but victory in a 'Major' championship continued to elude him. Internationally, he has played in the Ryder Cup four times, in 1991, 1993, 1995 and 1997. In the last, which was the first played on the continent of Europe, Montgomerie halved the vital match to secure a hard-fought European victory. He has also represented Scotland in the World Cup of Golf five times, and was individual winner in 1997.

ERC

Colin Montgomerie
US PGA, 15 August 1997
Jamie Squire/Allsport

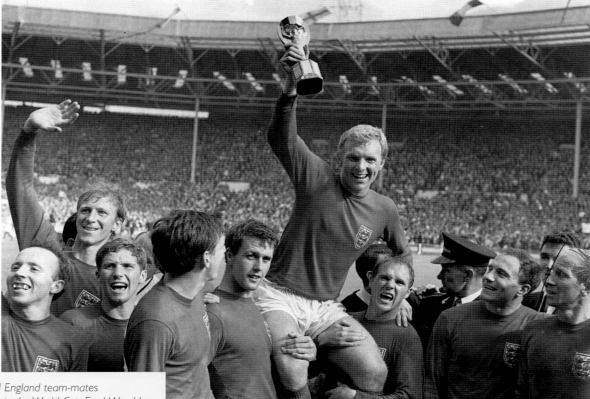

Bobby Moore and England team-mates celebrating victory in the World Cup Final, Wembley, 30 July 1966. (l to r): Nobby Stiles, Jack Charlton, Alan Ball, Martin Peters, Geoff Hurst, Bobby Moore, Ray Wilson, George Cohen, Bobby Charlton
Bippa, Hulton Getty
See also **Sir Geoff HURST** and
Sir Bobby CHARLTON

1966 World Cup Final

Hugh McIlvanney, doyen of British sports journalism, recalls the most famous moment in English football: 'nonchalantly breasting the ball down in front of Banks, Bobby Moore moved easily away, beating man after man. Glancing up, he saw Hurst ten yards inside the German half and lifted the pass accurately to him. The referee was already looking at his watch and three England supporters had prematurely invaded the pitch as Hurst collected the ball on his chest. At first he seemed inclined to dawdle out time. Then abruptly he went pounding through in the inside-left position, unimpeded by the totally spent German defenders, his only obstacle his own impending exhaustion...Hurst summoned the remnants of his strength, swung his left foot and smashed the ball breathtakingly into the top of the net...Stiles and Cohen collapsed in a tearful embrace on the ground, young Ball turned wild cartwheels and **Bobby CHARLTON** dropped to his knees, felled by emotion. Within seconds the game was over.' In the commentary box, as **Geoff HURST** moved towards the German goal, Kenneth Wolstenholme uttered the now-famous words: 'They think it's all over... it is now.' England had won 4–2, and the country witnessed celebrations not seen since VE Day.

Bobby Moore (1941–93)
Football

England's football captain in the country's finest sporting hour, the 1966 World Cup Final, should have been a bigger national hero than he was. When cancer killed him at the age of 51, the obituarists all asked why a man of Moore's stature had not been more involved in the game after his retirement – as manager, spokesman, or ambassador for the sport. Born in the East End, he played for West Ham from 1958 to 1974. Moore's domestic honours – an FA Cup followed by a Cup Winner's Cup – are a trifle compared to his international career. Earning 108 England caps (90 of these as captain), he played in three World Cups, coming of age in 1962, the player of the tournament in 1966, and returning to the stage in 1970 as one of the world's great central defenders. According to Hugh McIlvanney in 1993, Moore had an 'aura of imperious authority ... he patrolled his extensive area of influence, straight-backed, handsome, head up and eyes sweeping the field like a radar scanner ... His tackling was precisely timed and uncompromising and his brilliantly early and economical distribution constantly transferred pressure from his own to the opponent's goal area ... Just about everything he did, important or trivial, was characterised by efficiency and neatness'.

Adrian Moorhouse (b.1964)
Swimming

Aged only 18, Moorhouse won his first Commonwealth Games gold medal in the 100m breaststroke, giving Britain its most exciting swimming prospect: the following year, he won the 200m in the 1983 European Championships, and established himself as favourite to repeat these successes at the Los Angeles Games in 1984. But a combination of German measles, subsequent lack of training, over-confidence and poor tactics cost him dear as he finished fourth in the 100m and failed to qualify for the 200m final. His moment of Olympic glory had to wait another four years.

Despite occasional inconsistency, from 1983 to 1989 he won successive gold medals at the European Championships, and also three golds in the Commonwealth Games between 1982 and 1990. He began 1988 by breaking the 100m record, and arrived in Seoul for the Olympics as favourite. Moorhouse kept his nerve, winning a 'photo finish' from Hungarian Karoly Gutter, to take the gold medal. He broke the world 100m breaststroke record again in 1990, but failed to make it to a third Olympics in 1992. (Illustrated under **Duncan GOODHEW**)

Cliff Morgan (b.1930)
Rugby union

Cliff Morgan, British Lions vs.
South Africa, Johannesburg,
10 August 1955
Prior for Central Press
Hulton Getty

Many believe that Cliff Morgan was the finest of a long line of Welsh fly-halfs. Short and sturdy, his quick thinking, deceptive running, and reading of the game were crucial in converting team possession of the ball into try-scoring opportunities. He made his international début in 1951, and inspired Wales to the Triple Crown the following year. Always a strong performer against southern hemisphere sides, he was on the winning side for both his club Cardiff and his country against the All Blacks in the 1953–4 season. He was voted player of the series on the 1955 British Lions tour to South Africa, where he is still considered the best British fly-half to visit. He also captained Wales to the 1956 Five Nations Championship. Patriotic to the core and a fine singer, he was often to be heard leading the chorus of 'Land of My Fathers' *en route* to away fixtures. He retired in 1958, turning down a lucrative offer from Wigan to switch to rugby league: instead he joined the BBC, becoming Head of Outside Broadcasts and a well-known radio broadcaster. He remains an astute and eloquent observer of the game, and one of Wales' most popular sporting sons.

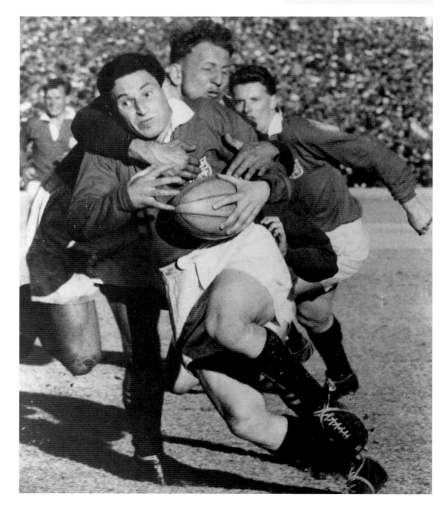

Tom Morris Junior (1851–75)
Golf

Tom Morris Junior was the greatest golfer of his generation. Son of **Tom Morris Senior**, he quickly eclipsed his father's exploits, winning his first tournament aged 13 and playing in his first Open Championship in 1866. He won the Open three years in succession, in 1868, 1869 and 1870; the last victory entitled him to keep the Challenge Belt. No competition was held in 1871 but he won the Championship again in 1872. He also won eight tournaments at St Andrews, Leven, Carnoustie, Musselburgh and Hoylake between 1867 and 1872, in an era when very few tournaments were held. In direct contrast to his father, he was an outstanding putter. He had power and dash in his long game and a quality of brilliance that could produce an extraordinarily great shot when it was needed.

He suffered tragedy in his personal life, never recovering from the death of his wife and child in September 1875. Two months later, already in low spirits, he played six rounds of golf in three days in freezing conditions on a snow-covered course. He died of a burst artery in his lung three weeks later, on Christmas Day, 1875, aged only 24. PNL

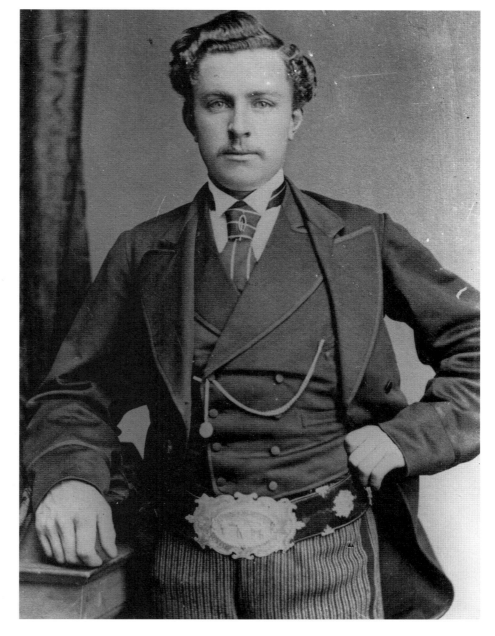

Tom Morris Junior wearing the Open Championship Belt
Unknown photographer, c.1870
Cowie Collection, St Andrews University Library

The Open Championship

In 1860 the first Open Championship was played at Prestwick over 36 holes. The prize was the Challenge Belt commissioned by Prestwick Golf Club and Willie Park was the first winner. The competition was held at Prestwick until 1870 when Tom Morris Junior won his third consecutive championship, winning the Challenge Belt outright as stated in the original rules. There was no tournament in 1871, and since 1872 the Championship has been played over a rota of courses with the Claret Jug as the prize. In 1892, the Open was increased to 72 holes over two days, and due to multiplying entries, had increased to four days by 1966. From an original entry of eight players in 1860, numbers increased with ever greater speed, to reach 2,200 in 1997. Similarly, the prize money has grown, from a modest £10 in 1863 to a fantastic £1.6m in 1997. A major factor in the increased popularity of the game has been television, with the first live coverage being broadcast in 1955. ERC

Tom Morris Senior (1821–1908)
Golf

Tom Morris Senior came to symbolise golf in the nineteenth century, and in later life was considered the 'Grand Old Man' of the game. Born in St Andrews, he quickly became one of the leading professionals of the era, while working as a feather ballmaker for **Allan Robertson**. However, he and Robertson had a falling out over the new gutta percha ball and in 1851, Morris was invited by his patron Colonel J.O. Fairlie to become the Keeper of the Green at the new Prestwick Golf Club. Morris won the Open Champion-

ship four times, in 1861, 1862, 1864 and 1867. Returning to St Andrews in 1864 as Keeper of the Green, he held this position until his retirement in 1903. During his career, he designed or worked on at least 69 British golf courses. As a golfer, he was long and straight off the tee and his approach shots to the green were one of his strengths. A good long putter, he was less reliable close to the hole. A letter was once sent to him, addressed to 'The Misser of Short Putts, Prestwick'; the postman carried it straight to Morris. PNL

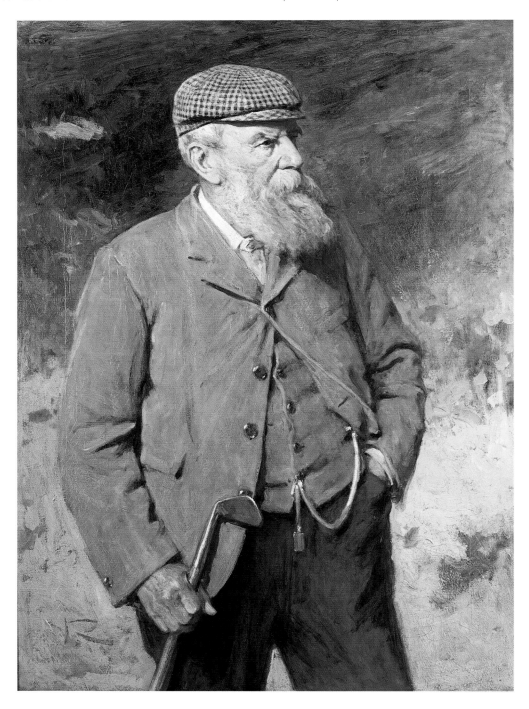

Tom Morris Senior
Sir George Reid, 1903
Oil on canvas, 1130 × 834mm
Royal and Ancient Golf Club
of St Andrews

Angela Mortimer (b.1932)
Tennis

Christine Truman and Angela Mortimer (r),
Wimbledon, 8 July 1961
Douglas Miller for Keystone
Hulton Getty
See also **Christine TRUMAN**

A mainstay of the renaissance of British women's tennis in the 1950s and early 1960s, Angela Mortimer reached the last eight at Wimbledon six times between 1953 and 1960. At one time three of the top seven seeds were British (**Ann JONES** at number three, **Christine TRUMAN** at number six and Mortimer at number seven). Runner-up at Wimbledon to America's Althea Gibson in 1958, Mortimer returned to the centre court in 1961 for the only all-British final since 1914: she beat Christine Truman 4–6, 6–4, 7–5, and became Britain's first champion since **Dorothy ROUND** in 1937. She also became world number one, having been in the top ten since 1953. Mortimer won three out of the four Grand Slam events, winning the French title in 1955, and the Australian in 1958: remarkably she made only one appearance in the Australian tournament, playing five games and winning them all, but never returning to defend her title. In the 1955 Wimbledon ladies doubles, she and Anne Shilcock became the only all-British women's pair to win since the Second World War.

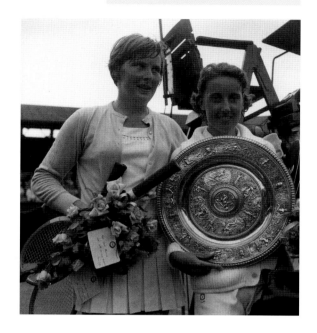

Alan Morton (1893–1971)
Football

The first star name in Scottish football, Morton made 31 international appearances – a record until 1952. He joined Rangers from Queen's Park in 1920 and, playing 495 games for the Glasgow club, shared in eight league championship titles in 10 seasons, and won two Scottish FA Cup medals and two runners'-up medals. The highlight of his career came when he was the architect of Scotland's 5–1 win over England at Wembley in 1928, while team-mate Alec Jackson scored a hat trick. The team were thereafter known as the 'Wembley Wizards' and according to the *Glasgow Evening News*, 'Morton … was half strangled by jubilant Scots at the close of the game. With attendants pulling him one way and his countrymen tugging the other, Alan thought he was going to be distributed as a souvenir.' Nicknamed the 'wee blue devil', Morton stood at only 5ft 4in, but was the complete all-round player, strong, well balanced, skilful on either foot, and a winger of great pace capable of creating and scoring important goals. A qualified mining engineer who would work on Saturday mornings before a match, he was unusually appointed a director of Rangers on his retirement as a player in 1933.

The Wembley Wizards

On 31 March 1928, Wembley witnessed the greatest day in Scottish football, as England were beaten by the unfancied Scots 5–1. Journalist Sandy Anderson wrote in the *Evening News*, 'Full revenge was extracted for all the London press forecasts about Scotland's midgets being foredoomed to heavy defeat. From toe to toe the ball sped. The distracted enemy was bewildered, baffled and beaten. One bit of weaving embraced eleven passes and not an Englishman touched the sphere.' The Scots had no chance, according to the form book. The Scottish selectors inspired little confidence, leaving out **Jimmy McGRORY**, but recalling an out of practice **Hughie GALLACHER** after injury. Three minutes into the game, Alec Jackson headed home Alan Morton's inch-perfect cross. The five-man attack consistently bore down on the English goal. Morton covered every blade of grass, tackling then setting up the attacks. **Alex JAMES** dominated the midfield and scored two goals, Alec Jackson scored a hat trick. Scotland humiliated England on their home turf. From then on, no Scottish schoolboy could call himself a patriotic fan if he was unable to recite the names of the newly christened Wembley Wizards: Harkness, Nelson, Law, Gibson, Bradshaw, McMullan, Jackson, Dunn, Gallacher, James and Morton.

Stirling Moss (b.1929)
Motor racing

The greatest runner-up in the history of motor racing, Moss enjoyed – or endured – seven seasons of finishing either second or third in the Drivers' Championship. Perhaps because of his status as a non-champion, Moss has remained among the most popular British sporting celebrities. His name has entered the national idiom with the sarcastic remark: 'and who do you think you are, Stirling Moss?' He was determined to drive only British cars at the outset, but having won little, joined Maserati for a season in 1954 before teaming up with Juan Manuel Fangio at Mercedes in 1955. They dominated the season, coming first and second in the Championship, with Moss winning his first race, fittingly the British Grand Prix. With Mercedes' withdrawal from Formula One, Moss returned to Maserati in 1956 and then drove with Vanwall in 1957. The result in both seasons was the same: Fangio first, Moss second, despite the Briton's two Grand Prix wins in 1956 and three in 1957. On Fangio's retirement, Moss expected success in the 1958 season: his four wins put him on course, but his disappointment was huge when he finished one point behind **Mike HAWTHORN**. After six more victories in British cars (taking his total to 16 from 66 Grands Prix) Moss retired in 1962 after a near-fatal accident.

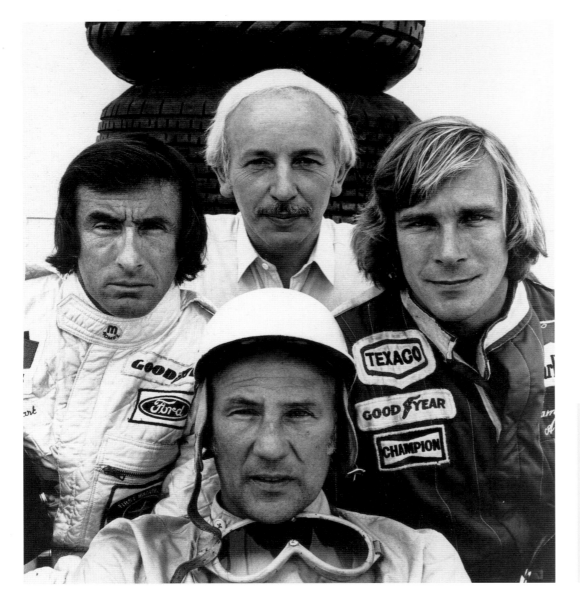

(clockwise from left): Jackie Stewart, John Surtees, James Hunt, Stirling Moss taken for The Great British, *1979* Arnold Newman National Portrait Gallery
See also **Jackie STEWART**, **John SURTEES** and **James HUNT**

Alex Murphy (b.1939)
Rugby league

A brilliant scrum-half, crafty and unpredictable, Murphy was able to read the game and see openings before anyone else on the pitch. His acceleration also won him 275 tries in his career, a big tally for a scrum-half. But he had many detractors; his cheeky and clever play often verged on the showy and selfish, as he always looked to be the star attraction. Born in St Helens, he brought a hat-full of honours to his hometown club. In the 1958–9 championship season, the Saints won 31 out of 38 games, and became the first club to top 1,000 points. The side retained the title in 1960, and again won it two years running, in 1965 and 1966, the year they also won the Challenge Cup. After ten years, Murphy left St Helens to join the unfancied Leigh team as player-coach, leading them to a Challenge Cup win in 1971. He then joined Warrington, who won the league title in the 1972–3 season and the Challenge Cup in 1974: Murphy thus became the first player to captain three different sides to Wembley Cup victories. In 1958 and 1962, he toured Australia with Great Britain, in all playing 27 test matches.

Alex Murphy
Daily Express, c.1960
Hulton Getty

A
B
C
D
E
F
G
H
I
J
K
L
M
N
O
P
Q
R
S
T
U
V
W
X
Y
Z

Alfred Mynn (1807–61)
Cricket

'The Lion of Kent', Mynn was cricket's first national figure and England's greatest player before the 'golden age' of cricket in the years 1890 to 1914. This Kentish hop merchant first appeared at Lord's in 1832, and for over two decades was the outstanding player in the team of 'Gentlemen' who regularly took on the 'Players'. A member of the Kent team until 1854, his presence made the county the strongest side in England. Mynn was also the leading cricketer in William Clarke's All England XI from its foundation in 1846 until 1854. His batting style was a little rustic compared to modern stroke-play, and he used his physical presence to thump the ball over the boundary. Also without equal as a bowler, he earned himself the title of 'The Champion' long before **W.G. Grace** took it on. William Denison described Mynn in 1846 as 'one of nature's finest specimens ... Not merely was he an excellent and powerful bat, but his bowling came upon the mass of the cricket public with startling effect. There was not anything like it wither for extraordinary rapidity of pace, or accuracy of length and general steadiness. Ere the batsmen ... could often times get their bats down to play his bowling, the stumps were shivered.'

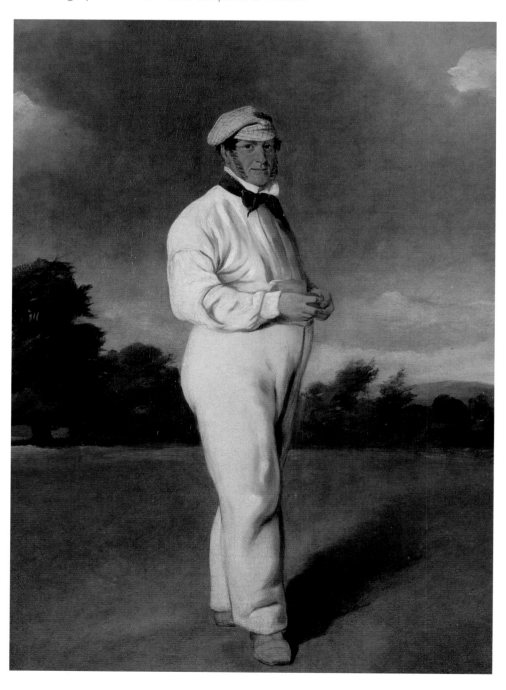

Alfred Mynn
William Bromley, c.1850
Oil on canvas, 813 x 647mm
Marylebone Cricket Club

Ernest Needham (1873–1936)
Football

Long before 'Chopper' Harris played for Chelsea and Norman 'bites yer legs' Hunter played for Leeds in the 1970s, Sheffield United had their own defensive hard man, in the shape of Ernest 'Nudger' Needham. Also known as 'The Prince of half-backs', Needham earned his nickname, according to *The Football Who's Who* of 1935, 'because of his habit of gently charging much bigger opponents off the ball ... his persistence and brilliance overshadowed his opponents ... they still talk at Sheffield of how Needham used to shout at colleagues "Leave it to me!" And leave it they did.' A small man, and modest on the field, Needham combined a cat-like agility with a determination to win the ball at all costs. Captaining his side, he led by example, covering every blade of grass in his team's cause. His presence in defence for Sheffield United spanned 20 years, from 1891 when Needham first signed for the club. Two years later the team were promoted to the first division. By 1897, Sheffield United were established among football's élite, and finished runners-up, becoming Champions in 1898, FA Cup winners in 1899, and runners-up again in 1900.

Ernest Needham
Ogden's Famous Footballers,
cigarette card series, 1908
The Trustees of the British Museum

Gwyn Nicholls (1874–1939)
Rugby union

At Cardiff Arms Park, once the proud home of Welsh rugby, the Gwyn Nicholls Memorial Gates pay tribute to the most celebrated of all Welsh players. Nicholls won 24 international caps by 1906, and became the first Welshman to play in a British rugby XV. Known as the 'The Prince of centres', he was a versatile all-round player and, according to his contemporary Rhys Gabe, Nicholls' greatest asset was 'in subduing his own ability in order to achieve combination with his fellows'. He reached legendary status when in 1905 he led Wales to victory over the All Blacks: 'Gather round, boys!' he told the team in the pre-match talk, 'The eyes of the rugby world are on Wales today, and it is up to us to prove that the Old Country is not quite barren of a team that is capable of giving New Zealand at least a hard fight…be resolute in your tackling…there must be no hair-combing, and every man with the ball must be put down, ball and all … come on, let's get out.'

Gwyn Nicholls
Ogden's Famous Footballers,
cigarette card series, 1908
The Trustees of the British Museum

The Foundation of Rugby League

During the 1880s, Association Football (soccer) became increasingly popular, drawing large crowds and generating money for clubs and players. While football gained a wider appeal, professionalism in rugby was becoming inevitable, as coaches sought out the best players and money and gifts changed hands. This practice was exposed in 1888, when the Halifax player J.P.Clowes accepted £15 to buy equipment. In the same year, the northern clubs demanded to be paid a broken-time allowance for working hours missed while playing rugby. Although the best clubs were in the north, notably Yorkshire and Lancashire, rugby union was governed from the south. It was the southern clubs who determined that money should not enter the game when an all-club vote was carried out. There were complaints from the north that the Oxford and Cambridge University vote was granted to all the colleges, not just the two universities. Eventually, on 28 August 1895, 20 of the top clubs met in Huddersfield and decided to create the Northern Union, later the Rugby League.

Betty Nuthall (1911–83)

Tennis

The most successful British player ever in the US Championships, Nuthall was also, in 1927, the youngest finalist until 1976. In that final, aged 16 and serving underarm, she was outplayed by the foremost player of the day, Helen Wills Moody. Three years later, she was back in the singles final again. This time, serving overarm, she beat the top two seeds in succession to win the trophy, taking it outside the USA for the first time. Not until **Virginia WADE** in 1968 did another British woman win the title. Nuthall was also semi-finalist in 1931 and in 1933, when she lost again to Wills Moody in three sets. She twice won the US ladies doubles, in 1931 and 1933, and the mixed doubles in 1929 and 1931. In the French Championships, she won the ladies doubles in 1931, and the mixed doubles in 1931 and 1933, in the latter playing with **Fred PERRY**. Surprisingly, she never shone at Wimbledon but she remained in the world's top ten for five years out of seven between 1927 and 1933. In the Wightman Cup, she was the youngest ever to play for the national team, and defeated the redoubtable Helen Jacobs in her début match.

Betty Nuthall at the Royal Orphanage, Wanstead, 1932
Topham Picture Point

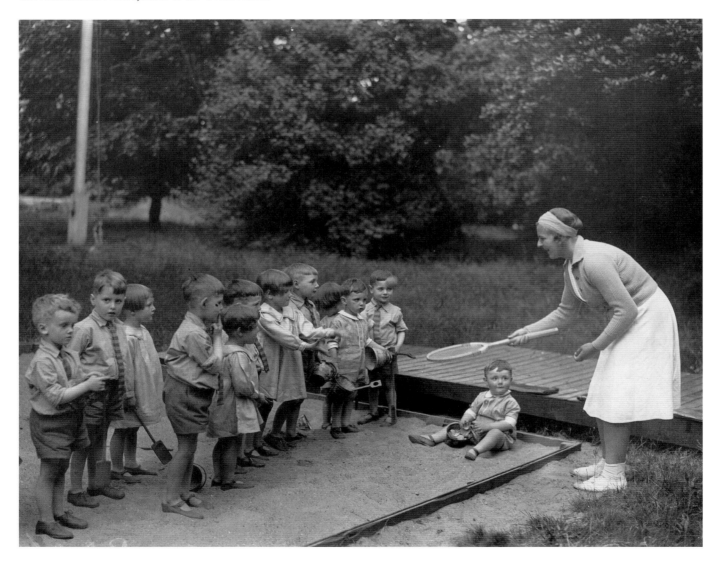

Martin Offiah
(b.1966)
Rugby league

Born in East London, Offiah became the first rugby league player to bring southern popularity to this largely North Country sport. A rugby union player for Rosslyn Park, and having already played for the Barbarians, Offiah signed for Widnes in 1987. A sensation from the outset, he was rugby league's leading try-scorer in his first four seasons. In the 1988–9 season, he scored 60 tries, twice the number of his nearest rival, and made his début for Great Britain in 1988. He broke the record for 100 tries, scoring them in only 70 matches. A world-class sprinter, he was nicknamed by the press 'Chariots' Offiah, and his pace, skill and power made Widnes one of the best sides in the league. In January 1991, he signed for Wigan for £400,000, nearly doubling the then record fee. The club then won three challenge cups, two championships, three premier trophies and two Regal trophies. Offiah played in 30 matches for Great Britain, touring with the British Lions in 1988, 1990 and 1992, and in August 1996, he signed for London Broncos.

Martin Offiah, England vs. Australia, Rugby League World Cup Final, Wembley, 28 October 1995
Anton Want/Allsport

Steve Ovett (b.1955)
Athletics

From schools competition in 1970, there was hardly a track event at 800m and 1500m that Steve Ovett failed to win. The final flourish of his career even brought a gold in the 5000m, at the 1986 Commonwealth Games. He ran in three Olympic Games from 1976 to 1984, but only the 1980 event yielded medals: disappointment was his only reward at the other two. Away from the Olympic arena, he rarely let himself down, dominating the European and World Championships from 1973 to 1981. He lowered the world mile record twice, and set three world records at 1500m. From 1977 to 1983, he set 12 British records, exchanging them regularly with **Sebastian COE**. On the track Ovett's devastating finish took competitors by surprise, and the crowd came to expect his cheeky wave and toothy grin on winning. Illness took its toll, however, at the 1984 Olympic Games. In defence of his 800m title, Ovett scraped into the final, but finished last and had to be carried from the track to hospital. Against medical advice, he took part in the 1500m, but this time, instead of collapsing at the tape, he pulled out altogether in the final lap: a sad end to a momentous track career.

(Illustrated under **Sebastian COE**)

Ann Packer (b.1942)
Athletics

A highly versatile teenage athlete, Packer competed in the sprints, hurdles and both long and high jump. By 1963, she had dropped all other disciplines to train for the 400m. Her fiancé Robbie Brightwell was Britain's leading 400m runner, and as they trained together, their hearts were set on a fairy-tale double gold medal at the Tokyo Olympic Games. Six months before the Games began, Packer took up the 800m as a distraction from her 400m training. In Tokyo, she ran a personal best in the 400m qualifiers and was confident of victory in the final, so her silver medal was a huge personal disappointment, compounded by Brightwell's failure to win a medal. Her consolation 800m event was still to come, but after her 400m 'failure', she had to struggle to prepare herself. When she crossed the tape in a new Olympic and European record, her 800m gold medal was the most unexpected of the Olympic Games; incredibly, it had only been her eighth serious race at the distance.

Ann Packer, Olympic 800m champion and PE teacher, Coombe County Girls' School, 2 November 1964
Keystone, Hulton Getty

Jonty Parkin (1897–1972)
Rugby league

Britain's first great scrum-half, Parkin played for Wakefield Trinity from 1913 until 1930. His loyalty was admirable: during his time he played alongside 21 partners at stand-off half, and had virtually no trophies to show for 17 years service. But he shone like a beacon in this struggling team, and soon became an ever-present Great Britain player in the 1920s. He was the first player to tour Australia in three Ashes Test series, winning all but three of the 17 tests in which he played. He was also the only captain to bring the Ashes home twice, in 1924 and 1928. Parkin was an agile and inventive player, and his home crowd at Wakefield idolised him. So it was a suprise when, in 1930, after 342 games, he left the club to join Hull Kingston Rovers at the age of 34. The manner of his departure shocked the world of rugby league: his price-tag of £100 was modest considering his achievements, and when Hull would not match the sum, Parkin paid the transfer fee himself. Such was the irregularity of this practice that the game's laws were changed so that it could not happen again.

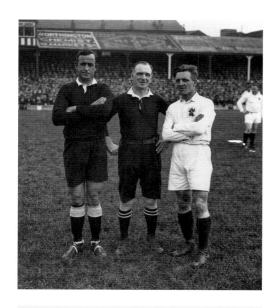

England captain Jonty Parkin (r) with New Zealand's Bert Avery and the match referee, Rugby League Test, Wigan 1926
Central Press, Hulton Getty

George Parr (1826–91)
Cricket

The son of a gentleman farmer from a cricket-playing family, Parr was for nearly 20 years the outstanding batsman of his day. He first played for the North against the MCC at Lord's in 1845, the year in which he began a 25-year association with Nottinghamshire. He took over the captaincy of the All England XI in 1857. Founded by William Clarke in 1847, this was the most successful and long-lasting of the professional wandering teams. Parr, 'The Lion of the North', played alongside **Alfred MYNN**, 'The Lion of Kent', and together they made a formidable partnership. Parr spanned two generations of cricket and batted for the Players against **W.G. GRACE** in the latter's first ever match for the Gentlemen. Despite suffering from lameness due to gout, Parr was a tireless cricket organiser and promoter. He introduced the annual match between the All England XI and the rival United England XI. In 1859, he took the England team abroad on their first-ever tour to Canada and the USA, returning unbeaten. He took another unbeaten team to Australia and New Zealand in the winter of 1863–4, and retired from the game aged 45 in 1871.

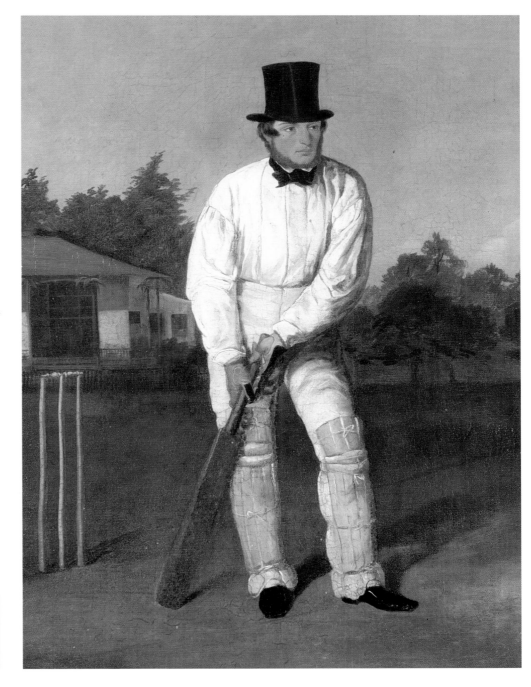

George Parr
William Bromley, c.1850
Oil on canvas, 762 × 610mm
Marylebone Cricket Club

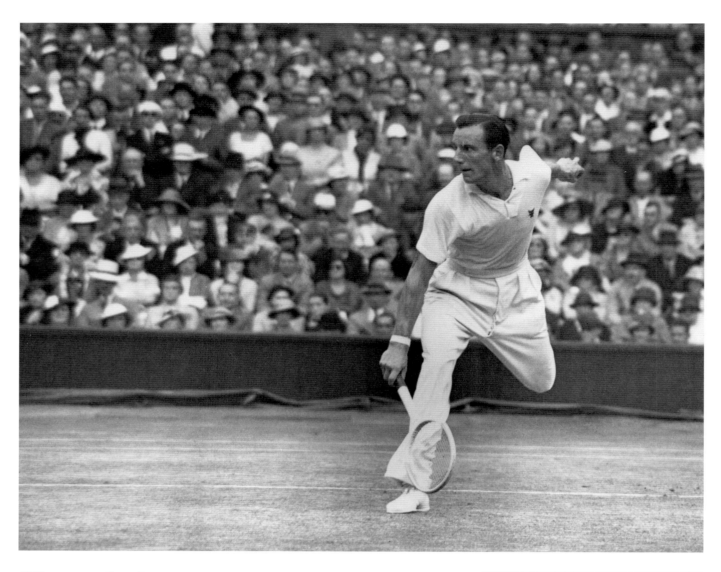

Fred Perry (1909-95)
Tennis

Fred Perry, Wimbledon Men's Singles Final against Gottfried von Cramm, 5 July 1935
Edward G. Malindine for the *Daily Herald*
National Portrait Gallery

Britain's most successful ever tennis player, Perry won a hat trick of Wimbledon singles titles from 1934 to 1936. The first British man to win Wimbledon since 1909, he restored some much needed pride to British tennis. For a while he was the world's number one player in two sports, tennis and table tennis, becoming world champion in the latter in 1929.

His first Grand Slam win was in 1933, when, defeating Australian Jack Crawford, he became the first Briton since **Laurie Doherty** 30 years earlier to win the men's singles title at the US Championships. Crawford was again Perry's victim in the Australian Championships singles final in 1934. Later in the year Perry won his first Wimbledon, against Gottfried von Cramm. The 1935 and 1936 tournaments in London and Paris began to have a familiar look as Perry met von Cramm in all four singles finals: out of four matches, Perry won three, failing only once in Paris. Perry became the first player to win all four of the world's major singles titles, although not simultaneously. He won eight Grand Slam singles titles between 1933 and 1936: three Wimbledons, three US, one Australian and one French. His greatest victory was perhaps his last, beating Donald Budge 10–8 in the final set of the US Championship in 1936. After this, he became a professional and moved permanently to America where, at the Beverly Hills Tennis Club, he numbered Errol Flynn and Charlie Chaplin among his doubles partners. He became a US citizen in 1940.

Mary Peters (b.1939)
Athletics

In 1955, 15-year old schoolgirl Mary Peters completed her first pentathlon. Forty-four events later, in 1972, she won the Olympic title in this most demanding of events. A veteran at 33, Peters had endured 17 years of bad luck and injury before achieving the ultimate Olympic goal – a gold medal combined with a world record: hers was one of the most popular medals ever awarded to a British athlete. Having won seven Women's Amateur Athletic Association pentathlon titles, as well as the Commonwealth title in 1970, and been fourth and ninth in the previous two Olympics, Munich 1972 was her last realistic chance of Olympic glory. Pitted against local favourite Heidi Rosendahl, Peters held a first-day lead of 301 points: by the end the difference was a mere ten. In one of the most exciting pentathlons ever seen, four of the five events had been completed when Peters and Rosendahl were drawn in the same heat of the 200m. Rosendahl won, taking her score to 4,791 points, a world record … until Peters crossed the line 1.2 seconds later, taking her points tally to 4,801. In celebration, Peters defied her years, grinning from ear to ear and blowing huge kisses to the crowd. It was the most joyous sporting scene of 1972, and Peters was the comfortable winner of the BBC Sports Personality of the Year title. Two years later, in her fifth Commonwealth Games, she successfully defended her pentathlon title before retiring.

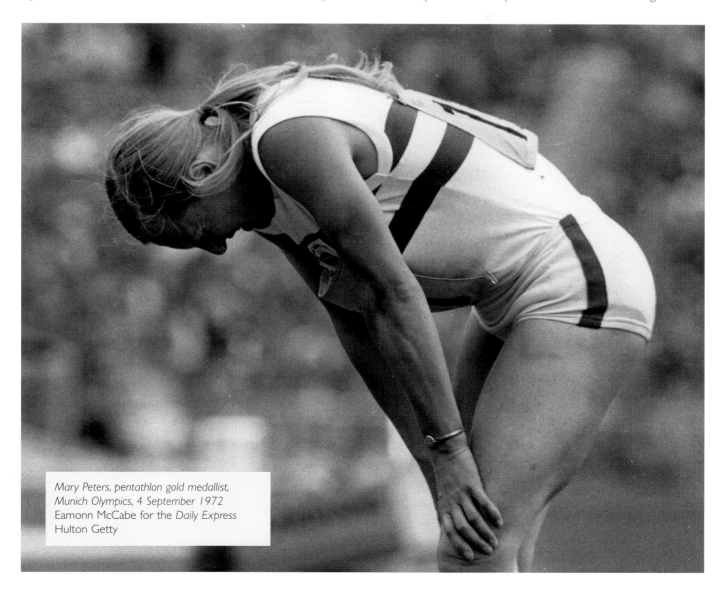

Mary Peters, pentathlon gold medallist, Munich Olympics, 4 September 1972
Eamonn McCabe for the *Daily Express*
Hulton Getty

Lester Piggott (b.1935)
Horse racing

Lester Piggott is a direct descendant of two of the greatest nineteenth-century jockeys, **John Barham Day** and **Tom Cannon**. His grandfather Ernest Piggott won the Grand National in 1919 and his father Keith, to whom he was apprenticed, was both trainer and jockey. 'The Long Fellow' rode his first winner at the age of 12, and at 18 won the 1954 Derby. His outstandingly successful association over the next 12 years with Sir Noel Murless included winning the 2,000 Guineas, the Derby and the Oaks in 1957. Piggott won the first of his 11 Champion Jockey titles in 1960; by 1967 he had won nine classics and, having acrimoniously loosened the ties with Murless, began to ride free-lance. Many of his greatest successes came on horses trained by Vincent O'Brien, including Nijinsky on whom he won the Triple Crown in 1970. Controversy over his erratic riding and his aggressive style dogged his career, however, and in 1954 his licence was suspended by the Jockey Club for six months. He was also imprisoned for tax evasion in 1987/8, but his popular return to the saddle was crowned with victory in the 2,000 Guineas in 1992, his thirtieth classic success in a career of 4,493 winners that made him the foremost jockey of his generation and without doubt the greatest Derby jockey of all time. HC

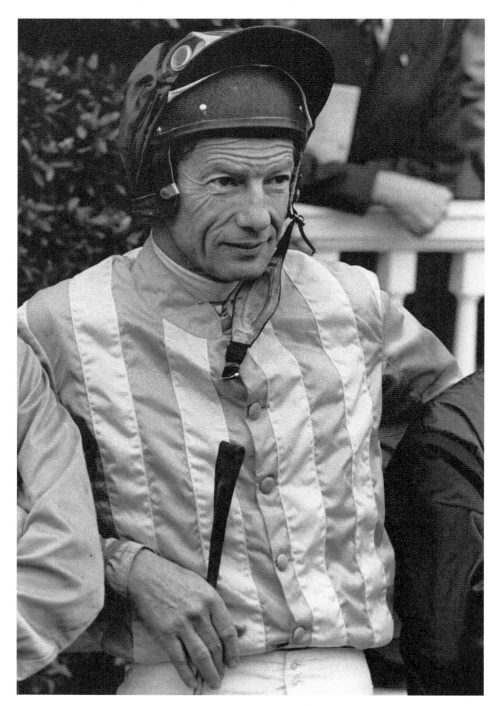

*Lester Piggott, Sandown Park,
21 October 1982
Chris Smith/The Sunday Times*

Gordon Pirie (1931-91)
Athletics

From 1951 to 1961, Gordon Pirie was the biggest draw in British athletics, and despite (or perhaps because of) never winning a gold medal in world competition, he became a highly popular figure, and was voted BBC Sports Personality of the Year in 1955. Known as 'Puff-Puff' Pirie because of his accentuated breathing pattern while running, he was inspired to become a long-distance runner, having watched Emil Zatopek in the 10,000m at the London Olympics of 1948. Pirie reached international class by 1951, winning his first Amateur Athletics Association (AAA) title, but at the Helsinki Olympics of 1952, he returned empty-handed, finishing seventh in the 10,000m and fourth in the 5000m. During his running career, he set 24 British records from 2000m to 10,000m, and was Cross-Country champion three years running from 1953 to 1955. At the 1956 Olympic Games Pirie finished second in the 5,000m, and eighth in the 10,000m. At home, he won six further AAA titles at three and six miles.

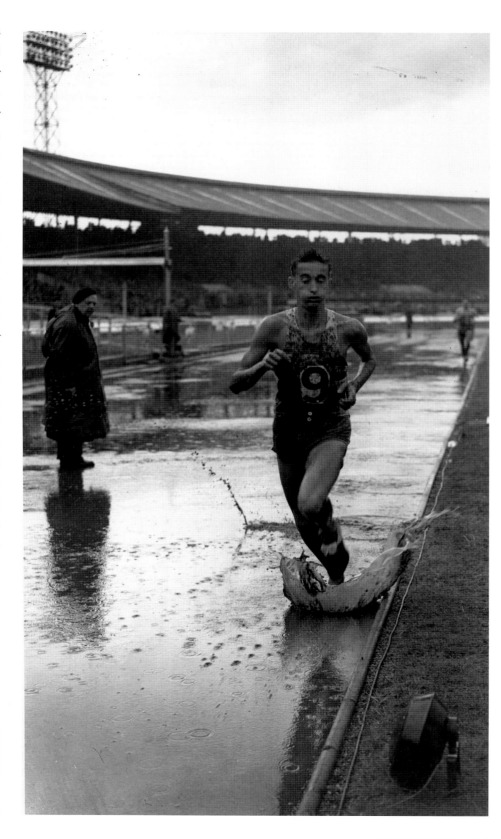

Gordon Pirie breaking the British three mile record, British Games, White City, London, 31 May 1952
Edward Miller for Keystone
Hulton Getty

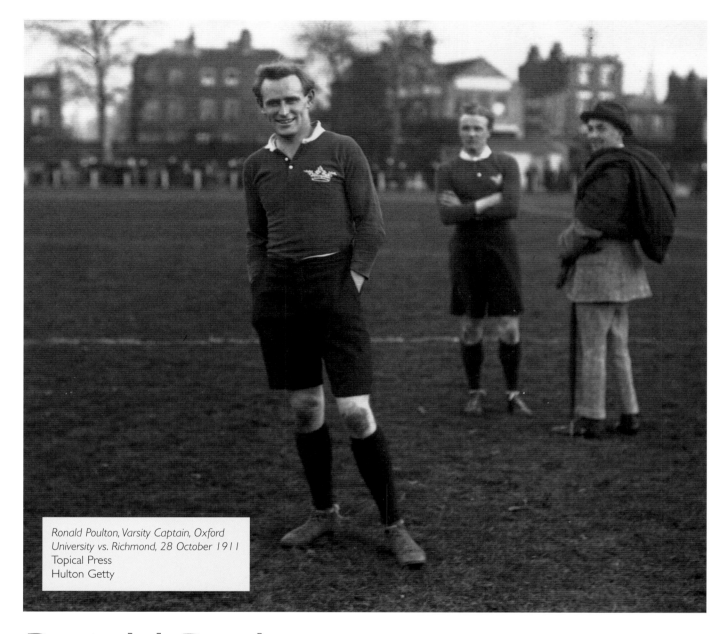

*Ronald Poulton, Varsity Captain, Oxford
University vs. Richmond, 28 October 1911*
Topical Press
Hulton Getty

Ronald Poulton (1889–1915)

Rugby union

Killed by a sniper's bullet in the trenches in 1915, the handsome and popular Poulton
was the outstanding rugby player in England in the years leading up to the First World
War. Having scored a record five tries for Oxford in the Varsity Match of 1909, he was
selected for England, for whom he made 17 appearances on the wing or at centre and
scored 28 points. In 1914, he scored four tries in a match against France, setting a
record for tries in a single international. After leaving Oxford, he inherited a fortune
from his uncle, G.W. Palmer, changed his surname to Poulton-Palmer, and joined the
family firm of Huntley & Palmer. His early death was much mourned, and it inspired a
poem by Alfred Ollivant, published in the *Spectator* in 1915.

> *Ronald is dead; and we shall watch no more
> His swerving swallow flight adorn the field
> Amid eluded enemies, who yield
> Room for his easy passage, to the roar
> Of multitudes enraptured, who acclaim
> Their country's captain slipping toward his goal,
> Instant of foot, deliberate of soul –
> 'All's well with England; Poulton's on his game.'*
>
> From 'RWPP (killed in the trenches)'

Foster Powell (1734–93)
Pedestrianism

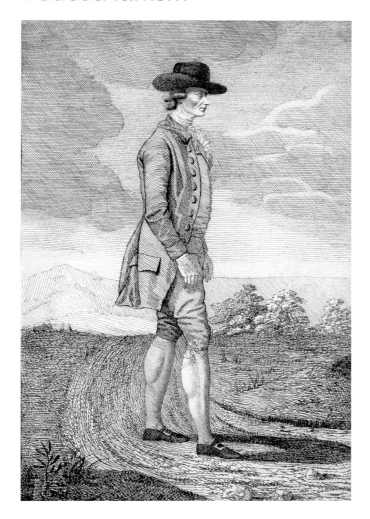

Powell, a mild Yorkshireman who worked as a solicitor's clerk in London, became famous for his walks from London to York and back. They started when he had gone to York to deliver some leases; a round trip of about 400 miles, which he completed, faster than any horse, in less than six days. This led in 1773, when he was nearly 40, to a wager that he could not repeat this trip in *less than* six days. He completed it with six hours to spare, repeating the journey in 1788 and 1790. Powell's final attempt was in 1792, at the age of 58, when he did it in five days, 13 hours and 15 minutes. Although these walks were potential money-spinners, he lived frugally and never earned any significant sums of money from his exploits.

Over a 28-year period, Powell engaged in various running and walking events, from one to 400 miles. He even went to France and Switzerland where he walked 200 miles beyond Paris and gained 'much praise'. In England he was the first pedestrian to become nationally famous and when he died, unexpectedly, at the age of 59, his funeral procession was followed by 'a very great concourse of people'.

PR

Foster Powell
S. Harding, 1788
Engraving, 270 × 180mm
Professor Peter F. Radford

Mary Rand (b.1940)
Athletics

As a teenager Mary Rand set national junior records in the long jump, the high jump, and the pentathlon: she proved such an all-round talent that she represented her country at ten events. Her Olympic baptism in 1960 was a disappointment, however, as she failed in the long jump, having been hotly tipped for a medal. Nonetheless she regained her confidence, and won bronze medals in the long jump and sprint relay at the 1962 European Championships. The 1964 Tokyo Olympics was a personal triumph for Rand as she returned with a hat trick of medals, one in each colour. Her long jump title was achieved with a new world record, the ultimate Olympic feat. She was the first British woman to win a field event, and uniquely there was a British long jump double at the same Games, with **Lynn Davies** winning the men's event. Rand's silver medal came in the most demanding pentathlon, and her bronze was as a member of the sprint relay team. After Tokyo, Rand was limited to a single gold medal in the 1966 Commonwealth Games long jump, injury having ruled out a third Olympic appearance.

(Illustrated under **Lillian Board**)

K.S. Ranjitsinhji (1872–1933)
Cricket

Colonel His Highness Shri Sir Ranjitsinhji Vibahaji, Maharaj Jam Sahib of Nawangar, was known as 'Smith' at Cambridge, but to the cricket fraternity, he was always just 'Ranji'. This Rajput prince was first selected to play cricket for England in 1896, and rising above the inevitable opposition to having an Indian in the team he scored 62 and 154 not out in his first two innings. In his first test match in Australia the following year, he made 175, and by 1900 he had twice scored over 3,000 runs in a season. Ranji captained Sussex for five seasons and between 1893 and his last game for the county in 1920, he scored 72 centuries, with a first-class batting average of 56.37. Tall and willowy, he was a wristy and supple batsman; in his silk shirts he was a sporting sensation, drawing large crowds to watch him, and was extremely popular especially with Edwardian ladies: a host of products bore his name, from sandwiches to hair restorer. A great Imperialist himself, Ranji's *Jubilee Book of Cricket* was fulsomely dedicated to Queen Victoria and in it he wrote that cricket was 'certainly amongst the most powerful links which keep our Empire together … one of the greatest contributions the British people have made to the cause of humanity'.

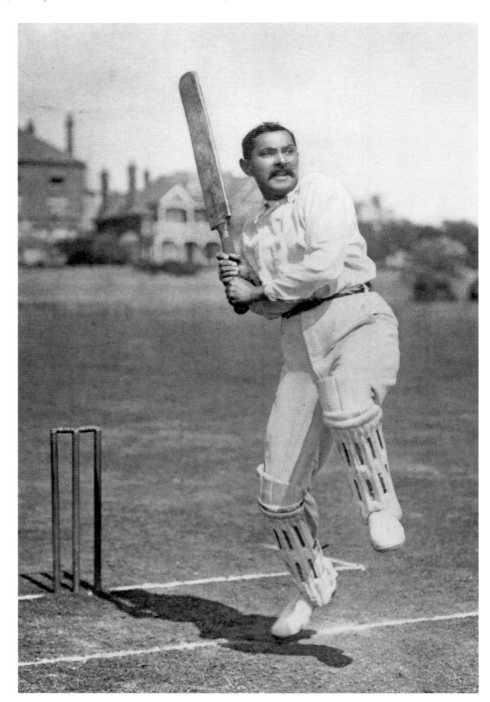

K. S. Ranjitsinhji
George W. Beldam,
1901
Michael Carr-Archer/
George Beldam
Collection

> *While I am thus writing about the beauty and impressiveness of technical prowess I cannot omit the famous name of Ranjitsinhji. Even now, when I want to have a little quiet wallow in the thought of something wholly delightful and perfect I think of Ranji on the county ground at Hove…nothing on earth could approach the special quality of Ranji's batting or fielding.*
>
> (Eric Gill, *Autobiography*)

Steven Redgrave (b.1962)
Rowing

One of the greatest British Olympians, Redgrave has four gold medals to his name, as well as seven world titles. Initially a sculler, he moved into a coxed four in 1984, and won his first gold medal in that year's Los Angeles Olympic Games. In 1986 he went into a coxed pair with Andy Holmes, and won the World Championships. An exhausting schedule proved no obstacle in either the 1987 World Championships or the 1988 Olympics: without a cox they won a gold medal at each event, adding a silver as a coxed pair in the first and a bronze in the Seoul Olympics. Holmes then retired, and was replaced by 19-year-old Matthew Pinsent. From 1991 to 1996, Redgrave and Pinsent were invincible, winning four world and two Olympic titles. After his fourth gold medal triumph, Redgrave announced his retirement almost while crossing the finishing line. But in the true style of sporting retirement, he returned, this time in a coxless four, to win a seventh World Championships medal.

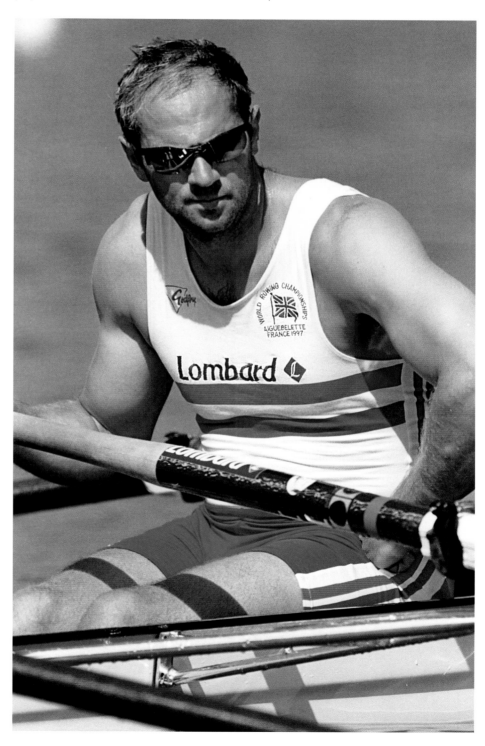

Steven Redgrave, World Rowing Championships, France, 1997
Mike Hewitt/Allsport

Ernest Renshaw (1861–99) and
William Renshaw (1861–1904)
Tennis

The Renshaw twins introduced some much needed vigour into the fledgling Wimbledon tennis tournament: the winners of the cup so far had been a man who called tennis 'monotonous', another on leave from his Ceylonese tea plantation, and a third a country parson from Yorkshire. The aggressive brothers from Cheltenham introduced a play-to-win approach which transformed tennis from a country-house pastime to a competitive sport. William was the greater of the two, and no man has ever repeated his straight six wins at Wimbledon between 1881 and 1886. Two of these consecutive victories were against his twin, and in his seventh Wimbledon win in 1889, William beat his brother again. Ernest won Wimbledon just once in 1888. As a doubles pair, they were almost invincible, pioneering the modern tactics of coming to the net simultaneously, and their hard serving and volleying came into its own. Their seven Wimbledon doubles titles in the 1880s were only overtaken by another brother pairing – the **DOHERTYS** – who won the title eight times between 1897 and 1905. The Renshaws took the game extremely seriously, playing a full English summer, then competing on the French Riviera at Cannes, where they had built themselves a tennis court.

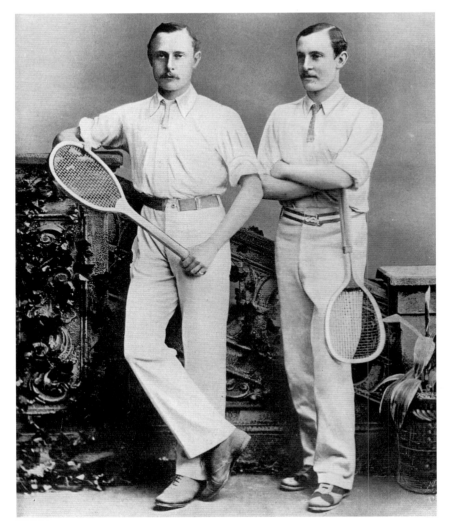

William and Ernest Renshaw, 1880s
Hulton Getty

The Evolution of Tennis

Royal tennis, or real tennis, originated in medieval France but it was in England that the courtly game survived. In 1596, Paris alone had 250 real tennis courts. By 1960 there were only two left in the whole country. In contrast, Britain had 16, three dated from the sixteenth century, with the remaining courts built by the Victorians. Lawn tennis, as played around the world today, was an English invention. In 1874, Major Walter Wingfield devised and patented the game, and began selling boxed sets with a net, balls, rackets and instructions on how to make a court. He saw that the new game could be played by simply raising a net on an already flat croquet lawn. Thus croquet was marginalised, much to the relief of early tennis apologist H.W.W. Wilberforce, who considered it a sport that 'fostered the ascendancy of the curate.' The Lawn Tennis Association was founded in The Strand, London, and took a lease on some land in southwest London. Here, in 1877, the first Wimbledon Tennis Tournament was held. Initially, the competition only comprised men's singles, but in 1879 doubles tennis was introduced and a ladies singles tournament was established in 1884. Ladies and mixed doubles trailed behind, only taking off in 1913. Only 16 players competed in the first men's tournament, cheered on by 200 people. By 1885, attendance had risen to 3,500.

Wilfred Rhodes (1877-1973)
Cricket

Wilfred Rhodes and **George Hirst** are often considered as more of a Yorkshire pairing than two individuals, but Rhodes also stands alone. His achievements, combined with his longevity, make him one of the most successful all-round cricketers ever. With unbeaten records of 4,187 first-class wickets and 16 doubles (100 wickets and 1,000 runs in a season), he topped 1,000 runs in 20 seasons, and exceeded 100 wickets in 23. His test-playing span of 31 years from 1899 to 1930 is also a record, and at 52, he is the oldest ever test player. One of only three cricketers to have played in every position in the batting order, he started at number 11 and worked his way up to opener:

his test average was 30.19. Together with **Jack Hobbs** at Melbourne in 1912, he enjoyed a partnership of 323 runs, an Ashes record which lasted for 77 years: he and Hobbs shared in seven more century partnerships. With his masterful spin bowling, Rhodes attacked the batsman's every weakness, and against Australia in 1902 he took 7 for 17 at The Oval. During the following series, he won back the Ashes for England with match figures of 17 for 134. Describing Rhodes' game in 1984, Neville Cardus wrote: 'Flight was his secret, flight and the curving line, now higher, now lower, tempting, inimical; every ball like every other ball yet somehow unlike, each over in collusion with the others, part of a plot. Every ball a decoy, a spy sent out to get the lie of the land; some balls simple, some complex, some easy, some difficult; and one of them – ah which? – the master ball.'

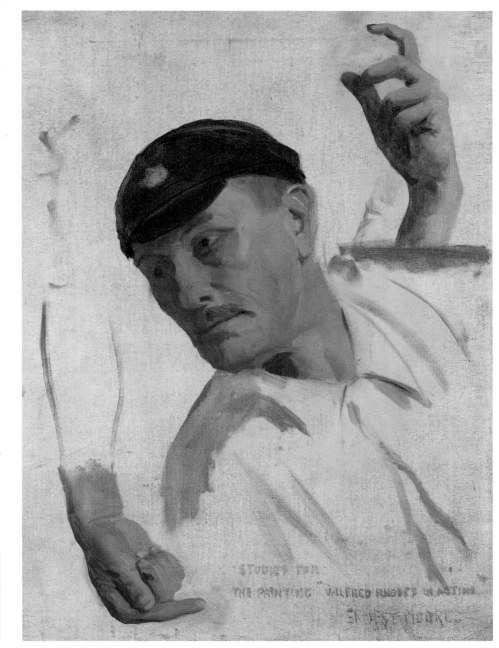

Wilfred Rhodes (studies for the painting Wilfred Rhodes in Action)
Ernest Moore, 1920s
Oil on canvas, 600 × 500mm
Bob Appleyard

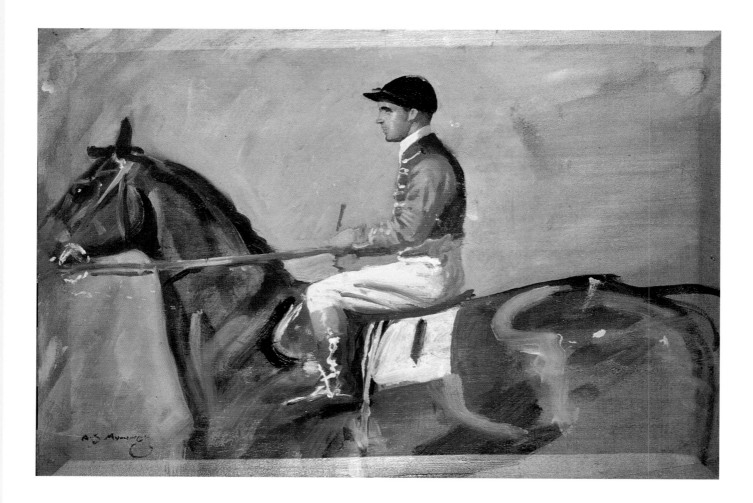

Sir Gordon Richards (1904-86)
Horse racing

Intended like his father for the mines, Gordon Richards was persuaded by two girls who worked with him to answer an advertisement for a stable apprentice in Martin Hartigan's yard. He won his first race in 1921. Between 1925 and 1953 he was Champion Jockey 26 times, beating all records and riding a total of 4,870 winners including 14 classics. Unorthodox in style and unmatchable in a finish, he earned himself the popular tag, 'Gordon always tries'. In three days in October 1933 he rode 12 winners in succession. Unfit for military service owing to an earlier tubercular episode, Richards won the 1942 wartime equivalent of the fillies' Triple Crown on the King's Sun Chariot, the best racehorse he ever rode. The Derby was to elude him on 27 attempts, but in 1953 he won an emotional victory on Pinza, beating the Queen's colt Aureole in a Coronation Derby that divided the loyalties of the nation. The following year after a serious paddock accident he gave up race-riding, but enjoyed a further 15 years as a trainer. In 1970 he was elected an honorary member of the Jockey Club, a unique distinction for a former professional rider, and he is the only jockey to have been knighted. HC

Sir Gordon Richards on Sun Chariot
Sir Alfred Munnings, 1942
Oil on canvas, 370 x 470mm
National Horseracing Museum

Tom Richardson (1870–1912)
Cricket

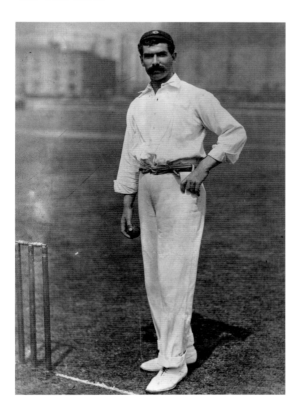

When consulted whether the number of balls in an over should be increased from five to six, this Herculean Surrey bowler replied, 'Give me ten!' Richardson bowled fast for as long as his captain demanded, and in the three seasons 1895, 1896 and 1897, he took 809 wickets, 290 in 1895 alone (the most ever taken in one season by a fast bowler). Surrey were county champions in four seasons while he was leading the attack. For England against Australia, he took 88 wickets in only 14 tests, including five wickets in each innings of his first match in 1893. He toured Australia twice in the 1890s, and headed the bowling both times, with 32 and 22 wickets respectively. His contemporary **C.B. Fry** described him as standing 'nearly seven feet high, with black hair and a southern complexion, something between a Pyrenean brigand and a smiling Neapolitan, brimful of fire and nervous strength. His arm is like the thong of a stock-whip and his leg as hard as oak…his back…must have double-action Damascus-steel fittings. He is the cheeriest and heartiest of mortals and has a splendid appetite. They keep special steaks for him at the Oval. He needs them!'

Tom Richardson
Reinhold Thiele for Topical Press, c.1905
Hulton Getty

Gus Risman (1911–94)
Rugby league

Gus Risman (r) and Harold Thomas with Bert Day (behind) celebrating Salford's victory against Barrow, Challenge Cup Final, 7 May 1938
Dennis Oulds for Central Press, Hulton Getty

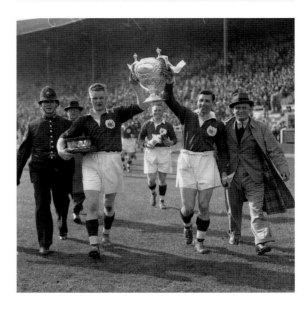

Risman's playing career of nearly 26 years is still the longest on record. He retired in 1954, at the age of 43, and two years earlier had become the oldest player ever in a Challenge Cup Final. In rugby league's all-time listings he stands second in terms of appearances (873), third in terms of points scored (4,050), and fifth in terms of goals kicked (1,678). The son of a Latvian sailor who had settled in Cardiff, the 17-year-old Risman was plucked from rugby union origins to play rugby league with Salford in 1929. A kicker of deadly accuracy, and a master tactician, he became one of the greatest centres the game had seen, and could also play at stand-off or full-back. Under Risman's leadership, Salford was the pre-eminent side of the 1930s, winning the championship three times, and the Challenge Cup in 1938. In 1946, he became player-coach with newly formed Workington Town, kicking 717 goals in 301 games and guiding the club to the Championship in 1951 and the Challenge Cup in 1952. Risman won 17 international caps, nine as captain.

Allan Robertson (1815–59)
Golf

Born and raised in St Andrews, Allan Robertson was the son of a golf ballmaker and caddie. Allan too became a ballmaker, but he was also a golfer of exceptional ability. In the late 1830s and early 1840s, the members of the Royal and Ancient Golf Club held tournaments for ballmakers, club-makers and caddies and Robertson won those held in 1837 and 1839. In 1842, he was prohibited 'by his brethren from competing on account of his superior play, it being their impression that they would have no chance in any contest in which Allan took part'. Between 1843 and 1846 he played a series of epic matches against Willie Dunn, and lost only one match (during 1844). He and **Tom Morris Senior** then played Willie and Jamie Dunn in 1849 and 1850, beating them on both occasions. Robertson made the golfing arrangements at the Royal and Ancient's Spring and Autumn Meetings, setting all the members' handicaps. He oversaw the conversion of the greens at St Andrews to double ones in 1856 and 1857, and also designed a very clever six-hole course, which opened in 1856, for the Cupar Golf Club. His death in 1859 at the age of 44 was much lamented.

PNL

Allan Robertson
Charles Lees, c.1847
Oil on paper, 505 × 317mm
Scottish National Portrait Gallery, Edinburgh

Professional Golf

The earliest records of professional golf survive from the first half of the nineteenth century when 'ballmakers, clubmakers and caddies' are known to have played in club-organised tournaments. The term 'professional' seems to have come into common use in the 1850s, although a living could not be made by playing golf alone. As the nineteenth century progressed, and the interest in golf increased, many new golf clubs were founded, with a corresponding rise in club professional posts. The status of professionals remained low, however, with even the top players relying on the support of amateurs. This began to change in 1901 when the Professional Golfers' Association was set up with the support of leading players. The PGA allowed some protection for its members and organised additional, regular competitions. The number of tournaments and their prize funds gradually increased until, in 1972, the PGA European Tour was formed. The number and wealth of tournaments has continued to rise with ever greater speed, fuelled by television and the increasing ease of international travel and communication.

ERC

James (Jem) Robinson (1793–1865)
Horse racing

Apprenticed to Robert Robson's stables in Newmarket, Jem Robinson learned much from the greatest jockey of the day, **Frank Buckle**. In later years he rode against Buckle in a number of famous matches including a dead-heat on an unnamed Vicissitude colt at Newmarket in 1821. The horse never forgot or forgave Robinson's savage use of the whip and when, two years later, Robinson visited Lord Exeter's stud, it attacked him on sight. In the summer of 1824 Robinson won the Derby, the Oaks and was married within the same week, a treble which netted him a wager of £1,000. By the time of his retirement – precipitated by an injury to his thigh which left one leg four inches shorter than the other – only Buckle's total of 27 classic victories exceeded his own 24. His nine victories in the 2,000 Guineas is unsurpassed and his six Derbys stood as a record until finally equalled and passed by **Lester Piggott**. A flamboyant lifestyle and generous spirit, however, left his finances in tatters and in later years he was saved from poverty only through the intervention of the Dukes of Rutland and Bedford. HC

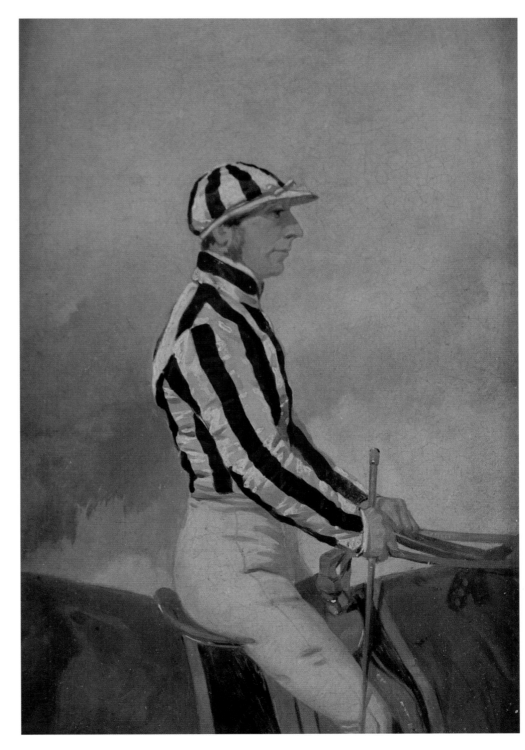

Jem Robinson (detail)
Harry Hall, 1850
Oil on board, 245 × 165mm
Jockey Club Estates Limited

Bryan Robson (b.1957)
Football

Bryan Robson
Liam Woon, 1990
National Portrait Gallery

Robson never offered tricks or wizardry, but exemplified the traditional English virtues of commitment. effort and bravery. Throughout the 1980s, his was the first name down on the England team-sheet, although he was plagued by injury, which meant that England were deprived of his services during the World Cups of 1986 and 1990. He won a total of 90 caps, playing many games as captain. As a midfielder he unusually scored 26 goals for England, most of them memorable. In domestic football, he was at the heart of the Manchester United team for over a decade, making his pres-ence felt in both penalty boxes and never shirking a tackle. Having transferred from West Bromwich Albion in 1981 for a record fee of £1.5 million, Robson played 345 games for Manchester United, scoring 74 goals. He captained the team to three FA Cup victories but although he shared in the title success of 1992–3 and the coveted league and cup double the following year, he was a bit-part player in these early winning years under manager Alex Ferguson, and was gradually eased out of the limelight. In 1994, he joined Middlesborough as player-manager.

Dorothy Round
(1909–82)
Tennis

The outstanding British female player of the 1930s, Round emulated **Kitty Godfree** by twice winning the Wimbledon ladies singles, in 1934 and 1937. She also became, in 1935, the first non-resident to win the Australian Championship. Although defeated by Helen Wills Moody in the Wimbledon final of 1933, Round had given the American a severe test, becoming the first player to take a set off her since 1927. She had also taken Helen Jacobs to three sets in their semi-final. In 1934, back in the final, she this time triumphed over Jacobs in three sets. With **Fred Perry** winning the men's singles, Britain enjoyed its first and only 'double win' since 1909. Round also won the Wimbledon mixed doubles three years running, playing with Perry in 1935 and 1936. A top ten player from 1933 to 1937, she was world number one in 1934 and regained her Wimbledon singles title in 1937.

Dorothy Round
Bassano, 1936
National Portrait Gallery

Ian Rush (b.1961)
Football

For almost 15 years with Liverpool, Rush was the most feared forward in the football league. Ungainly in stature, his nose for goal was uncanny, and partnered by **Kenny Dalglish** in the 1980s, his goals were the mainstay of Liverpool's long period of domination in English football. Initially slow in finding the back of the net following his move from Chester in 1980, Rush benefitted from Liverpool manager Bob Paisley's simple piece of advice to be more selfish. In the 1983–4 season, Rush scored 48 goals in 64 games. A predatory and instinctive striker, his off-the-ball running and intelligent passing were also a strong feature of his game. He overtook

Ian Rush
Tim O'Sullivan, 1991
National Portrait Gallery

'Dixie' Dean's record of goals in Merseyside derbies, and became Liverpool's leading goalscorer of all time. In the 1986 FA Cup Final, his two goals secured the league and cup double for Liverpool. In June 1987, he signed for Italian club Juventus, but it was a disastrous move for the Welshman, marred by illness, linguistic and cultural difficulties, not to mention uncompromising Italian defenders. He returned to Anfield after a season, and quickly rediscovered his form. Subsequent moves to Leeds and Newcastle have been a disappointment. He remains Wales' top goal-scorer in international football, with 28 goals from 73 games.

Tessa Sanderson (b.1956)
Javelin

In 1984, javelin thrower Tessa Sanderson became the first British woman and also the first black athlete to win an Olympic gold medal in a throwing event. Her longevity in the javelin contest – in which her competitive spirit never waned – is also remarkable, as she is the only British female athlete to have competed at five Olympic Games. In her last appearance at the Barcelona Games in 1992, she narrowly missed a second medal, finishing in fourth place. In addition to her Olympic success, Sanderson was thrice Commonwealth champion, and national champion for eight years, setting ten British records. At her Olympic début in 1976, she finished in tenth place. Two years later, she won her first major medal at the Edmonton Commonwealth Games. During her training for the 1980 Moscow Games she threw more than a metre further than the eventual gold medal winner, but on the day itself, her nerves got the better of her and she failed to make the final. But she made amends and took the gold at her third Olympics.

(Illustrated under **Fatima Whitbread**)

Tom Sayers (1826–65)
Pugilism

Sayers was the last great British bareknuckle fighter, and with his retirement interest in the prize-ring moved across the Atlantic, and America began its stranglehold on world boxing. From 1849 to 1859, all but one of Sayers' fistic encounters in London, Suffolk, Sussex and Kent went his way, as a string of challengers was dismissed. His last and greatest fight was in 1860 against the American John C. Heenan. Billed as the Championship of the World, the bout aroused phenomenal interest; 12,000 people travelled to Farnborough in Hampshire to witness the contest including peers and public figures such as Charles Dickens and William Thackeray; and there was an unprecedented assembly of reporters from both sides of the Atlantic. The fight itself didn't disappoint; after 2½ hours and 36 vicious rounds of bruising fisticuffs, Heenan could hardly see through the blood streaming down his face and Sayers' arm was broken. In the next round, the fight became a shambles; the crowd broke into the ring and the contest was abandoned. A draw was declared, with each man to receive a belt. Sayers was presented with £3,000 raised through public subscription and neither man ever fought again.

Tom Sayers, a fight history
Commemorative textile print,
522 × 730mm
Private Collection

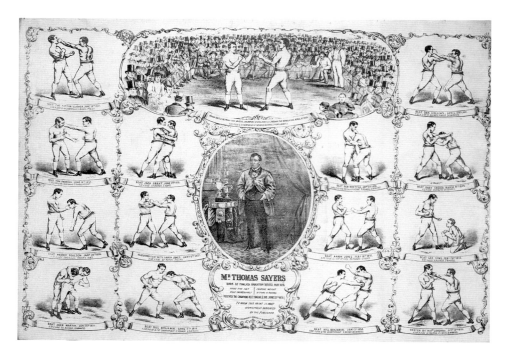

William Scott (1797–1848)
Horse racing

Abusive, aggressive and alcoholic, William Scott was the leading northern jockey of his generation. The son of a trainer, he was born in Newmarket and apprenticed in Middleham. In 1815 he became jockey to a Mr Houldsworth in Sherwood Forest, later joining his brother John Scott's training establishment at Whitewall, Malton, as his stable jockey. Together the brothers won 14 classics. William Scott still holds the record as the nine-times winner of the St Leger. Racing usually from the front and close to the rails, he spared his mounts nothing in fiercely driving finishes. Neither did he spare his fellow jockeys, abusing **James ROBINSON** and **Nat FLATMAN** before and during races. In the mid-1840s, William's increasing drunkenness brought the Scott brothers' partnership to a close and hastened the end of his career. In 1846 he won both the 2,000 Guineas and the St Leger on his own horse, Sir Tatton Sykes; he might have added the Derby too, gaining the first ever 'Triple Crown', had he not been so drunk that he was still shouting at the starter when his rivals had begun the race. He had his last ride the following year and was dead by the autumn of 1848. HC

Memnon with William Scott up, on Doncaster racecourse before the start of the 1825 St Leger
John Frederick Herring Senior, 1825
Oil on canvas, 675 × 845mm
Yale Center for British Art, Paul Mellon Collection

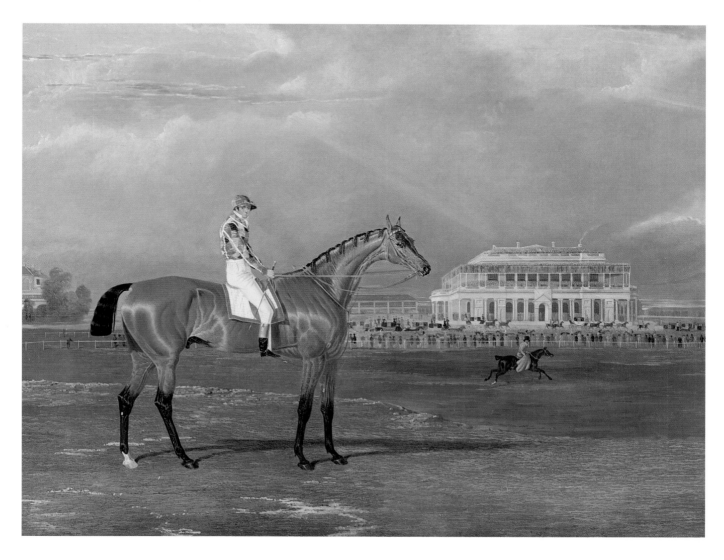

Peter Scudamore (b.1958)
Horse racing

Perhaps lacking the natural talent of his great contemporary **John Francome**, a combination of dedication and hard work made Peter Scudamore the most successful jockey in the history of National Hunt racing. After initial periods with David Nicholson and **Fred Winter**, Scudamore became stable jockey to Martin Pipe, and with the ammunition provided by the most influential jump trainer of modern times, rewrote every record in the book before retiring in 1993 with an astonishing 1,678 winners from 7,521 rides. The first jump jockey to ride 200 winners in a season, his record of 221 winners in 1988/9 stood until beaten in 1998 by another of Martin Pipe's jockeys, **Tony McCoy**. During 1981 and 1982 he shared the Jockeys' Championship with John Francome and was Champion again on seven further occasions. His wins include two Champion Hurdles, riding Celtic Shot in 1988 and Granville Again in 1993. Like John Francome he was never successful in the Grand National, a race his father had won on Oxo in 1959.

HC

Peter Scudamore, Wincanton, October 1988
Chris Smith /*The Sunday Times*

Alan Shearer (b.1970)
Football

Alan Shearer saluting the crowd, World Cup Qualifier, England vs. Poland, Katowice, 31 May 1997, with (l to r) David Beckham, Teddy Sheringham and Graeme Le Saux
Shaun Botterill/Allsport

The heir to **Gary LINEKER**'s golden boots for England, the pressure on Alan Shearer has been immense ever since his British record £3.3m transfer from Southampton to Blackburn in 1992. Four years later, he occupied the position of the world's most expensive player, when Newcastle paid £15m to prise him away from Blackburn. Shearer made his name with Southampton, where on his début in 1988, he displaced **Jimmy GREAVES** as the youngest player to score a hat trick in division one. Blackburn's investment paid off as the club's winning aspirations were realised when they won the premiership in 1995. Contributing 130 goals in three and a half years with the Lancashire side, Shearer became the first post-war player to score 30 goals in three consecutive seasons, and the first premiership player to pass 100 goals. Plaudits followed the goals: Player of the Year in 1994, PFA Player of the Year in 1995 and 1997. Injury has been unkind to Shearer, causing him to miss a significant number of games during his career: having scored on his international début in 1992 a knee injury cost him a place with England in the European Championships in the same year. He made up for the disappointment four years later, when he finished as Euro 96's leading marksman. Until the World Cup in France in 1998, Shearer had scored 18 goals in 38 games: his isolation in the group games, and England's untimely second round exit extended his goal tally by just two, a disappointment in his first World Cup Finals.

Barry Sheene (b.1950)
Motor cycling

Twice world champion at 500cc, Barry Sheene is lucky to be alive. Two high-profile crashes in particular made 'Bazza' a greater celebrity than his victories ever did. At Daytona in 1975 he broke a thigh, his wrists, a collarbone and six ribs; he later told reporters that he must have left enough skin on the track to cover a sofa. Incredibly, this happened the year before his two successive world titles. When he shattered both legs at Silverstone in 1982, he needed four metal plates and 23 screws to get him moving again. The public loved him for it: his ordeal coupled with his impish cockney manner and boyish good looks made him both a pin-up and television personality. Formerly a despatch rider, he won the British 125cc title as a 20-year old in 1971. He had to wait until 1976, however, before he won a world 500cc title on a Suzuki. With six wins in 1977, he retained the title that year, and was runner-up to the American Kenny Roberts in 1978. Roberts' pre-eminence and hat trick of 500cc titles denied Sheene the chance to improve on his career total of 19 Grand Prix wins. Eventually he began to feel his injuries on cold damp days, and in 1984 emigrated to Australia.

Barry Sheene
John Swannell, 1983
National Portrait Gallery

Arthur Shrewsbury (1856–1903)
Cricket

'Give me Arthur' said **W.G. GRACE** when asked to name England's second-best player. On difficult wickets, this Nottinghamshire batsman was considered even better than Grace himself, scoring 59 first-class centuries and ten double centuries. Along with James Lillywhite and county colleague Alfred Shaw, he organised four pioneering England tours to Australia; the games played there stood as the first test matches, and promoted cricket as the national game of the colony. As team captain in 1884–5, and again in 1886–7, Shrewsbury was greatly respected by his fellows for both his play and his sportsmanship. He was always immaculately turned out, and never without his cap, which he used to conceal his baldness. At the crease his timing and defence were unparalleled, and in the latter he was the first player to use his pads correctly. Shrewsbury's 164 at Lord's in 1886 stood briefly as the highest test score, and he was the first to score 1,000 runs against Australia. A frail constitution dogged him throughout his career, however, and, believing that he had an incurable malady, he shot himself in 1903.

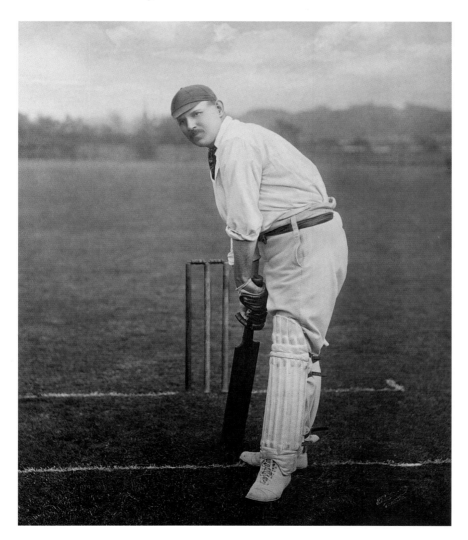

Arthur Shrewsbury
E. Hawkins & Co.,
Brighton, 1880s
Private Collection

Origins of the Ashes

In 1861–2, 1863–4 and 1873–4 English cricketers toured Australia for the first time. Matches were played on an 'odds' basis, with up to 22 opponents taking on the more experienced English. The first match recognised as a 'test', between two XIs, took place in Melbourne in 1877; Australia won by 45 runs. The following year, the Australians toured England, and although no test matches were played, the devastating skill of the tourists was demonstrated when they bowled out a strong MCC side for 19! They proved their worthiness as opponents; between 1880 and 1900 nine more Australian teams toured England, and eight parties from the mother country reciprocated (two of which were captained by the professional Arthur Shrewsbury). The first test match on English soil took place in 1880 and was won by the home team; thereafter, England won 24 games and Australia 18, with 6 drawn.

The generally accepted story of the Ashes is that after Australia beat England by seven runs at The Oval in 1882, a famously tense occasion, a mock obituary of English cricket was printed in *The Sporting Times*. It read:

IN AFFECTIONATE REMEMBRANCE
of
ENGLISH CRICKET
Which died at The Oval
on
29th August, 1882
Deeply lamented by a large circle of sorrowing friends and acquaintances.
R.I.P.
N.B. – The body will be cremated,
and the ashes taken to Australia

The next year, during England's tour of Australia, some ladies in the household of Sir William Clarke, president of the Melbourne Cricket Club, burned a bail and sealed the ashes in a small urn and presented it to the Hon Ivo Bligh, the Captain of England. The urn is kept permanently at Lord's, although the Ashes as a symbol of victory seem to have taken up permanent residence in Australia. JC

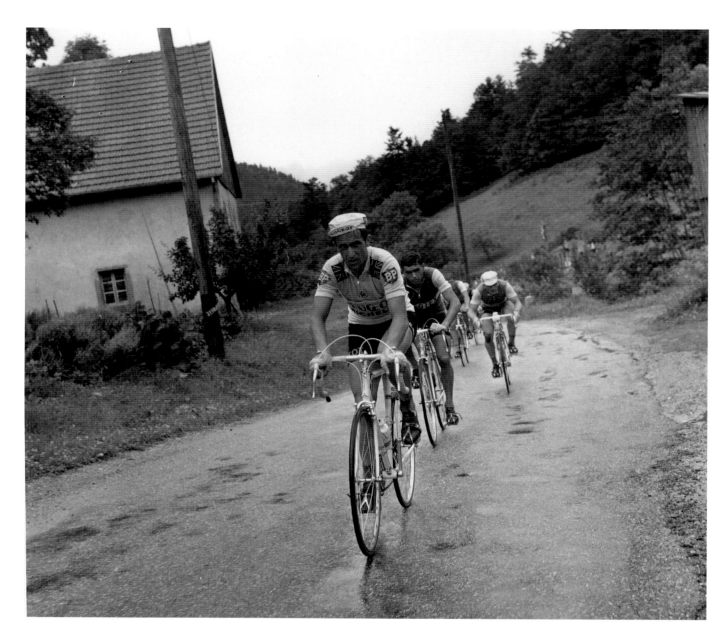

Tommy Simpson (1938–67)
Cycling

Tommy Simpson, Tour de France,
10 July 1967
Agence-France Presse
Hulton Getty

Tommy Simpson became, in 1962, the first British cyclist to win a stage in the Tour de France, and thus wear the coveted yellow jersey for a day. He turned professional in 1960, having enjoyed an amateur career which included a bronze in the team pursuit at the 1956 Olympics and an individual silver at the 1958 Common-wealth Games. He had more success in the one-day races than in the major tours: in 1961, his victory in the Tour of Flanders was the first British win at a classic for 65 years: subsequent wins included the Bordeaux–Paris race in 1963, Milan–San Remo in 1964 and

Paris–Nice in 1967. In 1965, he won both the Tour of Lombardy and the world professional road race and was voted BBC Sports Personality of the Year. Simpson died from heart failure in 1967, while competing in the Tour de France, on the notoriously demanding climb of Mont Ventoux. Amphetamines and other stim-ulants were found in his blood. Simpson's collapse and death made a deep impression, and he was eventually seen as a victim of leniency against widespread use of drugs in cycling.

G.O.Smith (1872-1943)
Football

According to **C.B. Fry**, writing in 1955, Gilbert Oswald Smith was 'a gem ... the finest man in his place who ever played for England ... He was inspired ... uncannily prehensile of foot and almost delicately neat. What made him was his skill in elusive movements, his quickness in seeing how best to bestow his passes, his accuracy and his remarkable penetrative dribbling. He swung a marvellously heavy foot in shooting – always along the turf and terrifically swift'. 'G.O.', as he was known, won 21 caps for England between 1893 and 1901. Educated at Charterhouse School, which was one of the breeding grounds of association football, he went to Oxford University, where he played first team football and cricket, scoring 132 runs at Lord's in the varsity match of 1896. In the same season, he played three times for Surrey. However, football was his first game, and he was soon the England captain, an amateur playing alongside professionals. From 1898 until 1902, he was also secretary and guiding light of the Corinthian Club, the organisation which represented the apex of amateurism in British sport. When Smith retired, he took a post as a schoolmaster, later becoming joint headmaster at Ludgrove School.

G.O. Smith, c.1900
Spelter figure, 250mm (h)
Professional Footballers' Association

Pat Smythe (1928-96)
Equestrianism

Equestrianism being initially a military discipline and thus a male preserve, it was not until after the Second World War that the sport became open to women at a competitive level. Pat Smythe was the first great woman rider to emerge, making her international début in 1949, with a win at the Grand Prix in Brussels. At the 1956 Olympics, women were invited to compete for the first time, and Pat Smythe was in the team that won bronze. Although only a third placing, the impact of this success was huge, and as she dominated the national championships for a decade from 1952 to 1962, she provided the inspiration for thousands of girls to take up riding. The nation's pony clubs and gymkhanas had never been so popular, and the 1950s was also the golden age of showjumping, with nightly extensive television coverage of the *Horse of the Year Show*. Smythe competed successfully all over Europe on a number of different horses, the most popular being Flanagan and Prince Hal. Her trophies included four women's European titles and eight British titles. Her influence on the equestrian world was no less important after her retirement, as she became a prolific and popular fiction and non-fiction writer on equine matters.

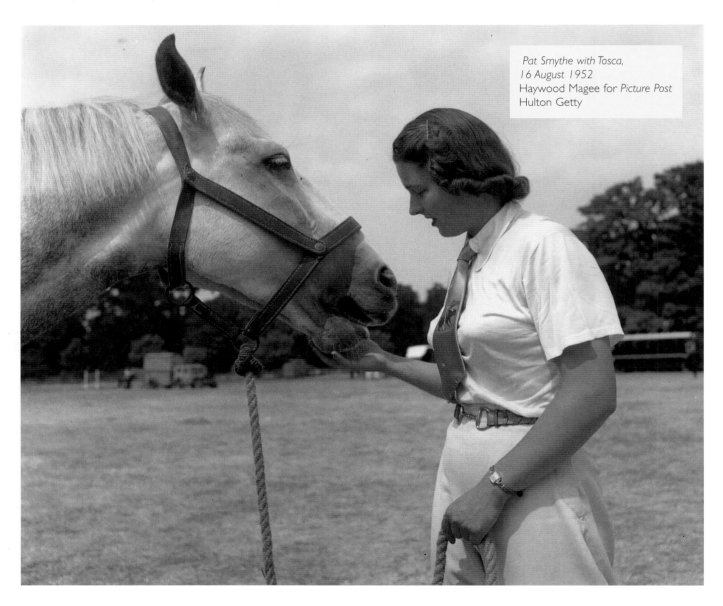

Pat Smythe with Tosca,
16 August 1952
Haywood Magee for *Picture Post*
Hulton Getty

Jackie Stewart (b.1939)
Motor racing

Stewart's record of 27 Grand Prix victories between 1965 and 1973 took him two wins beyond fellow Scot **Jim CLARK**, and stood until 1987 when it was overhauled by Alain Prost. It took the Frenchman 118 starts, whereas Stewart needed only 99.

In 1965, having won the Italian Grand Prix in his first full season driving with BRM, Stewart finished third in the Drivers' Championship, behind Clark and team-mate **Graham HILL**. 1966 and 1967 were lean years for Stewart, as he came seventh and ninth, but in alliance with constructor Ken Tyrell in 1968, he began to show his true ability. In the six years of driving his familiar blue Tyrell car, he finished either first or second in the Drivers'

Championship in every year but one. In both 1969 and 1971, the rest of the field was left in Stewart's wake as he dominated the Grand Prix season, winning six races out of eleven both years. Like Juan Manuel Fangio, **Stirling Moss** and Clark before him, Stewart set the standard for Grand Prix driving in his time. In only his second season, he broke a shoulder and cracked a rib in an accident, and he has remained an articulate and outspoken champion of safety codes for motor racing ever since. He retired in 1973, becoming a successful businessman, and has recently formed his own race team.

(Illustrated under **Stirling Moss**)

Adrian Stoop (1883–1957)
Rugby union

One of the few world sportsmen to have had a stadium, 'The Stoop' in south-west London, named after him, Stoop was associated with Harlequins Rugby Football Club for 50 years. Trained as a barrister, he only ever received one brief, as his passion for rugby enveloped his capacity for other work. Educated appropriately enough at Rugby School, he joined Harlequins in 1900, and in 1902 played his first game while still a student at Oxford University. Having graduated, he devoted himself to the affairs of Harlequins; by 1906, he was captain and secretary. Continuing to guide the club on and off the field of play, the period 1905 to 1914 became known as the 'Stoop era': as he developed high-speed attacking and running rugby other clubs followed the lead. A contemporary critic noted that Harlequins 'never miss an opportunity of throwing the ball about with a freedom bordering on recklessness, but they have learnt the art not only of passing, but of taking the ball on the run with safe hands'. Most of the Harlequins' three-quarters from the Stoop era were capped for England. After winning an MC in the First World War, Stoop returned to Harlequins as club president from 1920 to 1949, playing the occasional game in the 1920s.

Adrian Stoop (r), 2 November 1911 Topical Press Hulton Getty

Jim Sullivan (1903-77)
Rugby league

Jim Sullivan, former player and
coach for Wigan, 2 November 1950
Charles Hewitt for *Picture Post*
Hulton Getty

Whether place-kicking, punting or dropping goals, Sullivan was an unrivalled kicker and between 1921 and 1946 had a prodigious scoring rate: 2,867 points in 928 matches, and over 100 goals a season every year until 1939. In all but two of these seasons (when he finished second) he was the highest point-scorer in the league and his overall tally of 6,022 points has only ever been overtaken by **Neil Fox**. When Cardiff-born Sullivan signed for Wigan in 1921, Welsh rugby union lost a potential great, as he was already the youngest Barbarian in history. But he became an outstanding rugby league player at full-back, scoring 96 tries in his career. He captained Wigan for the best part of two decades, leading them to victory in the inaugural Challenge Cup Final in 1929. Inevitably Sullivan christened the Wembley turf by scoring rugby league's first points there after only three minutes. He won 26 Welsh caps, and played in 25 test matches for Great Britain. On his retirement in 1946, he took up coaching, overseeing Wigan's continuing success until 1952, then guiding St Helens to their first Challenge Cup victory in 1956 and two league titles in 1953 and 1959.

John Surtees (b.1934)
Motor cycling and motor racing

Surtees is the only man to have won world titles in both motor racing and motorcycling. With the Italian team MV Augusta, he became the world's outstanding rider, winning seven titles between 1956 and 1960: four were at 500cc and three at 350cc. During 1958 and 1959, he won each of the 27 races he entered. Switching to four wheels he accepted an offer to join Ferrari in 1963 and won the German Grand Prix. The following year, wins in Italy and Germany plus a second place in Mexico were enough to give him the Drivers' Championship, ahead of **Jim Clark** and **Graham Hill**. Defending his title in 1965, Surtees was involved in a near-fatal accident, which left him in hospital for several months. A brave comeback in 1966 saw two further Grand Prix victories, but these were marred – as were his chances of another Drivers' Championship – by a bitter disagreement with Ferrari, where he had been hugely popular, and was known as *Il Grande John*, because of his willingness and ability behind the scenes as a development engineer. Surtees later created his own racing team.

(Illustrated under **Stirling Moss**)

Herbert Sutcliffe (1894–1978)
Cricket

Sutcliffe's batting average of 60.73 from 54 test matches still remains the highest by any Englishman to date, exceeding even that of his opening partner **Jack HOBBS**. Sutcliffe first played for Yorkshire in 1919, aged 24, his career having been delayed by the First World War. In the county's batting records, he comes out ahead of both **Len HUTTON** and **Geoffrey BOYCOTT**. Sutcliffe made his England début in 1924, sharing in partnerships of 136 and 268 with Hobbs in his first two matches. The following winter in Australia, he averaged 81, including two centuries in one test, and his average against Australia was 66.85. The only man to play in every season between the two world wars, he scored over 1,000 runs in all 21 of them and made 149 first-class centuries. Immaculate in appearance, as well as technique, he was unshakeable at the wicket even in the face of the most hostile bowling. He was one of the great opening batsmen and his partnerships with Hobbs for England and with Percy Holmes for Yorkshire were time after time the foundation of a match-winning score. With Holmes, he scored 555 for the first wicket against Essex in June 1932, which stood as a world record for 45 years.

Yorkshire openers Percy Holmes and Herbert Sutcliffe (r) after scoring a world-record 555 first-wicket partnership against Essex, Leyton, June 1932
Bassano
National Portrait Gallery

Henry Taylor (1885-1951)
Swimming

An Olympic swimming prodigy, with a British record of eight medals gained between 1906 and 1920, Taylor is unique in having won a medal in the same event – the freestyle relay – in four successive Games. His name has since sunk into oblivion, and this once great swimmer ended his days as an attendant at the local baths. His beginnings were no less humble, as he learned to swim in the industrial canals of Lancashire. Once a week, on dirty-water day when admission was cheaper, he had access to the local swimming pool. Such privations proved good preparation for his first Olympic races, because at the unofficial 1906 Games in Athens, the swimming events took place in the polluted sea off Piraeus. Taylor won medals of all three colours, before he had even won a single title at home. He soon put the record straight with four domestic titles, and his winning streak continued at the London Olympics of 1908, where he won three gold medals, breaking world records at 800m and 1500m. After his winning performance in the 4 x 200m relay, he was chaired around the stadium by his team-mates at White City. In 1969, 18 years after his death, he was inducted into the International Swimming Hall of Fame in Florida, USA.

Heroes of the 1908 Olympics

The fourth official modern Olympic Games, held in London in 1908, was by far the biggest yet, with 2,035 competitors: 36 were women, a total that beat the first three Olympics put together. Britain finished top of the medals' table, claiming 56 gold, 50 silver and 39 bronze medals. This incredible haul has never been bettered: the next highest total, in 1924, was 42, and Britain has only won over ten gold medals at two other Olympic Games (1900 and 1920). The heroes of 1908 included Queenie Newall, who, at 53, became Olympic Archery Champion. Britain's senior oarsman, Guy Nickalls, was also among the victors, recalled out of retirement at the age of 41. **Lottie Dod**'s brother William won a gold in archery while Johnny Douglas, who went on to become England's cricket captain, became the Olympic middleweight boxing champion. Paul 'Raddy' Radmilovic, five times Olympic competitor, and the first Briton to feature in Florida's Swimming Hall of Fame, won the first of three water polo golds. There was controversy in the 400m, as Britain's Wyndham Halswelle took the gold following the disqualification of an American and the subsequent withdrawal of some of the other runners in protest. Gold medals were won across the board, with football, hockey, shooting, yachting, wrestling and cycling all dominated by the British.

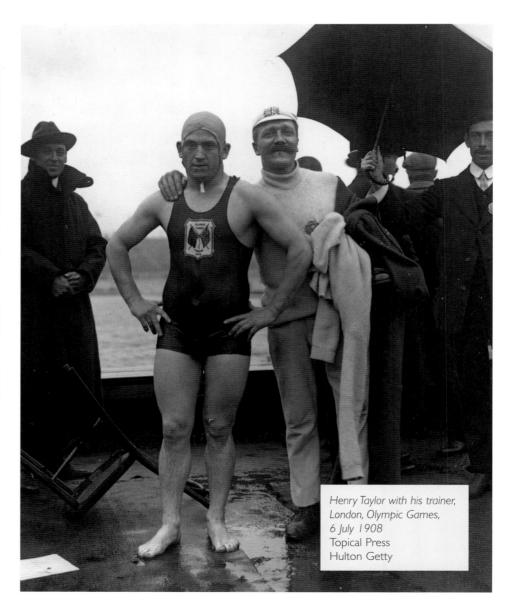

Henry Taylor with his trainer, London, Olympic Games, 6 July 1908
Topical Press
Hulton Getty

J.H. Taylor (1871–1963)
Golf

Born in Northam, Devon, John Henry Taylor was the first truly successful English professional golfer, whose triumphs helped spur the popularity of the game in England. Known as one of 'The Triumvirate', alongside **Harry Vardon** and **James Braid**, he won the Open Championship five times, in 1894, 1895, 1900, 1909 and 1913. He also won the *News of the World* Tournament twice, the French Open twice and the German Open once. Between 1894 and 1914, he was the winner at 32 tournaments in total and played in over 520 exhibition matches. Taylor initially worked as a gardener, later becoming a groundsman at the Royal North Devon Golf Club. In 1890, he became Burnham on Sea's professional, and worked at Winchester and Wimbledon before moving to Royal Mid-Surrey Golf Club in 1899, where he spent the rest of his career. A strong advocate of the rights of professional golfers, in 1901 he helped to found the Professional Golfers' Association, becoming its first chairman. He was an outstanding all-round golfer, particularly adept with his irons, and helped to make the mashie (the modern five iron) a popular club. Taylor had a highly strung temperament which he himself felt was better suited to stroke play rather than match play. PNL
(Illustrated under **James Braid**)

Daley Thompson (b.1958)
Athletics

With two Olympic gold medals, four world records, three Commonwealth titles, and wins at European and World Championships, Francis Morgan Daley Thompson is one of Britain's most decorated athletes. He is also the greatest decathlete that the world has ever seen, a fact he was not shy to share with both his supporters and his detractors. He transformed the ten-part event, the content of which had never really been grasped by the British, into a cause for national celebration. His clear ability and determination were matched by his irrepressible self-belief, for which he was almost as famous. His greatest challenger for a decade, the German Jurgen Hingsen, complained that Thompson would laugh loudly at him during the competition. He was prone to wearing T-shirts printed with provocative slogans: in Stuttgart, one read 'Germany's favourite sons – Bernhard, Boris and Daley', and another shirt worn at the Olympics bore a legend about Carl Lewis being the world's second greatest athlete. Thompson's Olympic medals came in 1980 and in 1984, when he became only the second man in history to defend a decathlon title successfully. A contemporary of **Sebastian Coe**, **Steve Ovett** and **Allan Wells**, he helped to attract a much wider audience to British athletics.

Daley Thompson
David Buckland, 1987
National Portrait Gallery

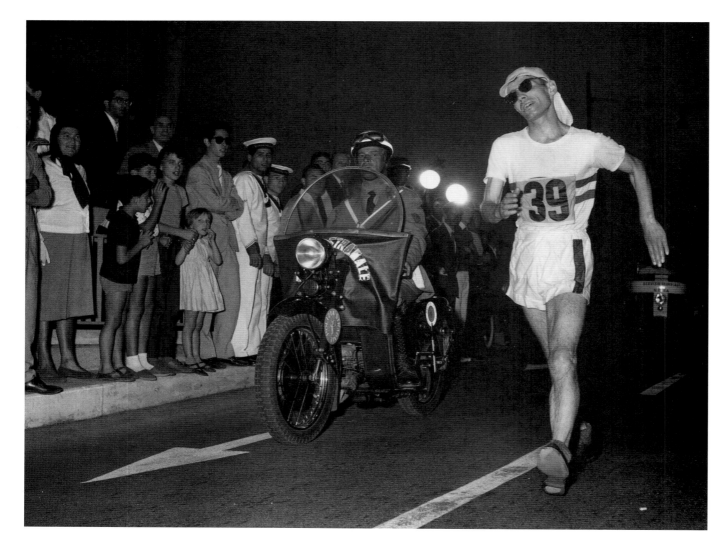

Don Thompson (b. 1933)
Athletics

Resources for British athletics are notoriously meagre, so in the build-up to the 50km walk event at the 1960 Olympics, the intrepid Don Thompson took affairs into his own hands. Having collapsed in the heat at the previous Games in Melbourne, he prepared himself for the humidity of Rome by creating a steam-room effect (using kettles and heaters) in his bathroom and walking up and down continuously on the bathmat. When the day came, this slight, bespectacled insurance clerk pulled off one of the most heroic of all British Olympic triumphs: he won the 50km gold medal, in the process performing the feat of beating all three of the post-war medallists at the event. The Italians took to Thompson, christening him *Il Topolino* ('The Little Mouse'), and he became one of the stars of the Games. His extraordinary appearance, with a legionnaire-style hat, dark glasses and woolly socks, added greatly to his appeal. It was one of only two British golds at the 1960 Games, and the eccentric 50km walk event – mechanically pumping arms and legs where running would have been easier – briefly hit the headlines. Thirty years later, in 1990, Thompson re-emerged from obscurity at the age of 57 to claim second place in the National Roadwalking 100-mile Championships.

Don Thompson, leading in the 50km walk, Rome Olympics, 8 September 1960
Central Press
Hulton Getty

Alicia Thornton (1774–1834)
Horse racing

'Fair-haired, blue-eyed and very handsome', Alicia Thornton was a colourful figure in the racing world of the early nineteenth century. In 1804 she beat her brother-in-law Captain Flint in a private race and was challenged to a re-match in public. A crowd of some 100,000 people gathered at the Knavesmire course in York to watch Mrs Thornton on Vingarillo take on Captain Flint riding Brown Thornville. The four-mile race proved a fiasco as Vingarillo went lame in the last mile and Captain Flint finished alone. Alicia demanded a re-match, but her husband Colonel Thornton, growing suspicious of her assignations with Captain Flint, banned further contests and defaulted on the Captain's winnings. The enraged Captain took a horsewhip to the Colonel, landing himself in prison and incurring damages. Undaunted, Alicia Thornton rode another match at the Knavesmire against the great **Frank BUCKLE** the following summer, beating him by a head, though his horse carried 13st 6lb and hers 9st 6lb. HC

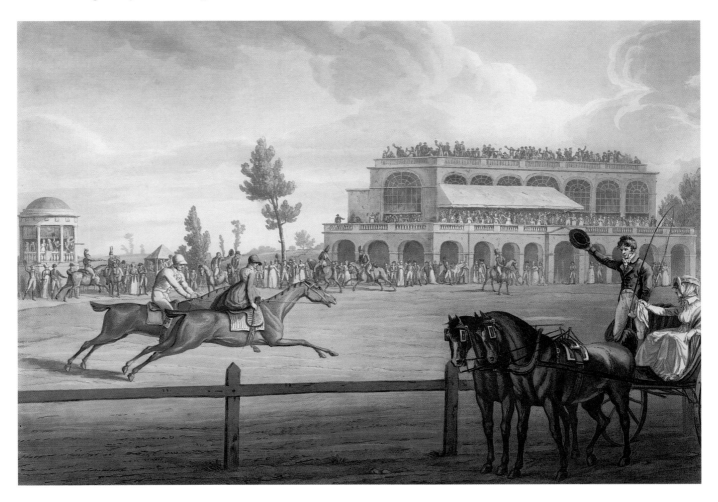

York Meeting: the celebrated race between Mrs Thornton's
Vingarillo and Mr Flint's Thornville on Knavesmire, 25 August 1804
Possibly after Philip Reinagle, 1804
Hand-coloured engraving, 368 × 527mm
Private Collection

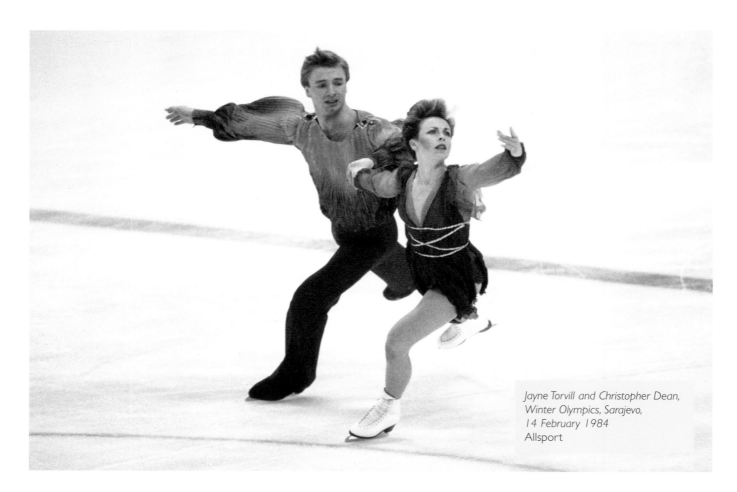

Jayne Torvill and Christopher Dean,
Winter Olympics, Sarajevo,
14 February 1984
Allsport

Jayne Torvill (b.1957)
and Christopher Dean (b.1958)
Ice skating

They came from Nottingham. He was a tall policeman, she was a chubby-cheeked insurance clerk. On Valentine's Day in 1984, in a memorable four minutes of balletic gliding on the ice, they created possibly the most popular spectacle in British Olympic history. Their breathtaking gold medal-winning ice-dance routine was awarded the maximum marks available to the judges and they made an instant hit out of Ravel's *Bolero*, a tune which immediately entered the national consciousness.

Torvill and Dean first teamed up in 1975, and five years later they came fifth in the Moscow Olympics. Having won both the European and World ice dance titles in 1981 they held the World title for the next three years, and only injury in 1983 prevented them from winning four European titles in a row. Then, at Sarajevo in 1984, they became Olympic legends, and their total of 12 sixes for the competition broke the world record. Their artistry and technique won thousands of followers for their sport, and thanks to their outstanding success, the skating rinks of Britain were soon packed. After a decade of performing as professionals, they reverted to amateur status in 1994 and won the British and European titles. But their real goal was a repetition of their Olympic triumph ten years before. A staggering British television audience of over 20 million joined in their disappointment as the best the couple could achieve was the bronze medal.

Fred Trueman (b.1931)
Cricket

The first bowler to take 300 test wickets, Trueman's strike rate of a wicket every 49 balls has only ever been bettered in modern cricket by Waqar Younis and Malcolm Marshall. 'Fiery Fred' lived up to his nickname, aggressive, belligerent and deliberately rude on occasion. Fortunately, he was also one of England's finest genuinely fast bowlers since the Second World War. He made his test début in 1952, when he terrified the touring Indian batsmen with his pace, and took 24 wickets in three test matches. But in England's victorious Ashes series in 1953, he only played in one match. Stiff competition from bowlers such as Frank Tyson and Brian Statham, together with his outspoken opin-

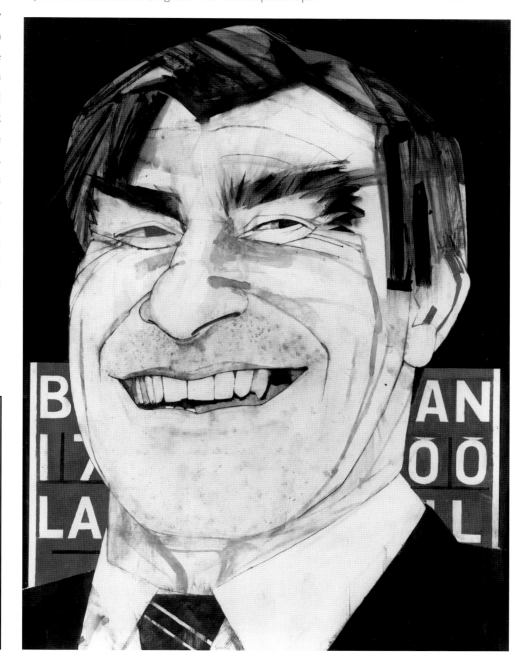

Fred Trueman
Barry Fantoni, 1970s
Black and white gouache,
494 × 372mm
Private Collection

ions and his falling out with county colleague and England captain **Len Hutton**, cost him his place in the England test team. But Trueman was re-instated in 1957, and until 1966 – during which time he took over 100 wickets each season – he was a regular England player. A passionate Yorkshireman, he was county favourite for two decades, a period when Yorkshire won seven championships. In retirement he remains part of the cricket fraternity, a great raconteur and a popular broadcaster.

The Art of Fast Bowling

The pivotal tension of Larwood, Bedser, Tyson, Lindwall, Trueman: cumulative rhythm exploding in the fire of delivery. The left arm drags down the sky, the right arm reaches back to draw strength from the earth. Leonardo once drew the dynamics of it. The fast bowler's art is among the most beautiful expressions of the human body; energy, stamina, control, combined in vivid fluency of movement. He is a man of sweat and determination and of necessary hatred in action.

(Alan Ross, *The Boundary Book*, 1962)

Christine Truman (b.1941)
Tennis

When 18-year-old Christine Truman won both the French and Italian singles in 1959, it seemed as though a British tennis star was born. The youngest winner of the French Open until Steffi Graf in 1987, she briefly occupied the world number two position. At the age of 16, Truman had already reached the last four at Wimbledon, beating French champion and number three seed Shirley Bloomer. Surely the Wimbledon ladies' crown would be hers within a few years. But this great crowd favourite was never to win the ultimate prize. She reached the semi-final on two further occasions, in 1960 and 1965. Her one final appearance, against **Angela MORTIMER** in 1961, was the first all-British final since 1914. Truman took the first set but, to the disappointment of the crowd, she lost the match 4–6, 6–4, 7–5.

Truman was a regular top ten player between 1957 and 1961 and again in 1965. In 1958, she helped Great Britain to their first Wightman Cup victory in 28 years, and her defeat of world number one Althea Gibson was among her finest moments. (Illustrated under **Angela MORTIMER**)

Randolph Turpin (1928–66)
Boxing

Randolph Turpin, Britain's most exciting boxing discovery of the 1950s, turned professional at the age of 18 and soon became British and European middleweight champion. (Until his elder brother Dick appeared just after the Second World War, black boxers had been excluded from contesting a British title.) His finest hour – and perhaps the greatest night of British boxing since the war –

Randolph Turpin in training, 10 December 1949
Bert Hardy for Picture Post
Hulton Getty

came in July 1951, when he sensationally defeated the peerless American Sugar Ray Robinson. Robinson had lost only one of his previous 133 fights, and Turpin shocked the world of boxing and became a national hero overnight. Only 64 days later, however, he was punished by Robinson in their re-match. In 1952, Turpin took the British and Commonwealth light-heavyweight titles from **Don COCKELL**, and on Robinson's retirement was claimed by the British authorities as World Champion. However the Americans had a man of their own, Carl Olsen, and when the two met in 1953, Olsen emerged the victor. From this point, Turpin's career steadily declined and he later endured unemployment, poverty and depression, finally taking his own life in 1966 at the age of 37. Robinson's 1951 post-fight comment should be Turpin's epitaph: 'you were real good just like everybody said you were', he said to the British fighter. 'I have no alibis. I was beaten by a better man.'

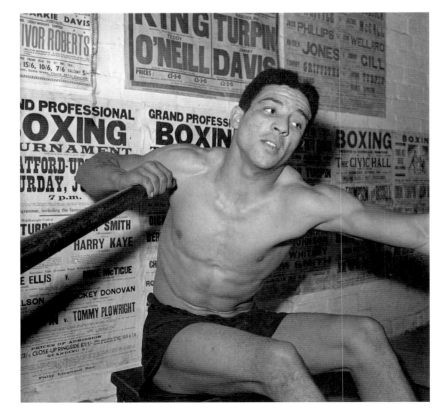

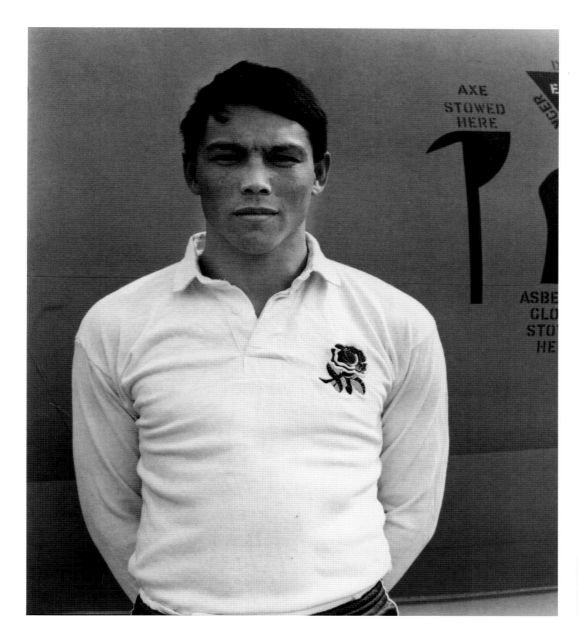

Rory Underwood
Liam Woon, 1989
National Portrait Gallery

Rory Underwood (b.1963)
Rugby union

England's most capped player, with 85 appearances between 1984 and 1996, Rory Underwood is also the highest ever try-scorer with 49, mostly from the left wing. His brother Tony was also an England winger, and their enthusiastic Malaysian mother became a well-known face as the television cameras sought her out in the crowd. Underwood sometimes appeared to be drifting away from the game, but when the ball came to him, he used pace and determination to run with it, and was able to squeeze over the line through the tightest of defensive gaps. **Cliff MORGAN** recalls a time when Underwood seemed to get more caps than passes, as the England team spurned running rugby by kicking from the fly-half position. In his first 22 internationals, he scored only four tries, as the ball was kicked from fly-half, or lost as opposing centres ran straight at each other without releasing the ball. But when England developed into the best of the Five Nations teams, Underwood's skill was allowed to blossom, and this diminutive ex-RAF flying officer was at last allowed to combine balletic running with speed and good handling to cross the line and notch up a series of match-winning tries.

Harry Vardon (1870–1937)
Golf

Harry Vardon won the Open Championship a record six times, in 1896, 1898, 1899, 1903, 1911 and 1914. He took the title at the US Open in 1900 and also won the *News of the World* Tournament in 1912. At his peak between May 1898 and June 1901, he won 17 of the 22 tournaments in which he played and finished second in the remaining five. Born at Grouville in Jersey, Vardon became Ripon's professional at the age of 20, subsequently moving to Bury, Ganton and finally, in 1903, Totteridge. As accurate with his tee shots as **J.H. TAYLOR**, he had more power off the tee. Contemporary commentator Horace Hutchinson felt that at his peak, Vardon was two strokes a round better than Taylor and **James BRAID**; the three men were known in golfing circles as 'The Triumvirate'. In 1900 Vardon undertook a strenuous tour of America and always claimed that he left a little of his best game there. From 1903 onwards he had serious health problems: his putting touch was never the same again and he became famous for missing short putts. Between 1894 and 1914, he won a total of 52 tournaments and played in over 540 exhibition matches. PNL (Illustrated under **James BRAID**)

Hedley Verity (1905–43)
Cricket

The finest English spin bowler of the 1930s, Verity took 1,956 first-class wickets at an average of 14.87, the best return by any bowler taking more than 1,500 wickets this century. Subtle and determined, he regularly tricked batsmen, spinning the ball prodigiously either way. Verity was initially kept out of the Yorkshire side by the ever-present **Wilfred RHODES**, but became a key figure in Yorkshire's championship-winning side during the 1930s, taking an average of 185 wickets a season. In all but one season, he took 100 wickets, thrice exceeding 200. In 1932 he took 10 wickets for 10 runs against Nottinghamshire. Against Essex in 1933, he took 17 for 91 over two innings in the match. In his final appearance, he took 7 wickets for 9 runs against Sussex. He was equally effective in his 40 test matches, taking 144 wickets, and once taking 14 for 80 against Australia in one day's play at Lord's, in June 1934. He died in an Italian prisoner of war camp, at the age of 38.

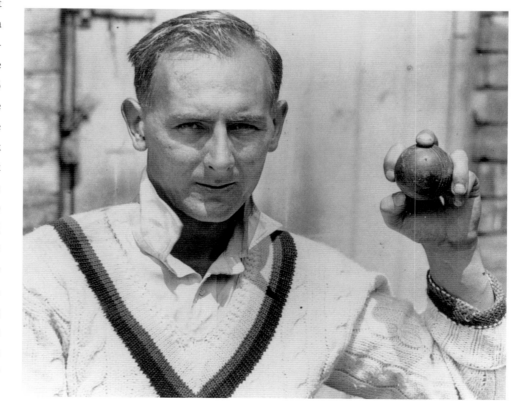

Hedley Verity, The Oval, 1934
Central Press
Hulton Getty

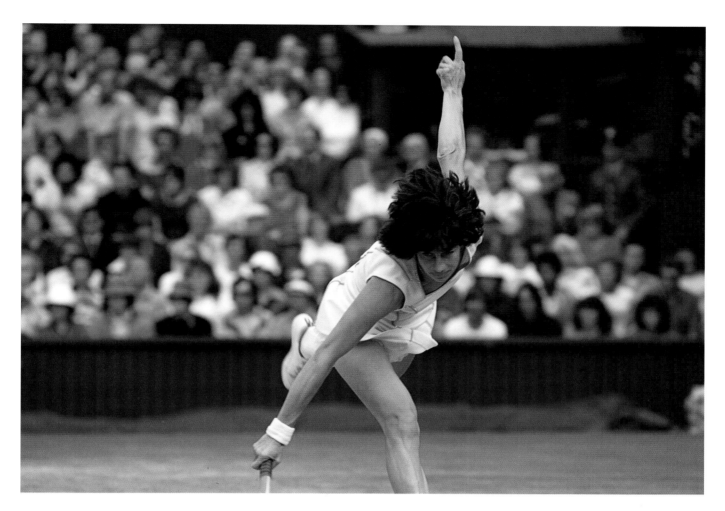

Virginia Wade (b.1945)
Tennis

The greatest sporting moment of the Queen's Silver Jubilee year of 1977 was Britain's tennis queen Virginia Wade winning Wimbledon, accompanied by a jubilant Centre Court crowd's rendition of *For She's a Jolly Good Fellow*. Nine days before her 32nd birthday, Wade had come back from a set down to beat Betty Stove 4–6, 6–3, 6–1. It had been a long time coming for the British player – 18 years had passed since her Wimbledon début, but Wade's career from the mid-1960s until the late 1980s was dotted with personal triumphs. In 1968, her win in the inaugural US Open at Forest Hills included the scalps of Billie Jean King and Rosemary Casals. Four years later she won the 1972 Australian title, beating local pin-up Yvonne Goolagong, and becoming only the third British player to win in Australia. She also won four Grand Slam doubles titles with Margaret Court, but the Wimbledon ladies singles crown was her ultimate goal. Throughout the 1970s, she made it through to the quarter-finals. In 1977, Sue Barker was also in the last four but where she failed to overcome Stove, Wade beat the holder, Chris Evert, to go through to the final.

Britain's best player for nearly a decade, in the world's top ten from 1967 to 1980, Virginia Wade was infuriatingly inconsistent. On occasion feline and predatory, on others error-prone and clumsy, she could beat the best, but she could equally lose to the worst. What she lacked in consistency, she made up for with effort and dogged determination, qualities that greatly endeared her to the British public.

Virginia Wade, Wimbledon Ladies Singles Final against Betty Stove, 1 July 1977
Gerry Cranham

Harold Wagstaff (1891–1939)
Rugby league

The youngest rugby league player on record, Wagstaff became – along with **Billy BATTEN** – the sport's first star player. He made his début for his hometown team Huddersfield in 1906, at the age of 15 years and 175 days, and remained there throughout his career. Either side of the First World War, in the seasons 1909–15 and 1918–20, Huddersfield was known as 'The Team of all the Talents' and Wagstaff as 'The Prince of Centres', because of his performances in that position. Having played 494 games for club and country by the time he retired in 1925, he became the yardstick by which players of the next generation were judged. By the age of 17, he was playing for Great Britain, and led two touring sides to Australia in 1914 and 1920. On the first of these, captaining his country aged only 23, he enjoyed his finest hour, in the Sydney international that became known as the 'Rorke's Drift' Test. His injury-ravaged team had been reduced to ten men for most of the game, and in an inspired performance, a depleted England humbled Australia 14–6. 'Ten men and thirty minutes to go!' the captain later recalled, 'But never had I nine such men with me on a football field as I had that day.'

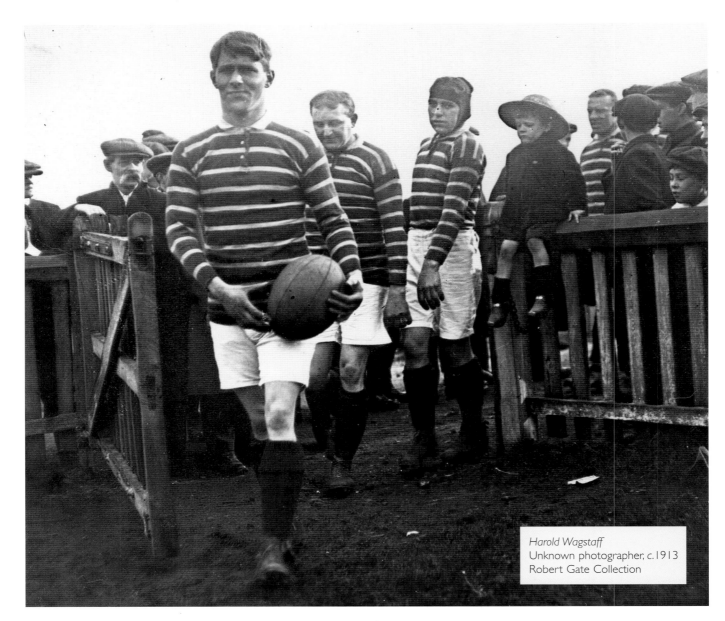

Harold Wagstaff
Unknown photographer, c.1913
Robert Gate Collection

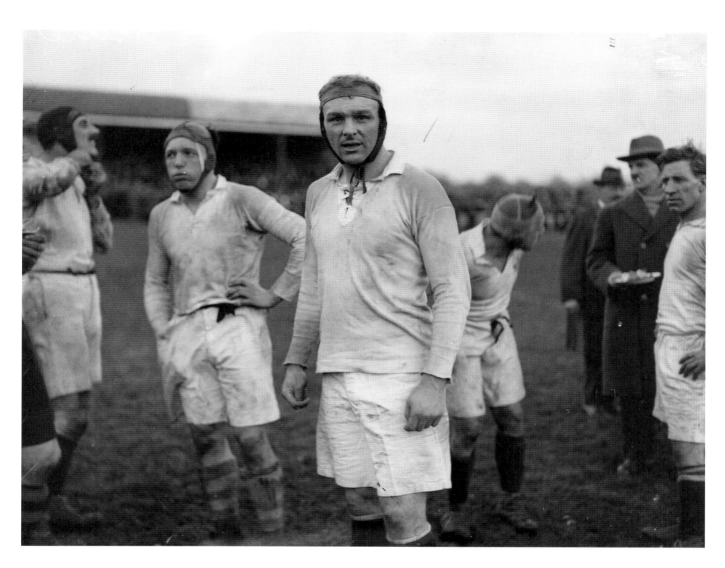

Wavell Wakefield
1st Baron Wakefield of Kendal (1898–1983)
Rugby union

The earliest important theorist on the game of rugby, Wakefield was England's first great captain, and later developed into an influential coach. His 31 appearances for England in the 1920s remained a record for 42 years. Winning his first cap while at Cambridge in 1921, he became one of the decade's best-known sportsmen, a considerable all-round athlete who ran against **Harold ABRAHAMS** and also played cricket for the MCC. Strong, fast, and agile, with his famous scrum-cap laced onto his head, he transformed rugby's scrum play, himself playing at prop, number eight or flanker. He developed specialist playing roles and positions, in scrums and in loose play. As England captain, he led his country in the most dominant period of rugby union since the breakaway in 1895 of most of the Northern clubs to form the Rugby League: England won successive Grand Slams in 1923 and 1924. Wakefield retired from rugby to become a politician, entering Parliament in 1937. He served briefly as President of the Rugby Football Union in 1950–51.

Wavell Wakefield (centre) in an England 'possibles and probables' trial match, 1 December 1923
Topical Press, Hulton Getty

Matthew Webb (1848–83)
Cross-channel swimming

The first man to swim across the English Channel, 'Captain' Matthew Webb failed on his first attempt, on 12 August 1875, but twelve days later, he dived again from Admiralty Pier, Dover, at 1 pm, reaching Calais at 10.40 the next morning. He had swum 40 miles, mainly breaststroke, in 22 hours, without any support. His body was covered in porpoise grease, and sustenance (cod-liver oil, beef-tea, brandy, coffee and strong beer) was taken while treading water. News of his feat spread quickly, and he returned to a hero's welcome in Dover and London, where a public subscription of £1,400 was raised. He was presented with cups and medals, and arriving back in Shropshire, he was magnificently fêted; and a triumphal arch was erected in Coalbrookdale. His fame led him to perform endurance tests and give swimming and diving exhibitions throughout England. Swimming soon became a national craze and Webb a celebrity, whose face appeared on a host of products from mugs to matchboxes. In 1883 he sailed to the USA with his family hoping to swim through the rapids and whirlpool at the foot of the Niagara Falls. He jumped into the water at 4 pm on 24 July and was never seen again.

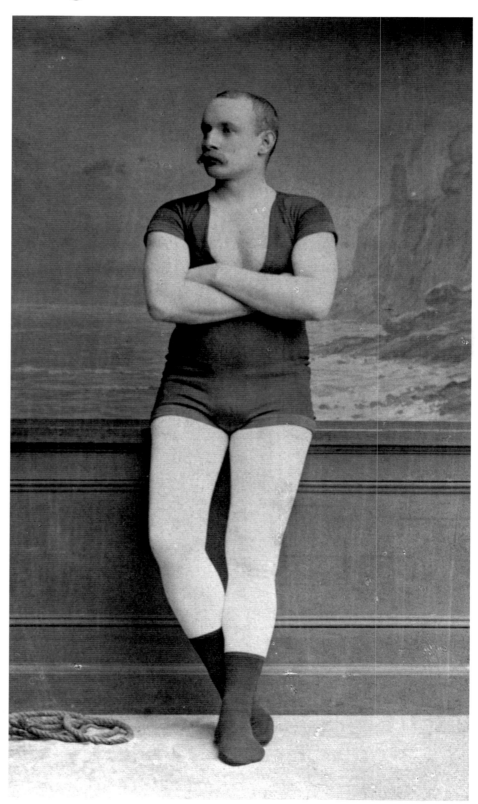

Captain Webb
Elliott and Fry, c.1875
National Portrait Gallery

Allan Wells (b.1952)
Athletics

Scotland's Olympic flame could be considered more a glowing ember than a raging fire, but it was burning brightly in 1980 when Edinburgh's Allan Wipper Wells won a gold and a silver medal at the Moscow Olympics. Wells had initially competed in the long jump and triple jump, but after seeing the Jamaican Don Quarrie win the sprint events at the Commonwealth Games in Scotland, Wells switched disciplines. Eight years of training later, he beat Peter Radford's 20-year-old British 100m record. The following month, he won the Commonwealth title at 200m, adding a silver medal in the 100m. Then, in 1980, aged 28, he became the oldest 100m Olympic gold-medal winner and finished second in the 200m. The Scottish runner continued winning sprints, at the World and European Championships of 1981, and at the Brisbane Commonwealth Games of 1982.

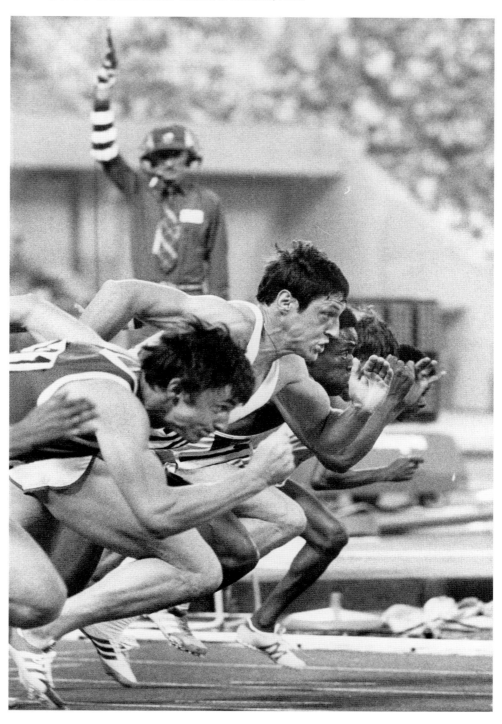

Allan Wells, 100m start,
Moscow Olympics, 25 July 1980
Chris Smith/*The Sunday Times*

Freddie Welsh (1886-1927)
Boxing

Born Frederick Thomas in Wales, Welsh fought mainly in America, where he was better known than he was at home. He originally disguised his name in order not to be discovered fighting by his mother. Although he lacked a big punch, he was a clever close fighter and a master of defence: in 168 fights, he only lost four, although nearly half of the results were 'no decisions'. In 1909, contesting the lightweight crown, he won the first Lonsdale Belt, and went on to retain it after successful defences. He held his title (except for one defeat) until 1919, at which point he moved to the USA for good.

In addition to his British and Empire crowns, Welsh became the world lightweight champion, and successfully defended the title for three years in a series of fights in America. But in 1917, he was knocked out for the only time in his career, by Benny Leonard. His subsequent fights were minor affairs, and he retired in 1922. Welsh invested his money in an unsuccessful health farm, and in 1927 he died penniless in New York.

(Illustrated under **Jim DRISCOLL**)

Joyce Wethered
Lady Heathcoat-Amory (1901–98)
Golf

In 1920 Joyce Wethered decided to enter the English Championship at Sheringham for the fun of it, but surprised herself by winning, beating fellow woman golfer **'Cecil' LEITCH** in the final. She won the English ladies' title a further four times, winning 33 consecutive matches. She was also British ladies' champion in 1922, 1924, 1925 and 1929 and lost only two matches in this Championship. The last victory was after four years of retirement, and was achieved over the US ladies' champion Glenna Collett. She then concentrated on international competition, being captain of the Curtis Cup team in 1932 and playing for many years in the Worplesdon Mixed Foursomes, winning eight times. An English international player on six occasions, she was also the first president of the English Ladies' Golf Association (ELGA). Wethered had learned the game of golf with her elder brother Roger (amateur champion in 1923), on their childhood holidays in Scotland. Both were fine players, and Joyce, according to famous American amateur Bobby Jones, had the best swing of anyone. Her contemporary player and golf writer Enid Wilson commented on her power, perfection of style and incredible accuracy. Wethered's concentration was also legendary: an anecdote tells how she coolly sank a putt at Sheringham despite the distraction of a passing train. When asked, she replied 'What train?' ERC

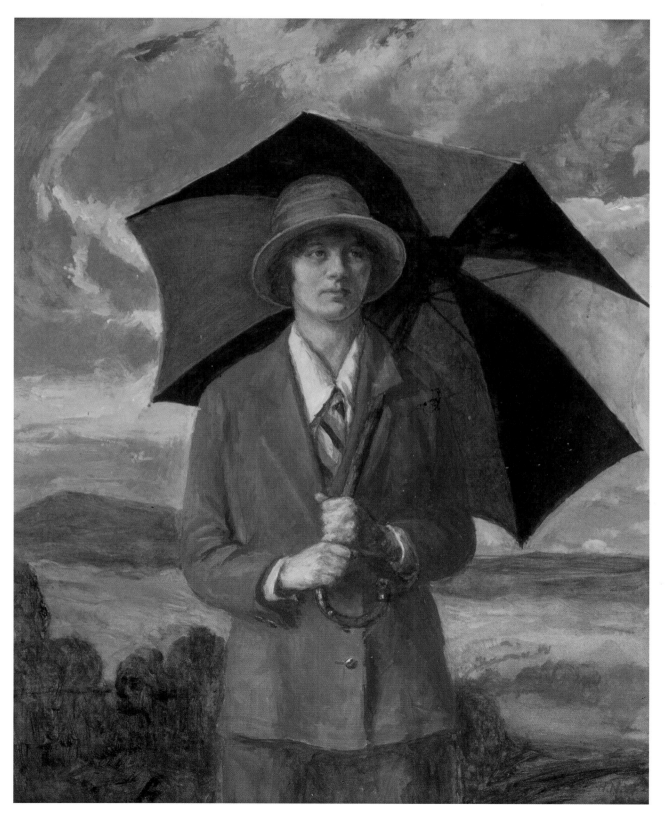

Joyce Wethered, Lady Heathcoat-Amory
Vernon Wethered, 1923
Gouache on paper on fibre board, 482 × 362mm
Knightshayes, The Heathcoat-Amory Collection (The National Trust)

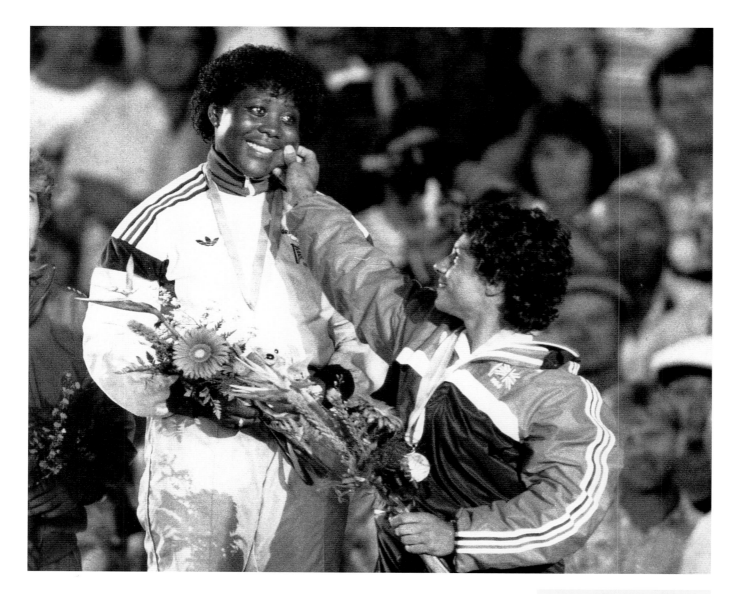

Fatima Whitbread (b.1961)
Javelin

*Fatima Whitbread, javelin bronze
medallist, congratulates gold
medallist Tessa Sanderson, Los
Angeles Olympics, 6 August 1984
Chris Smith/The Sunday Times*

The winner of silver and bronze Olympic medals, gold and silver World Championship medals, and a European Championship title, Fatima Whitbread is one of the world's greatest ever javelin throwers, but it was her misfortune (as well as a blessing for British athletics) that her career should co-incide with that of 1988 Olympic Champion **Tessa SANDERSON**. Their rivalry was as keenly followed as that between runners **Steve OVETT** and **Sebastian COE**. Born Fatima Vedad, of Cypriot parentage, she was adopted by the national javelin coach Margaret Whitbread at the age of 13. Fatima Whitbread's first major breakthrough came in 1983 at the World Championships: at first she led the field but local

Finnish star Tiina Lillak edged her into second place. Whitbread won the bronze medal behind Tessa Sanderson's gold at the 1984 Olympics, but went on to beat Sanderson in their next seven encounters. In 1986, she set a new world record at the European Championships, took the gold medal, and became the world number one thrower. The following year, during which she won 16 out of 17 events, she became World Champion, and was voted BBC Sports Personality of the Year – now well and truly out of Sanderson's shadow. At the Seoul Olympics of 1988, she bettered her 1984 bronze by taking silver, but her career was subsequently curtailed by injury.

Jimmy Wilde (1892-1969)
Boxing

'The Tylerstown Terror' was not the least bit terrifying in appearance. More aptly nicknamed 'The Mighty Atom', and 'The Ghost with the Hammer in his Hands', at 5ft 2in tall, Wilde was built like a gymnast and had the weight of a jockey: at his heaviest, he still weighed under eight stone. With his spindly frame, he was by necessity an unorthodox fighter, relying on guile and timing, bobbing around the ring, before letting loose a sudden volley of punches from his tentacle like arms. He was phenomenally successful, only losing three out of 145 recorded professional fights. Starting out as both a glove fighter and in illegal bare fist contests while working as a miner, he had won his first world flyweight title by 1916, and soon became a great favourite at the National Sporting Club. Invincible during the First World War, success was accompanied by financial reward: on one occasion when a cash prize was banned, his wife was presented with a bag of diamonds worth £3,000.

By early 1917, he was British, European and world flyweight champion, and was running out of challengers. During 1919 and 1920 he triumphantly toured America, making his fourth and final defence of his world title against 22-year-old Pancho Villa in New York. Wilde was 31, and in losing, he received £13,000, the largest purse of his career.

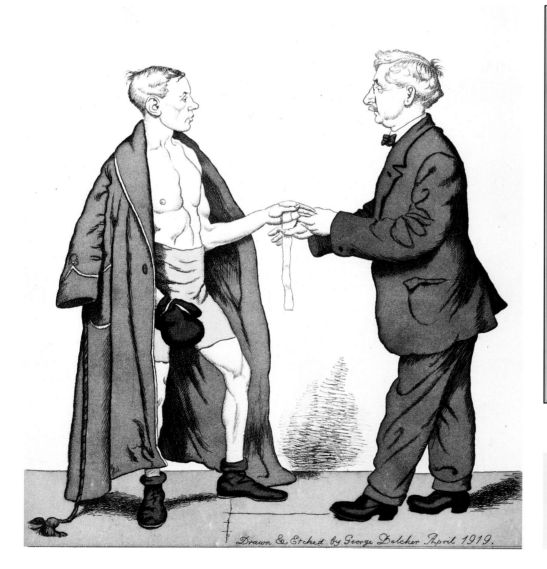

Drawn & Etched by George Belcher April 1919.

Welsh Valleys Boxers: Wilde, Welsh and Driscoll

The iron and coal centres in the valleys of South Wales were rich breeding grounds for boxers, and many emerged from illegal barefist contests to become world class fighters. Boxing for money was an escape from the harsh routine of pit work and although the names of most of those who fought in the boxing booths are long forgotten, three stand out. Jimmy Wilde, **Freddie WELSH**, and **Jim DRISCOLL** were all born within a five-mile radius of one another: each became a world champion. Capturing the imagination of the people, they are part of the history of modern Wales. But all ended their days in poverty. Wilde wasted his considerable earnings on hare-brained schemes for London musicals and Welsh cinemas. Driscoll died of pneumonia at the age of 45, and Welsh died in America aged 43.

A Hero of the Ring and his Agent (Jimmy Wilde and Teddy Lewis)
George Belcher, 1919
Coloured etching,
344 x 239mm
National Portrait Gallery

David Wilkie (b.1954)
Swimming

Britain's first male Olympic swimming gold medallist since **Henry Taylor** in 1920, David Wilkie ushered in a mini golden age of British swimming, as **Duncan Goodhew** and **Adrian Moorhouse** followed him to titles in the Olympics of 1980 and 1988. Wilkie was the most successful of the three, winning two Olympic silver medals in addition to his gold at the Montreal Games of 1976.

Wilkie grew up in Sri Lanka, where learning to swim was a more instinctive process than a weekly trip to the municipal baths. Following a Commonwealth bronze medal in 1970 and his first Olympic silver medal in 1972, he won a scholarship to the University of Miami. Building up to the 1976 Games, he won 200m breaststroke titles at two World Championships, and was also Commonwealth and European champion. He then became the first Briton to win a US national title. His 1976 200m gold medal was achieved by knocking three seconds off the world record. Wilkie finished way ahead of one of the strongest fields at the Games, and his was the only European win in the Olympic pool. A few days later, he added a silver medal in the 100m breaststroke. (Illustrated under **Duncan Goodhew**)

J.P.R. Williams (b.1949)
Rugby union

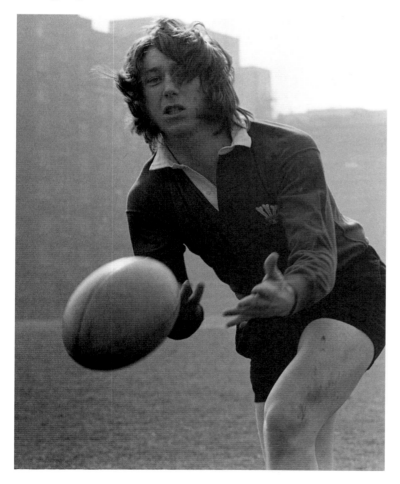

'J.P.R.' virtually re-invented the position of full-back, becoming the first player in that position regularly to join the three-quarter attack. Unpredictable and competitive, with his familiar long hair and sideburns, he became a much-feared sight in 1970s rugby. Williams' sporting success started when he won Junior Wimbledon in 1966, beating the British player John Lloyd on the way. Later, as a medical student at St Mary's Hospital in London, he played rugby for London Welsh, and made his début for Wales in 1969. Rock-like in his position at full-back for the victorious Welsh team of the 1970s, he won 55 caps before retiring in 1981, and was in the team that won the Grand Slam on three occasions, and the Five Nations Championship six times. Even more importantly for the Welsh, he was on the winning side in all 11 of his matches against England. For the British Lions, on their two most successful tours in 1971 and 1974, he was only on the losing team once in eight starts. His tackling and defence were as solid as his attacking running was exciting.

J.P.R. Williams
Snowdon, March 1972

George Wilson (1766–?)
Pedestrianism

Born in Newcastle-Upon-Tyne, the slightly built Wilson (he weighed only 8st 6lbs) earned his freedom from the debtor's prison in 1812 by winning a wager to walk 50 miles in 12 hours in the exercise yard measuring 11 × 8½yds, negotiating 10,300 turns on the way.

For the next ten years he arranged and took part in walking events of 50 miles or more 'against the clock'. He recognised the value of publicity and marketing and advertised his events well, selling engravings of himself in action to the onlookers. This strategy was so successful that, on one notorious occasion in 1815 at Blackheath, the event had to be stopped. Wilson had arranged to go 1,000 miles at the rate of 50 miles a day for 20 consecutive days. Every day the crowds turned out in their thousands, together with entertainers, vendors and pick-pockets. Wilson needed men with whips and ten-foot staves to protect him and to cut a way through the crowd. After 15 days the local magistrates produced a warrant for his arrest, and so brought this vast event to an end. He had completed 751 miles but lost most of his hoped-for income.

Despite this set-back Wilson continued to arrange and take part in events until he was in his mid-50s. Among his achievements he completed 100 miles in 24 hours, and twice completed 1,000 miles in 18 days. PR

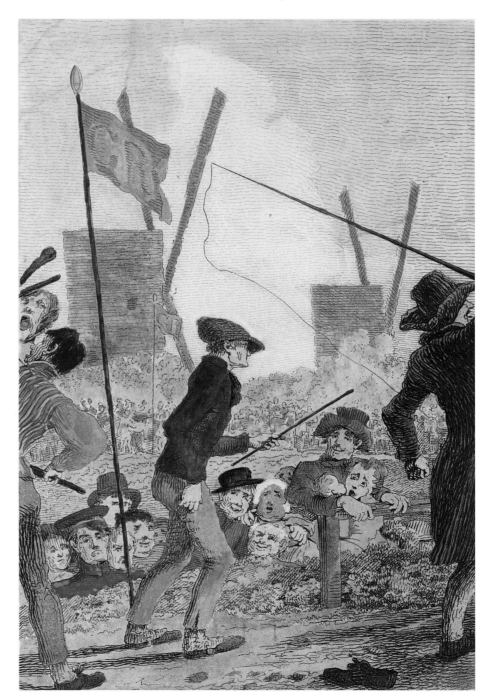

George Wilson the Pedestrian
Unknown artist, 1815
Hand-coloured engraving, 415 × 360mm
Professor Peter F. Radford

Fred Winter (b.1926)

Horse racing

The son of a trainer, Fred Winter was apprenticed in his father's stable as a flat-race jockey and rode his first winner in 1939 at the age of 13. Finding difficulties with his weight, he switched in 1947 to riding over jumps. Within five years he was Champion Jockey, the first of four such wins. He won the King George VI Chase three times and the Grand National twice, first in 1957 on Sundew and again in 1962 on Kilmore. In the late 1950s and early 1960s he was particularly successful at Cheltenham, in 1961 winning the Champion Hurdle on Eborneezer, and the Gold Cup on Saffron Tartan. His skills as a rider were perhaps most graphically demonstrated when he won the 1962 four-mile Grand Steeple de Paris at Auteuil on Mandarin, after the bit had broken in the horse's mouth early in the race. He retired in 1964 and matched all his earlier successes in the saddle by winning the same races as a trainer. He was seven times Champion Trainer between 1970 and 1978, the only jockey apart from Fred Rimmell to have achieved the championships as both jockey and trainer. His CBE in 1963 was the first awarded to a National Hunt jockey. HC

Fred Winter studying the Racing Calendar, *10 February 1953*
Chris Ware for *Key Features*
Hulton Getty

Sydney Wooderson (b.1914)
Athletics

But for the interruption of the Second World War, Sydney Wooderson might well have been the first man to run the mile in under four minutes. At least, this was the opinion of **Roger BANNISTER**, the man who did break the four minute barrier in 1954. Wooderson was Bannister's idol. The two milers were remarkably similar: both pale, spindly, bespectacled, studious-looking, and, most of all, fast. Wooderson was also robbed of probable glory at the two Olympic Games that never took place in 1940 and 1944, but either side of the war he flew the flag for British athletics. In 1937, he broke the world mile record, and in 1938 he lowered the 800m mark by over a second. At the 1946 European Championships, he won the 5000m in perhaps his greatest race: he had never run this distance before, and destroyed an experienced field. In his day, Wooderson enjoyed huge popularity, once described as having the 'pep of Arthur Askey with the will to win of that other small man Montgomery'. The press loved 'Cyclone Syd', and cherished this unassuming suburban solicitor as the embodiment of the national character.

Sydney Wooderson coaching schoolboys, 1939
Unknown photographer
National Portrait Gallery

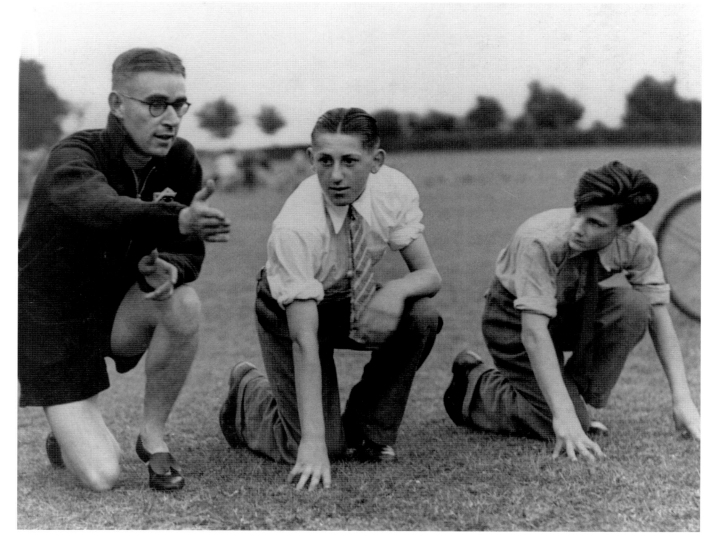

Frank Woolley (1887–1978)
Cricket

Tall and regal in bearing, Frank Woolley at the crease was one of the most handsome spectacles in county cricket. The second-highest run-scorer in the world, he ranks one place behind **Jack Hobbs**, with 58,969 runs to his name. He made his England début in 1909 and then played in 52 consecutive test matches, setting a record not matched until **Peter May** broke it in the 1950s. The scorer of 140 first-class centuries, Woolley was also out in the 90s on 35 occasions, obviously a player who preferred to make strokes for pleasure than centuries for posterity. As a slow left-arm bowler, he took 2,068 career wickets at an average of 19.85, and he was the nonpareil of English slip fielding, his 1,018 catches being a world record for a non-wicketkeeper. Kent's greatest-ever player, he

served the county for over 30 years, and in 28 seasons he scored over 1,000 runs, adding 100 wickets in eight of them. According to R.C. Robertson-Glasgow in 1943, 'Frank Woolley was easy to watch, difficult to bowl to and impossible to write about. When you bowled to him there weren't enough fielders, when you wrote about him there weren't enough words. In describing a great innings by Woolley, and few of them were not great in artistry, you had to go careful in your adjectives ... in the first over of his innings perhaps there had been an exquisite off-drive, followed by a perfect cut, then an effortless leg-glide. In the second over the same sort of thing happened and your superlatives had already gone.'

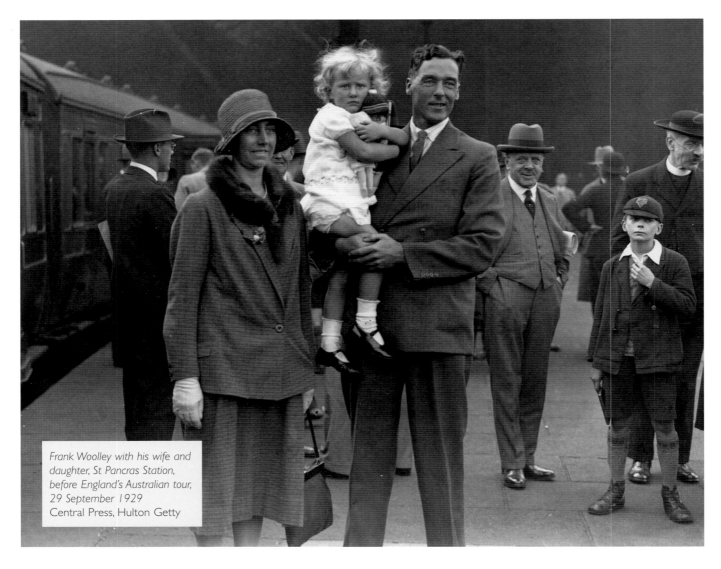

Frank Woolley with his wife and daughter, St Pancras Station, before England's Australian tour, 29 September 1929
Central Press, Hulton Getty

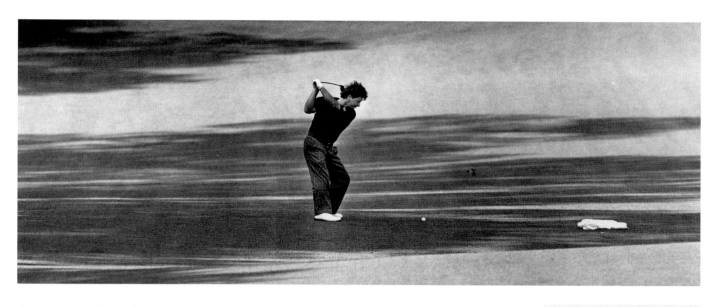

Ian Woosnam (b.1958)
Golf

Ian Woosnam, US Masters,
Augusta, 21 October 1982
Chris Smith/The Sunday Times

Born in the Welsh Marches, Ian Woosnam struggled in his early career, but eventually reached the top ranks, winning the US Masters tournament in 1991. As a young player he failed twice in the Qualifying School for the European Tour, eventually gaining entry on his third attempt in 1978. From his first Tour victory in 1982, he rose to be European number one in both 1987 and 1990, and world number one in 1991. In 1987 he became the first Briton to win the World Match Play Championship, beating fellow Briton **Sandy LYLE** in the final. Woosnam has also been successful in international competition. He was part of the 1985 and 1987 winning Ryder Cup teams and won the individual title for Wales in the World Cup in 1987. At only 5ft 4in tall, Woosnam is nevertheless a very long hitter. In 1996, after coaching from Bill Ferguson, he proved that he remains very much a top player, fighting **Colin MONTGOMERIE** every step of the way to Montgomerie's fourth consecutive European Order of Merit win. In 1997 Woosnam finished sixth. By the end of that year he was one of only four people who had won more than £5 million on the European Tour.

ERC

Billy Wright (1924-94)
Football

Billy Wright was strictly a one-club player at Wolverhampton Wanderers, and as such remains the town's most famous sporting son. He became a professional during the Second World War, and as soon as peace returned, Wright immediately established himself as captain of the club (managed by former player Stan Cullis). He made his England début in 1946 and by the time he retired in 1959, after playing 105 games for England (90 as captain) he was the most capped international player in the world. Between 1949 and 1959, he led Wolves to three championships and the FA Cup, played in three World Cup finals, and was voted Footballer of the Year in 1952. Playing as a striker or in midfield, his temperament was such that he was never booked for misdemeanour and he was the idol of British football in the 1950s, particularly after his marriage to Joy Beverley, youngest of the glamorous singing sisters. But as captain in 1953, he was blamed for England's humiliating 6–3 loss to Hungary at Wembley. It was England's first national defeat on home soil. Attempting to stop the Hungarian Puskas, Wright was described by Geoffrey Green as 'coming in for the intended tackle like a fire engine going to the wrong fire'.

(Illustrated under **George YOUNG** and **Sir Stanley MATTHEWS**)

Ian Wright (b.1963)
Football

A scorer of brilliant and frequent goals, Wright has always been a huge crowd favourite, firstly at Crystal Palace and then at Arsenal. He became one of Highbury's legends when he overtook the club scoring record set in the 1930s by **Cliff Bastin**. Towards the end of his playing career, in the 1997–98 season (his own least productive year), he at last collected a league championship medal with Arsenal. Wright was a late-comer to the professional game, having been spotted as a 21-year-old, playing Sunday league football. His speed, strength and instinct for shooting on sight are the corner-stones of his game. After six seasons with Crystal Palace, he was transferred to Arsenal in 1991 for a club record fee of £2.5 million. He repaid manager George Graham's faith by scoring 24 goals in only 30 games in his first season, including three hat tricks. In 1993, Arsenal won both the FA and League Cups, and in 1994–5 they were runners-up in the Cup Winners' Cup, with Wright scoring in every round. But despite his impeccable scoring record for his club, especially in cup games, his England caps have been limited.

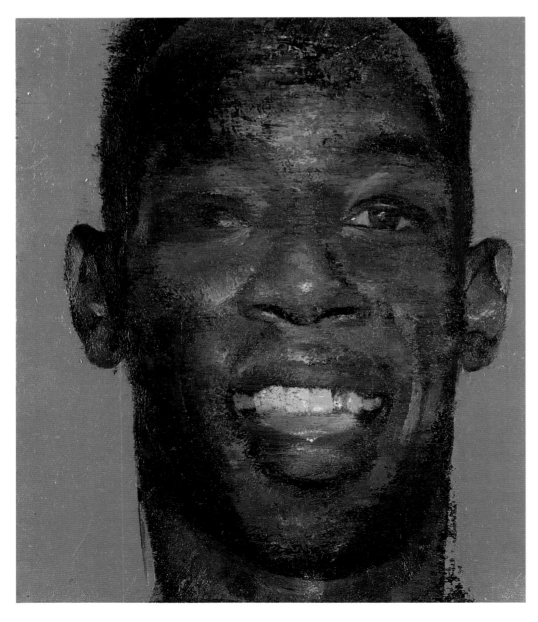

Ian's Gold Tooth (Ian Wright)
Justin Mortimer, 1995
Oil on board, 370 x 330mm
Private Collection

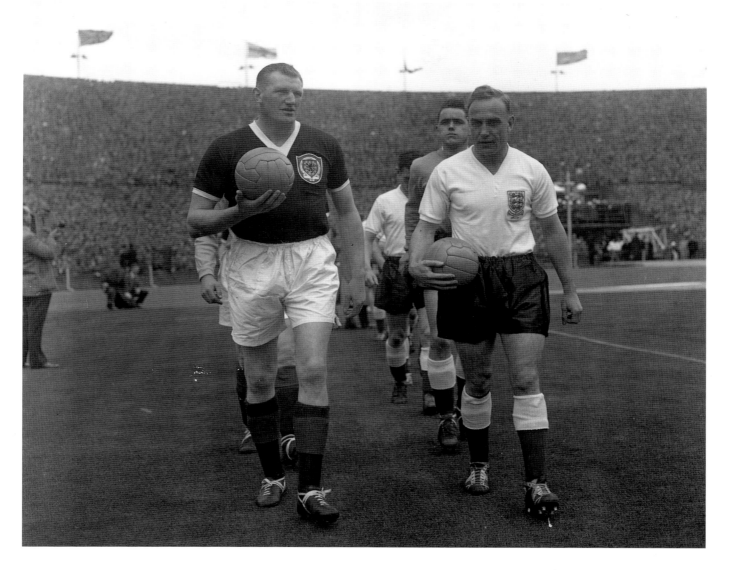

George Young (b.1922)
Football

From 1946 to 1957, George Young marshalled the defence for Rangers and Scotland. His achievements, including 53 Scottish caps, 34 consecutive internationals and 48 matches as captain, established him as Scotland's foremost international player until 1960. A giant at 6ft 2in and weighing 15st, he remained a loyal Rangers player throughout his career, and in 428 games over 11 seasons, helped the team to six Scottish championships, four Scottish FA Cups and two Scottish League Cups. In three seasons, Rangers won a league and cup double, and in the 1948–9 season, they won the treble, claiming the league title and both domestic cups. Young was an unspectacular player, and with his huge torso on long legs, looked a little ungainly. Yet he rarely came out second in a tackle, and his timely outstretched leg saved many an advance on his own goal. His distribution on winning the ball consisted of a highly accurate long ball, leading to a counter-attack in seconds and leaving opposing defences exposed.

George Young (l) and Billy Wright leading out the teams, England vs. Scotland, Wembley, 6 April 1957
Hulton Getty
See also **Billy WRIGHT**

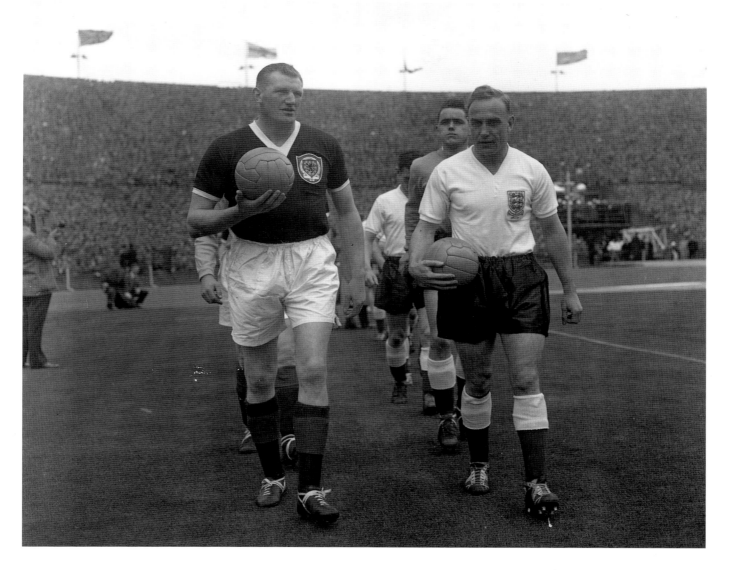

Sporting Heroes on Sporting Heroes

The National Portrait Gallery would like to thank Sir Bobby Charlton, Cecilia Colledge, Henry Cooper, Gerald Davies, David Gower, Sally Gunnell, Stirling Moss, Mary Peters and Lester Piggott for kindly contributing their top five sporting heroes for this catalogue.

Sir Bobby Charlton

1. Gareth Edwards. Brave, tough, competitive.
2. Jackie Milburn. Never spoke ill of anyone and took that attitude on to the field.
3. Henry Cooper. Not just a great boxer – a great sport.
4. Daley Thompson. Commitment and desire.
5. Jayne Torvill and Christopher Dean. Raised the sport to an art form.

Cecilia Colledge

1. Sir Gordon Richards
2. Jayne Torvill and Christopher Dean
3. Sir Roger Bannister
4. Fred Perry
5. Kay Stammers

Henry Cooper

My favourite sporting hero of all time was born Cassius Marcellus Clay in 1942. This internationally renowned American boxer adopted the name Muhammad Ali following his promotion from Olympic Games light-heavyweight champion to world heavyweight in 1964.

After refusing to be drafted into the US army in 1967, his title was withdrawn. Triumphantly winning his case against the US Supreme Court, he returned to professional boxing and went on to regain his world heavyweight title in 1974, subsequently losing and regaining the title until he finally lost it to Larry Holmes in 1980.

My five British Sporting Heroes are:

1. Ted 'Kid' Lewis – a world middleweight boxing champion whom I knew well when he was an elderly gentleman. He was a great character.

Followed by:

2. Sir Bobby Charlton
3. Lester Piggott
4. Denis Compton
5. Sir Henry Cotton

Gerald Davies

1. Sir Stanley Matthews – a 1950s childhood soccer hero: the soccer player as artist; the singular talent of one man rising above the *mêlée* of team effort. His gifts were amply displayed in the famous Cup Final at Wembley which, as golden memory still has it, he won single-handed.
2. Lynn Davies MBE – the only Welshman to win an Olympic gold medal (in Tokyo, 1964) in the intensely competitive and high-tension arena of track and field athletics. From a small Welsh valley village with no real tradition for the sport, his achievement – and his British long jump record still stands

after 30 years – demonstrates that anything is possible provided a person is endowed with the single-minded desire to succeed and the will power to win, regardless of the odds, which, in Tokyo, were heavily stacked against him.

3. Carwyn James – he represents the standards by which all rugby union coaches in these islands are measured. His premise was based on not treating rugby players as if they had the mentality of muddied oafs. Seeing his role as resolving complexities into simplicities, he adopted a cerebral approach to his game more akin to our continental neighbours than to that of the more stolidly pragmatic British mood. He succeeded not only with Welsh club and Lions teams, but also with a club in Italy. A philosopher-king he was most certainly no barking sergeant-major.

4. Ted Dexter – a cricketer, once again from my impressionable past, who combined an effortless elegance with the colourful temperament of the cavalier. He maintained the tradition of which Denis Compton was the exemplar (I didn't see him play. And to see the hero perform is a criterion I've adopted in this selection) and of which David Gower is the most recent example. A fine stroke player with a panache bordering on the reckless, there were more consistent run-getters, but Dexter's sense of gambling and adventure was compulsively attractive.

5. Danny Blanchflower – again, as I was growing up, he was the greatest captain of my favourite soccer team, Tottenham Hotspur, who succeeded in winning the 'double' of cup and league titles. A courageous competitor, wonderfully skilful, he applied a rare intelligence to his game's tactics and articulated his views, at the time and later, with clarity and humour. His team played beautiful attacking football; an inspiration. Like others on this list he gave the impression that his chosen sport formed only part of his life. It was he who said something to the effect that 'Sport was not just about winning. It was about going in search of glory.' That, I think gets closer than most to the point of it all.

David Gower

1. Denis Compton as the man who balanced supreme talent against the basic need to enjoy life to the full.

2. Bobby Moore – the quintessential gentleman cum England soccer captain.

3. Ian Botham as the embodiment of self-belief – he could/can do anything!

4. Gareth Edwards as the representative of a great era of Welsh rugby, closely attended by Barry John and J.P.R. Williams.

5. Steven Redgrave – he is the ultimate competitor, the definition of dedication.

Sally Gunnell

1. David Hemery
2. Mary Peters
3. Bobby Moore
4. Sir Bobby Charlton
5. Red Rum

Stirling Moss

1. Sir Roger Bannister for his fantastic mile so many years ago.
2. Jimmy Clark because of his superb motor racing career and gentlemanly character.
3. Alex Higgins for bringing so much excitement to snooker.
4. Henry Cooper for contributing so much to boxing by his personality and respect for the sport.
5. John Surtees for achieving so much on both two wheels and four.

Mary Peters

1. Joey Dunlop
2. Cliff Morgan
3. Mary Rand
4. Sir Roger Bannister
5. Henry Cooper

Lester Piggott

1. Fred Archer
2. Henry Cooper
3. Jim Clark
4. John Surtees
5. Sir Stanley Matthews

Picture Credits

We are grateful to the following owners and lenders to the exhibition and copyright holders who have kindly agreed to make their photographs available for reproduction in this catalogue: © Allsport: pp.1 (Mike Hewitt), 59 (David Cannon), 81 (Simon Bruty), 83, 104 (David Cannon), 121, 129 (Mike Hewitt), 154 (Bob Martin), 157 (David Cannon), 158, 170 (Jamie Squire), 181 (Anton Want), 191 (Mike Hewitt), 203 (Shaun Botterill) and 216; Bob Appleyard: pp.193 (© Reserved); © Collection of Edgar Astaire: pp.142; © John Austin: pp.32; © Richard Bailey: pp.115 and 118; © Peter Blake. All Rights Reserved, DACS 1998: pp.45; © The British Museum: pp.35, 39, 66, 78 and 179; © Michael J. Browne/Eric Cantona: pp.24; © David Buckland: pp.213; © The Burghley House Collection: pp.56 and front cover; © James Butler/Reg Harris Memorial Fund: pp.123; © C. Capstack Portrait Archive: pp.82; Michael Carr-Archer/George Beldham Collection: pp.190; © Henri Cartier-Bresson/Magnum Photos: pp.87; © Cheltenham Art Gallery and Museum: pp.141; © Colorsport: pp.4 and 5, 37, 70, 74 and 106; © Cottesbrooke Hall, Northampton: pp.163; © Cowie Collection, St Andrews University Library: pp.173; © Gerry Cranham: pp.43, 60, 138, 143, 156 and 221; © Andrew Crocker: pp.119 and back cover; *Derby Evening Telegraph*: pp.46; © Carol Djukanovic: pp.114 and 166; © Patrick Eagar: pp.49, 112 and 145; © Jillian Edelstein/Network Photographers: pp.67; © Ford Motor Company: pp.68; © Robert Gate Collection: pp.37 and 222; © Hulton Getty: pp.2 and 3, 28, 29, 30, 34, 36, 43, 47, 48, 54, 57, 61, 62, 63, 64, 72, 78, 85, 89, 91, 92, 100, 101, 103, 105, 117, 120, 124, 128, 136, 137, 140, 141, 146, 148, 149, 150, 152, 153, 155, 156, 157, 164, 165, 169, 171, 172, 175, 177, 182, 185, 187, 188, 192, 195, 206, 208, 209, 210, 212, 214, 218, 220, 223, 232, 234, 237 and back cover; © The Hamilton Collection, Brodick Castle (The National Trust for Scotland): pp.77 and 167; © Harris Museum and Art Gallery: pp.97; © Derek Hill: pp.69; © Jockey Club Estates: pp.197 and back cover; © Trevor Jones Thoroughbred Photography: pp.159; © The Klemantaski Collection/Colin Waldeck: pp.130; © Knightshayes, The Heathcoat-Amory Collection: pp.227; © David Mach: pp.125; © Marylebone Cricket Club: pp.76; © Marylebone Cricket Club, London, UK/Bridgeman Art Library, London/New York: pp.17, 40, 42, 110, 113, 178, 183 and front cover; © Alistair Morrison: pp.86 and 111; © Justin Mortimer: pp.236; © Sir Alfred Munnings Art Museum, Castle House, Dedham, Essex, England: pp.194; © John Murray: pp.139 (detail) and 240; © The National Horseracing Museum: pp.89 and 98; © Arnold Newman: pp.176; © North End News/Michael Scott: pp.16; © Terry O'Neill: pp.162; © Tim O'Sullivan: pp.107, 116, 199; © Tom Phillips/DACS: pp.50; © Popperfoto: pp.65, 79, 94, 115, 135, 144 and 168; © Private Collection: pp.52 (*The Set-to*), 138 (*A Flannelled Fighter*), 200 (*Tom Sayers, a fight history*), 205 (*Arthur Shrewsbury*), 215 (*York Meeting*) and 217 (*Fred Trueman*); © Professional Footballers' Association: pp.207; © Public Record Office: pp.18, 90, 102 and 168; Professor Peter F. Radford: pp.189 and 231; © Alex Ramsay (photography): pp.139 (detail) and 240; © Miriam Reik: pp.101; © Ray Richardson: pp.151; © Royal Albert Memorial Museum and Art Gallery, Exeter: pp.57; © Royal and Ancient Golf Club of St Andrews: pp.51, 75 and 174; © Royal Blackheath Golf Club: pp.108; Rugby Relics: pp.111; © Sefton Samuels: pp.44 and front cover; © Scottish National Portrait Gallery, Edinburgh: pp.196; © Gerald Scarfe: pp.38 and 73; © Mark Shearman: pp.127; © Chris Smith/*The Sunday Times*: pp.80, 93, 95, 160, 186, 202, 225, 228 and 235; © Lord Snowdon: pp.230; © Surrey County Cricket Club: pp.133 and back cover; © John Swannell: pp.204; © The Tate Gallery, London: pp.41 and 84; © Topham Picture Point: pp.180; © The Wimbledon Lawn Tennis Museum: pp.109 and front cover; © The Wimbledon Lawn Tennis Museum (Tom Todd Collection): pp.88; © By Courtesy of Michael Woodward: pp.53; © Liam Woon: pp.198 and 219 and © Yale Center for British Art, Paul Mellon Collection: pp.201.

Lord Byron's boxing screen
The main figures in the upper part of the screen are, from left to right: Jack Broughton,
George Stevenson, James Figg (half length), Tom Cribb, Tom Molyneux, John Jackson (with top hat).
Below: Thomas Belcher, Daniel Mendoza, Richard Humphreys, John Gully, Hen 'game chicken' Pearce
John Murray, on loan to Newstead Abbey, Nottingham